HENRY MOORE DRAWINGS

HENRY MOORE DRAWINGS

KENNETH CLARK

with 304 illustrations, 40 in colour

THAMES AND HUDSON · LONDON

© 1974 Thames and Hudson Ltd, London
Text © 1974 Kenneth Clark

Printed in the Netherlands by L. van Leer & Co. Ltd
Bound in the Netherlands by Van Rijmenam NV
ISBN 0 500 09098 X

Contents

Some time ago, with the approval of Henry Moore, I was asked to write an introduction to a selection of his drawings. I gladly accepted, but when I began to go through the five hundred or so photographs from which the reproductions were to be chosen I realized that a short introduction to such a large volume would be disproportionate and unhelpful. After several months spent in turning over these photographs, and trying to give them some rational order, I cut them down to about two hundred and fifty and tried to divide the drawings into ten categories, which could then be arranged more or less chronologically, although with inevitable overlaps. This is the plan of the present book. Like all classifications it involves a few omissions, and may sometimes seem rather forced. However, I believe that it will give the reader a better idea of how Moore's ideas developed than would a mechanical arrangement by date or subject. To each of these ten sections I have written a short introduction in which, by description or analogy, I try to help the reader understand what was in Moore's mind when he discovered certain forms or expressed certain emotions. I have avoided deep psychological explanations, partly because I am not qualified to make them, partly because Moore himself dislikes them. As far as possible I have talked about the actual drawings and not about the motives behind them. However, the fact remains that the best of Moore's work comes from somewhere very far down in his being, and the kind of straightforward technical approach that would work well enough for Degas or Menzel does not get us very far in front of Moore's external-internal forms. The analogies, and they can hardly be called explanations, that I put forward

will not satisfy everyone, but at least I can claim that they are the result of daily intimacy with the original drawings, and incorporate certain hints dropped by Moore when we have looked at the drawings together.

All the quotations of Moore's actual words will be found in the excellent compilation by Philip James called *Henry Moore on Sculpture* (1966). I am most grateful for the help given me in tracing drawings by David Mitchinson, who looks after the Moore archive with a kindness and efficiency that any museum curator might envy.

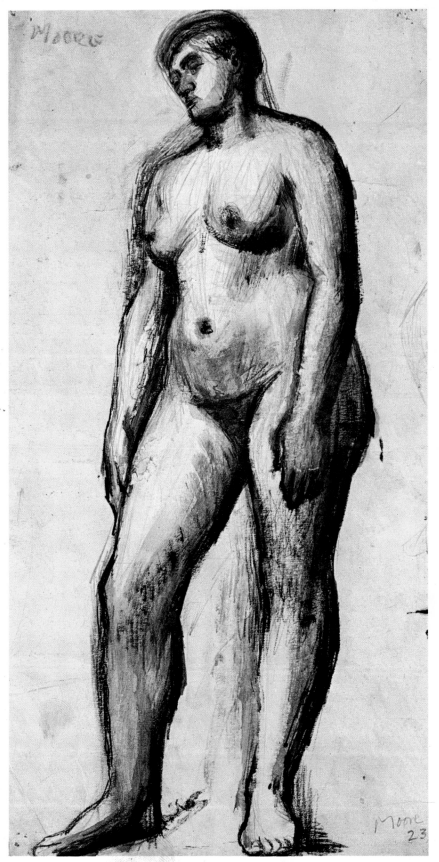

I Standing Figure · 1923

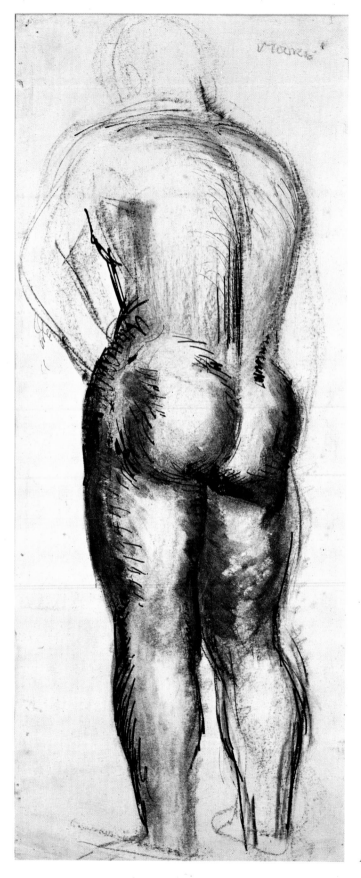

II Standing Male Nude · c. 1924

1 Life Drawings

It is impossible to write about Henry Moore's drawings without also writing about his sculpture. The best of them are studies for sculptural ideas, and even the early drawings of models seem to be part of the process of discovering his feelings about shape and weight that were later to be realized in wood, metal or stone. And yet the drawings have a life-sequence of their own, and, from about 1934 to 1948, they reveal aspects of Moore's character as an artist that might not otherwise have been comprehensible. They are magnificent works of art in themselves, and often foreshadow the best and greatest period of his sculpture in the 1960s.

As a student Moore was an exceptionally skilful draughtsman of the human body. The study of a reclining woman on *Pl. 1* would be an outstanding drawing in any epoch since the Renaissance. The black chalk drawing of a model seated on the ground (*Pl. 4*) would have been admired by any of the romantic artists from Géricault to Rodin.

Students sometimes do drawings in the life class which are as good as anything they ever do again, but these are only exercises. They do not discover in the model forms that relate to the artist's inner conviction. Early on in his life drawings Moore discovered those aspects in the figure that were to become necessary to him, and that must have embodied deeply buried experiences. These can be described by the words 'mass' and 'weight'. It was partly the sculptor's feeling that form is something one can put one's arms round. Ruskin said that 'bossiness or pleasant roundness irrespective of imitation' was the essence of all good sculpture; and, although he would have recoiled in horror from the standing figure on *Pl. 16*, those thighs and

11

buttocks perfectly illustrate his dictum, and anticipate as much as any of Moore's college drawings his mature form-world. As for weight, Moore has always felt that a basic fact of physical existence is the force of gravity. The model slumped on her stool is entirely subject to its pull (*Pl. 15*). A study of a woman standing shows in the modelling of breasts and shoulders how heavy a weight she has to bear (*Pl. I*), and even when she is young and thin she needs enormous legs (*Pl. 10*). A seated model leans on the pillar of her arm (*Pl. 14*), which becomes the whole subject of the drawing and anticipates the vital dominance of a single form in one of his greatest sculptures, the reclining figure with an arch leg of 1969.

Writers on Moore have sometimes tried to explain his work by analogy with natural objects that have accepted or defied gravity, the fallen rocks on the Yorkshire moors or the incredibly sustaining trunks of trees. These objects can indeed be related to his later sculpture, but I see no sign of their influence in his early drawings. On the other hand, the passage in an interview where he describes rubbing his mother's back with embrocation does seem to me relevant, and helps to explain, not only the mighty backs on *Pls. II* and *17*, but a drawing of a back (*Pl. 13*), in which plasticity is achieved by the simplest means, and, as in some drawings by Rembrandt, can only be the result of some experience deeply felt and stored. Thirty-three years later the same back reappears on the splendid bronze figure of a seated woman (*Pl. 12*).

A visit to Paris in 1928–29 was clearly a liberating experience. After the heavy solemn figures of the early 1920s, Moore did some drawings of superb sensuality and bravura (*Pl. 19*), and others that are stylish in a Parisian manner (*Pl. 18*) that was seldom to appear again.

Two years later, in England, he again set to work, in a more resolute spirit, on a series of life drawings which are a strange contrast to his other work, both graphic and sculptural, of the same years (1933–35). They are done directly from life, and represent a woman seated on a low stool or the arm of a chair, head and torso erect, one hand resting on an enormous knee (*Pls. 25–30*). They are drawn from very close to, and may have been undertaken as an exercise in foreshortening, by which a confined space adds to the effectiveness of weight. The whole emphasis is on the legs, which are often in almost identical poses. The torso is sometimes lightly indicated, some-

times carried almost as far as the legs. The curious thing about the drawings is not only the length of time that he continued to do them (his obsessions have often dominated him for three years or more) but the fact that they had no apparent influence on his sculpture. Almost all Moore's other drawings are of motifs that reappear in his sculpture; but the two or three carvings of seated women date from before the long series of drawings, as does a sheet of studies for a carving of a seated figure (*Pl. 24*). These variations on a theme of gravity have an impassive, undramatic dignity that does not reappear in Moore's work till the draped figures of the 1940s. As a stage in Moore's development they can, perhaps, be thought of as complementary to the ghostly inward-turning drawings of the same period, which are the subject of my third section.

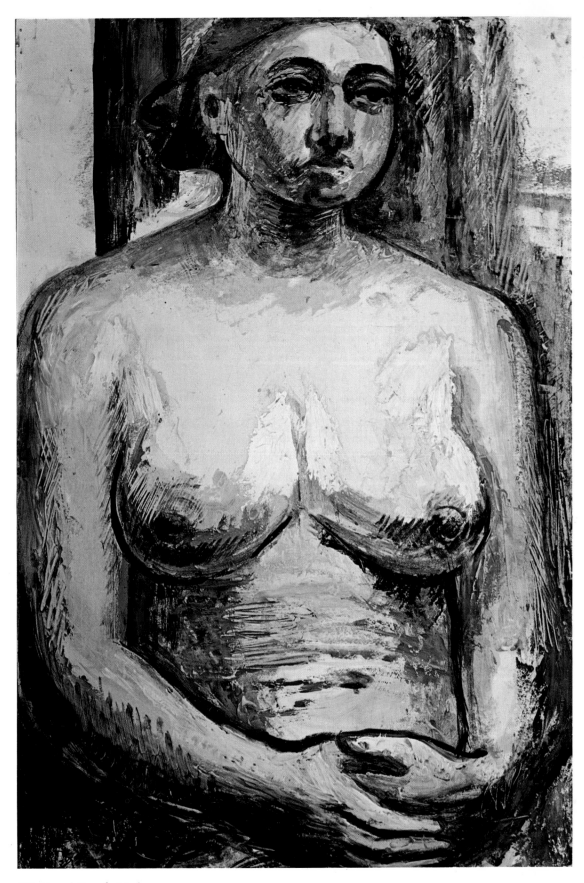

III Seated Female Nude · 1929

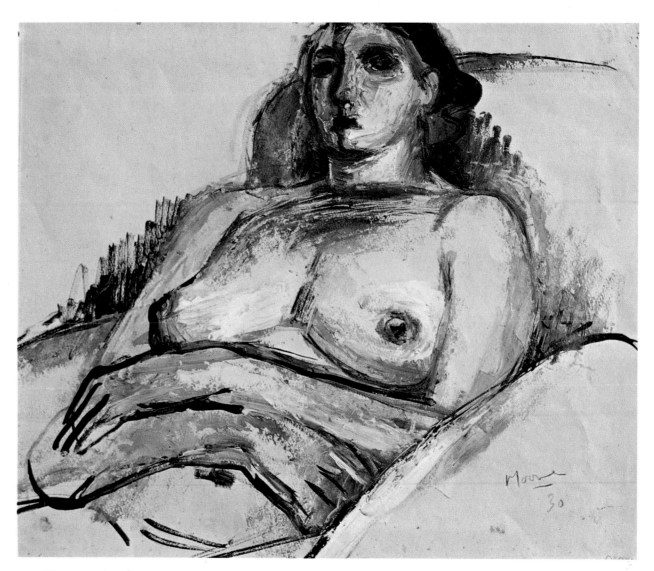

IV Woman in Armchair · 1930

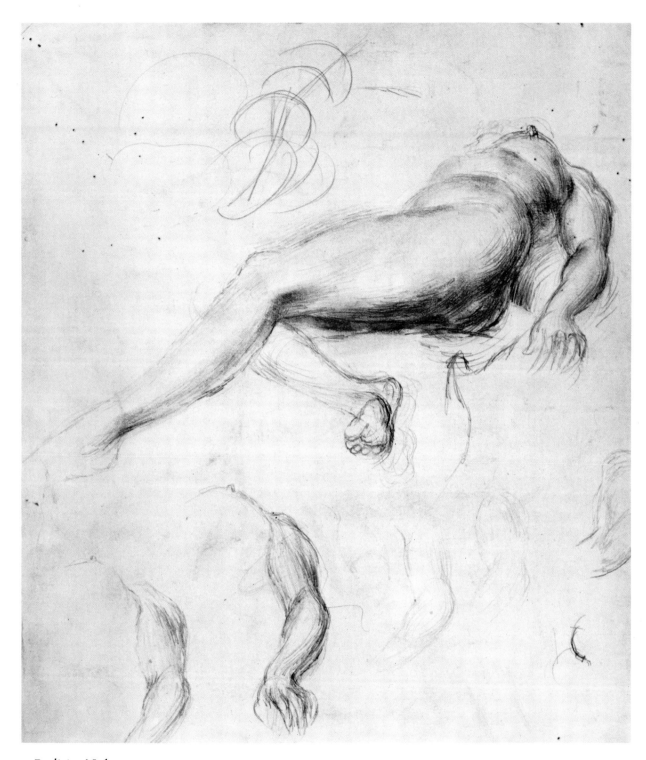

1 *Reclining Nude* · *1922*

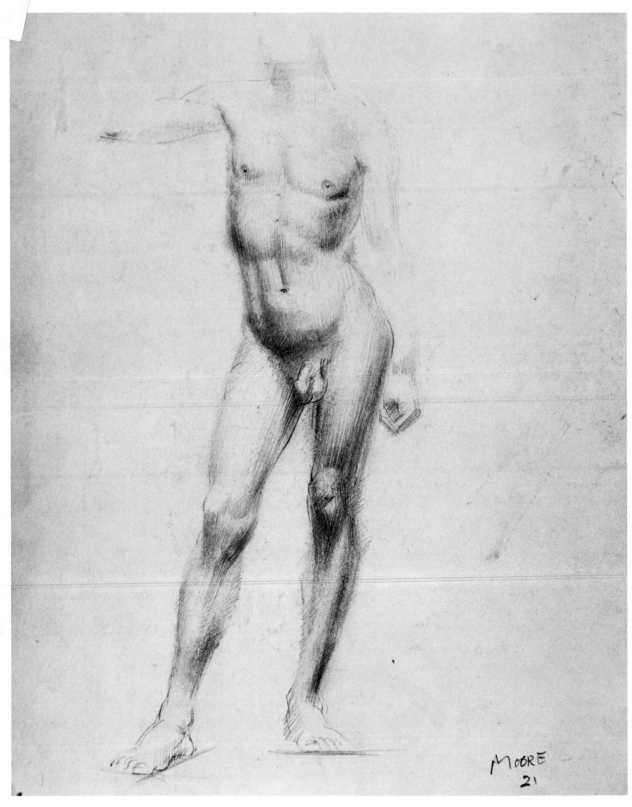

MOORE
21

2 *Standing Man* · *1921*

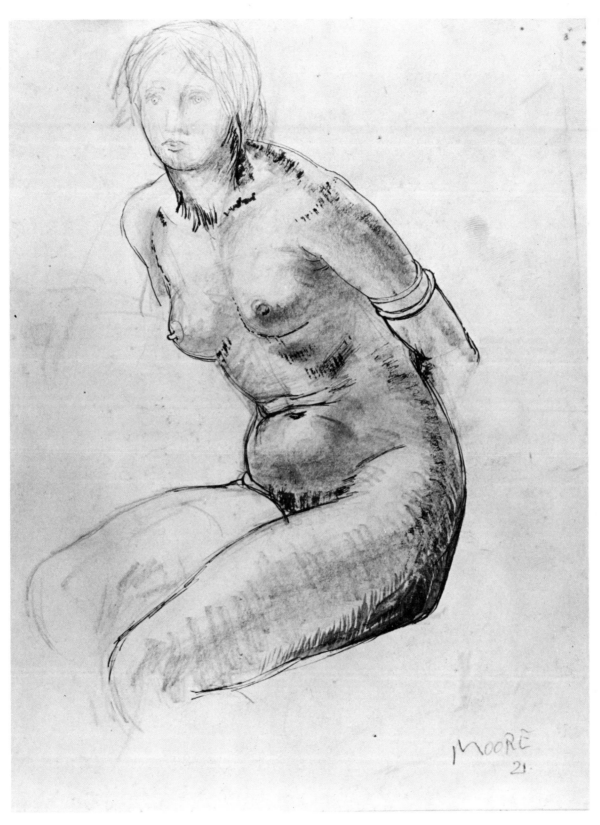

3 Seated Woman · 1921

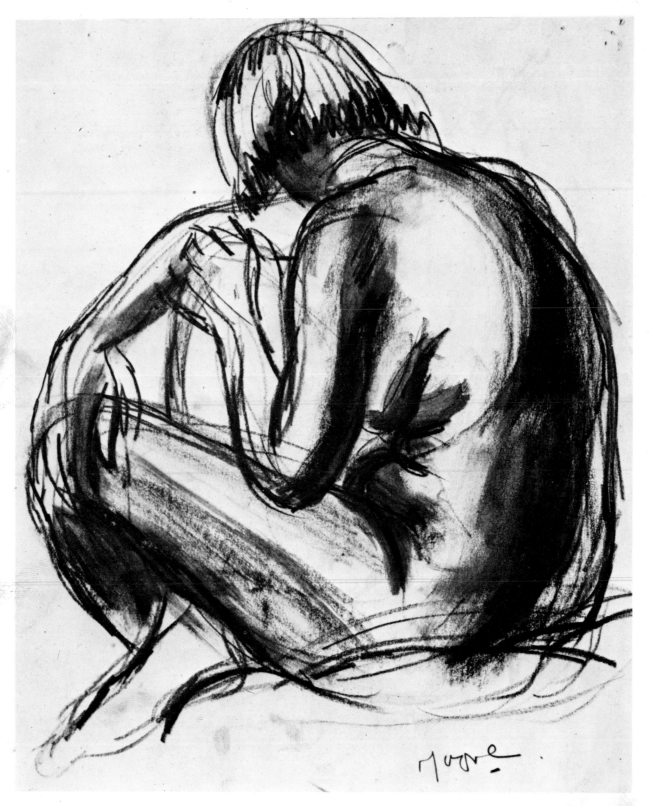

4 *Figure Study* · *1924*

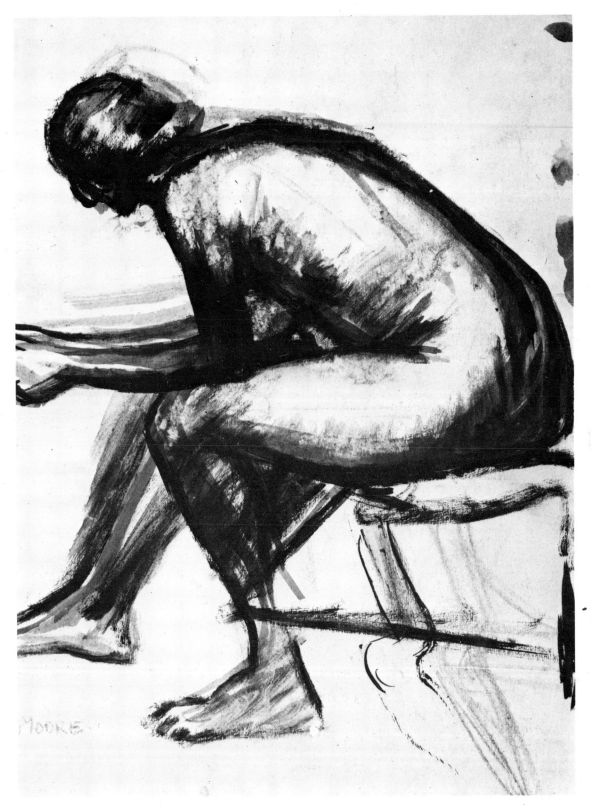

5 *Seated Figure* · *1923/24*

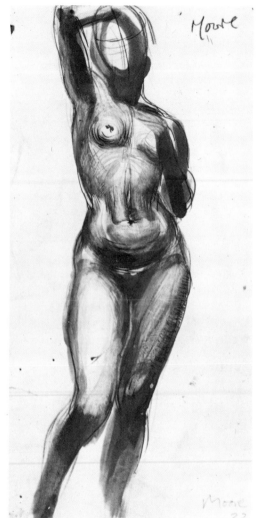

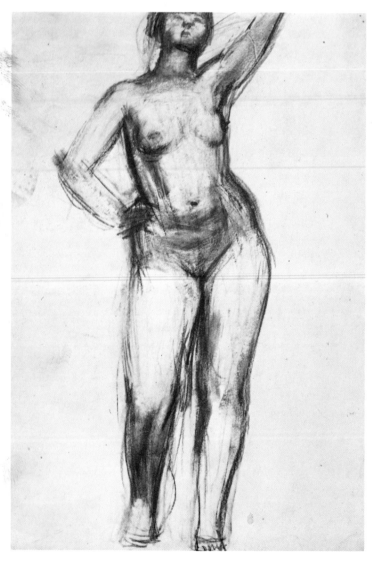

6 *Standing Girl · 1922*

7 *Standing Woman · 1923*

8 *Standing Nude · c. 1923*

MOORE

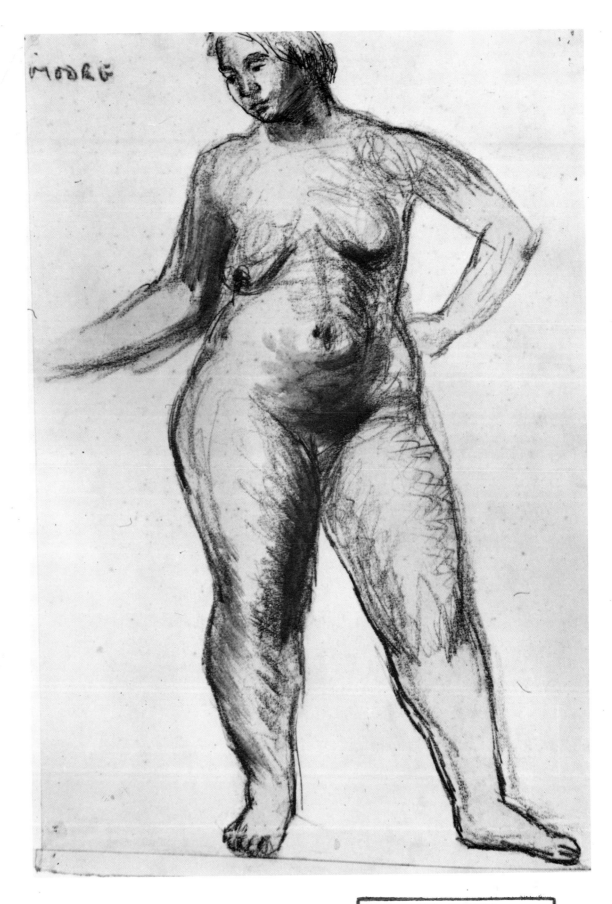

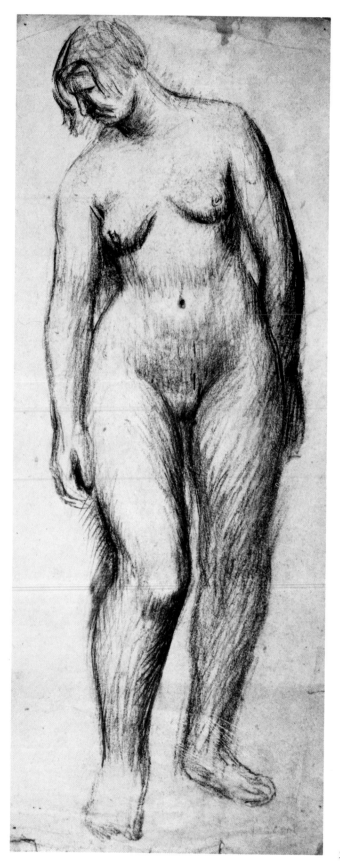

9 *Standing Woman · c. 1924*

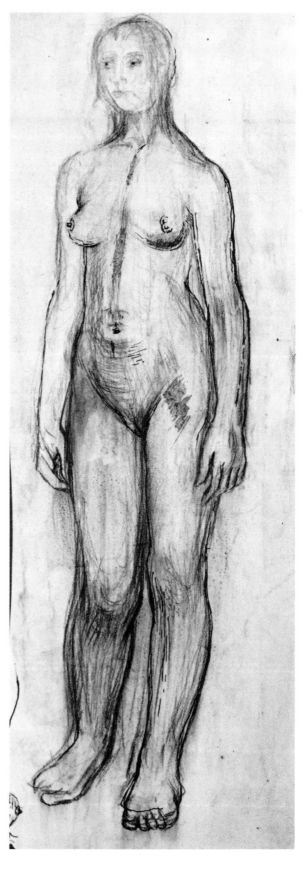

10 Standing Girl · 1924

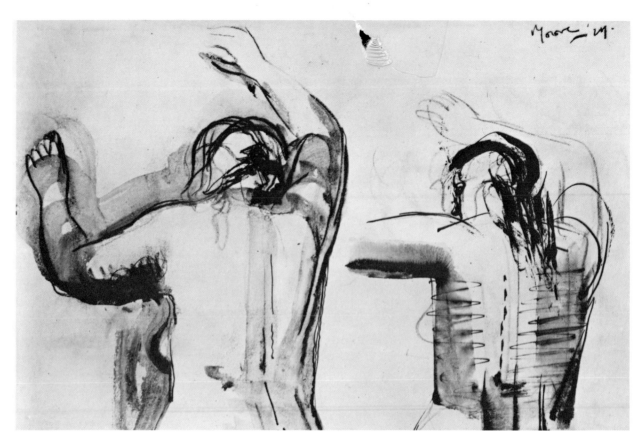

11 *Figures with Arms Outstretched* · *1927*

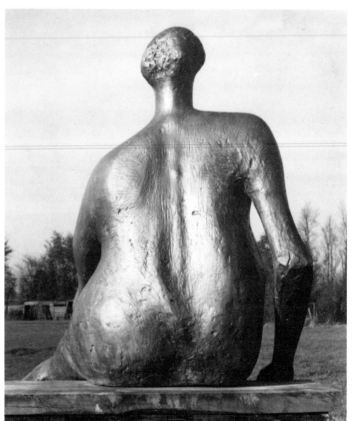

12 *Seated Woman* · *1957*

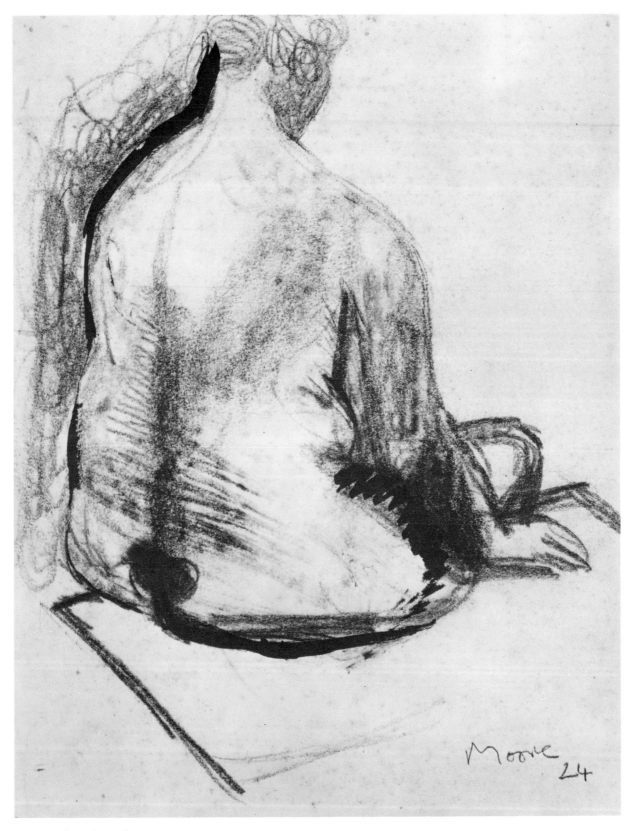

13 *Seated Nude, Back View · 1924*

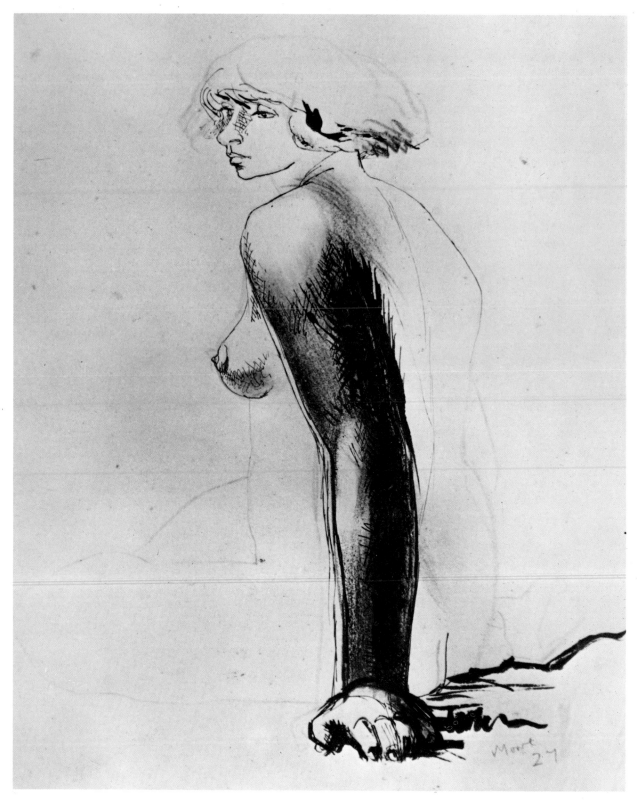

14 *Seated Nude, Life Drawing · 1927*

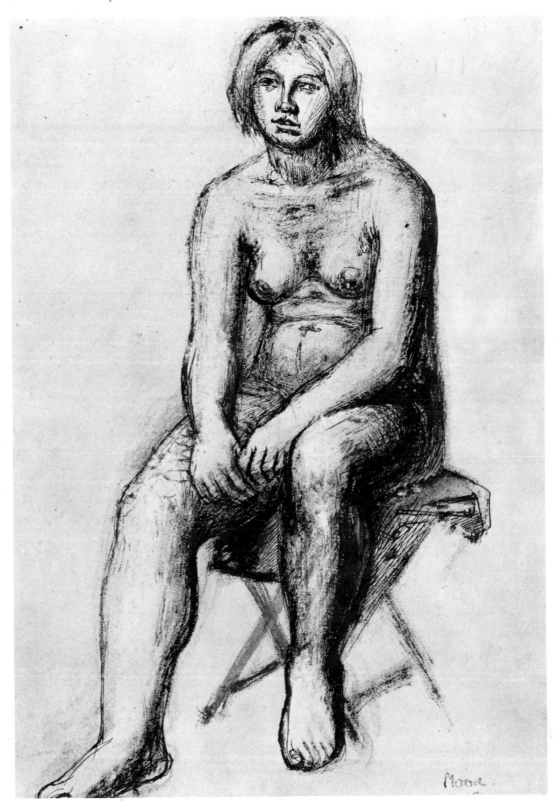

15 *Seated Nude · c. 1928*

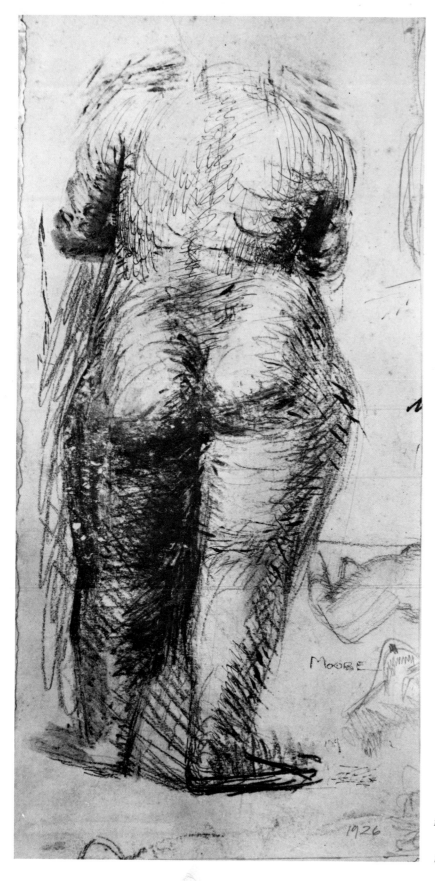

16 *Standing Figure, Back View* · *1926*

17 *Standing Figure, Back View* · *c. 1928*

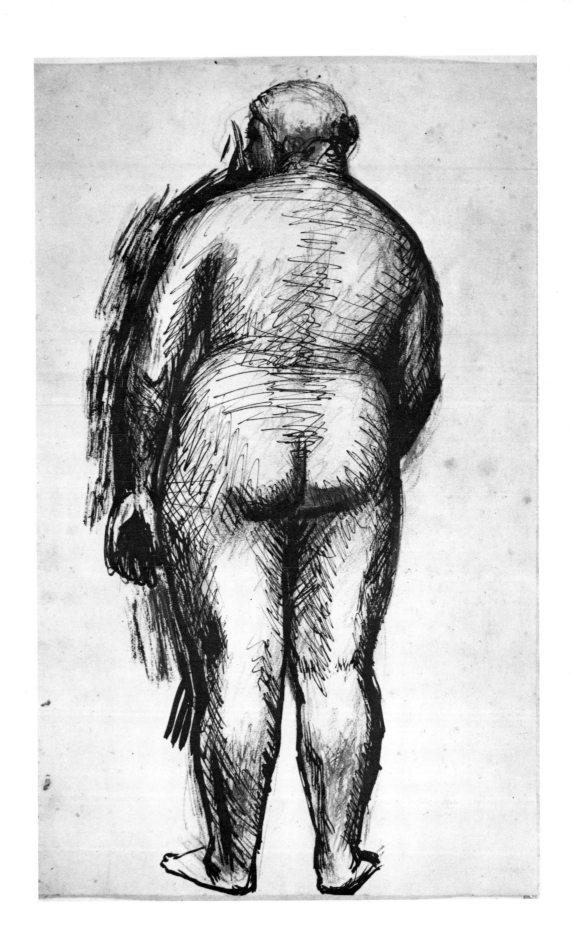

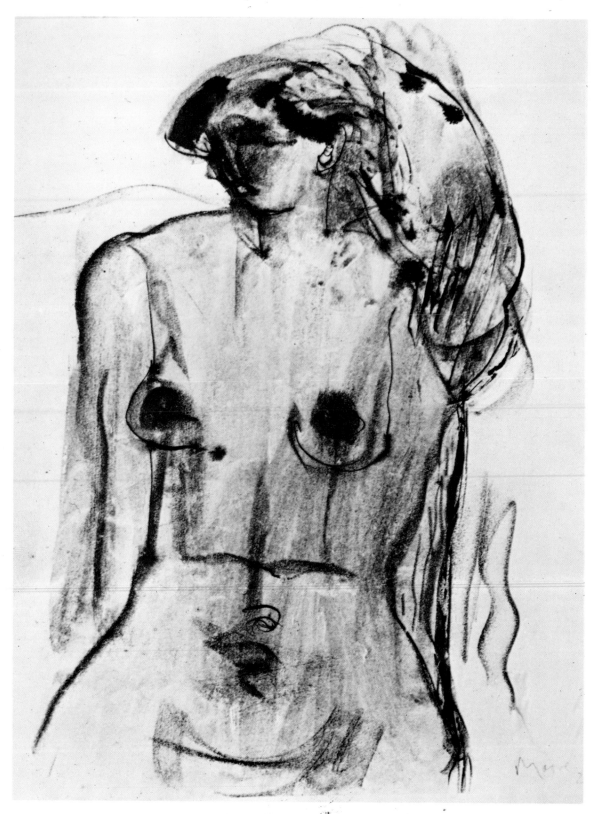

18 *Three Quarter Figure · 1928*

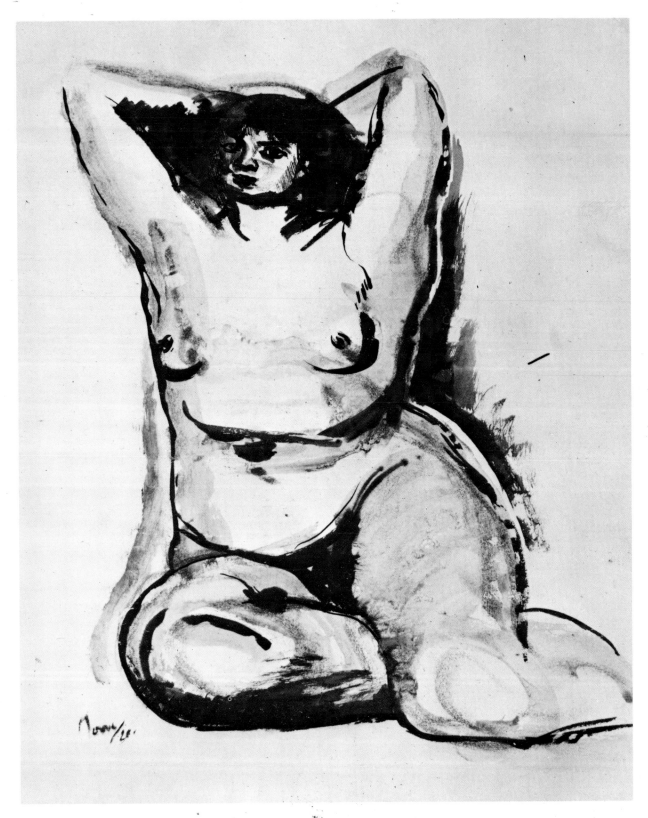

19 Seated Nude · 1928

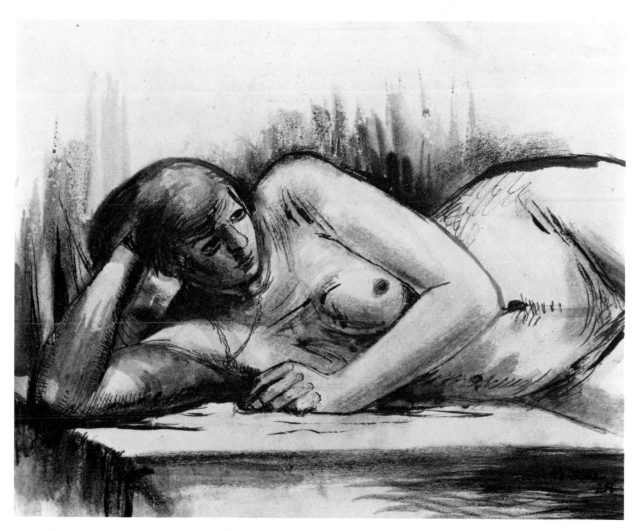

20 Life Drawing, Reclining Nude · 1928

21 Standing Female Figure · 1928

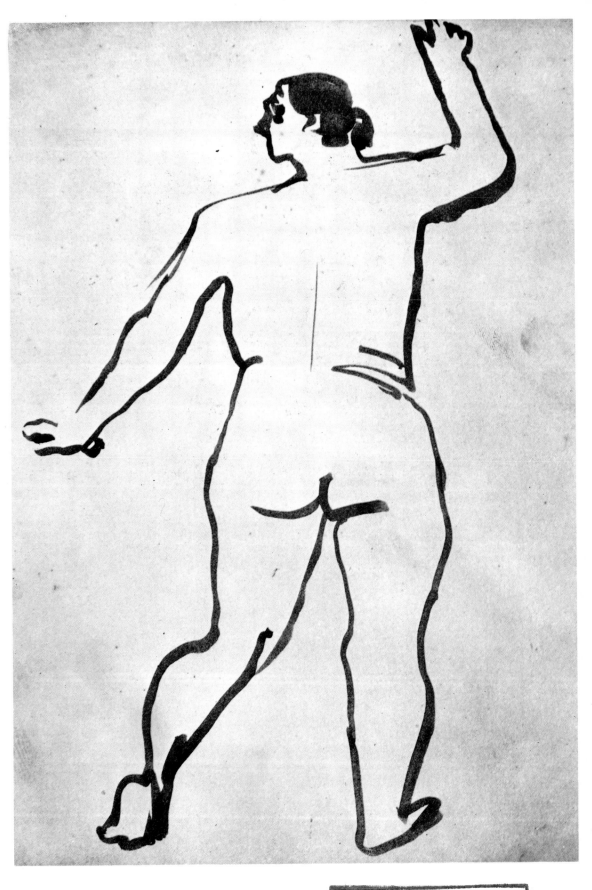

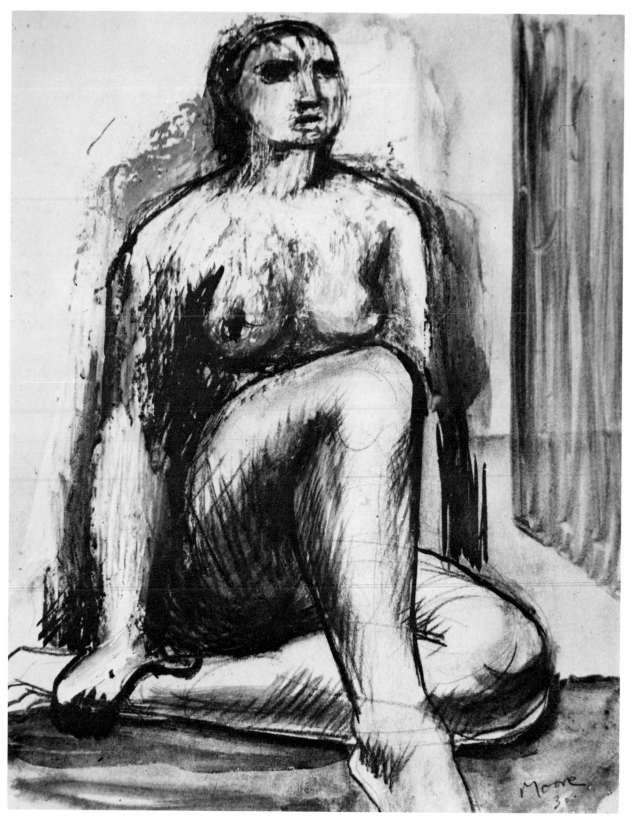

22 *Seated Figure* · *1930*

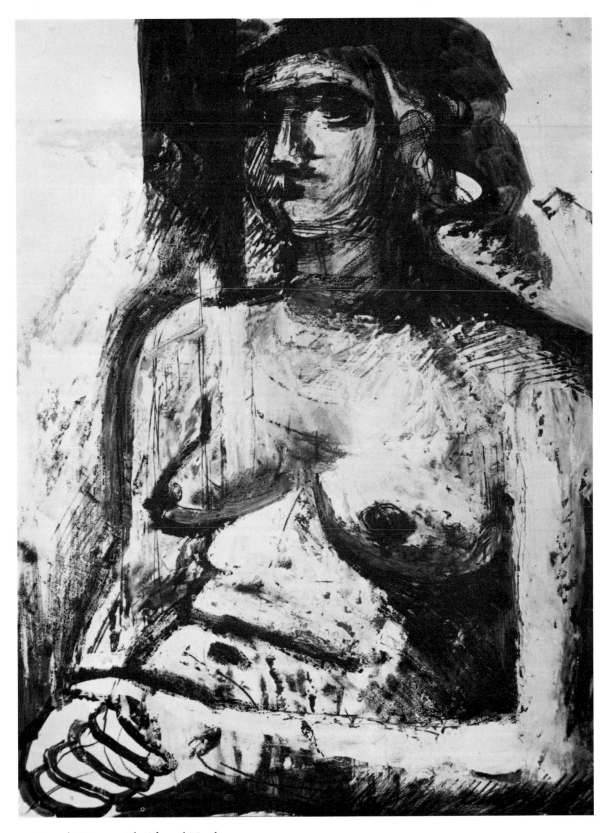

23 Seated Woman with Clasped Hands · c. 1930

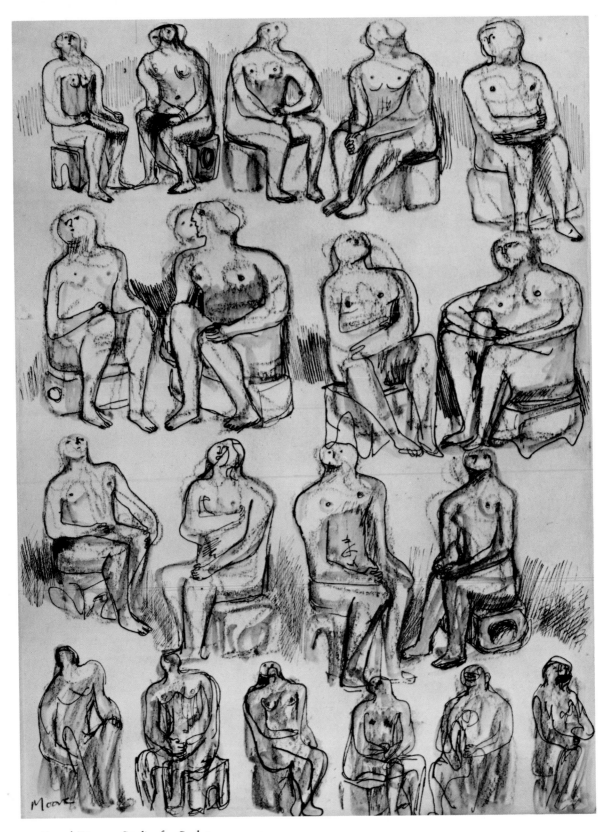

24 *Seated Figures, Studies for Sculpture · 1932*

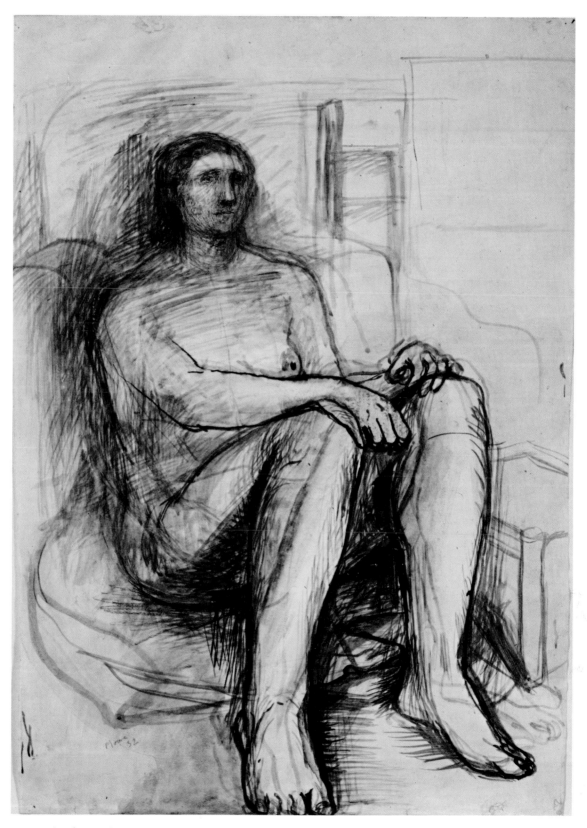

25 *Study of Seated Nude · 1932*

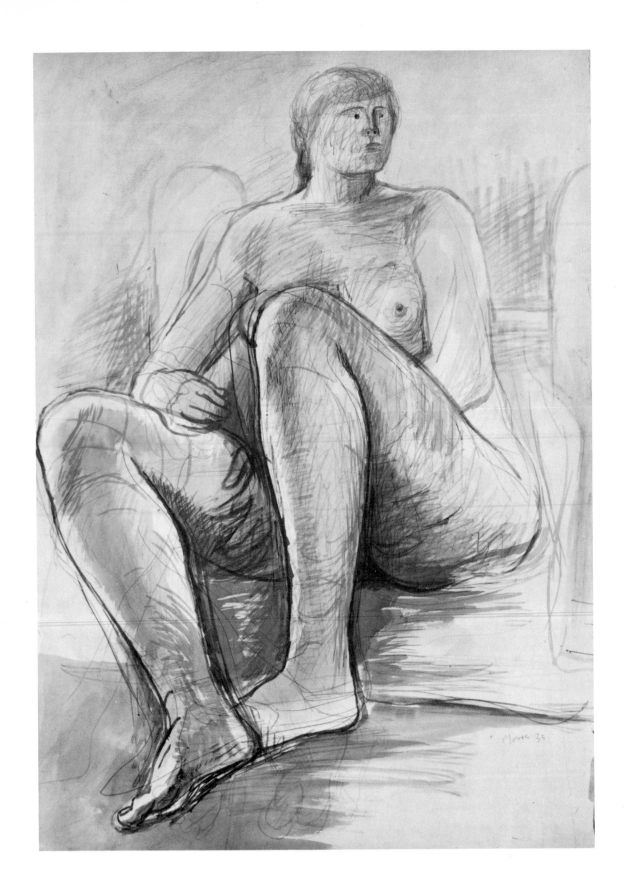

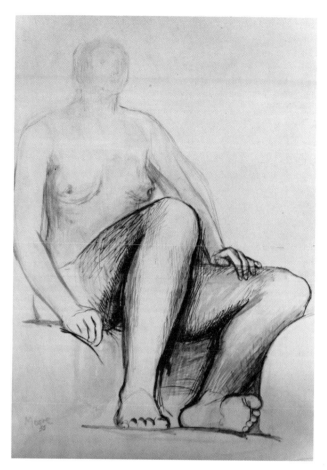

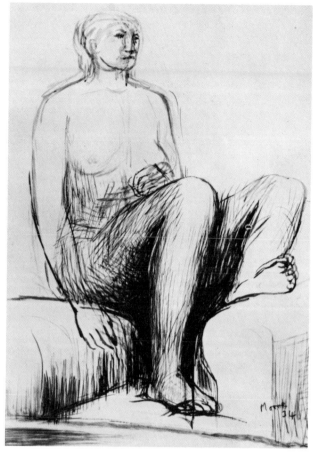

27 *Study of a Seated Nude · 1933/34*

28 *Seated Figure · 1934*

26 *Drawing from Life, Seated Figure · 1933*

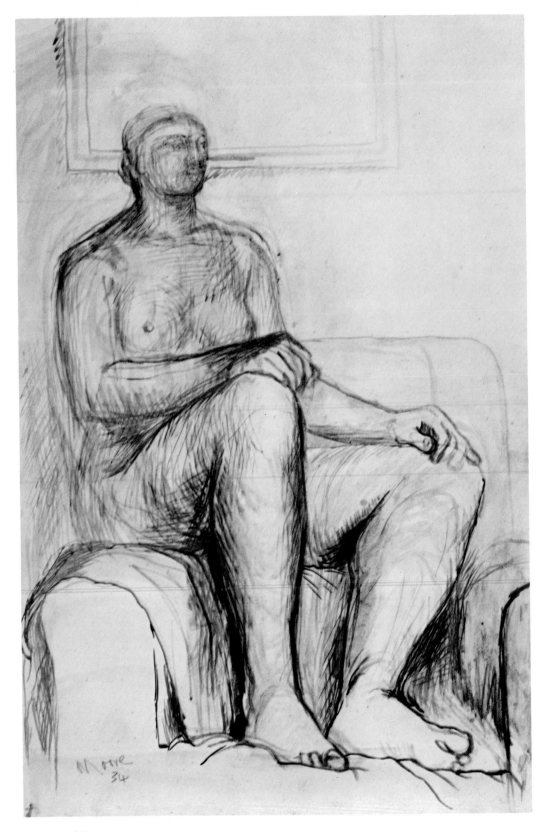

29 *Seated Figure · 1934*

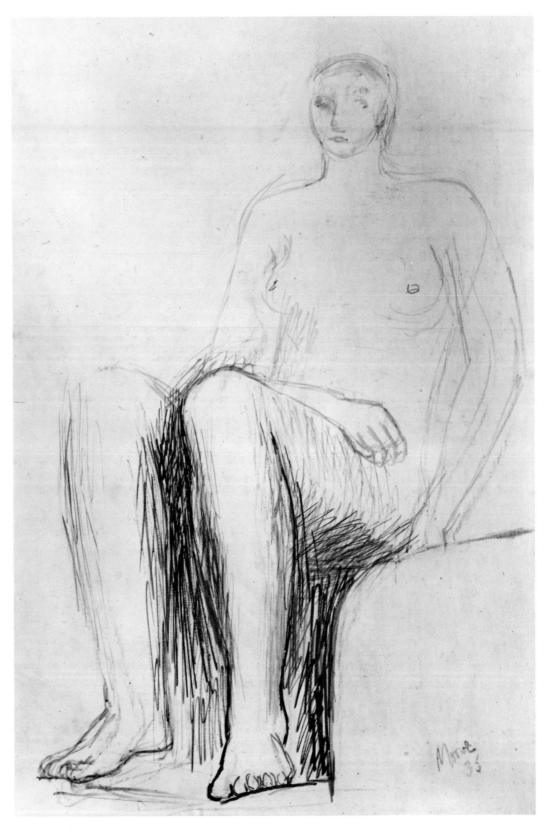

30 Seated Figure · 1935

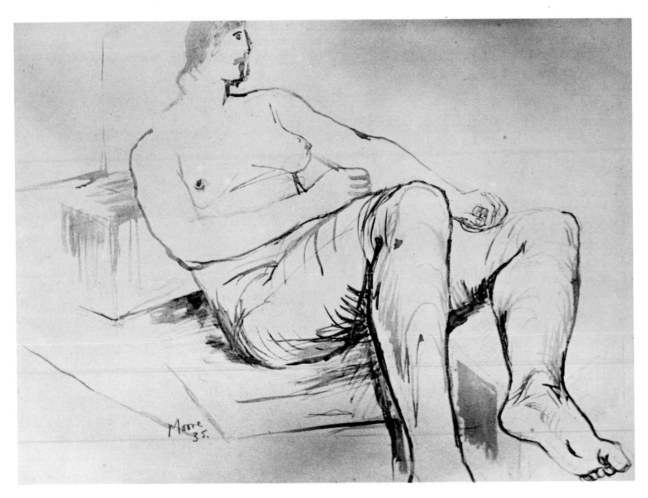

31 Reclining Woman · 1935

2 First Drawings for Sculpture

A magnificent drawing of a seated woman (*Pl. 32*) may be considered either as the culmination of the life drawings, or the first of those in which Moore discovers a sculptural style. It is dated 1928, the year of his first public commission, the North Wind on the St James's Park Underground building. He had of course been carving for some years, and in 1925 had executed an ambitious figure of a woman with a child on her back, now in Manchester, which is rather too self-consciously monumental. The drawings for it are also self-conscious (*Pls. 33–35*), and one sees that the struggle to achieve a personal style, the critical moment in any young artist's development, was still oppressing him. In Moore's case it was a particularly tough struggle because of his intense and catholic responsiveness to the art of the past. He could not sweep tradition aside, as could, shall we say, Jackson Pollock. He had been to Florence on a travelling fellowship in 1926, and been bowled over by the frescoes of Masaccio; also, although he hardly dared to admit it to himself, by the Michelangelos in the New Sacristy of San Lorenzo. But at that date Renaissance art was still the preserve of academies, and no student with Moore's need to belong to his own time could have allowed its influence to appear in his work. Instead he sought for his style in 'primitive' art: Negro, Cycladic, Etruscan, and above all Central American. Personally I think that these influences were much exaggerated by the earlier writers on Moore's sculpture. As it turned out Cycladic and Negro art were as remote from his sense of form as was the sculpture of Brancusi. But they were, so to say, the licensed liberators of the period, and there is no doubt that one piece of early exotic sculpture made a

45

great impression on him: the Maya-Toltec figure of a reclining man at Chichén Itzá, which Moore says he first saw reproduced in Elie Faure's *Histoire de l'art*. The relationship of man to the earth, which was to mean so much to him all his life, was already working in his mind, and this figure, with its simplified planes and its sharply turned head balancing, by dramatic emphasis, the upward thrust of the knees, seemed to give him an alternative to the two familiar solutions of Greece and the high Renaissance. He was thinking of the Chichén Itzá figure when he set to work on his first public commission, the relief on the Underground building symbolizing the North Wind. The Mexican figure appears, with relatively little modification, in some careful, laborious drawings in a sketch book used at the time (*Pls. 36–38*); it is in fact a one-aspect piece, almost a silhouette, and could properly inspire a relief. Moore's Underground figure, although a portent in English sculpture of the 1920s, has the look of a task rather than of a free creation, and introduces us to Moore's sustained dislike of commissions. A drawing done in Paris when the work on the North Wind was over shows the flying figure let out of school with a shout of joy (*Pl. 51*).

In the same year, 1929, contemplation of Mexican sculpture was to produce a masterpiece, the reclining woman now in the City Art Gallery at Leeds (*Pl. 43*). It retains the simplified planes of the Mexican piece, and the abrupt turn of the head: but as a composition in depth it is far more complex, and gives us the feeling of the beginning, rather than the impassable end, of an exploration. Soon afterwards Moore did some impressive drawings of a reclining woman (*Pls. 49, 50*), which anticipate the grandeur, but not the complexity, of the great recliners. During these years many of his finest carvings represent half lengths of a woman, often a mother and child. Moore has recorded how much this subject meant to him; but there are relatively few drawings of this motive (*Pls. 44–46*), perhaps because it came alive only in the execution. On the other hand this period contains the first drawing that foreshadows his use of metal, a sheet of studies of thin standing men (*Pl. 53*). It dates from about 1933, and, together with the first lead 'recliners', shows that the sanctity of stone carving is over.

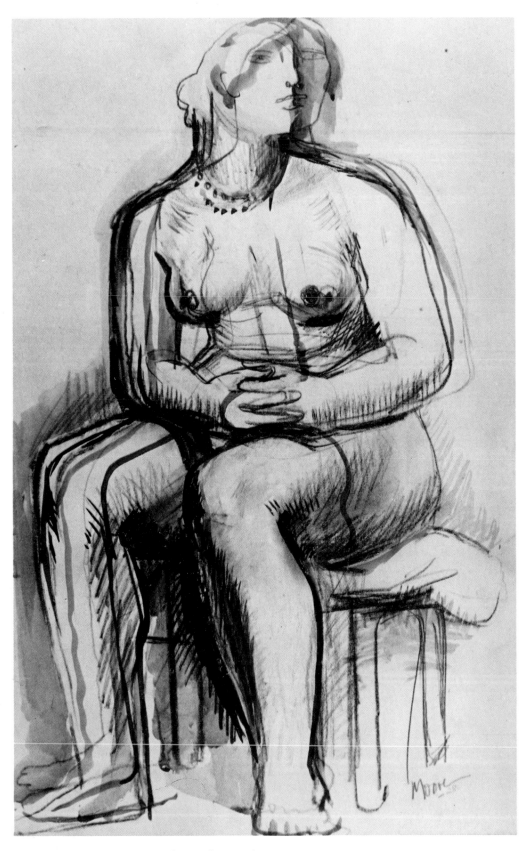

32 Seated Woman, Drawing from Life · 1928

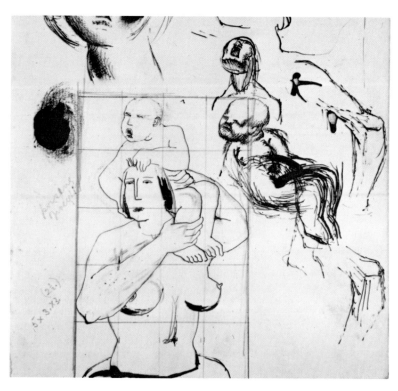

33 Page from Sketchbook (Fragment) · 1924

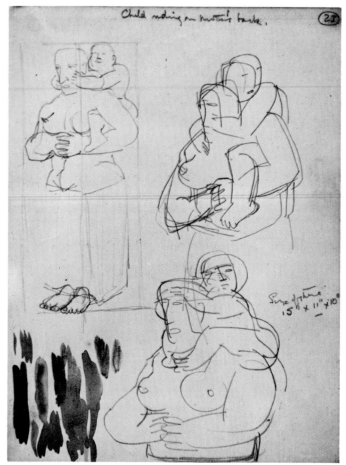

*34 Page 23 from No. 4 Notebook:
Mother with Child on Back · 1925*

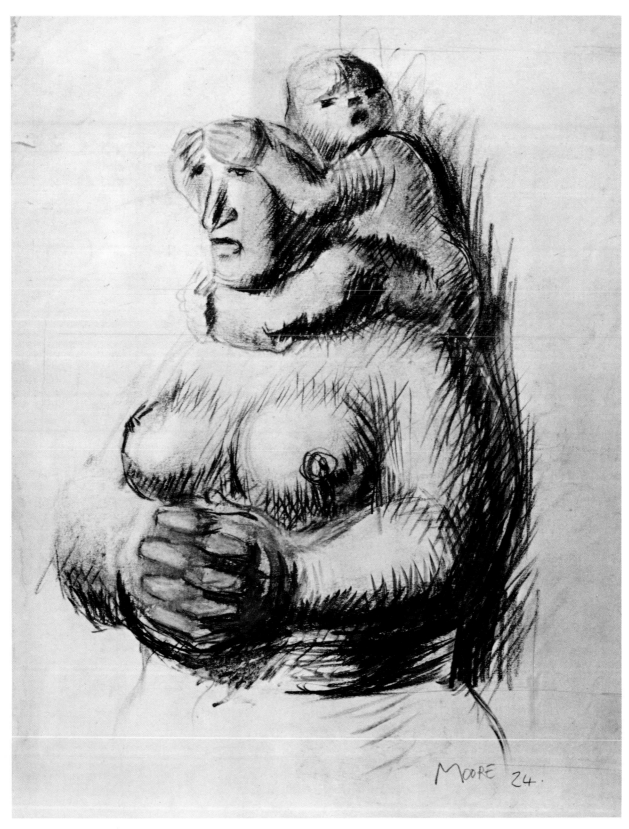

35 *Mother and Child · 1924*

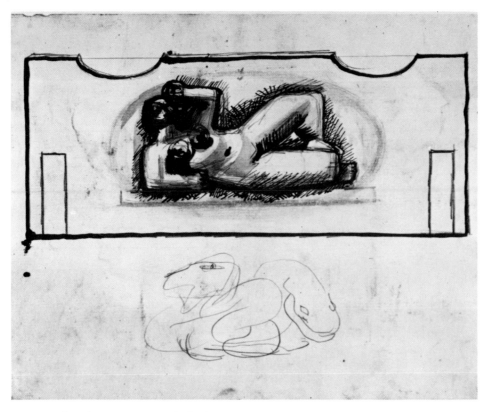

36 Page from 'Underground Relief' Sketchbook · 1928

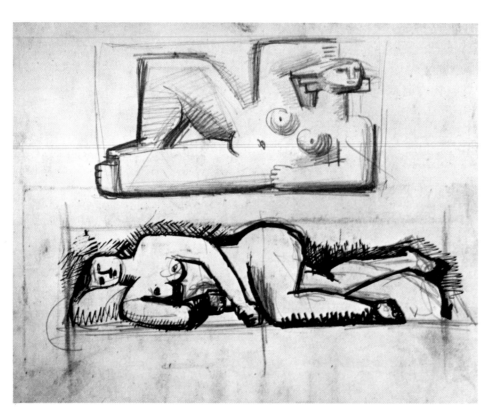

37 Page from 'Underground Relief' Sketchbook · 1928

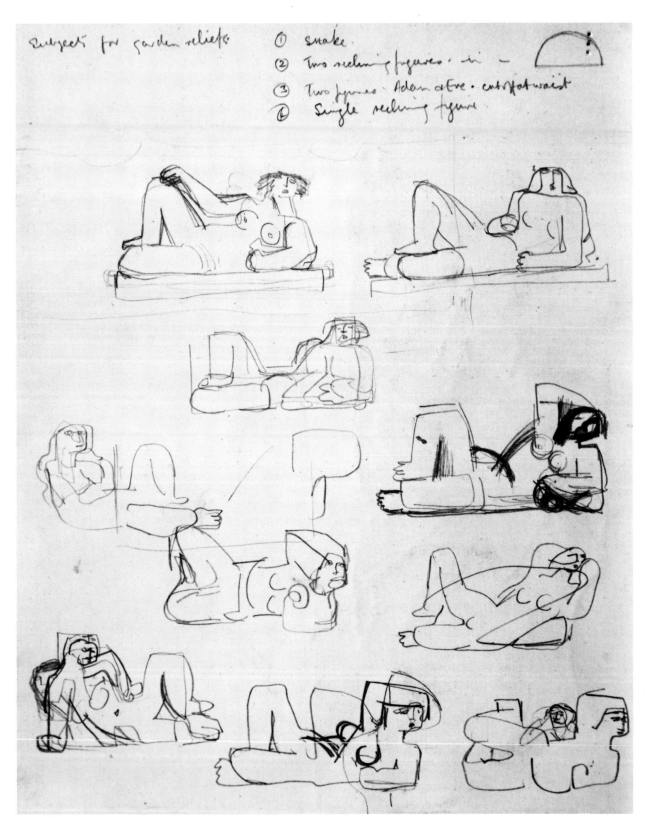

Subjects for garden reliefs ① snake.
② Two reclining figures. in —
③ Two figures · Adam & Eve · cut off at waist
④ Single reclining figure

38 *Page from 'Underground Relief' Sketchbook · 1928*

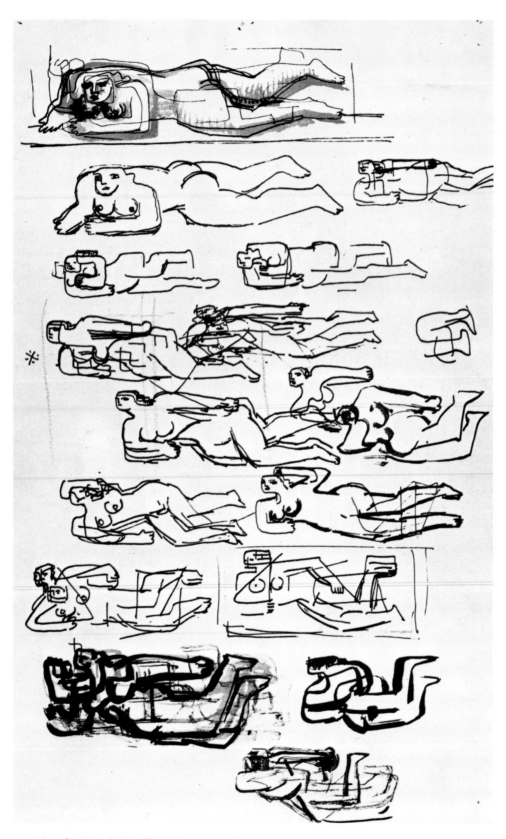

39 Ideas for 'North Wind' Sculpture · 1928

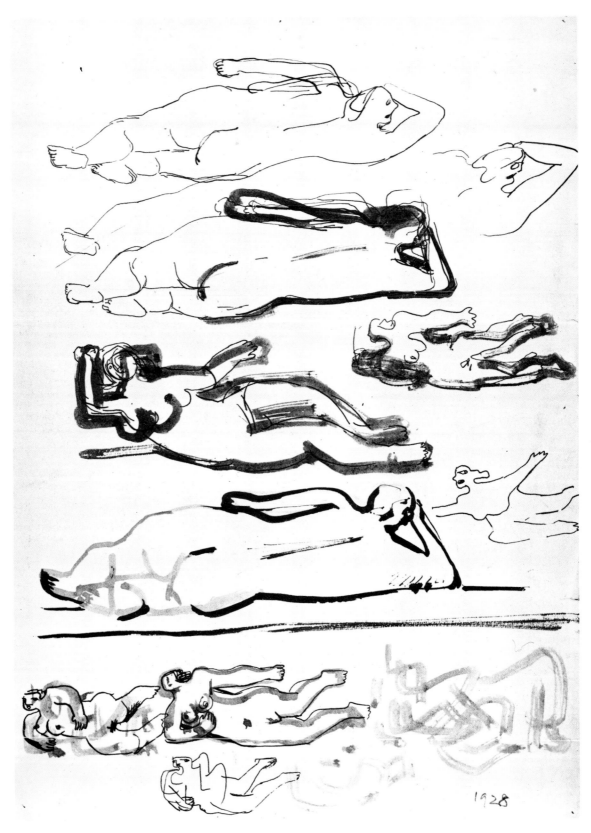

40 *Ideas for 'North Wind' Sculpture · 1928*

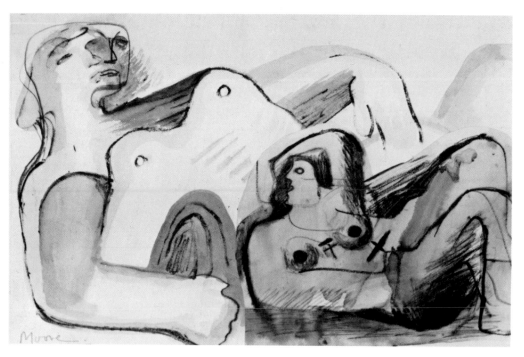

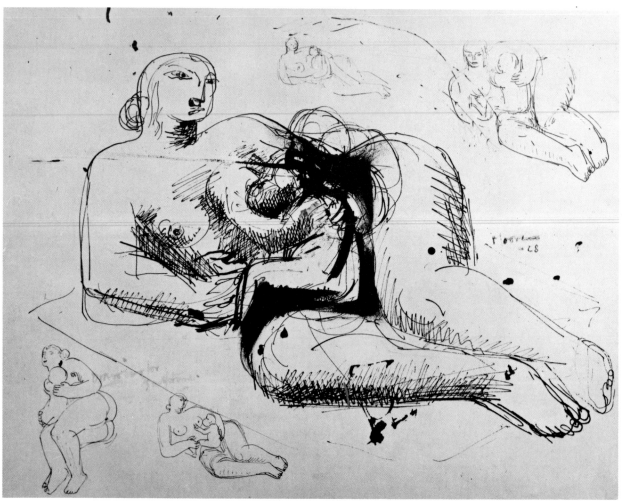

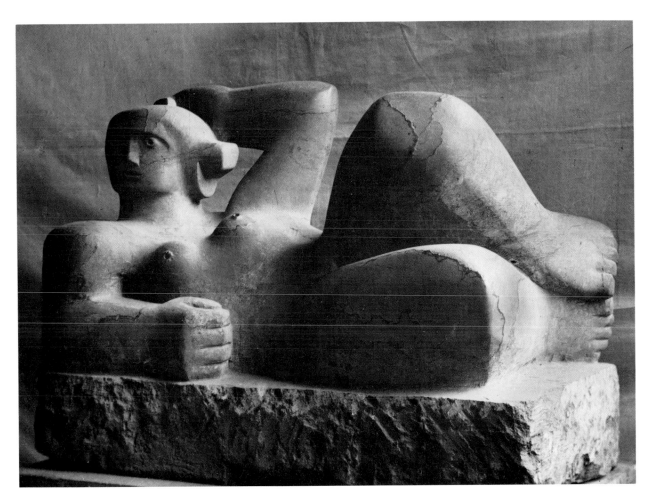

43 *Reclining Figure* · *1929*

41 *Montage of Two Studies for Reclining Figures* · *1928*

42 *Studies of Reclining Figure with Child* · *1928*

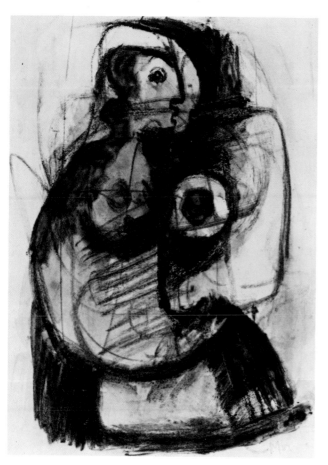

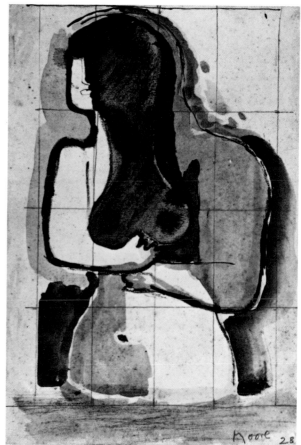

44 *Drawing for Sculpture · 1928*

45 *Half Figure · 1928*

46 *Half Figure (Drawing for Figure in Concrete) · 1929*

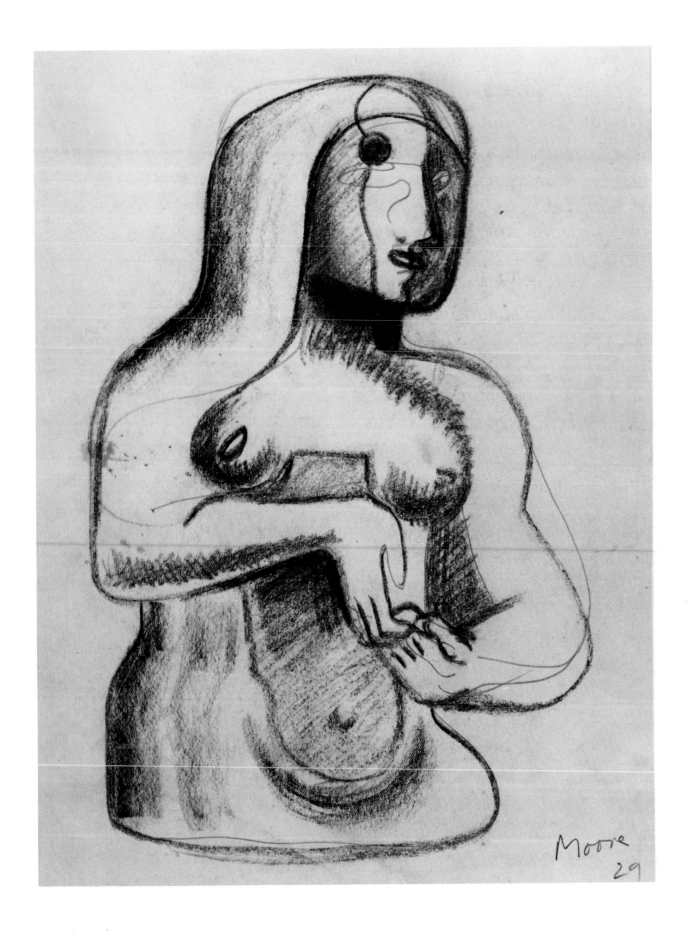

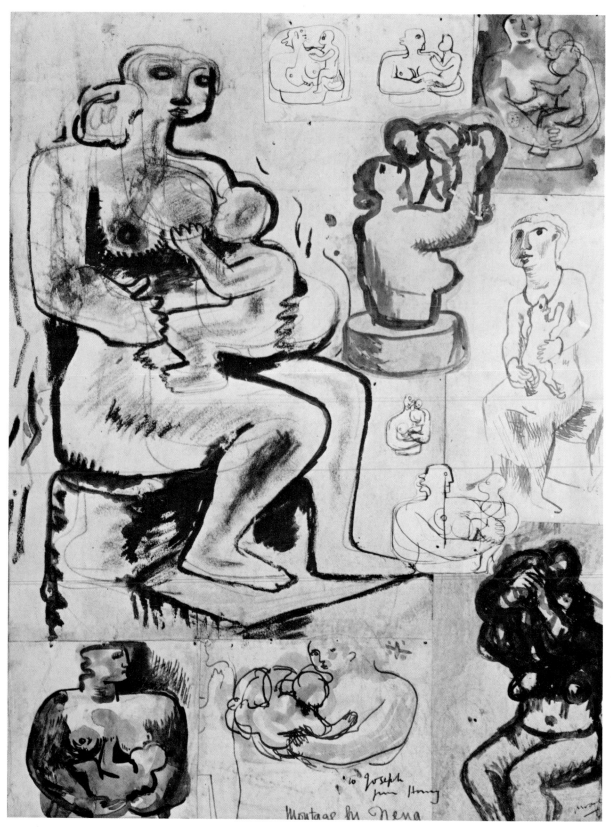

47 *Montage of Mother and Child Studies · c. 1929*

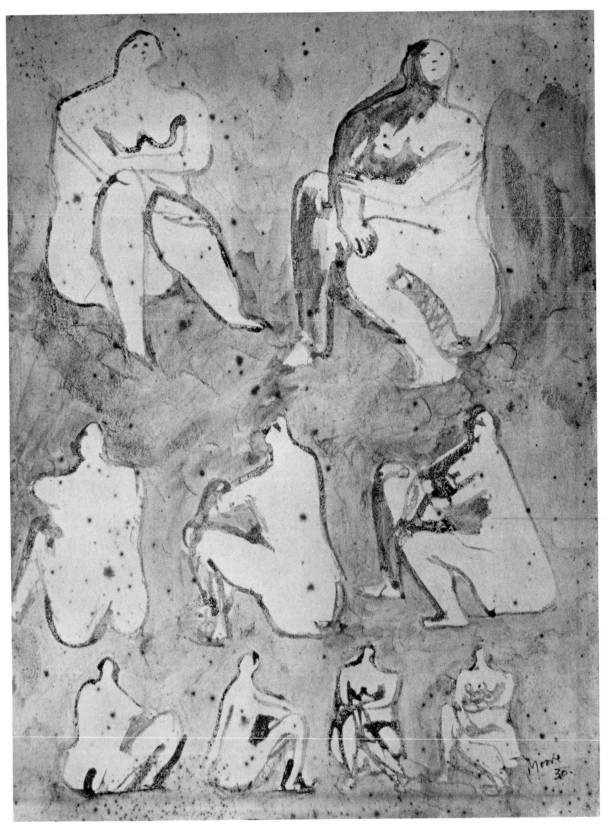

48 Drawing for Sculpture, Seated Women · 1930

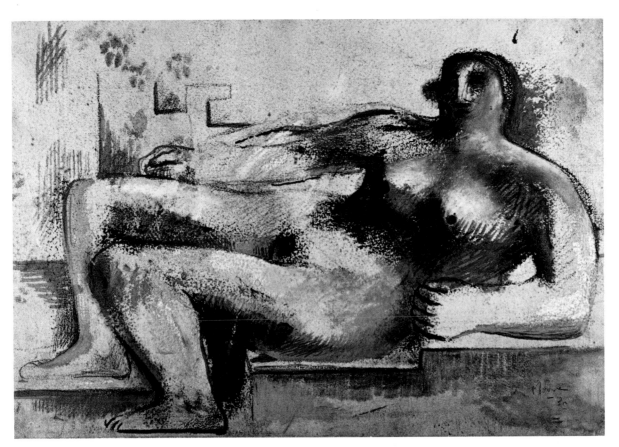

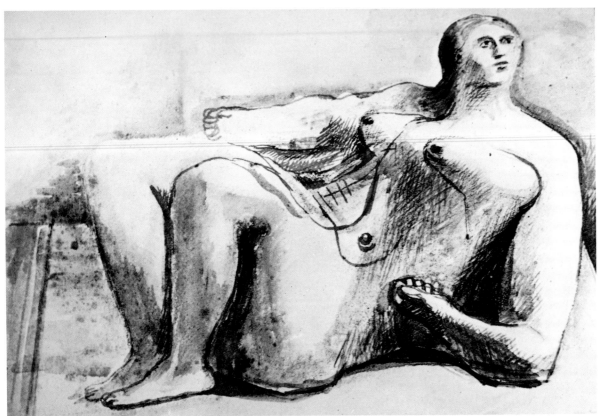

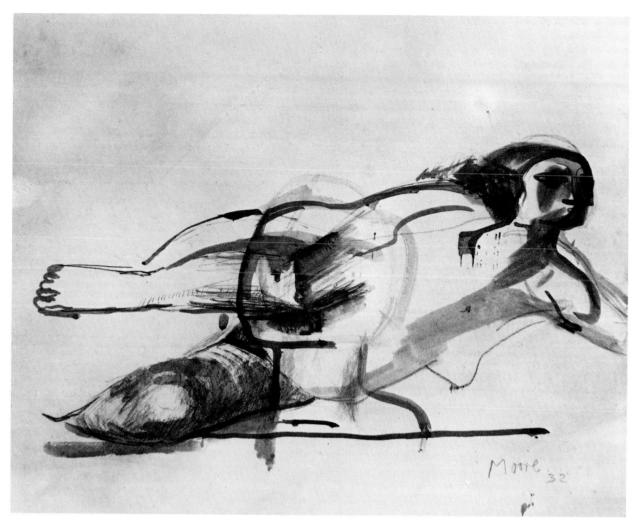

51 *Flying Figure · 1932*

49 *Figure on Steps · 1930*

50 *Reclining Woman · 1931*

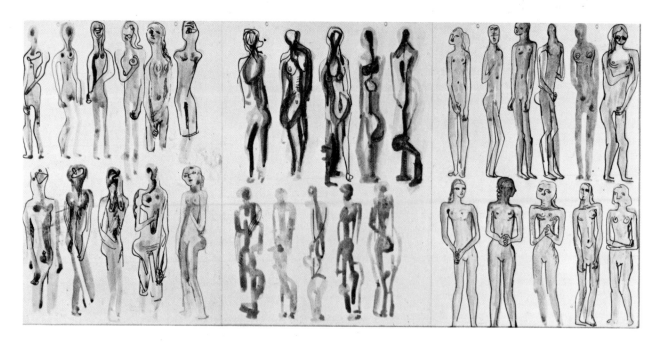

52 *Standing Figure (Ideas for Wood Sculpture)* · *1932*

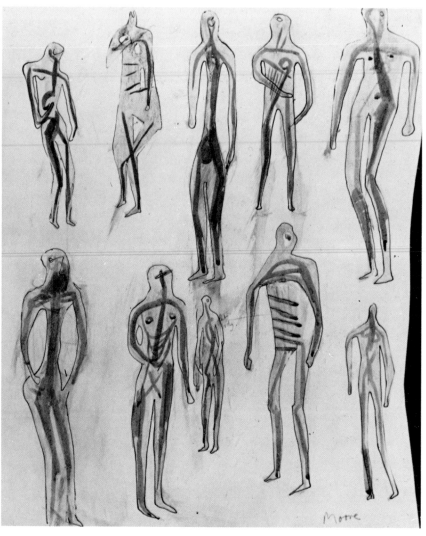

53 *Ideas for Bronze Standing Figure c. 1933*

3 *Looking Inwards*

Parallel with the variations on monumental legs, from 1932 to 1934, Moore was producing drawings of an entirely different character. I have called this section 'Looking Inwards', because for the first time he does not take as his point of departure the object that confronts him, with all its weight and substance, but evokes a curious form-world that was taking shape within him. It is pale, almost ghostly, as if the formal ideas it contains did not yet feel they had the right to a full existence; and yet how many of his later ideas are floating there already! Almost all of them have as their centre a reclining figure (*Pls. 60–65*); but it is a figure totally transformed from the still human female of a drawing like *Pl. 49*. The parts of the body—legs, breasts, arm and head—are just recognizable and are disposed with some memory of their anthropomorphic order. But in effect these figures are creations, the half-born children of Moore's formal imagination. In most of the drawings the main figure exists in a sort of caul or cocoon, and round it is a ring of much smaller figures, some echoing the central idea, others adding new and astonishing variations. Among these marginalia one may find many of the thoughts that were to be realized in Moore's sculpture at a much later date; and some of the central figures have the huge legs turning into a flint, the vestigial heads, and even the holes running right through, which were to excite and baffle early admirers of the sculpture. All these transformations suggest that Moore had begun to study the structure of fossils and pebbles; and in fact his earliest studies of stones are of this date, and in one of them (*Pl. 59*) we see the transformation taking place. These drawings are entirely personal; they come from a part of his imagination of which he

himself seems hardly to have been aware, and sometimes they are slightly spooky. This is particularly true of the fascinating drawing on *Pl. 63*, where the reclining figure idea has almost vanished, and in its place is a sinister and formidable goblin, who reappears years later in sculpture. As usual the central figure is surrounded, but these fringe benefits are of even greater interest, because they contain the germs of so many of Moore's ideas for sculpture in metal. As in the thin man on *Pl. 53*, Moore's plastic imagina-tion had gone far beyond the naive faith in carving, the pious materialism, of Eric Gill, and was pouring out inventions that could be realized only in metal.

These first explorations of his inner form world are among the most haunting of Moore's early works. They admit us to a shadowy ante-room of his mind. But one may conjecture that Moore found them too tentative and wayward. He needed to combine the firm grasp of form that appears in his life drawings with the new intuitions that were coming to birth in his imagination. Thus there followed, in the next few years, a resolute explora-tion and consolidation of his inner form-world during which many of his greatest and most durable ideas were born.

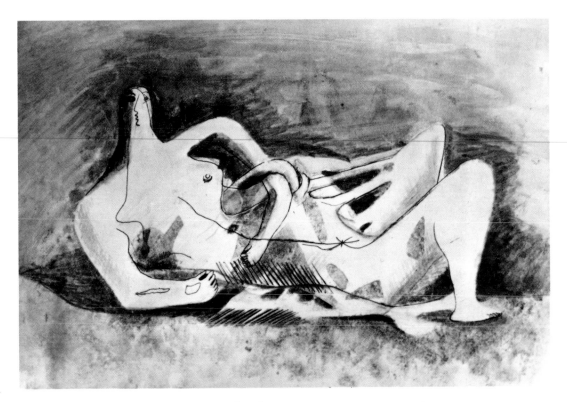

54 *Drawing for Reclining Figure in Reinforced Concrete · 1931*

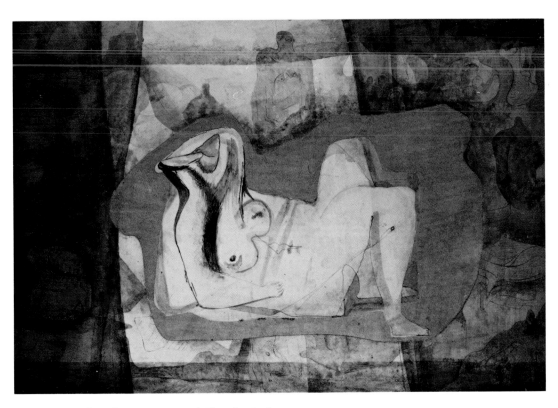

55 *Montage of Reclining Figures and Ideas for Sculpture · 1932*

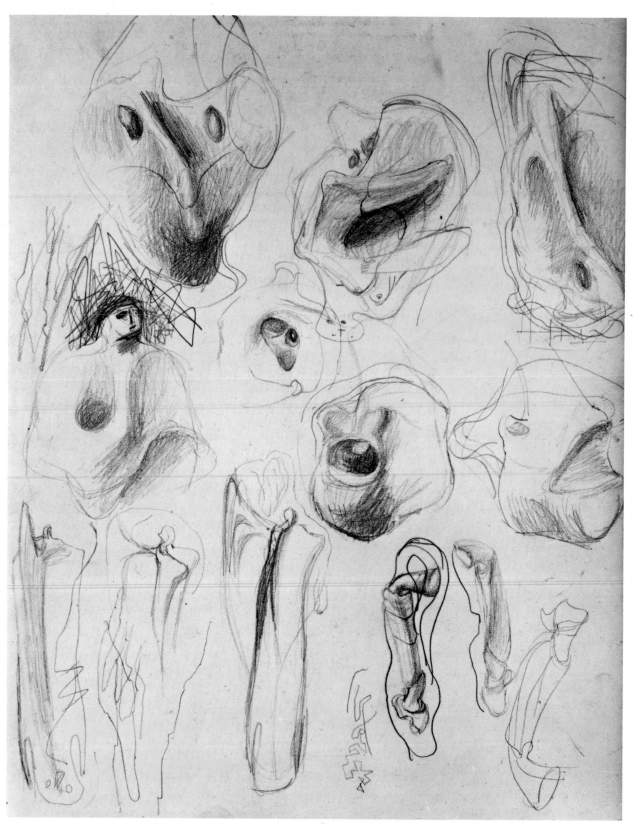

56 *Studies and Transformation of Bones · 1932*

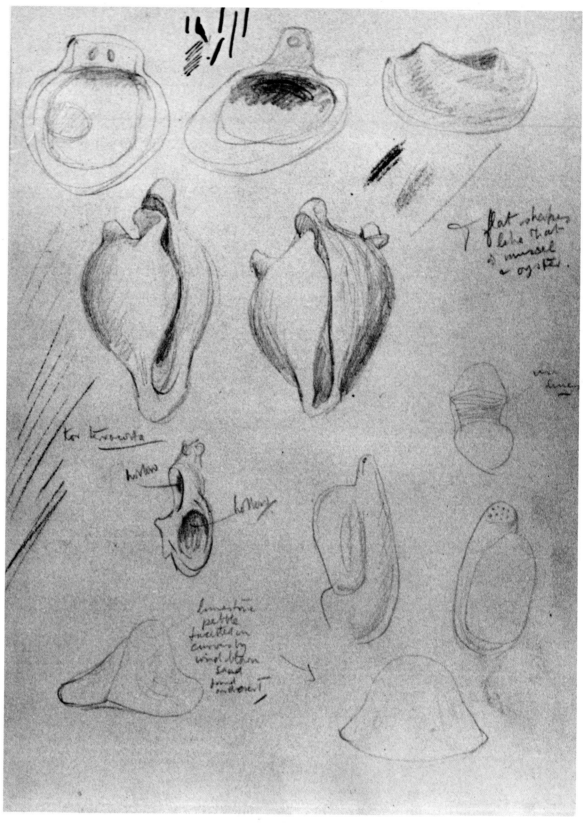

57 *Drawing of Shells · 1932*

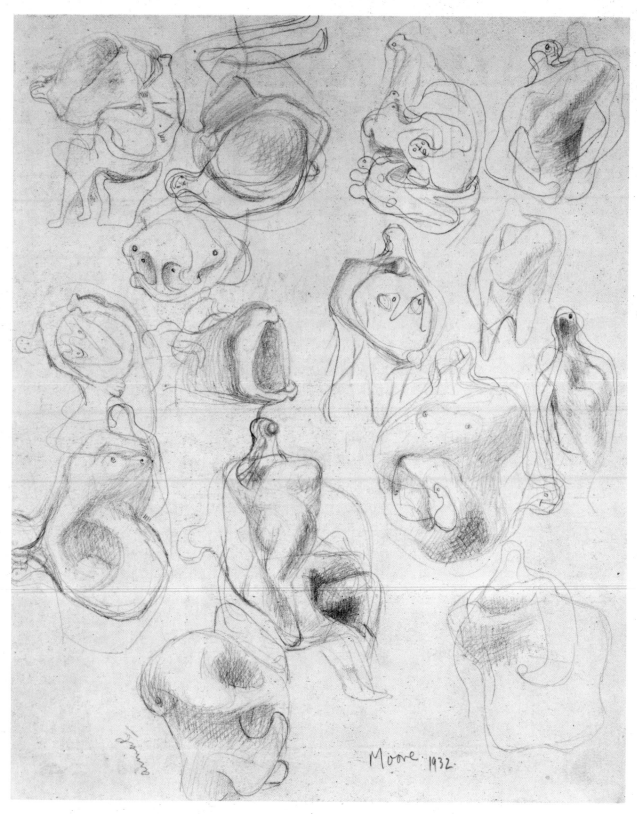

58 *Transformation Drawing · 1932*

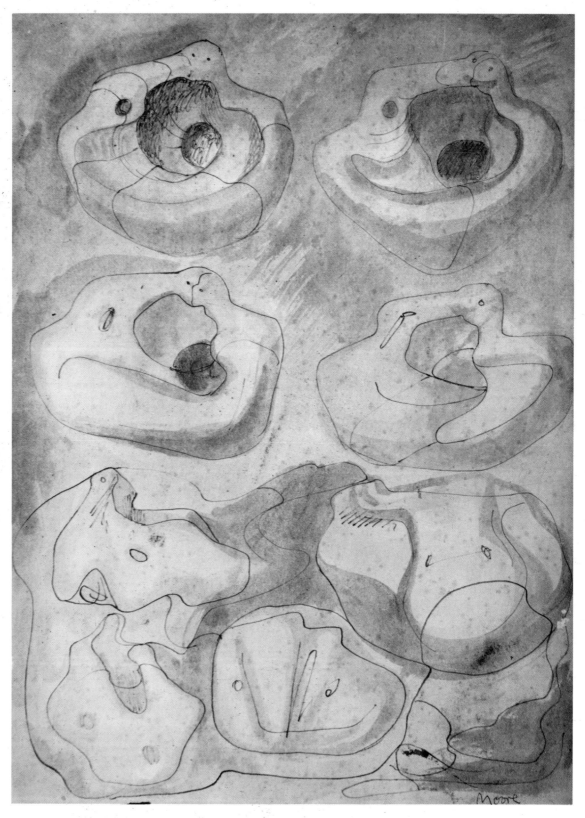

59 Ideas for Sculpture · 1933

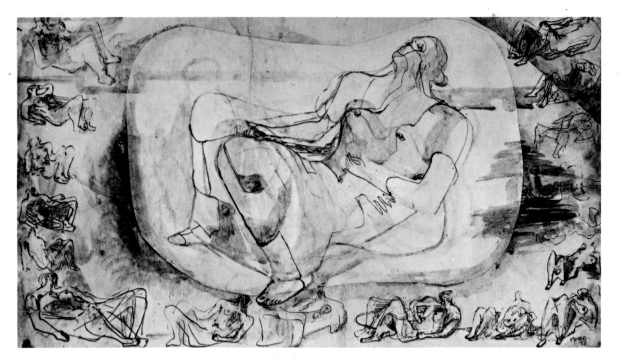

60 *Drawing for Sculpture, Montage* · 1933

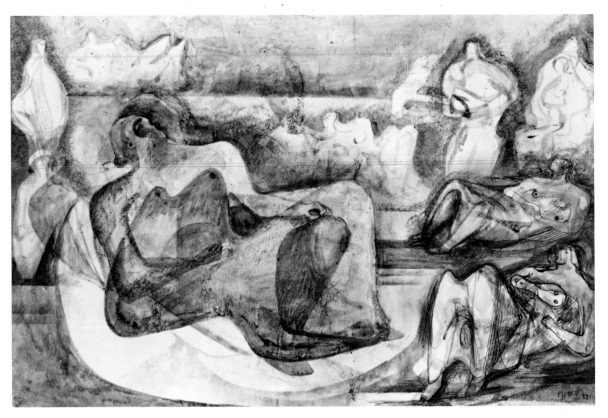

61 *Reclining Figures* · 1933

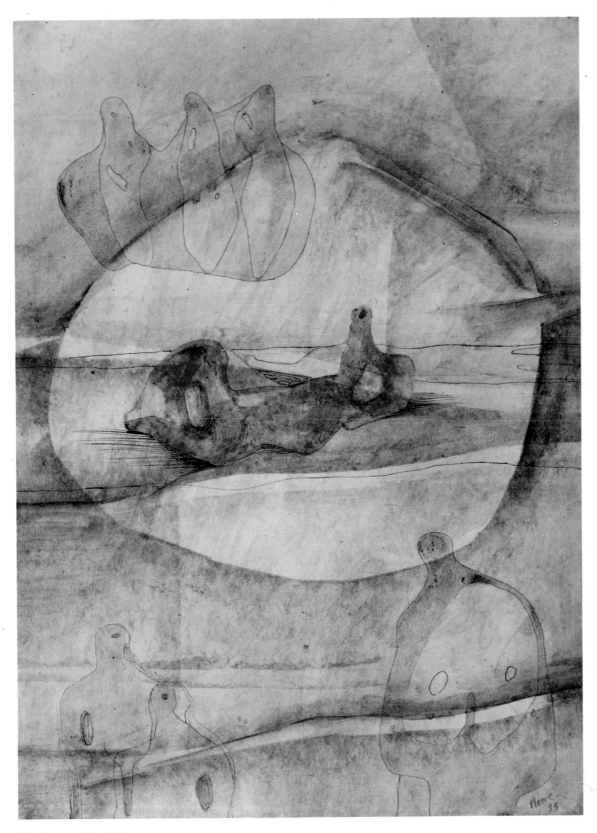

62 *Drawing for Sculpture · 1933*

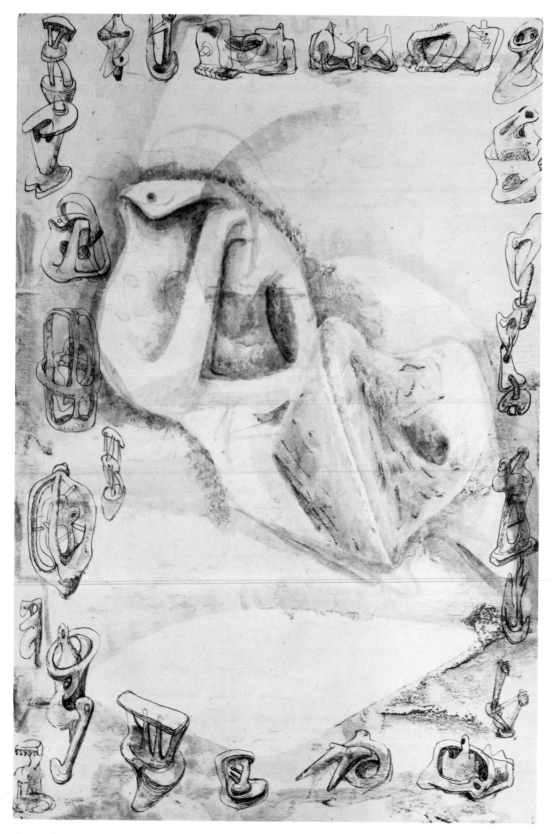

63 *Reclining Figure and Ideas for Sculpture · 1933*

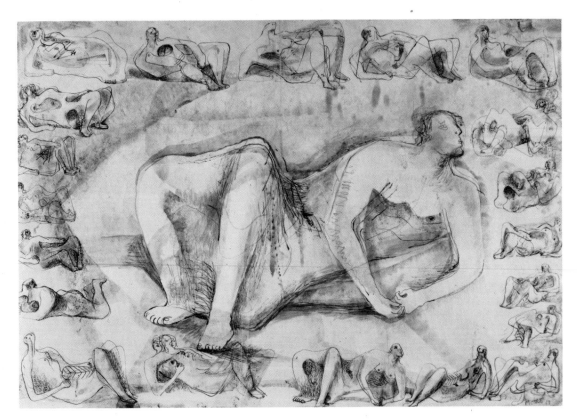

64 *Reclining Figures* · 1933

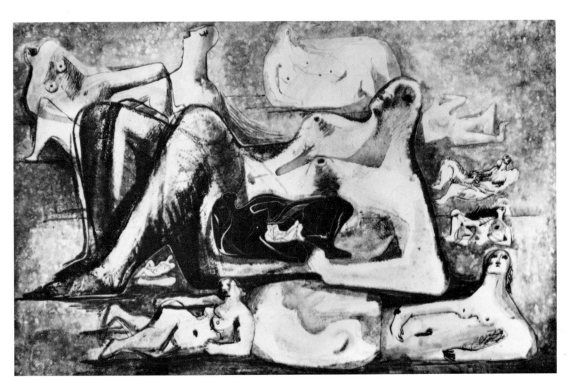

65 *Montage* · 1933

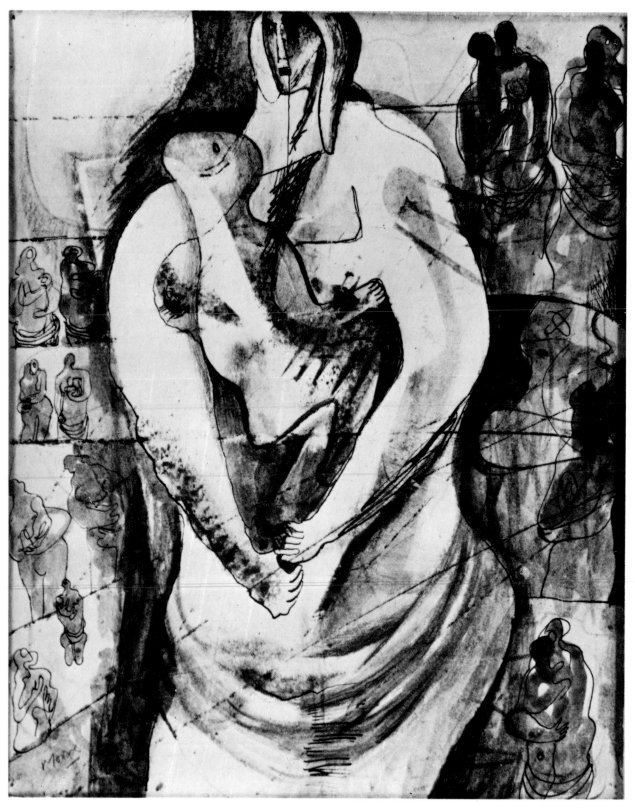

66 *Mother and Child, Drawing for Sculpture · 1933*

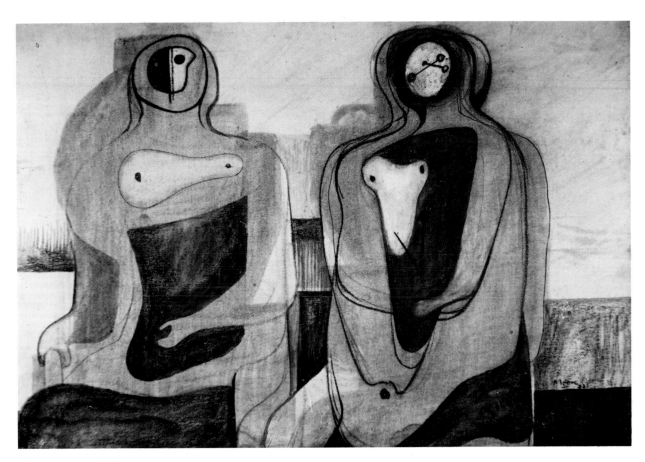

67 Two Seated Women · 1933

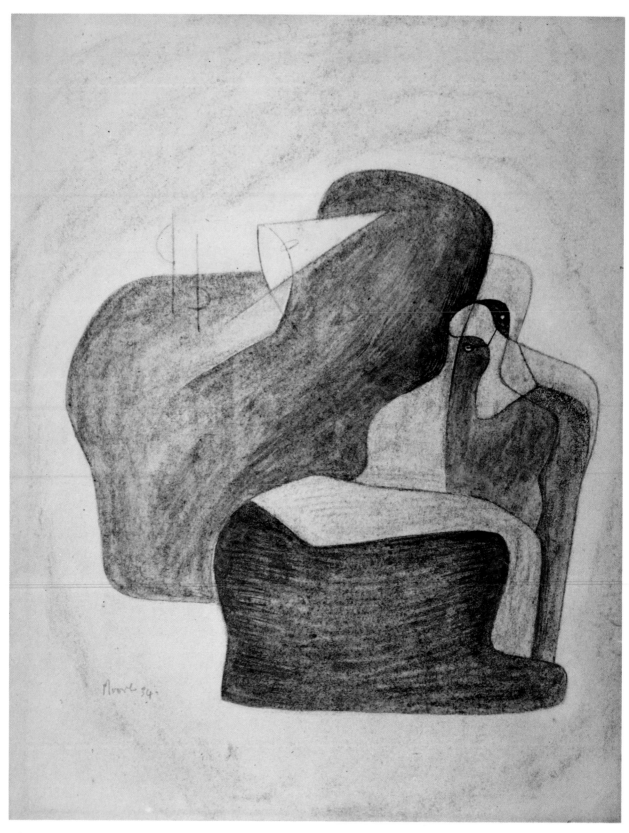

68 *Seated Woman · 1934*

4 Discovering Forms

All artists hate the word abstraction, and Moore has said that his drawings and sculptures always have some human or animal reference. But if the language of criticism is to be of any value, it must discriminate between works that give us some immediate inkling of their origin in experience, and those that impose themselves on us chiefly by their design; and on this basis one must agree that many of Moore's drawings in 1934 can reasonably be described as abstract. Even in the last of his inward-looking drawings (*Pl. 68*) the connection with the visible object has become very remote. And at the same time he has begun to experiment with the idiom of post-cubist art that seemed at the time to be the *lingua franca* of all forward-looking young artists.

Five of these 'abstract' drawings will be found on *Pls. 70–74*, and they show a remarkable power and energy of design. One of them (*Pl. 70*) comes as near as anything in Moore's work to reflecting current fashions; and yet how different is the vigorous confrontation of these two figures from the disembodied contemplations of such a painter as Juan Gris. The longer one looks at this drawing, the more one is aware of the human character of what seem, at first sight, to be arbitrary mechanisms. There is also an element of play, as if Moore was enjoying the funny side of his half-human mechanisms, and this leads to results not altogether unlike the contraptions of the seventeenth-century mannerist Braccelli (*Pl. 71*). I may add that this element of having a bit of fun with his forms is very much in Moore's character, and survives in many later drawings (*Pl. 262*).

The two most severe of the 'abstract' drawings are reclining figures pared down to their simplest essences (*Pls. 73, 74*). For all their power and

authority, these drawings are too schematic. A drawing done in 1933 (*Pl. 69*) shows a stone shape given the vitality of the human body in a spontaneous act of imagination that was to be one of Moore's greatest achievements all his life. It is followed by several magnificent drawings (*Pls. 75, 76*) in which the tentative ideas of the preceding series suggest the completeness and solidity of sculpture. How far these drawings are prophetic of Henry Moore's whole development can be seen by comparing them with a drawing (*Pl. 77*) dated 1971. Of course the construction of this late drawing is more complex and articulate; but fundamentally it is the same, and suggests that the year 1934 was a key point in Moore's development.

In these drawings the lump of stone has taken over, although some vestige of the reclining figure is still visible in legs and thorax. But many of the drawings of these years are more obviously 'recliners'. One of them (now unfortunately lost) (*Pl. 78*) seems to have been done especially for the benefit of art historians, because in it he lays out, like a programme, three ways of dividing the reclining figure up into related but sculpturally comprehensible parts. The bottom drawing, in particular, where the figure is split into three sections, anticipates a solution that does not dominate his sculpture until the 1960s. These drawings are done without emotion, as if Moore were determined to make a careful record of some intimation which he was not yet ready to use. Other 'intimations' of the reclining figure are done with more warmth and excitement (*Pl. 86*), and show Moore connecting the idea with the recumbent figure on the lid of a sarcophagus (*Pls. 85, 86*). It was a powerful and haunting motif, and remained in his mind for thirty years, reappearing in one of his finest lithographs (*Pl. 87*). Several of these ideas were realized in sculpture, including the reclining figure that seems to have become part of its own bath (*Pls. 79, 80*). The row of plastic lumps on *Pl. 90* was also preliminary to sculpture, and several drawings such as that in *Pl. 89* show Moore already intent on arranging them in groups or rows.

A year or two later Moore did studies of square and upright forms (*Pl. 93*) which come very close to the great 'abstract' carvings of 1935–36, although, unlike the bronzes, the carvings never reproduce the drawings exactly. Looking at these inexhaustibly vigorous and inventive drawings, one is reminded of Moore's words: 'Drawing keeps one fit like physical exercises . . . and it lessens the danger of repeating oneself and getting into a

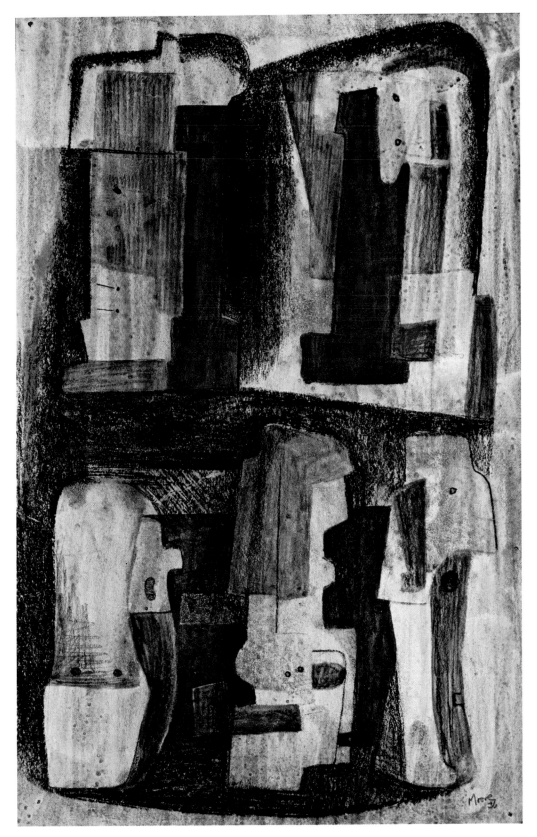

V Square Forms · 1936

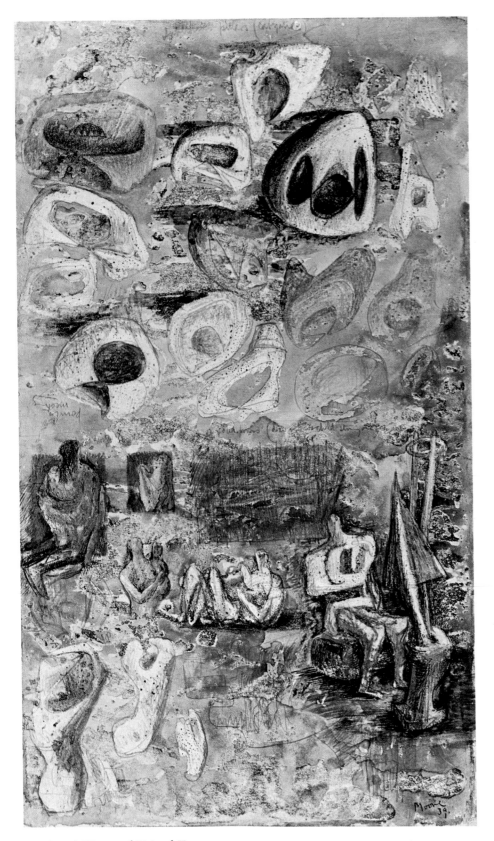

VI Seated Figure and Pointed Forms · 1939

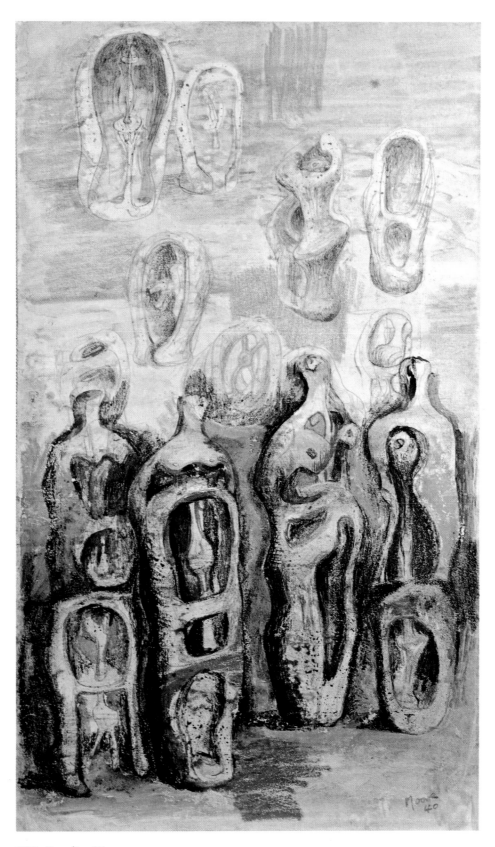

VII Standing Figures · 1940

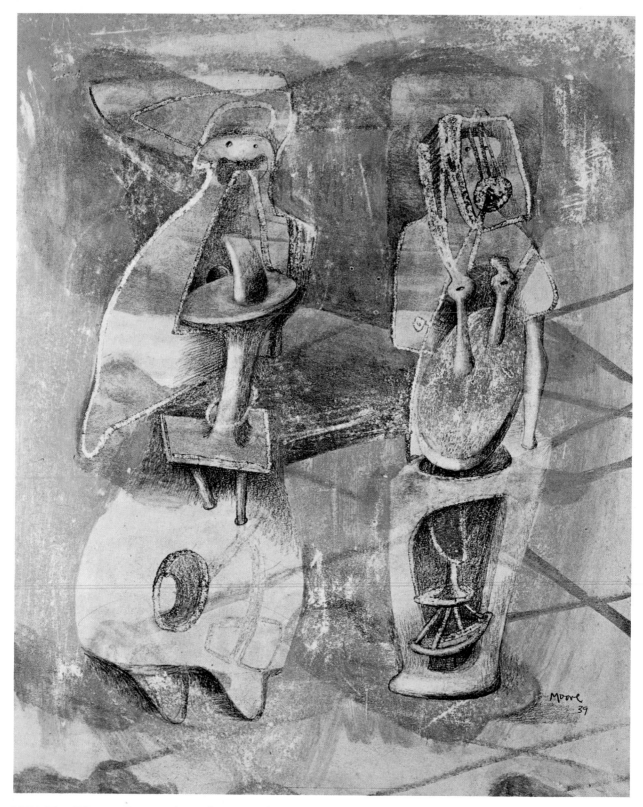

VIII Two Women: Drawing for Sculpture Combining Wood and Metal · 1939

formula.' Certainly the variety of invention in these drawings is astonishing.
There are mysterious constructions like bread-ovens (*Pl. 91*), and similar
upright forms in which a machine has produced a kind of fungus (*Pl. 92*).
There are drawings done for their own sakes, like the sheet of upright forms
(*Pl. 95*) that reminds us of his abiding admiration of Seurat. There are
grave and solid blocks (*Pl. 93*) which were to lie at the back of his mind till
the Time-Life Screen of 1952 that stands unnoticed in Bond Street; and
they reappear in a lithograph of 1963 (*Pl. 94*). A sheet such as *Pl. 88* shows
the range of his plastic invention, in which the distant stimulus of reclining
and standing figures provides fifteen complete and vital solutions, each of
which could have been turned into a carving; and in fact a few of them
were, whereas others were worked up into magnificent drawings (*Pl. 91*)
which are clearly an end in themselves. Others (*Pls. 100, 101*) remain part
of the pool of ideas in which Moore will continue to fish for the next
thirty years. They are sometimes the same ideas that floated round the
'inward-looking' drawings; but they are done with infinitely greater
assurance. There are also the first (1938) of the hollow, mummy case forms
(*Pl. 99*) that develop into the internal-external discoveries of the 1940s.
And perhaps this series of fabulous and intractable inventions should be
extended to 1939, the date of one of Moore's greatest drawings (*Pl. VIII*).
It is officially described as 'Two Women: drawing for sculpture combining
wood and metal'. Of course it is not a drawing for sculpture in any medium,
but a creature of his imagination which has taken so strong a hold on him
that he has made it into a painting. These, once more, are goblins, question-
able spirits who seem to have been discovered by X-ray, and whose bones
conform to some crazy logic. They are natives of the interior who have
emerged with the confidence of Martian invaders.

The effect of this drawing depends largely on its colour; indeed without
the interplay of orange and leaden grey, and the crimson of the right hand
figure's vital organ, heart or stomach, it is almost incomprehensible. This
may therefore be the right point at which to say a word about Moore's use of
colour, which was to play so great a part in his drawings of the 1940s.
Because he has been essentially a creator of form it is sometimes assumed that
the colour in his drawings is merely decorative, almost accidental. This is to
mistake his whole character as an artist. He is not concerned with an
intellectual exercise in pure form but believes that art should involve all our

emotions. Titian and Rembrandt are near the summit of his Pantheon,
little short of Masaccio and Michelangelo. Turner is the only English artist
he admires wholeheartedly.

His first use of colour is subservient to form. It is the green wash that he
adds to pen and ink in his life drawings, which not only makes them more
effective, but, by its lighter tone, helps him to emphasize the most substantial
part of the figure. But already in 1937 his ideas for sculpture are set in slabs
of broken colour in such a way as to make them both more vital and more
mysterious (*Pl. V*). And a few years later his forms swim in a sea of colour
(*Pl. VII*), which adds to their mysterious power, and must surely have
increased his excitement when he came to fish them out. A curious example
of how colour comes into his mind simultaneously with form is a small study
(*Pl. XXVI*) for the magnificent drawing in the British Museum (*Pl.
XXVII*). The red rocks in the final drawing might seem to be a decorative
afterthought; the notebook study shows that they were present in his
imagination from the beginning. Even as late as 1961 Moore continued to
use colour as a stimulus, as in the reclining figures (*Pl. XXXIX*) where a
motive that had been in his mind for twenty-five years is given impetus for
him by an exchange of red, blue and green. This process is made very clear
by the coloured lithographs produced during the 1960s, which often go
back to ideas of the 1930s for their imagery, but are given an added vivacity
by brilliant colour. There is nothing puritanical about Moore's attitude to
his own work. However, these decorative afterthoughts are less important
than the use he made of colour in the early 1940s to enhance drama and
create atmosphere; and it is to this dramatic and space-creating aspect of
Moore's drawings that I must now turn.

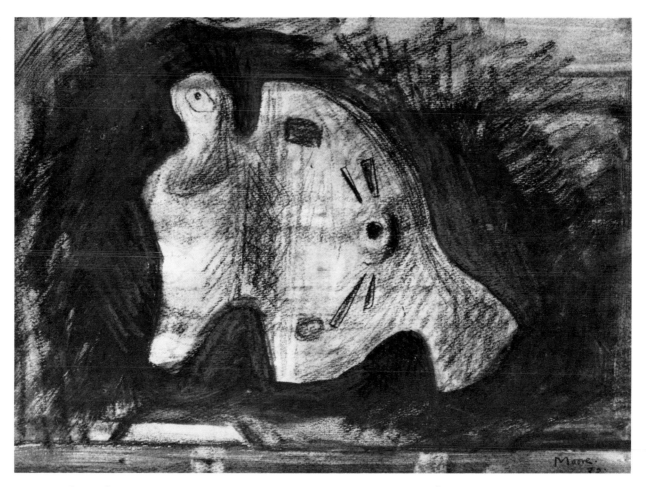

69 Study for Sculpture · 1933

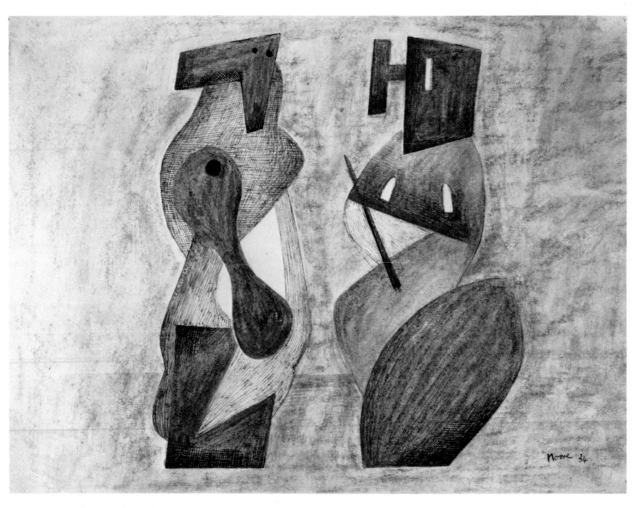

70 *Drawing for Metal Sculpture · 1934*

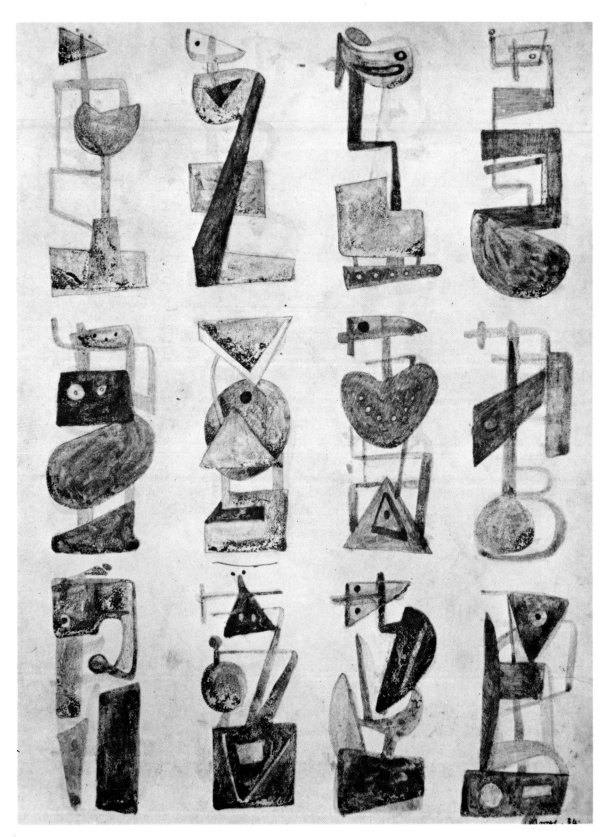

71 *Ideas for Metal Sculpture · 1934*

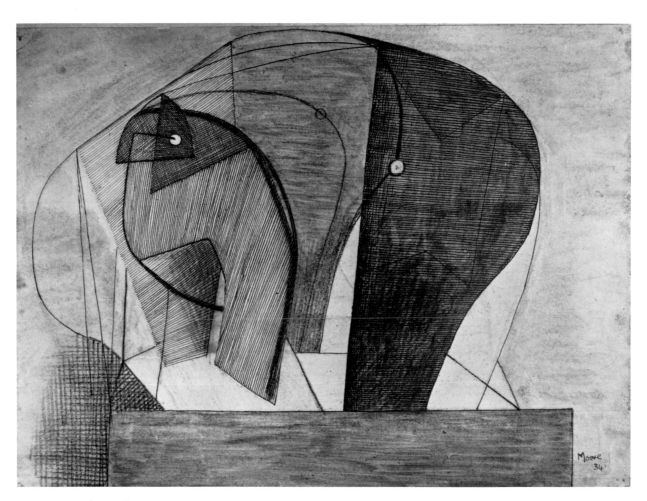

72 *Drawing for Sculpture : Head · 1934*

73 *Reclining Form · 1934*

74 *Study for Sculpture · 1934*

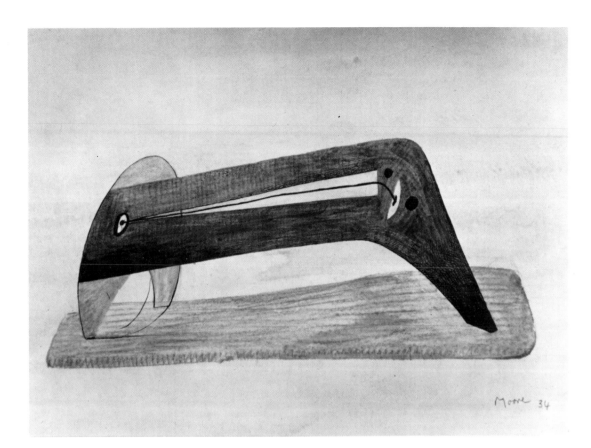

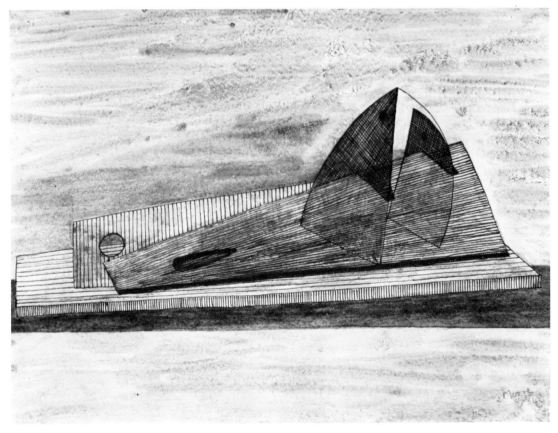

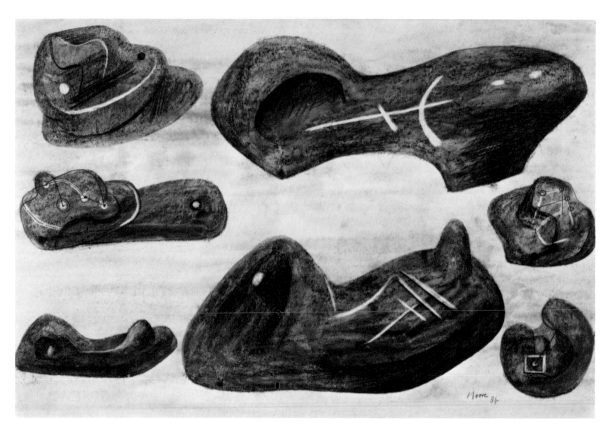

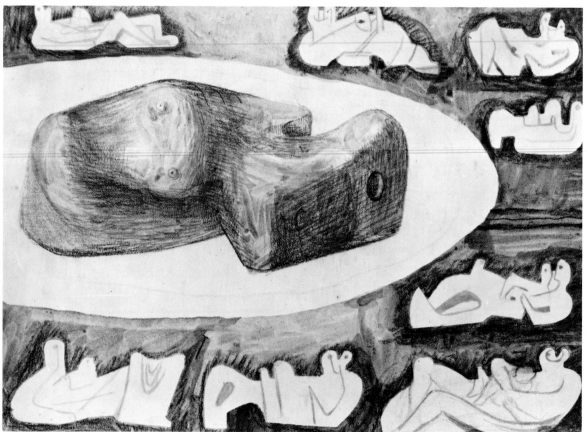

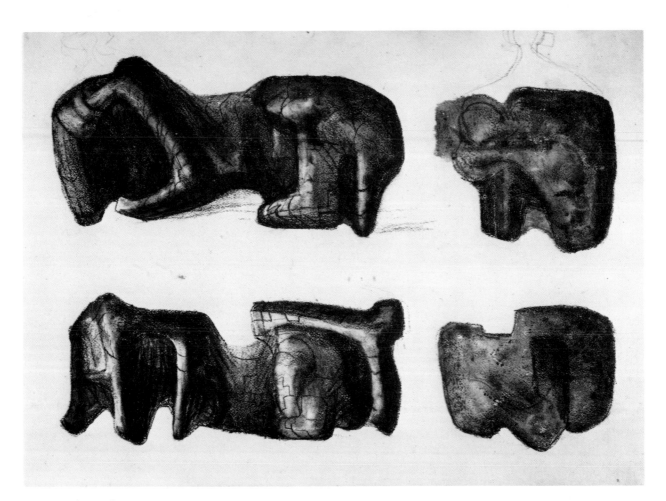

77 *Ideas for Sculpture · 1971*

75 *Studies for Sculpture · 1934*

76 *Studies for Recumbent Figure · 1934*

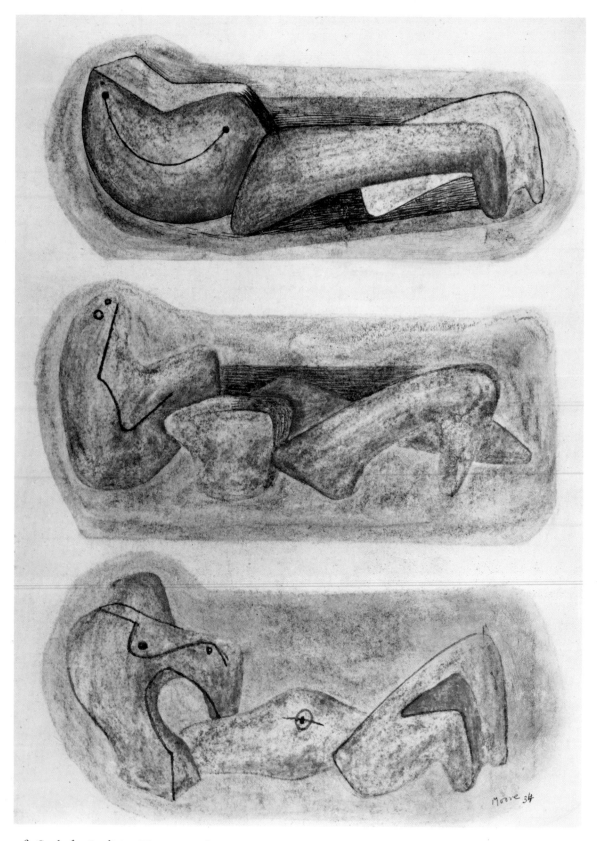

78 *Study for Reclining Figure as a Three-piece Composition · 1934*

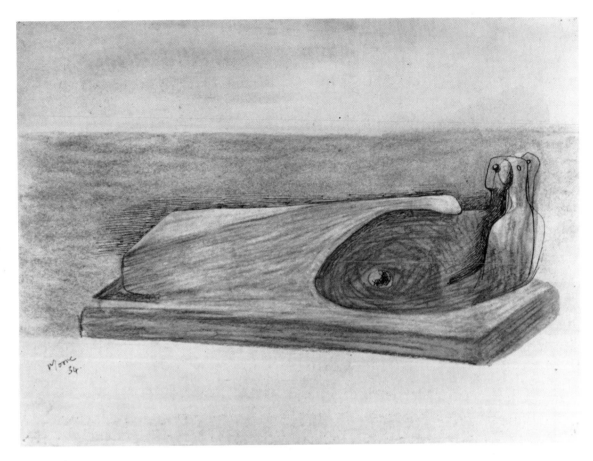

79 *Reclining Figure* · *1934*

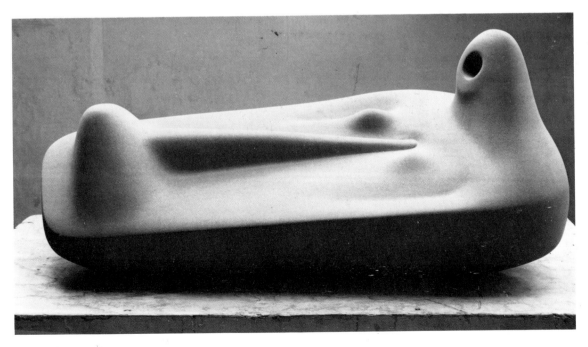

80 *Reclining Figure* · *1935*

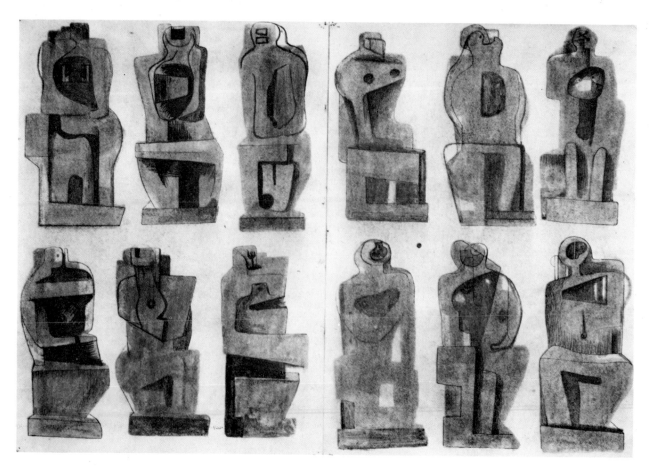

81 *Ideas for Stone Seated Figures*

82 *Drawing · 1935*

83 *Ideas for Two-piece Composition · 1934*

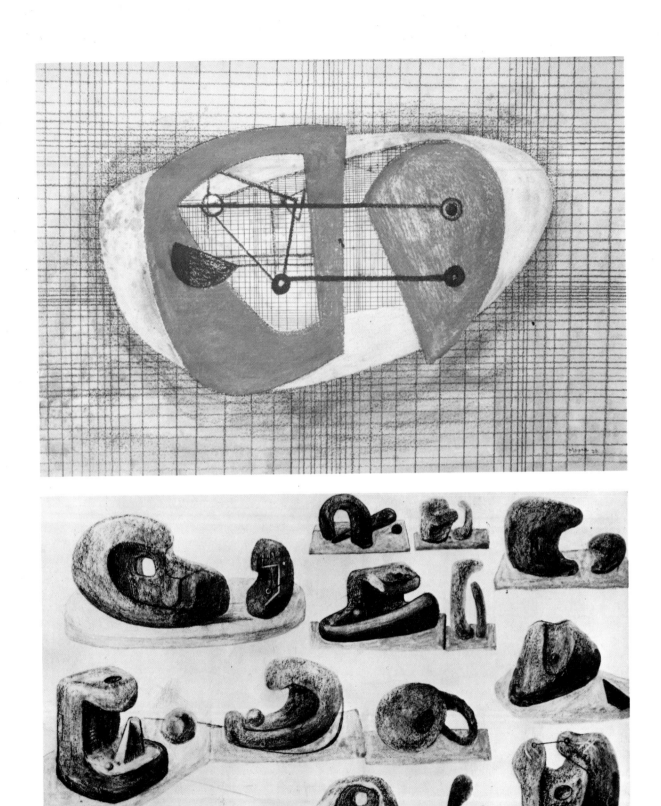

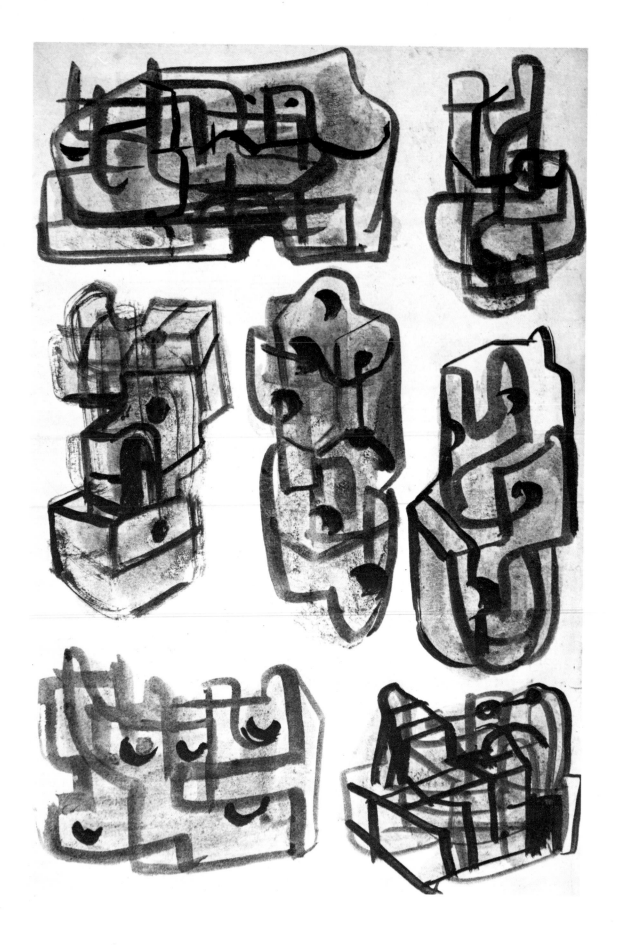

84 *Page from 'Square Forms' Sketchbook · 1934*

85 *Drawing · 1936*

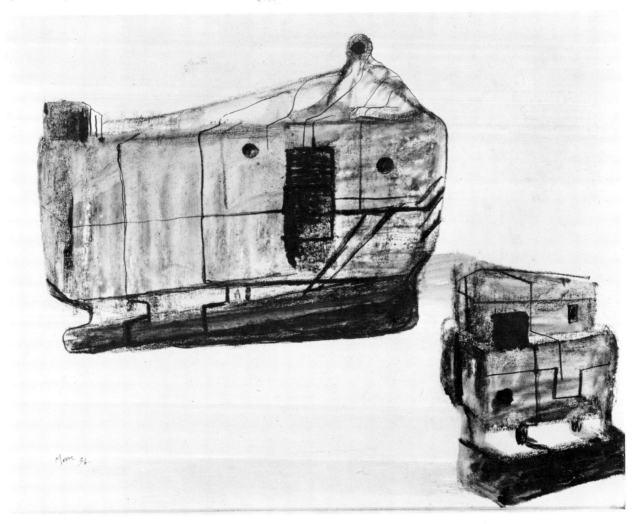

Moore 36.

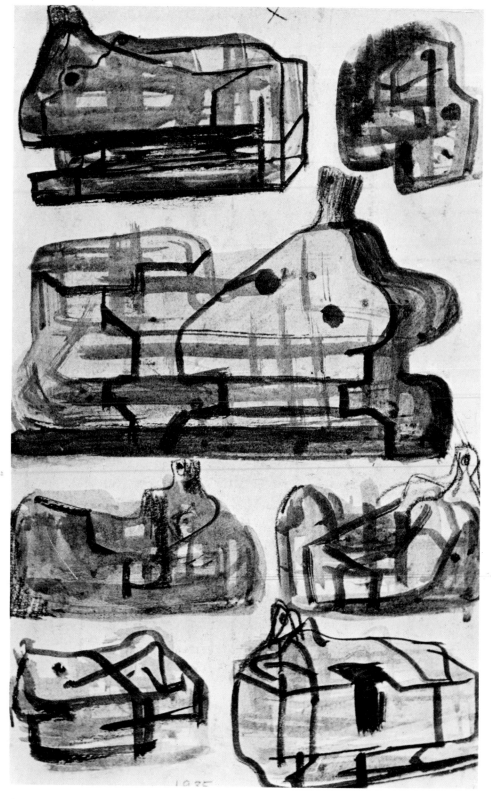

86 *Square Forms* · 1935

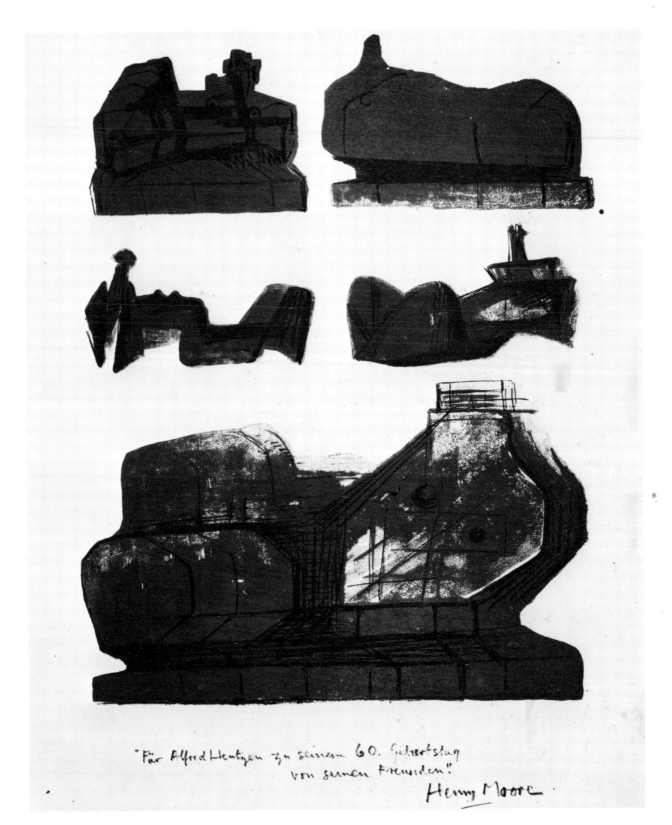

"Für Alfred Hentzen zu seinem 60. Geburtstag
von seinen Freunden."

Henry Moore

87 *Five Reclining Figures · 1963*

88 *Ideas for Stone Carving · 1935*

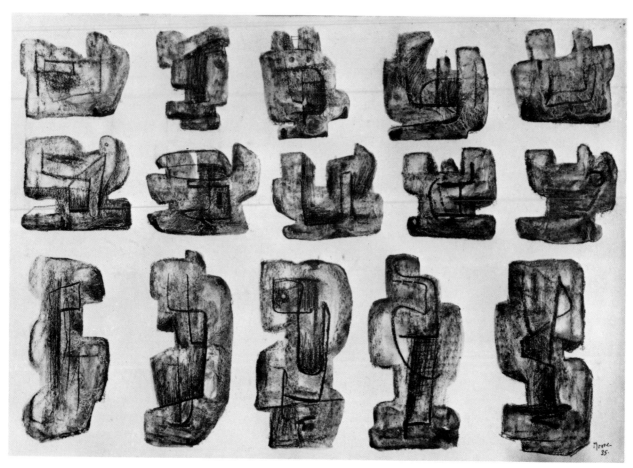

89 *Nine Drawings for a Carving · 1935* 90 *Eight Ideas for Sculpture · 1936*

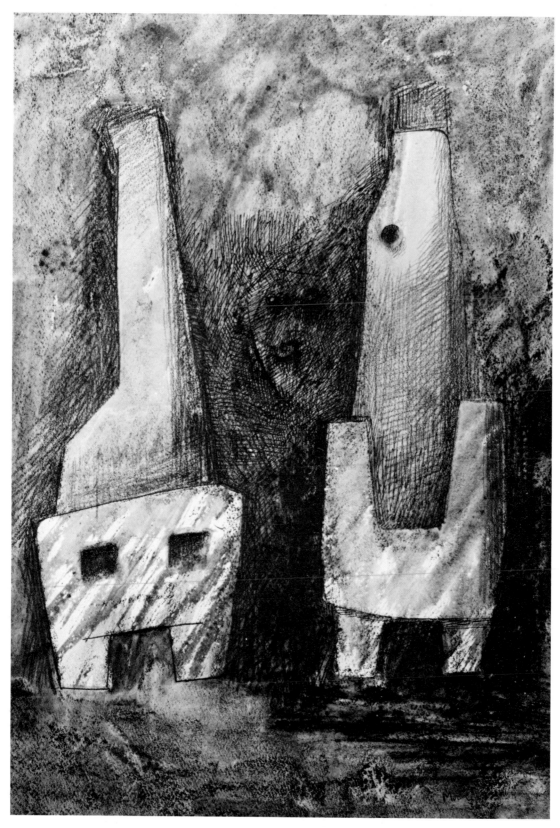

91 *Two Stone Forms* · *1936*

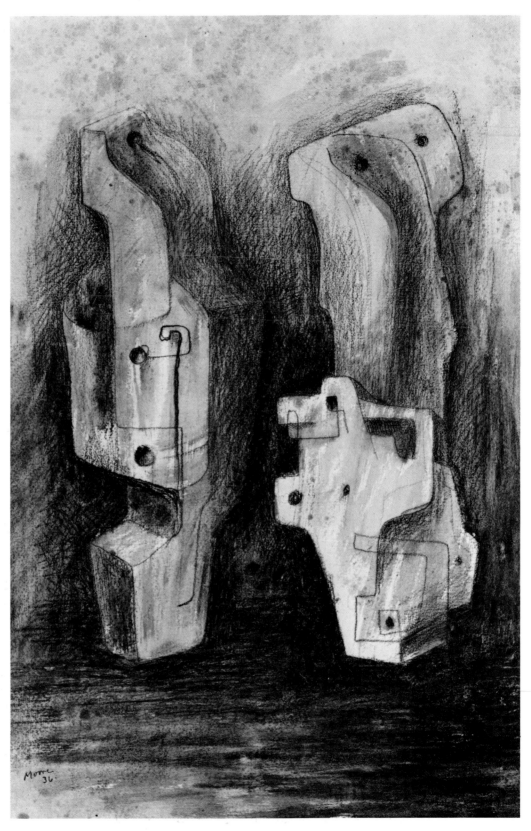

92 *Drawing for Sculpture · 1936*

93 Drawing for Sculpture, Square Forms · 1936

94 Square Forms · 1963

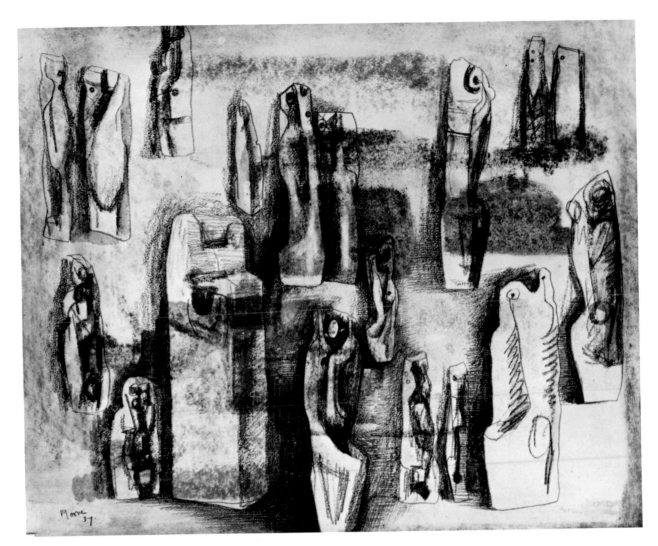

95 *Drawing for Stone Sculpture* · *1937*

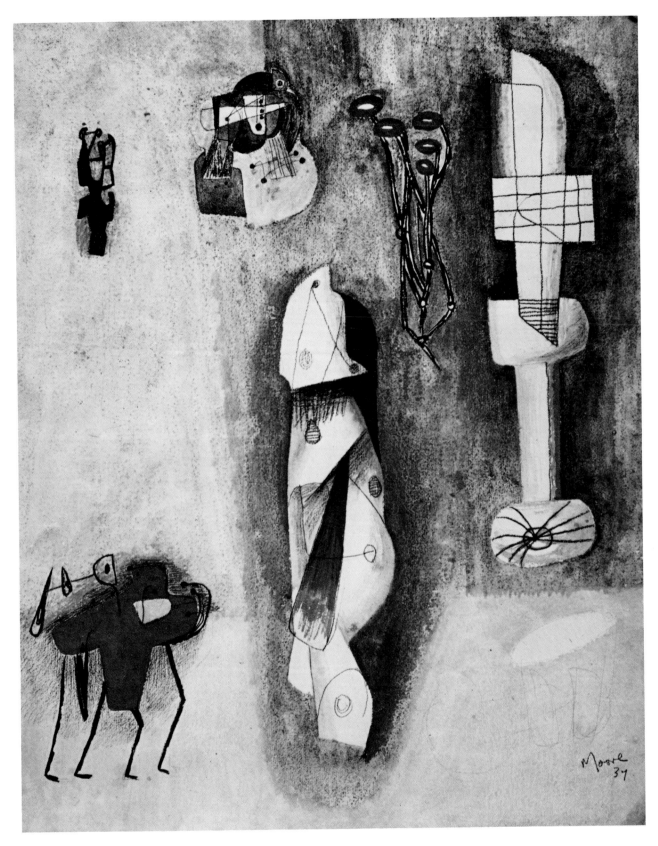

96 *Drawing · 1937*

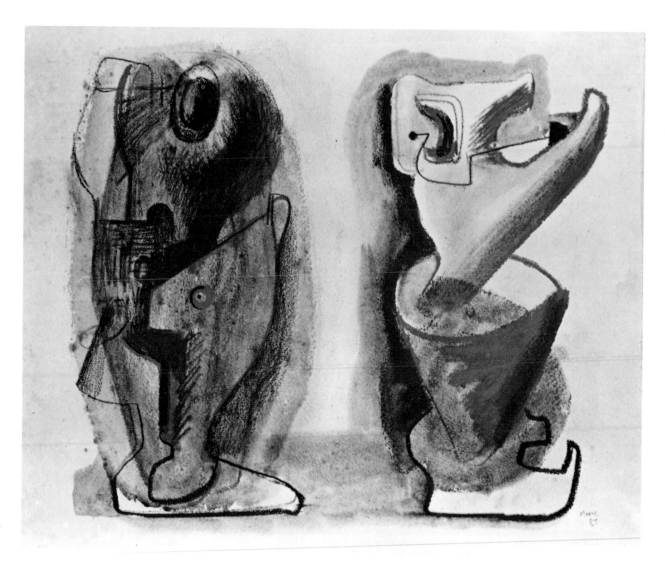

97 *Two Forms: Drawing for Sculpture* · 1937

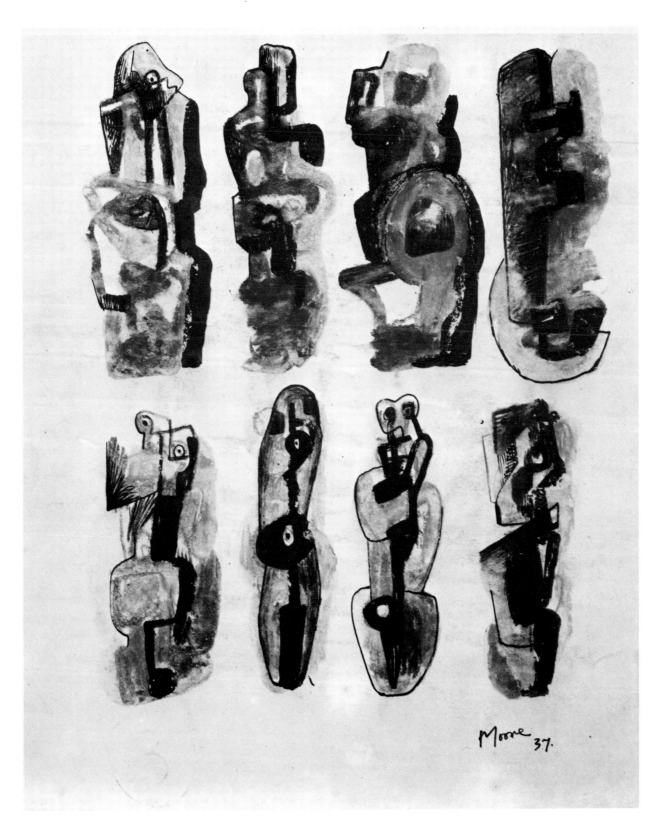

98 *Ideas for Stone Sculpture · 1937 ·*

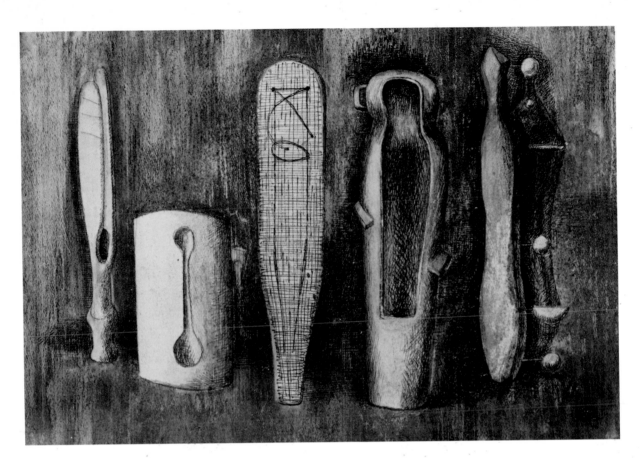

99 *Sculptural Ideas, Hollow Form · 1938*

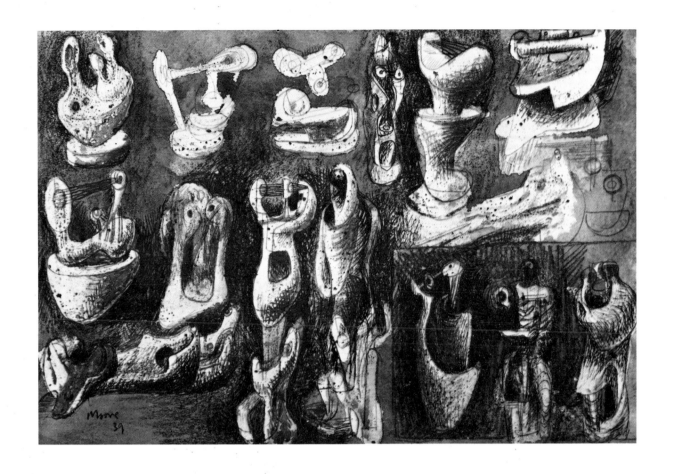

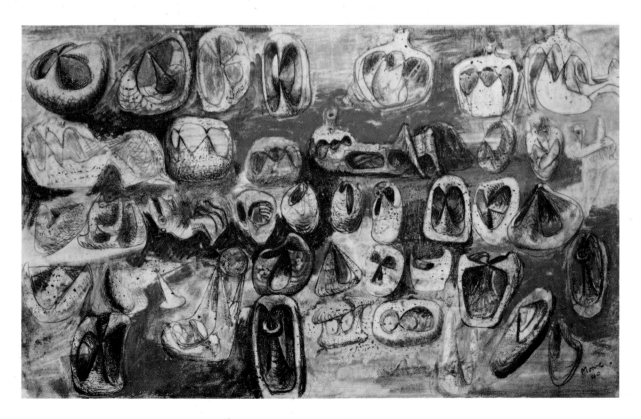

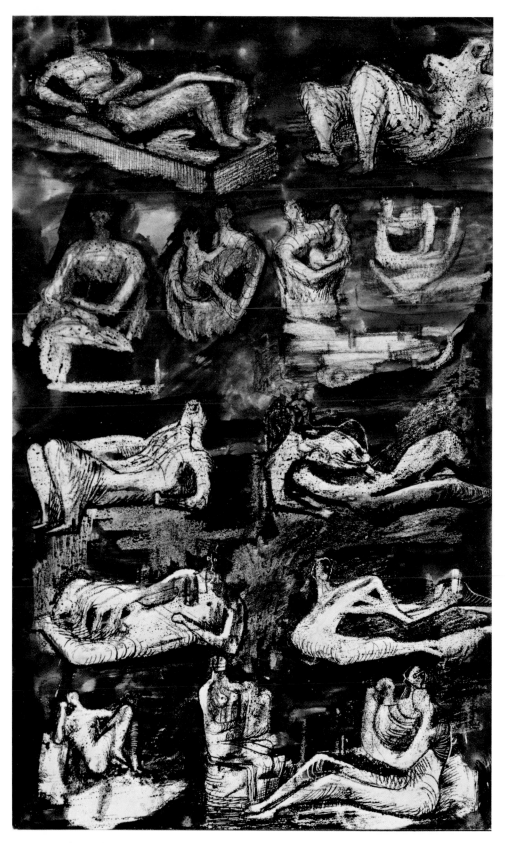

102 *Ideas for Sculpture · 1940*

5 Dramatis Personae

The early writers on Henry Moore, concerned, as they were, with truth to materials, did not mention his feeling for drama. Yet it is clear enough in almost all his early carvings, and particularly arresting in one of his early masterpieces, the Mother and Child in the Robert Sainsbury collection (*Pl. 103*). This figure shows what is perhaps the strongest of Moore's dramatic themes, the feeling of approaching menace, the self-protective tension that gives each form its maximum intensity. In his drawings Moore makes the dramatic quality of his forms explicit by relating them to each other in a unified space. In one magnificent and unique example (*Pl. 104*) he places his upright forms in a kind of landscape, and, in the background, by a few vertical strokes of white chalk, suggests the porticos of antique temples. Another drawing of the same date depicts four draped figures walking into a tunnel (*Pl. 105*). It is a purely pictorial idea, in which the inhabitants of Moore's sculptural repertoire appear only incidentally, and it, too, is conceived in the spirit of antique tragedy. No wonder that producers of Wagner's *Ring* and Shakespeare's *King Lear* have tried to persuade Moore to design the scenery, offers that he has very wisely declined. (In fact one of Wieland Wagner's productions of *The Ring* was admittedly based on Henry Moore's ideas.)

In many of his early dramatic groups the protagonists are familiar figures from his notebooks, but they are arranged dramatically near the front of a sort of stage. Occasionally shadowy projections of themselves hang in the space behind (*Pl. 107*), or they are echoed in a kind of backcloth. They consist largely of the contraptions that had been occupying a part of Moore's

form-world since the marginalia of *Pl. 63*, and make a curious impression halfway between a goblin market and a *commedia dell'arte*. Occasionally they are rather sinister, like the three figures to the left of *Pl. 109*; but on the whole they are lighthearted. Their places are soon taken by portraits of actual pieces of sculpture, including the stringed figure known as a Bird Basket (*Pl. 112*), and these are put into a bare cell, with several rectangular windows high up the wall. What led Moore to imprison his creations in this way it is difficult to determine. Perhaps he felt that it allowed an unrestricted concentration on their plastic qualities. But on the whole I think that they gain intensity when they are able to fill the whole sheet, or take the stage in front of ghostly relations (*Pls. 108, 109*).

Dominating most of these reunions are hollow men (or women) who reveal through huge apertures in their bodies the struts and stays that constitute their biologically simple, but formally complex, inner mechanism. They achieve a remarkable reality, so that, when they walk about in pairs (*Pl. 119*), we feel that they are conversing on the way to market. Moore seems to have created a credible alternative to the human race, as if millions of years ago, evolution had taken a different course. The strange fact is that, although these figures were invented in 1940, and carried to their fullest conclusion in such a drawing as that on *Pl. 122*, they did not appear in sculpture till 1951.

A group of these hollow figures appears on *Pl. 123*, and from one of them Moore made a clay maquette. Moore says that he thought of casting it in bronze, but at the last minute discovered a piece of elm large and flawless enough for him to realize it in wood (*Pl. 124*). Describing the sculpture, he speaks of 'a mother and child idea, something young and growing being protected by a shell'. But at its first appearance the internal-external idea seems to have a different character. In such a drawing as that on *Pl. 122* the internal forms are not at all in need of protection, but aggressively powerful. It is as if by removing the outer shell of his forms, like the lid of a mummy case, he has revealed the organs that give it life; and it is these organs, which are within us all, pounding away relentlessly, that Moore, by an intuition of genius, has symbolized.

That Moore first carved this idea in wood is one of those chances that is not an accident, because the internal-external forms, in addition to their biological and psychological implications, are examples of his responsive-

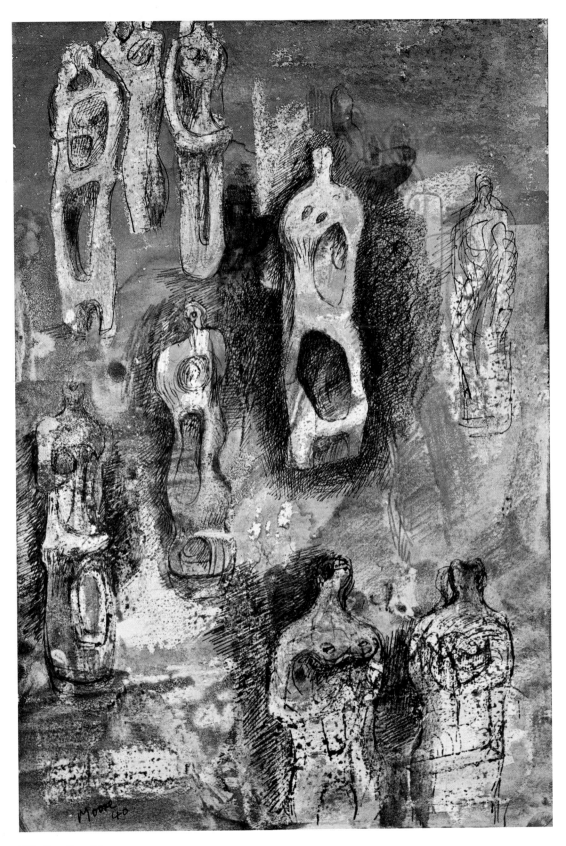

IX *Standing Figures* · *1940*

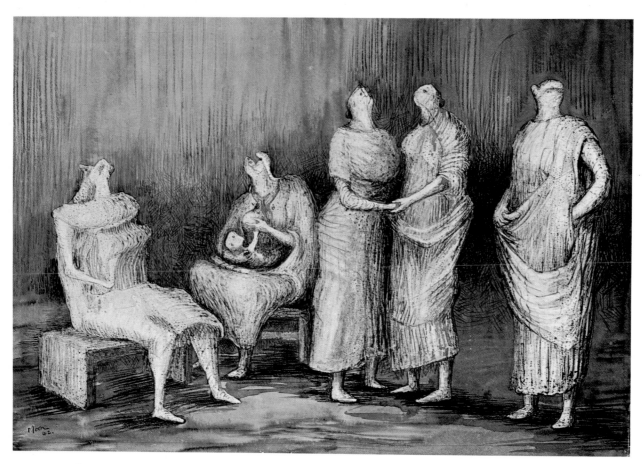

X Group of Women · 1942

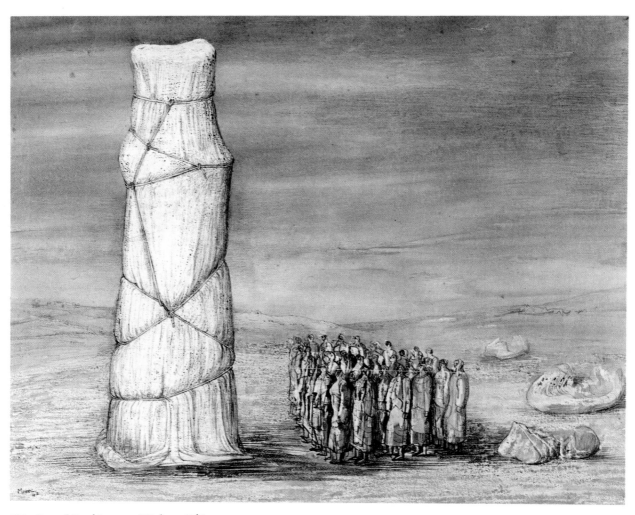

XI Crowd Looking at a Tied-up Object · 1942

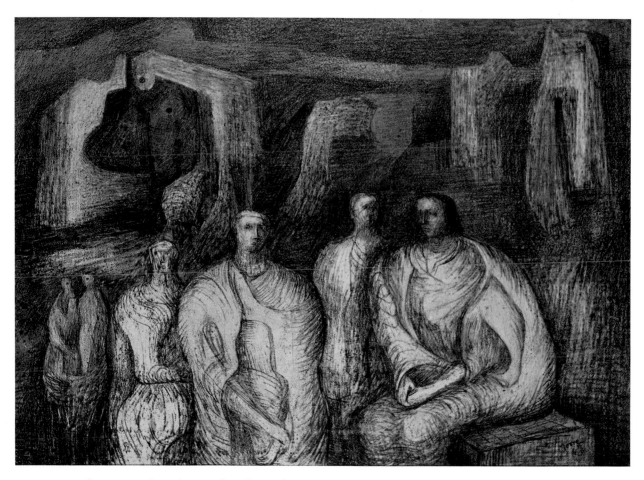

XII Group of Figures with Architectural Background · 1943

ness to nature. The apertures and caves of a hollow tree, however familiar they may become, never quite lose the mystery that they held for us in our childhood. That the internal-external figures are, to some extent, inspired by hollow trees, is clear enough in the early drawings of the motif (*Pls. 120, 121*), where the edge of the aperture has the gratifying bluntness of wood. Gradually, as the mechanism of the interior becomes more assertive, the outer shell becomes less wooden, until in the great terminal drawing on *Pl. 122* it is unmistakably metallic.

Parallel with these extraordinary creations were *dramatis personae* of a kind that approximated more closely to human experience. The notebooks with small scenes of compositions, which were the overspill of his prodigious powers of invention in the latter 1930s ('done usually in an evening, when I sit by the fire after a day's work in the studio'), contain, side by side with plastic creations, scenes of ordinary life, women sewing, even street scenes. Some of them were worked up into full-scale drawings, such as the sculptural object in a field, obviously suggested by an animal's bone (*Pl. 116*). Others were to remain at the back of his mind for many years.

It was only after the shelter drawings discussed in the next section that Moore conceived the groups of draped figures, three of which were to grow into the stone ladies of Battersea Park (*Pl. 125*). I do not know the exact sequence of these drawings. Perhaps the first example of menaced standing figures is the magnificent drawing (*Pl. 126*) which, like the seated women in *Pl. X*, is a distillation of the shelter experiences. Once more we are reminded of Seurat. The next example of the tragic *mise en scène* could be the drawing on *Pl. 127*, which also includes a reminiscence of the shelters, a reclining figure, which is dramatically out of context. Then comes a group with two seated figures, one of them nursing a child (*Pl. X*). It has already the quality of Greek drama. The crucial drawing, now in Chicago (*Pl. 128*), is full of tragic foreboding. The figures seem to hear the approach of some dreaded messenger, and turn their beaked heads in apprehension. The two figures to the left are almost exactly as they were to be used, five years later, in the Battersea group. There remained the problem of reducing the six figures to three, and Moore explores it in a sheet of studies (*Pl. 130*). But he never quite arrives at the final solution, in which the left-hand figure is passive and motherly, without the nervous tension of her companions. She does not appear until the clay maquette of 1947. Then we realize that she was

necessary if the group was to reach the stage of sculpture. She is the shock-absorber and the potential comforter, who gives the group, when realized in stone, its monumental character.

This Aeschylean sense of menace is present in all Moore's drawings of the 1940s. Three women winding wool are like the Three Fates (*Pl. 131*). Two women handing over a child to be dried seem to be taking part in some ancient ritual (*Pl. 132*); and two women engaged in the harmless pursuit of visiting an art gallery look at one of Henry Moore's own figures with a sense of religious awe (*Pl. 133*).

Although it is earlier than the Battersea figures, and may even have influenced them, I have left to the last the famous drawing in which a crowd is looking at a tied-up object (*Pl. XI*). Moore says that he saw a tied-up piece of stone being transported by a lorry, and this made him feel how mysterious such an object can be, half revealing its form by the tension of the cords, and half arousing our curiosity as to its real shape. In the drawing it has become a sort of fetish, the *objet de culte* of a primitive community. But I think there was also present in his mind an etching by Goya in *Los Proverbios* in which a group of soldiers is terrified by a huge draped figure who appears to them on the left of the frame. If there were any doubt that Moore looked at his tied-up figure with a certain atavistic dread, it is dispelled by two much later variations on the same theme: a wrapped Madonna and Child (*Pls. 134, 135*). The drawing of the tied-up object precedes the ladies of Battersea; the two after-thoughts succeed the Northampton Madonna. The serenity and benevolence of the Madonna has been hidden under draperies and constricted by criminal-looking cords.

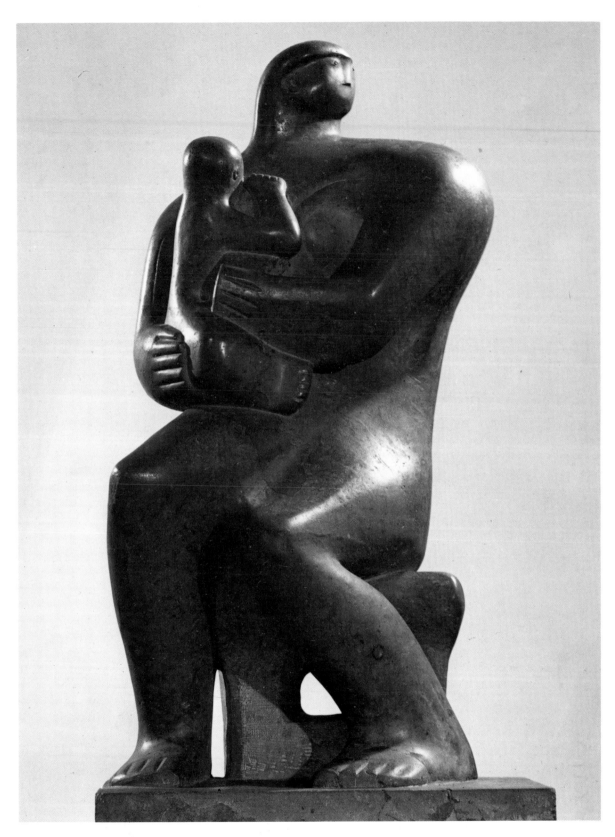

103 *Mother and Child · 1932*

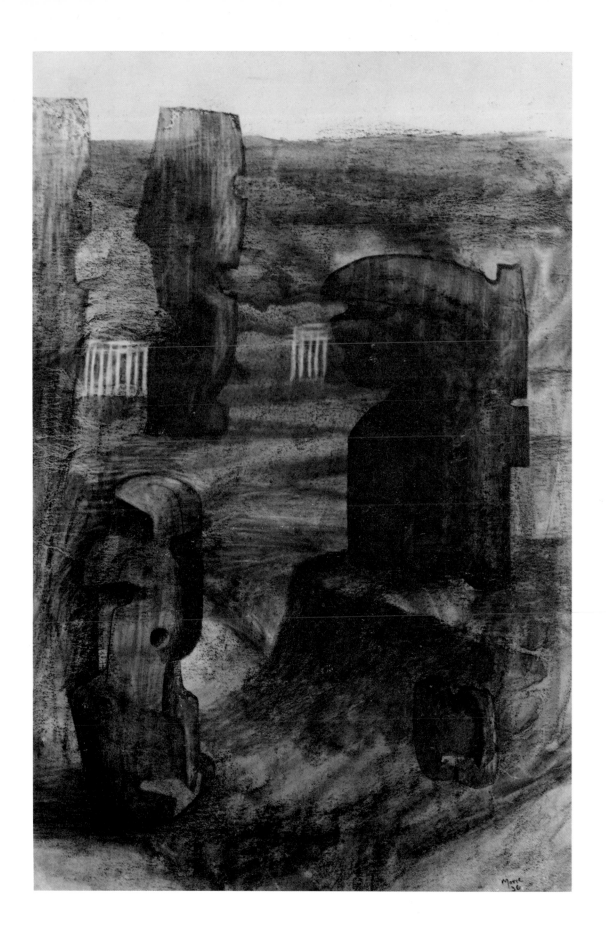

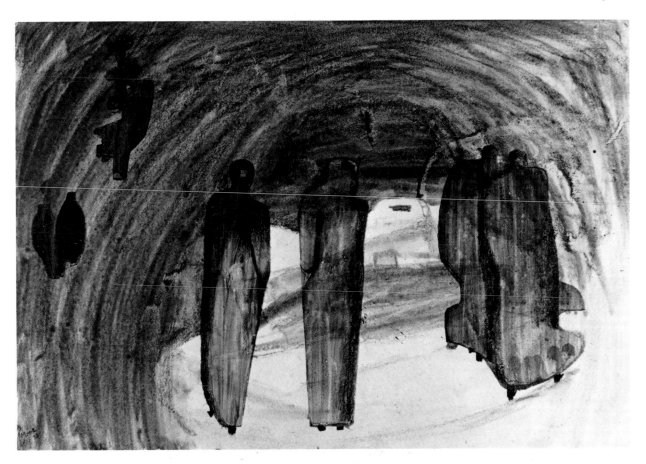

105 *Figures in a Cave · 1936*

104 *Stones in Landscape · 1936*

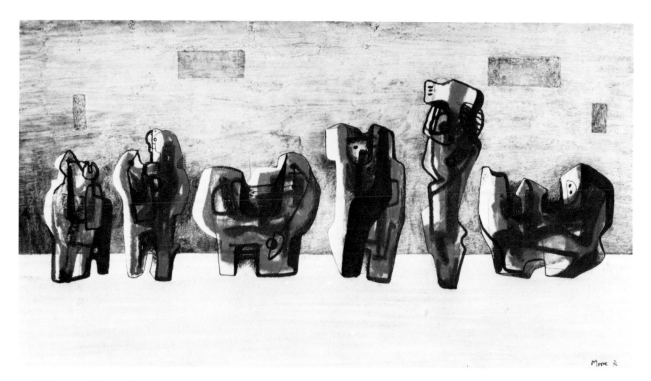

106 Drawing for Sculpture · 1936

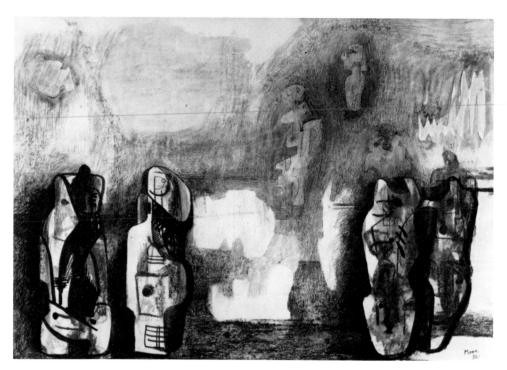

107 Ideas for Stone Figures · 1936

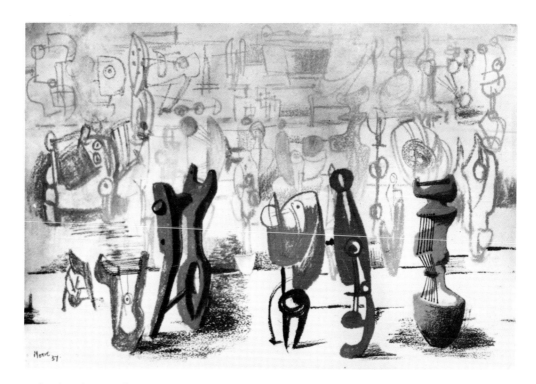

108 Ideas for Metal Sculpture · 1937

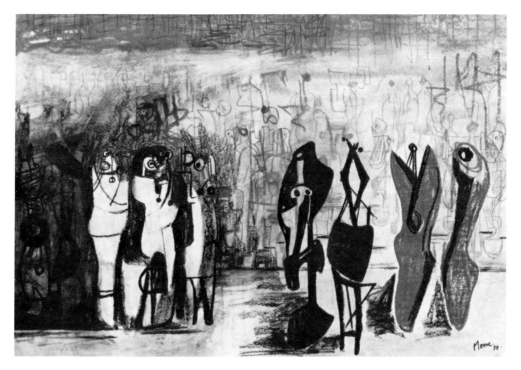

109 Drawing for Metal Sculpture · 1938

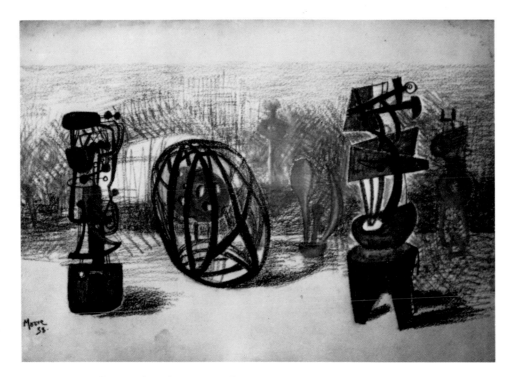

110 Drawing for Metal Sculpture · 1938

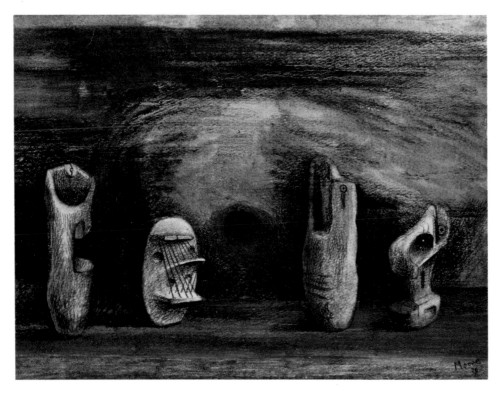

111 Four Forms · 1938

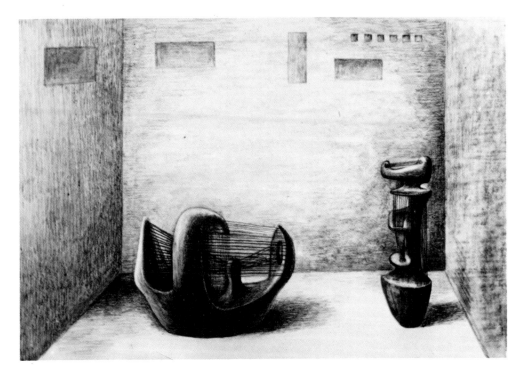

112 *Ideas for Sculpture · 1938*

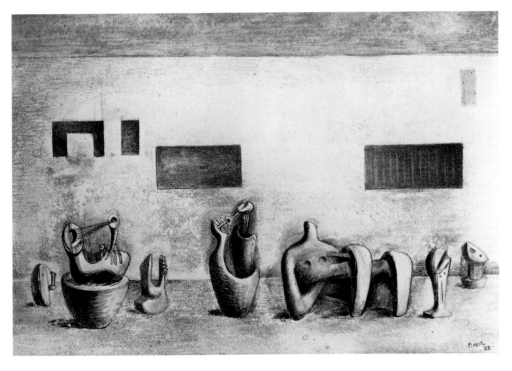

113 *Ideas for Sculpture · 1938*

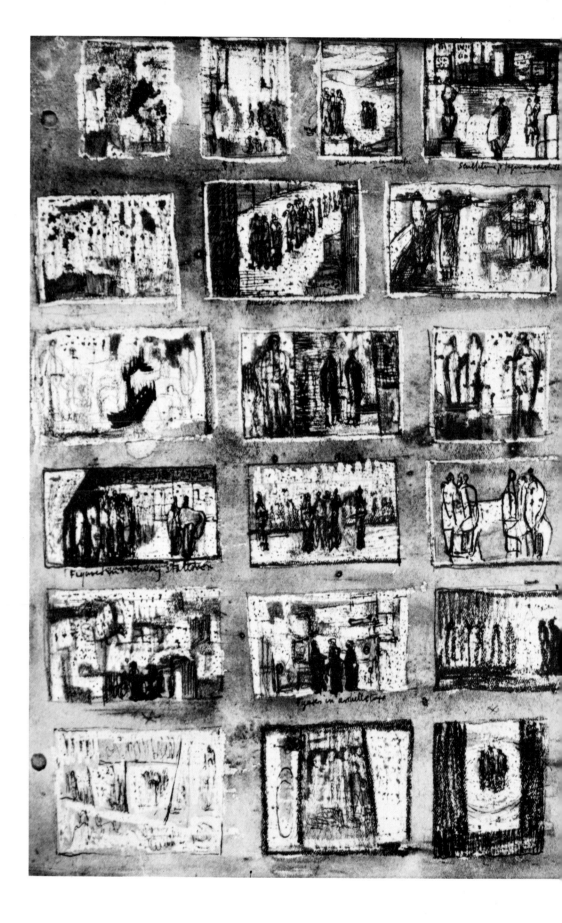

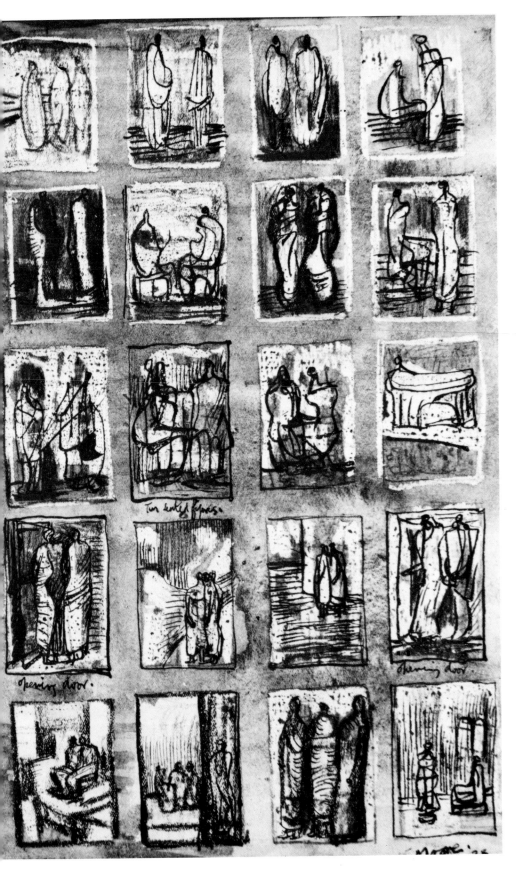

114
Thirty-nine Ideas for
Sculpture · 1938

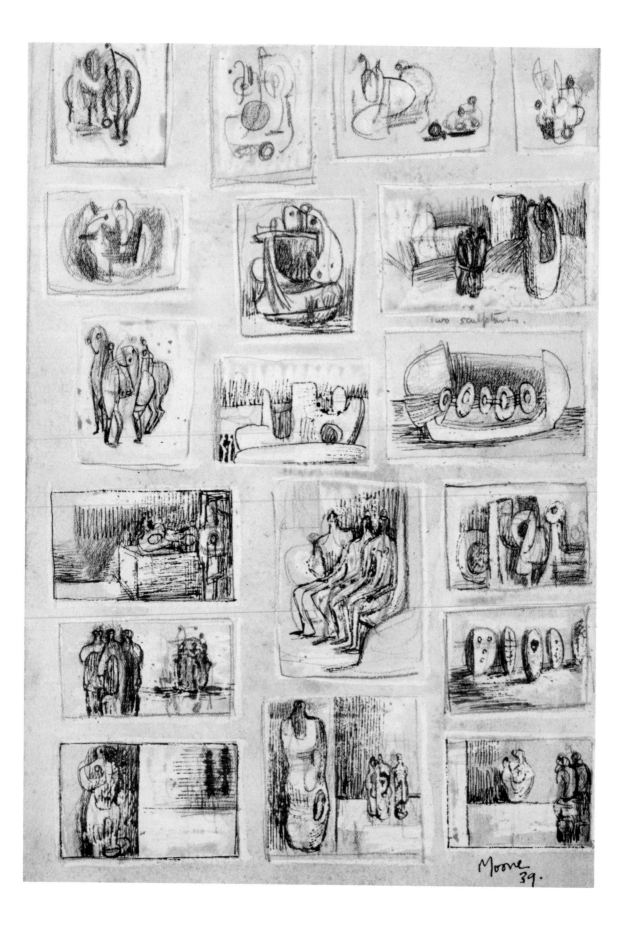

two sculptures.

Moore
39.

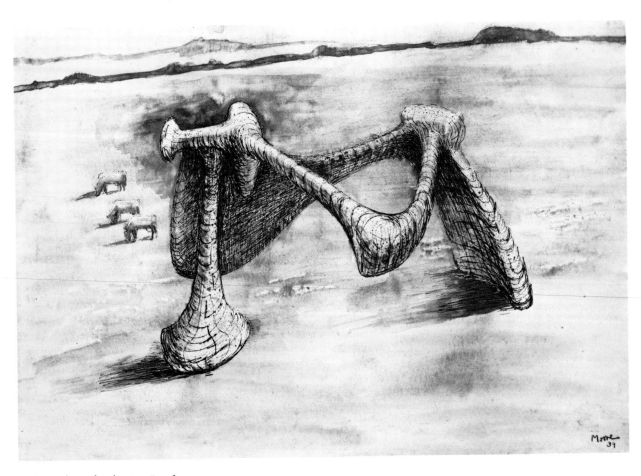

116 *Sculptural Object in Landscape · 1939*

115 *Pictorial Ideas and Settings for Sculpture · 1939*

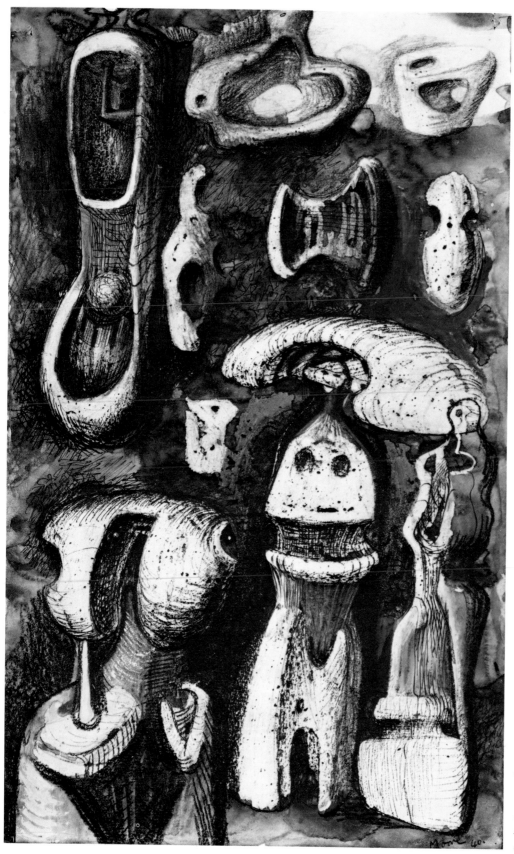

117
Ideas for Sculpture · 1940

118
*Drawing for Sculpture :
Standing Figures · 1940*

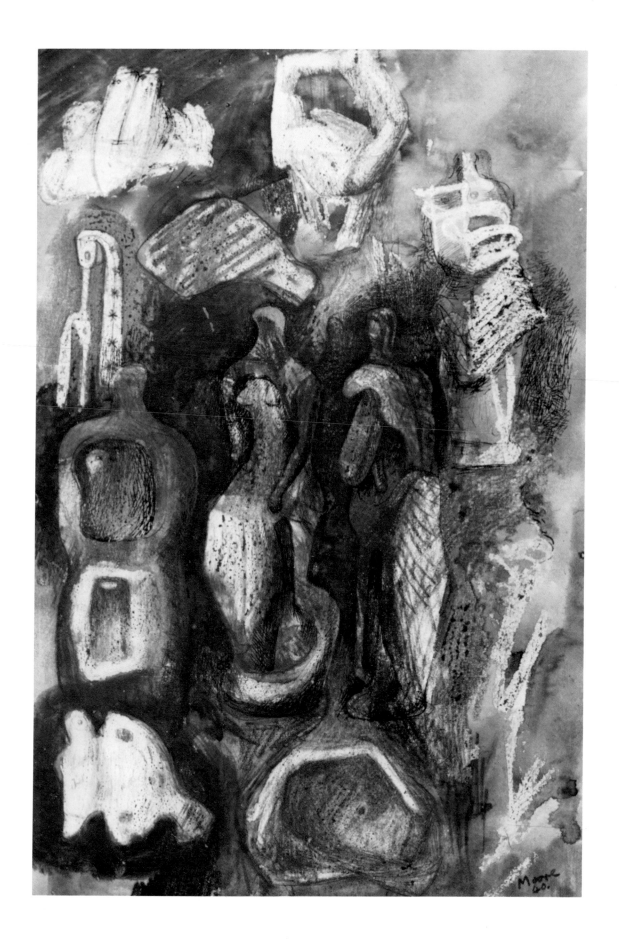

119 *Standing Figures, Drawing for Sculpture · 1940*

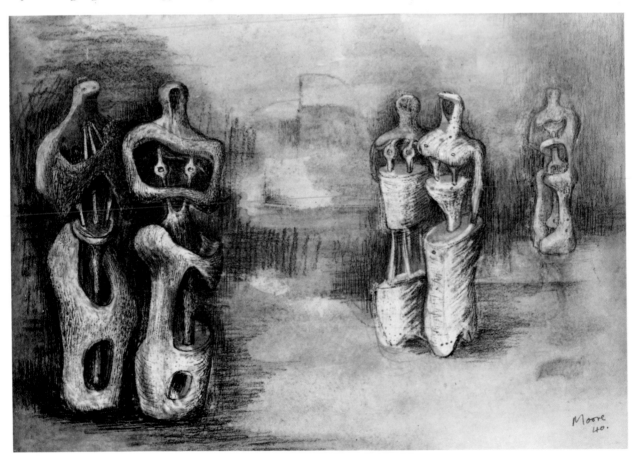

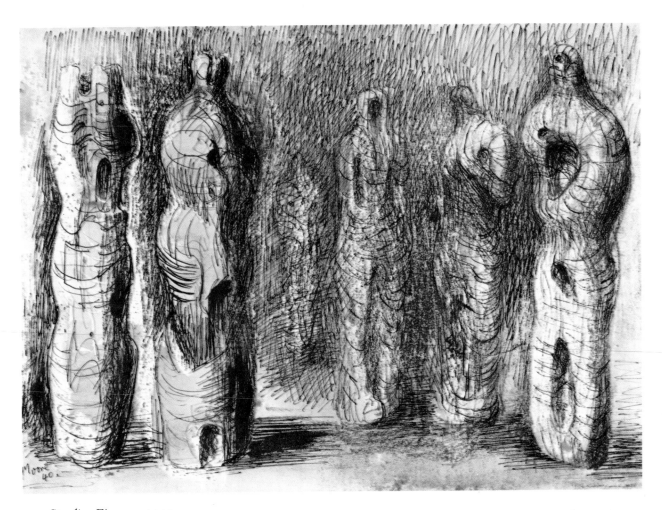

120 *Standing Figures · 1940*

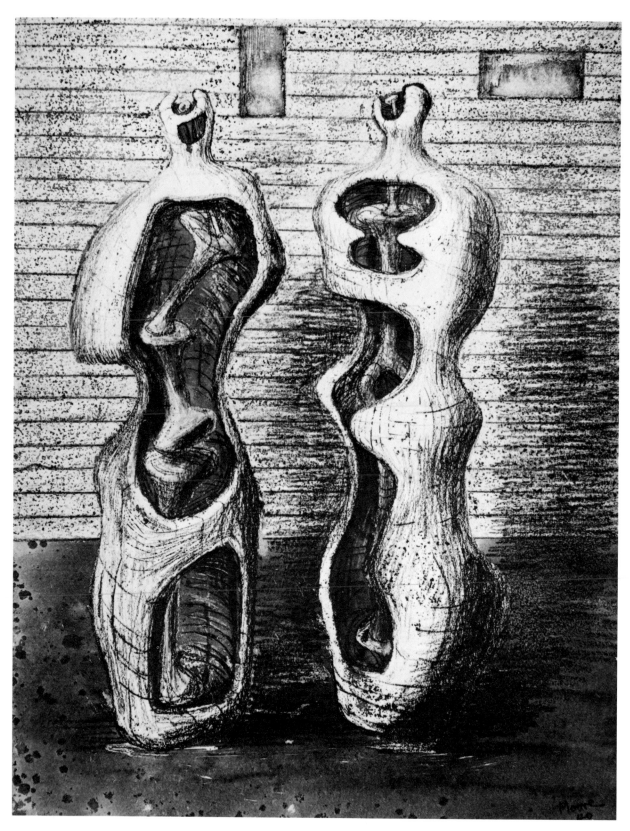

121 *Two Standing Figures · 1940*

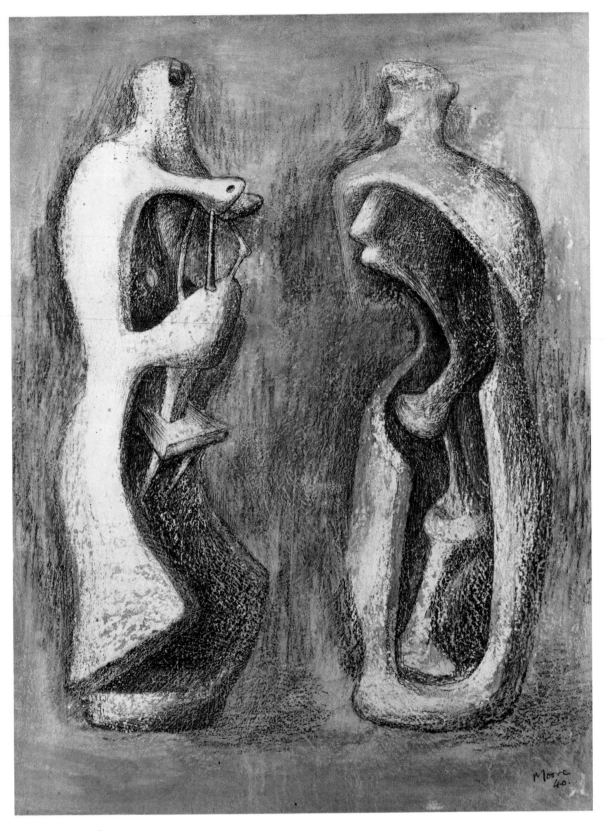

122 *Two Standing Figures · 1940*

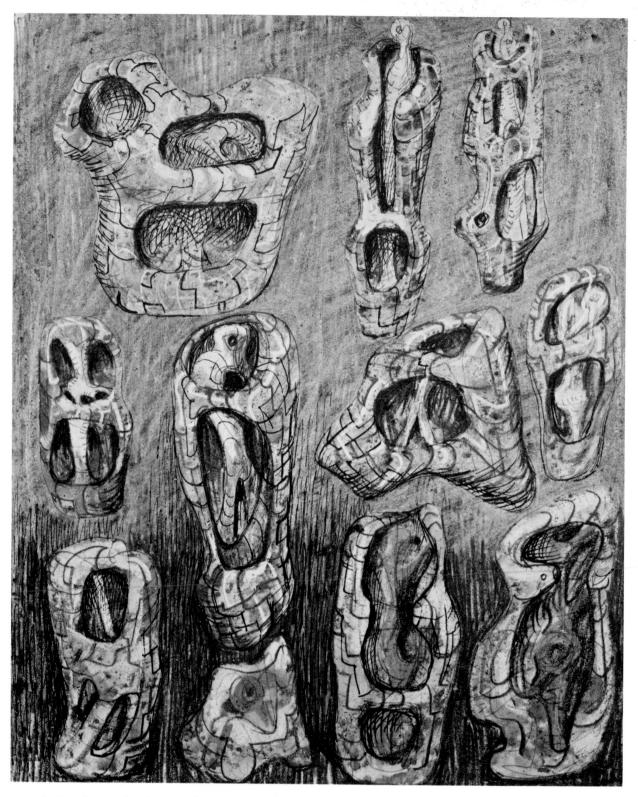

123 *Studies of Internal and External Forms · 1948*

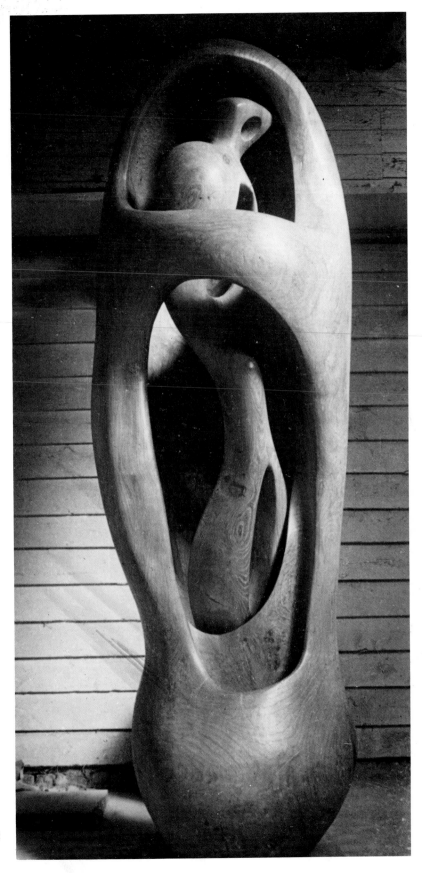

Upright Internal and External Form
1953/54

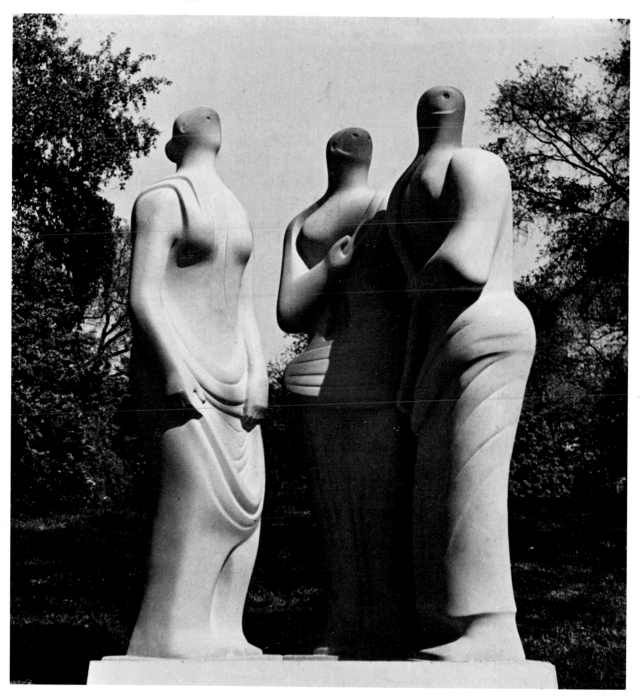

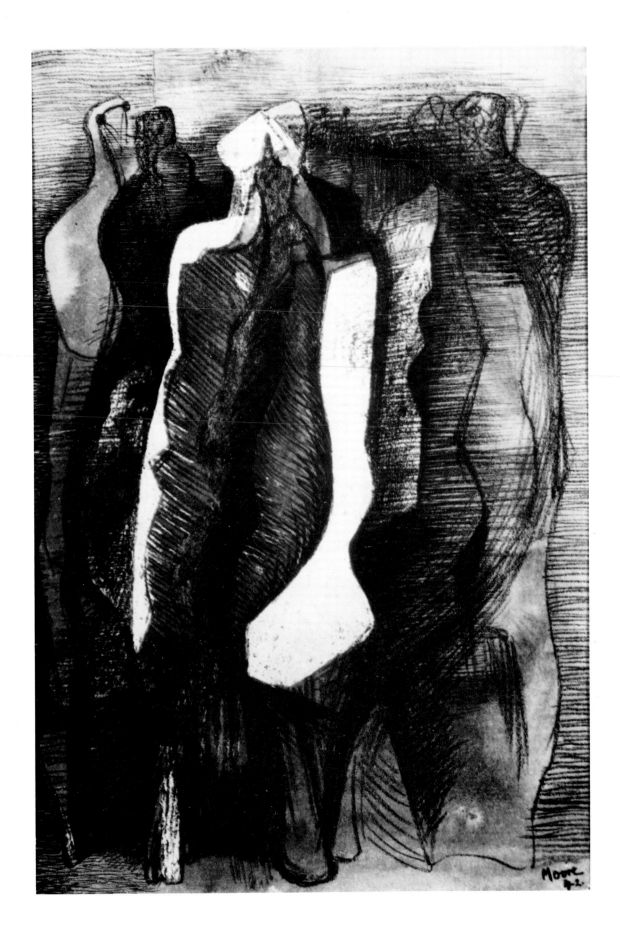

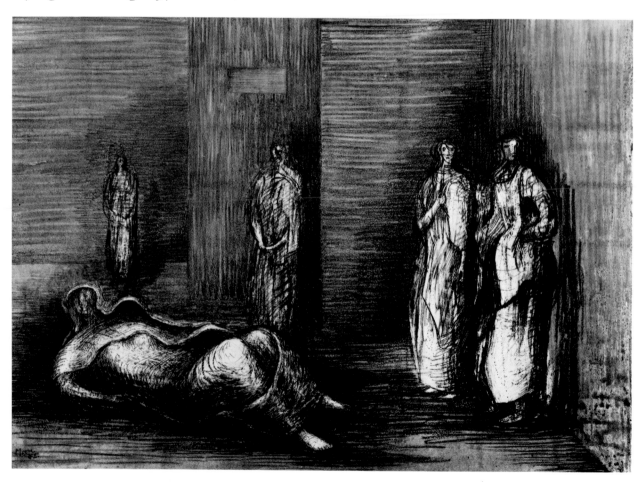

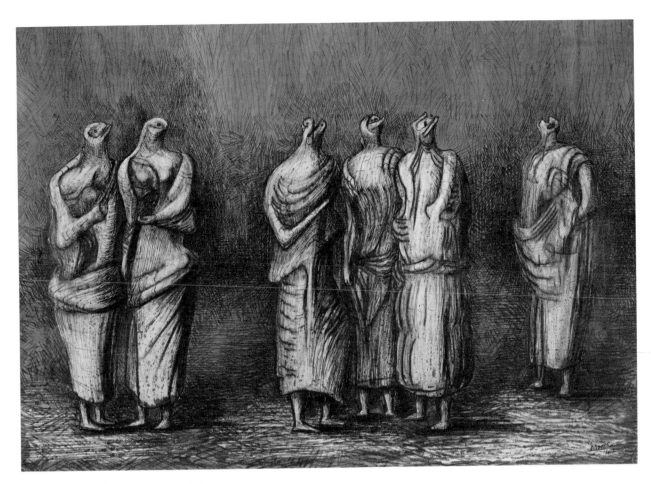

128 Group of Draped Standing Figures · 1942

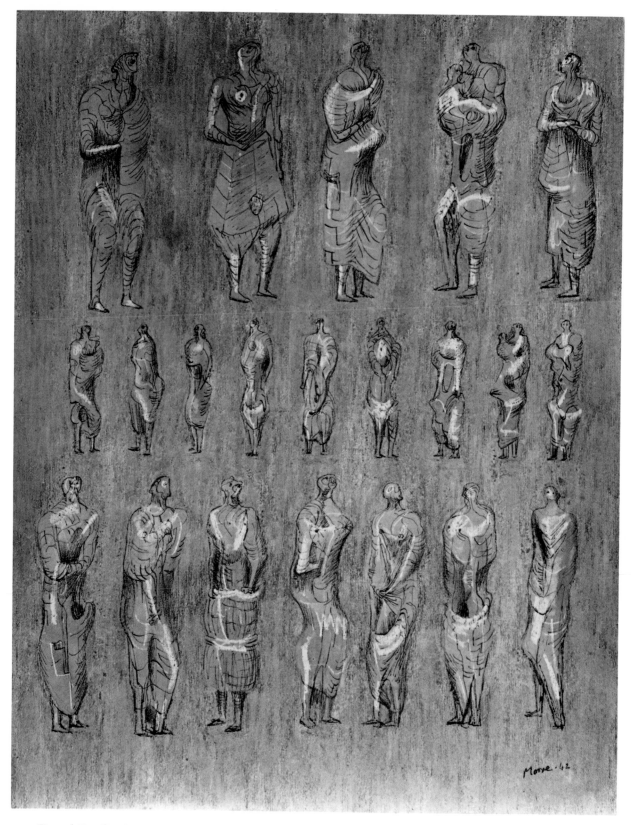

129 *Draped Standing Figures* · *1942*

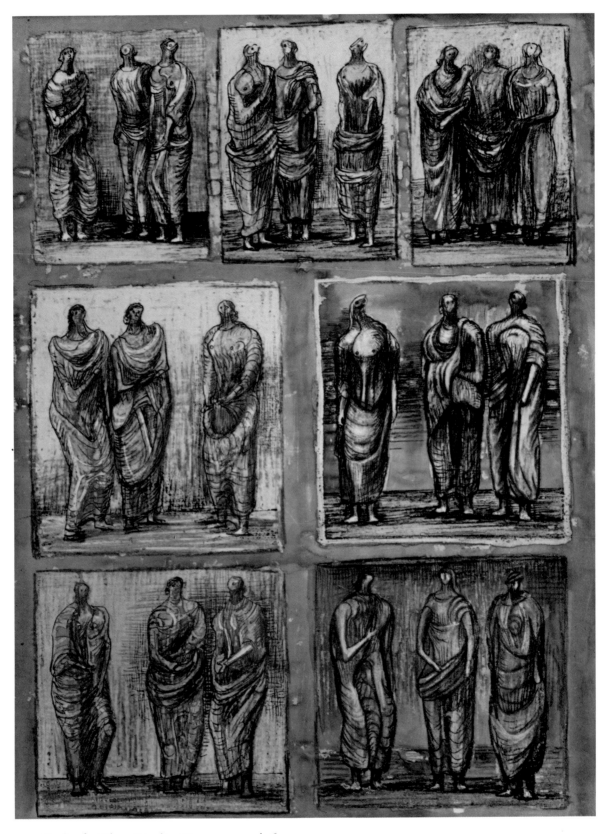

130 *Studies for Three Standing Figures · 1945/46*

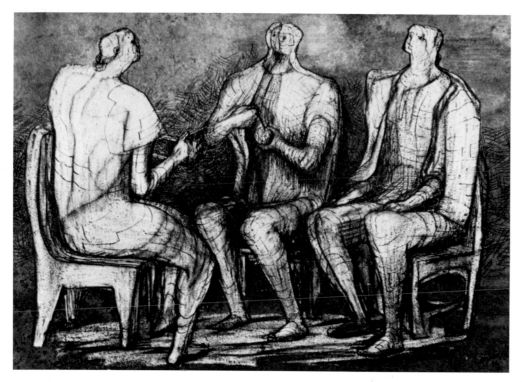

131 *Women Winding Wool* · 1942

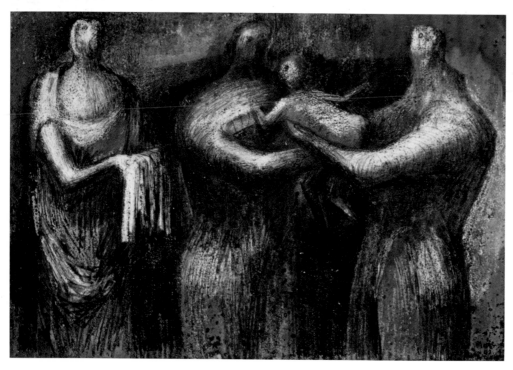

132 *The Presentation: Three Standing Figures and Child* · 1943

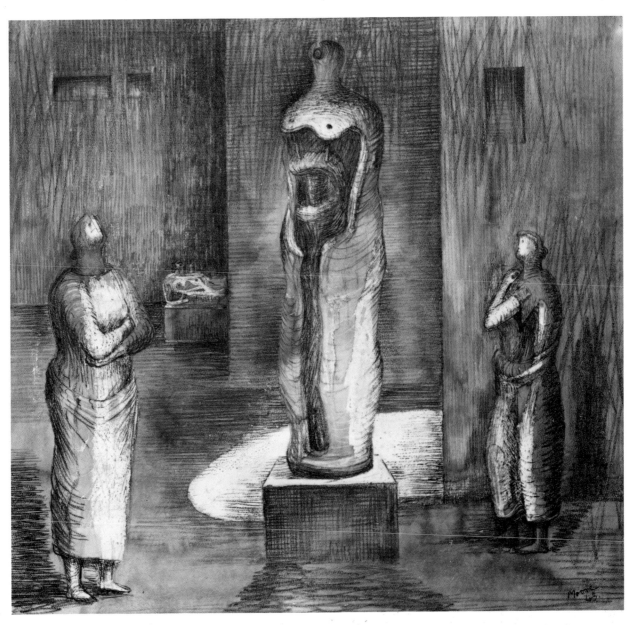

133 *Figures in an Art Gallery · 1943*

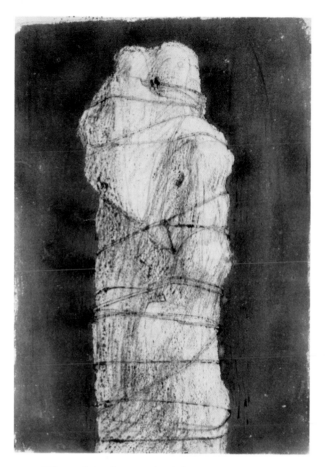

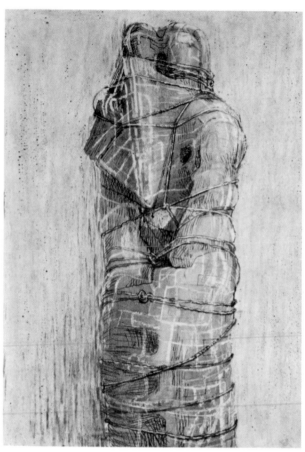

134 *Wrapped Madonna and Child : Night Time · 1950* 135 *Wrapped Madonna and Child : Day Time · 1950*

6 Shelterers and Miners

Admirers of Henry Moore's sculpture, who had followed his various phases of abstraction and learned to understand his form-language, sometimes felt a little dismayed by the popularity of his shelter drawings. It was as if the prophet of a secret society had suddenly joined the Salvation Army. But nothing, of course, could be further from Henry Moore's own thoughts. On the contrary, the sight of these passive, patient fellow creatures became a visible confirmation of the world of form that he had been extracting from his inner consciousness for the last ten years. The reclining figure was once more a suffering human being. 'Here was something I couldn't help doing.' The drawings exhibit varying degrees of naturalism; but all of them refer back to a visual and emotional experience, and in consequence I believe they had an entirely beneficial effect on Moore's development. The continued concentration on certain plastic problems, like the internal-external forms, might have led to an impasse (indeed the solution on *Pl. 122*, which I have called terminal, is very nearly frozen). Henry Moore realized this himself, and said: 'Curiously enough, on looking back, my Italian trip and the Mediterranean tradition came once more to the surface. . . . I sometimes wonder if . . . the wartime drawings were not perhaps a temporary resolution of that conflict which caused me those miserable six months after I had left Masaccio behind in Florence and had once again come within the attraction of the archaic and primitive sculptures of the British Museum.'

As we can see from *Pl. XIII*, the response to the thing seen was not solely due to the impact of the war, and in fact one of the most striking drawings

in the first shelter sketch-book (*Pl. 136*) is an amplification of studies made in 1938. There are also groups of seated women and domestic scenes that anticipate the groups of women in the shelters. However, these incursions into experience might have come to nothing without the deeply moving spectacle of the shelters. Moore did not immediately abandon his earlier brain-children: on the contrary, he submitted them to the hazards of war and placed them in bomb-shattered streets (*Pl. XIV*). But gradually the pathos of what he saw, combined with the plastic interest of these involved figures, overcame his formal obsessions. He filled his notebooks with delicate observations (*Pl. 135*) and with groups worthy of a Greek pediment (*Pl. XIX*); he conveyed the stoicism of the shelterers by the fall of their cloaks, coats and blankets (*Pls. 138, 155*); he recorded the pathos of children (*Pl. 142*), and the utter oblivion of snoring heads (*Pl. 144*); and finally he created a synthesis of the tunnel with its population of larvae that will remain one of the abiding images of the Second World War (*Pl. XXI*).

In all this he showed not only insight and compassion, but marvellous graphic skill. Since circumstances kept him from his sculpture, he became in effect a painter. His watercolour sketches of the darkened caves render space and atmosphere like a picture by Goya (*Pl. XV*); but, as was to be expected, his renderings of the human body are given weight and substance, and related to each other like great sculpture (*Pl. XVI*). Many of the poses and groups that he discovered were made into full-size drawings, but practically all of them occur in the two notebooks that are, to my mind, among the most precious works of art of the present century. Although the finished drawings often follow the original sketch almost exactly, by 1941 he began to feel the need of turning his recorded experiences back into forms that seemed to him grander and more durable, and are certainly more in keeping with the general line of his development. The resulting drawings are perhaps the finest things in all his graphic work, the *dramatis personae* with added dramatic power (*Pls. 157, 158*).

After a year, during which Moore worked continuously at shelter drawings, the raids were over and the subject was exhausted. But the War Artists Committee, which had commissioned the shelter drawings, was naturally unwilling to lose the services of its most distinguished artist, and suggested to Moore that he make a series of drawings of coal miners. It wasn't a bad idea. Moore had been brought up among miners, and felt

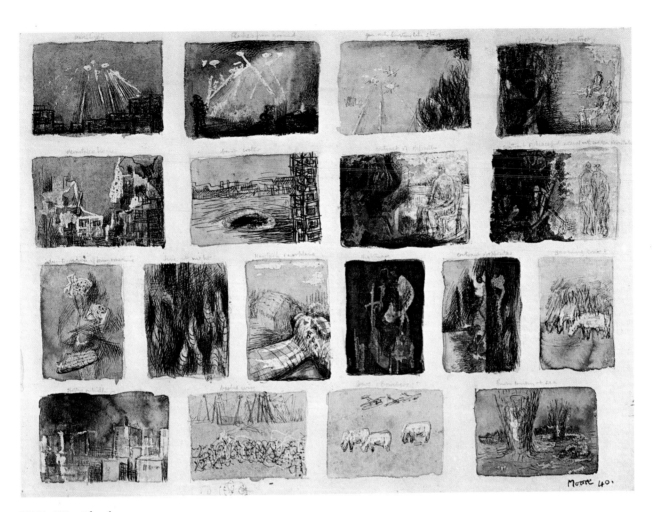

XIII War Sketches · 1940

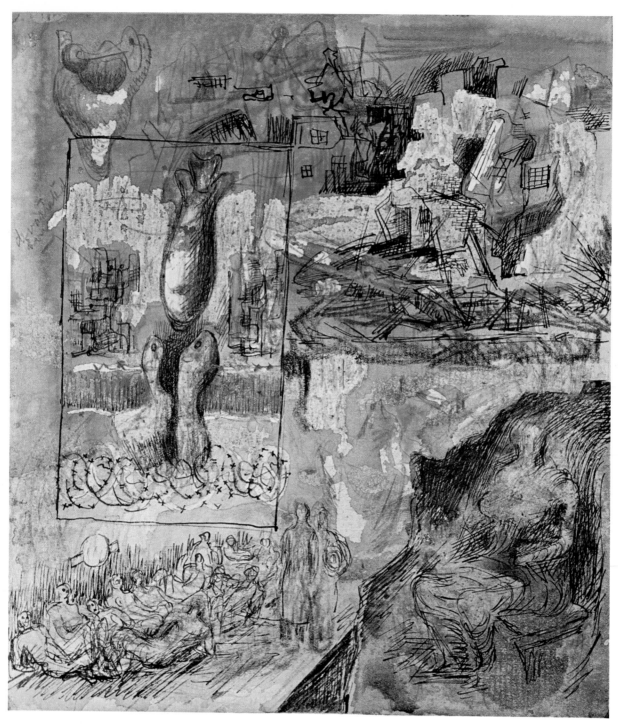

XIV Page 4 from First Shelter Sketchbook · 1940/41

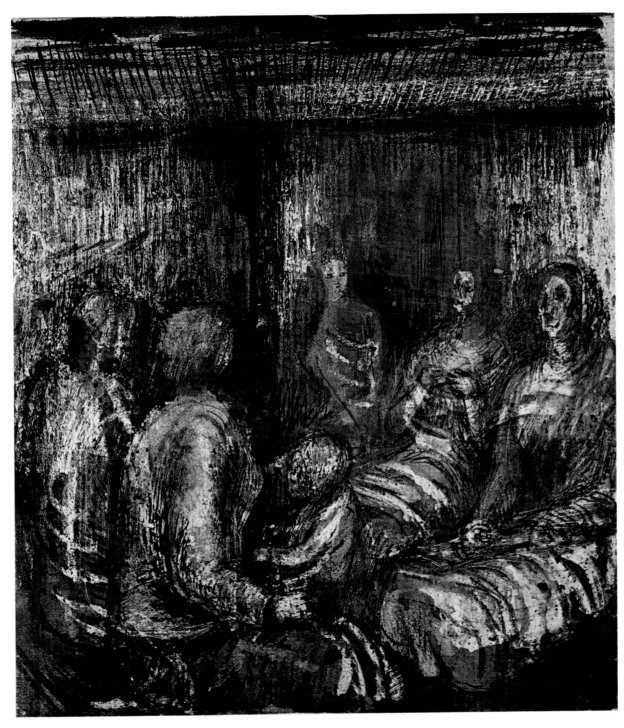

XV Page 35 from First Shelter Sketchbook · 1940/41

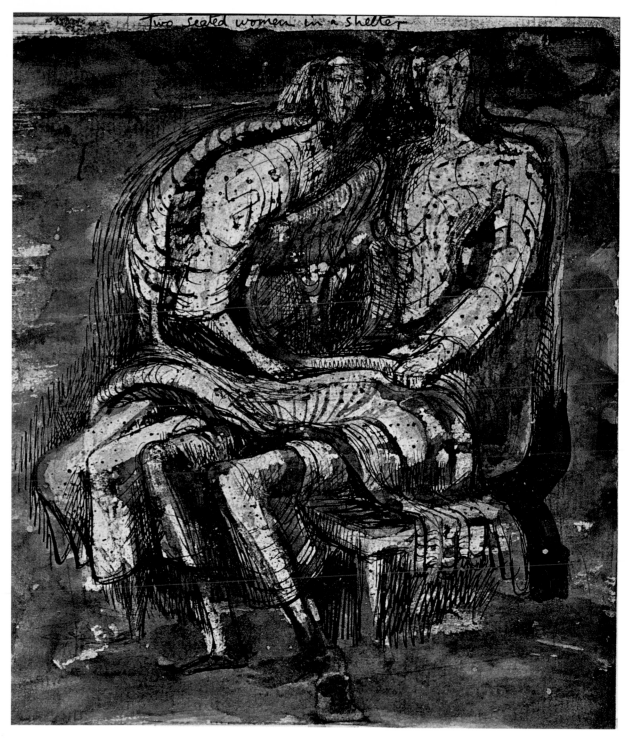

XVI Page 56 from First Shelter Sketchbook · 1940/41

sympathy for their way of life. Moreover, it extended from the tube shelters the motif of the tunnel, of figures imprisoned in claustrophobic space, which has had a recurrent interest for him. But for some reason the spectacle of miners at work did not move him. It was, he said, 'A commission, coldly approached', and I suppose we must take his word for it. But the drawings show no signs of the dutiful deadness that is apparent in some of his sculptural commissions (e.g. the Madonna and Child at Claydon), and personally I think they are underrated, both as works of art and as an influence on Moore's development. If the miner's back on *Pl. 163* is not a piece of drawing worthy of the great tradition, then I have been wasting my time during the last fifty years. In the darkness of the coal face he was able to indulge his love of black (*Pl. 167*) and make full use of the Seurat technique that has reappeared so impressively in his latest lithographs. As he himself says, 'Through these coal mining drawings I discovered the male figure and the qualities of the figure in action.' The wedge-shaped male body was added to the pear-shaped female, and such a figure as the fallen warrior would not have come into existence without the drawings of miners working on their backs (*Pl. XXIV*).

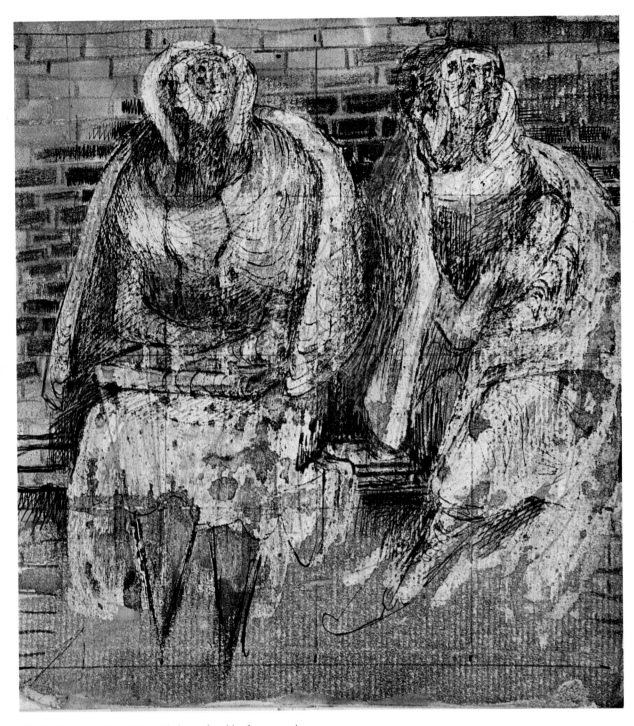

XVII Page 46 from First Shelter Sketchbook · 1940/41

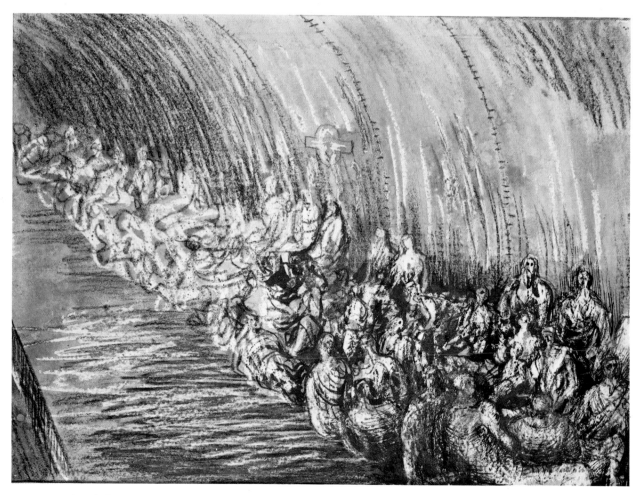

XVIII Tube Shelter · 1940

136 Standing, Seated and Reclining Figures Against Background of Bombed Buildings · 1940

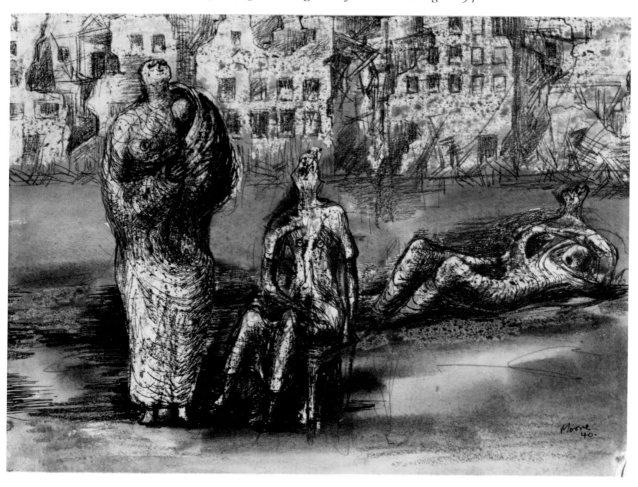

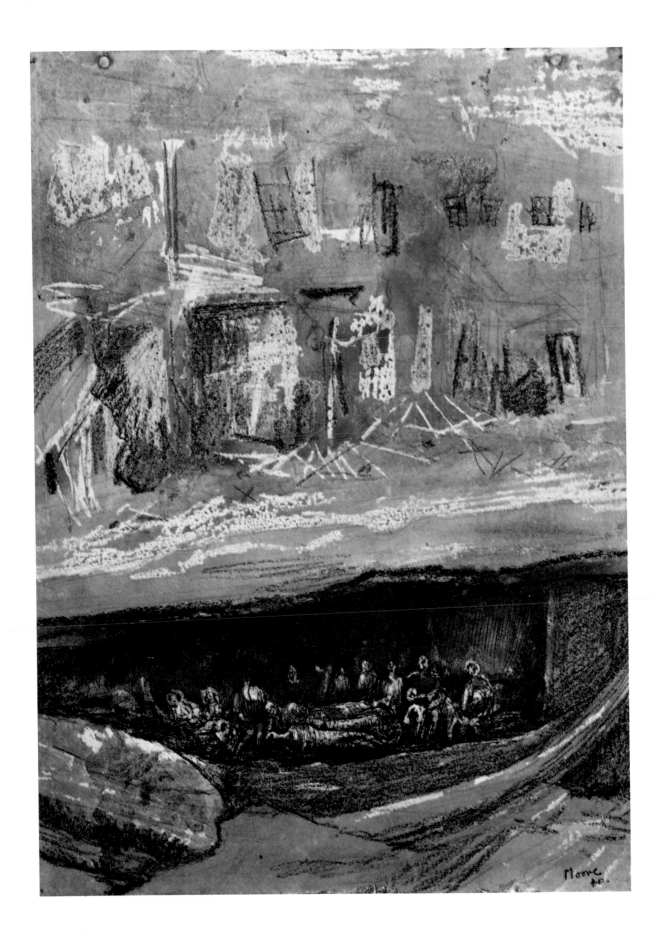

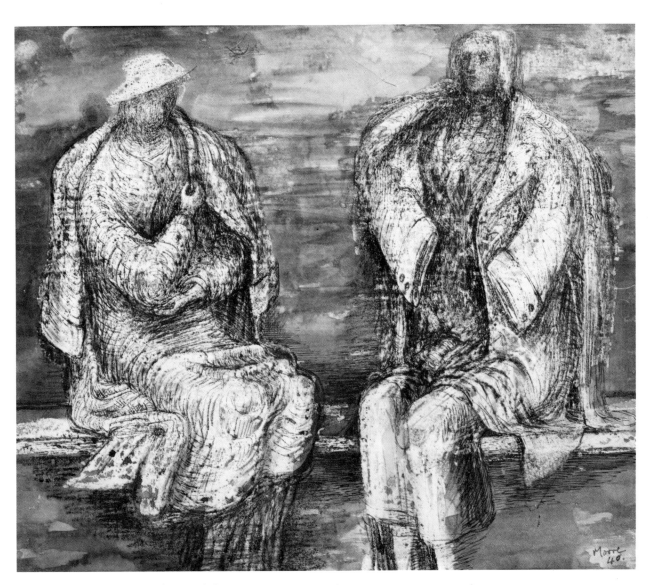

138 *Two Women on a Bench in a Shelter · 1940*

137 *Gash in Road (Air-raid Shelter Drawing) · 1940*

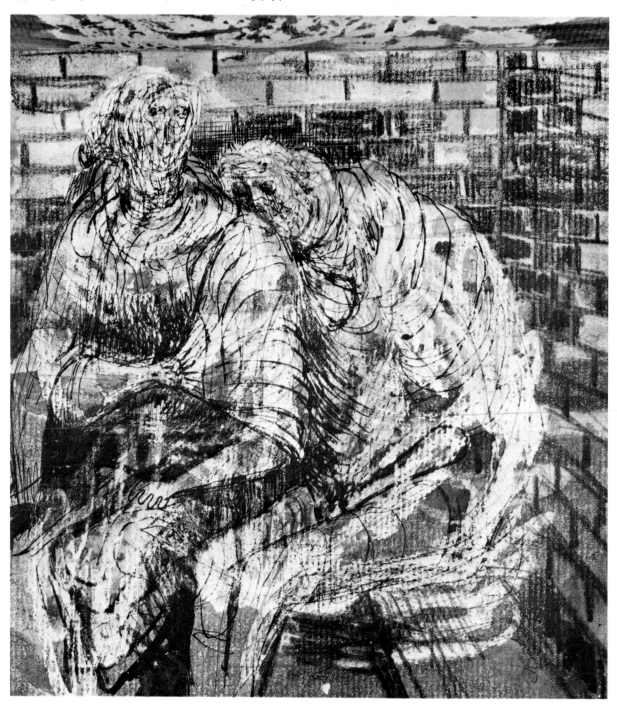

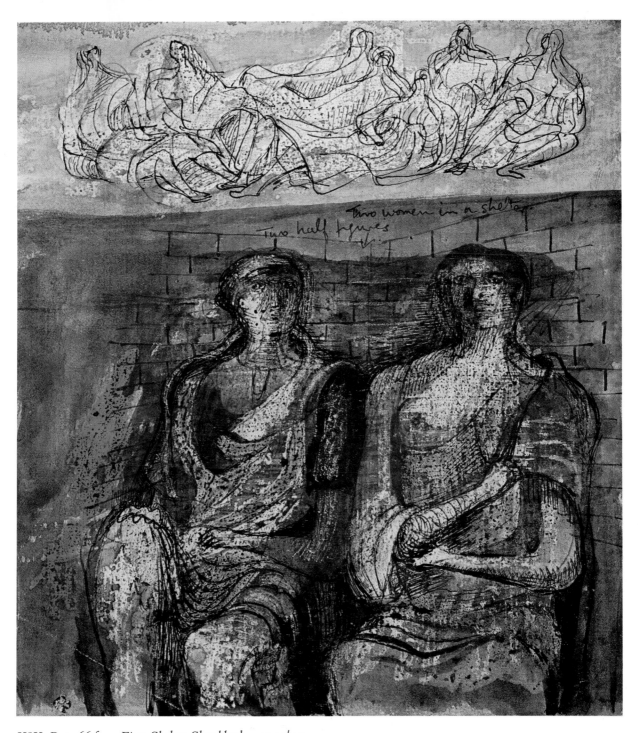

XIX Page 66 from First Shelter Sketchbook · 1940/41

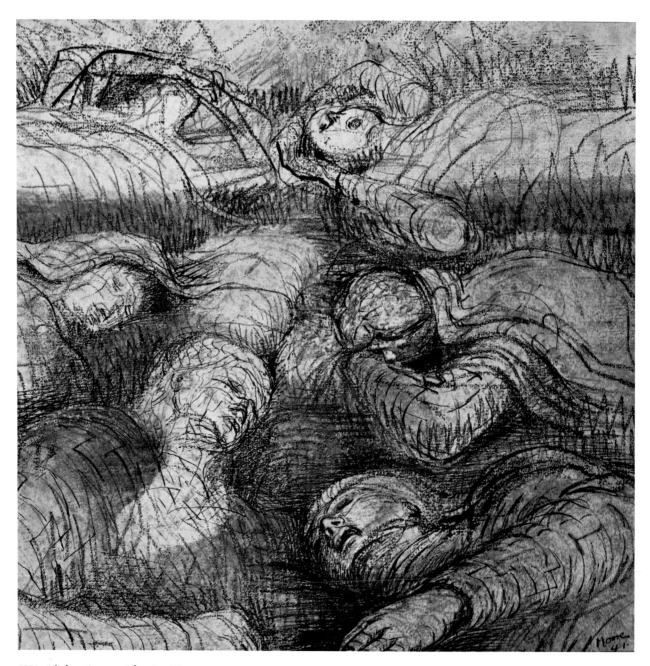

XX Shelter Scene: Sleeping Figures · 1941

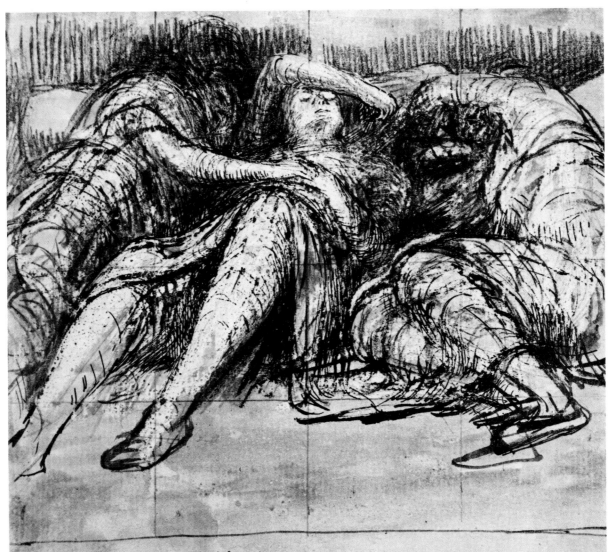

Platform scene of sleeping people.
3 or 4 people under one blanket — uncomfortable positions, distorted
Twistings — All kinds & colours of blankets, sheets & old coats.
Two figures in sleeping embrace
Masses of sleeping figures fading to perspective point of tunnel.
Group of people sleeping, disorganised angles of arms & legs. covered
here & there with blankets.

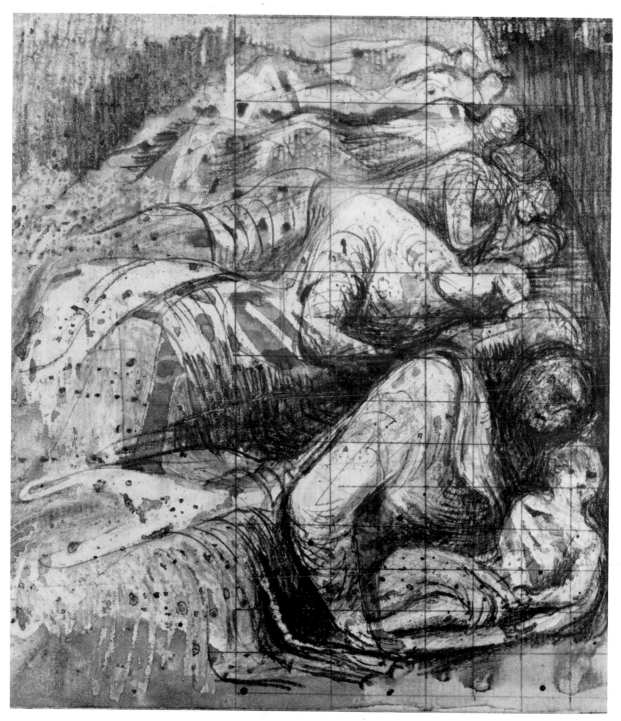

141 *Page 32 from Second Shelter Sketchbook · 1941*

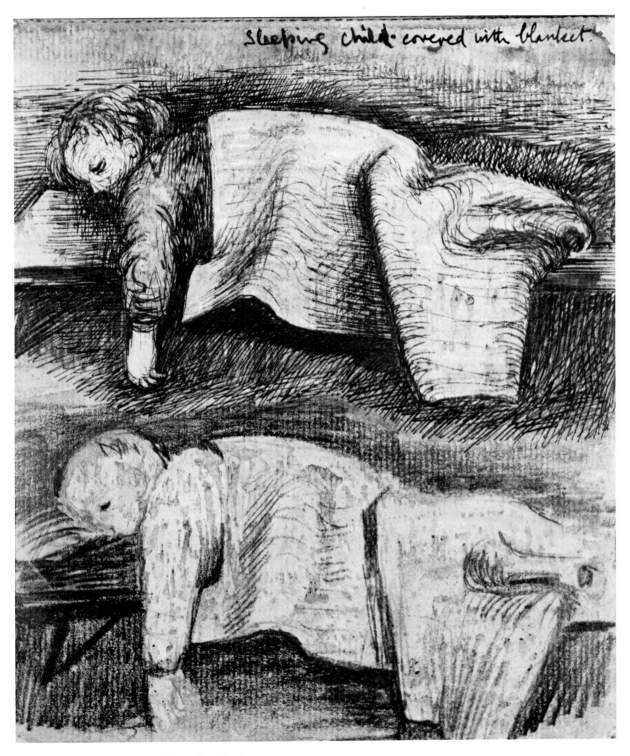

sleeping child covered with blanket.

142 *Page 63 from Second Shelter Sketchbook · 1941*

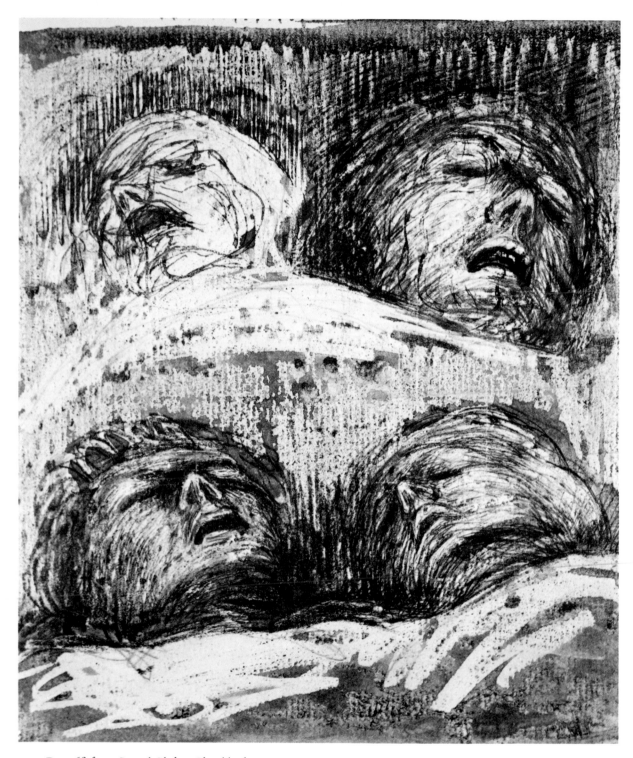

143 Page 68 from Second Shelter Sketchbook · 1941

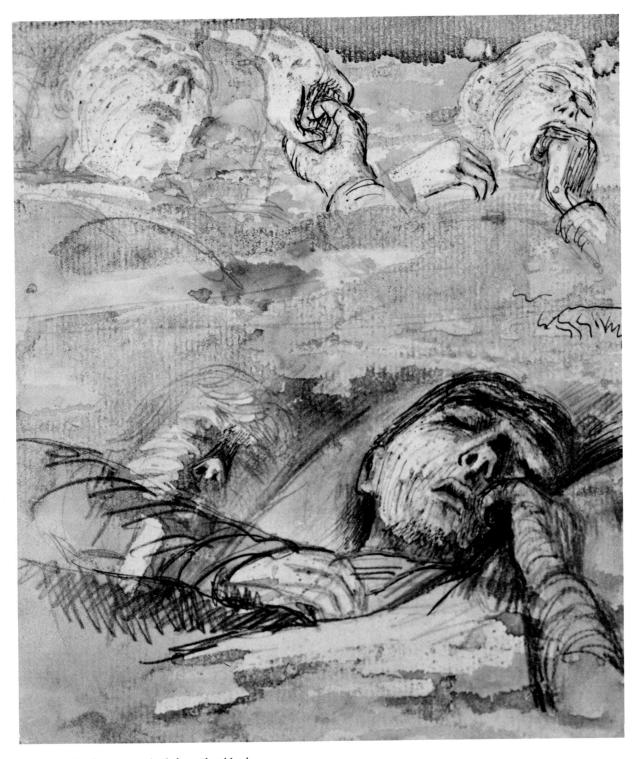

144 Page 86 from Second Shelter Sketchbook · 1941

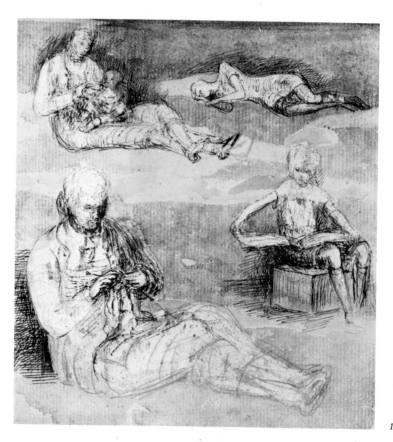

145 *Page 24 from First Shelter Sketchbook · 1940/41*

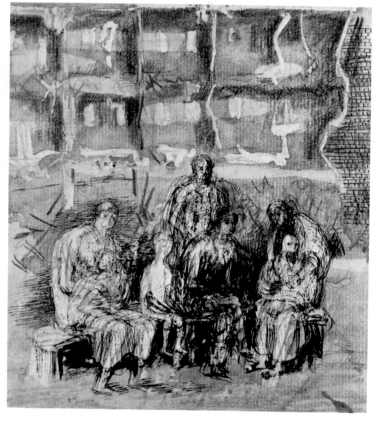

146 *Page 26 from First Shelter Sketchbook · 1940/41*

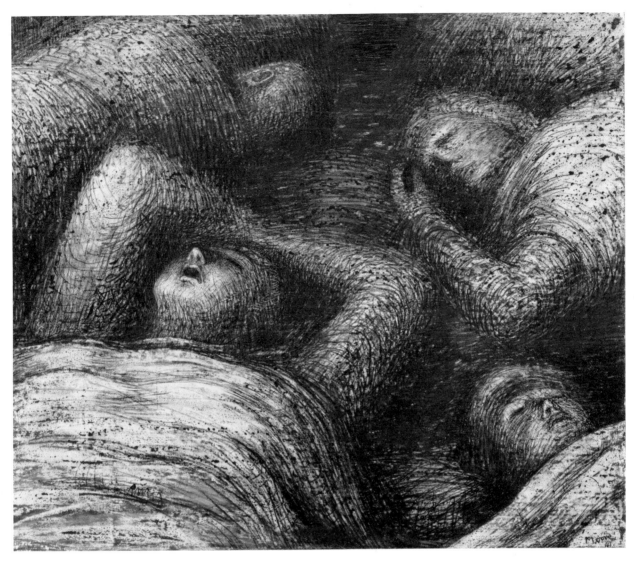

147 *Four Grey Sleepers* · *1941*

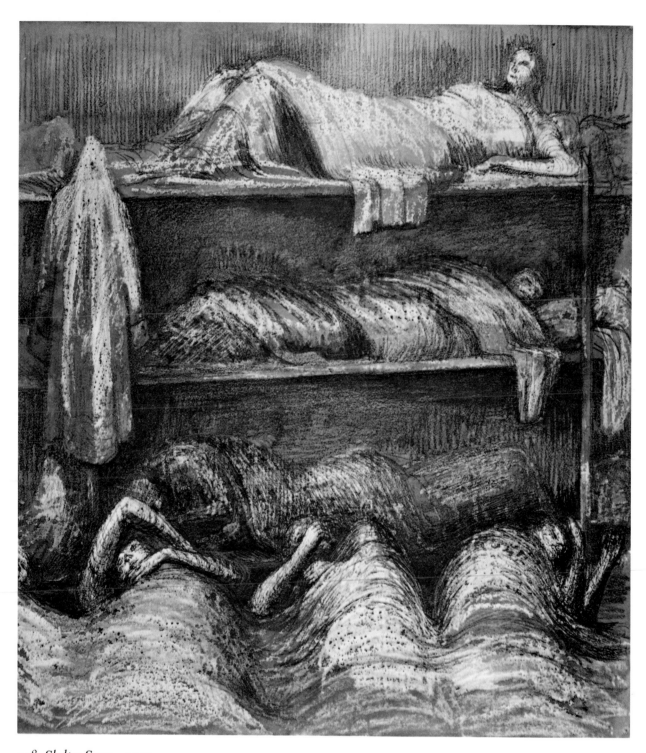

148 Shelter Scene · 1941

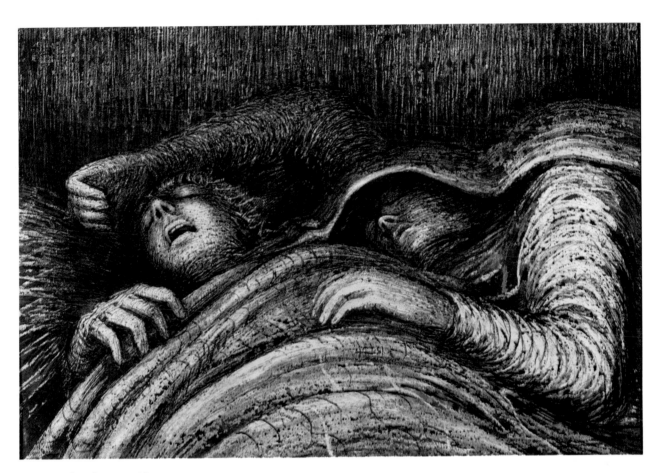

XXI Pink and Green Sleepers · 1941

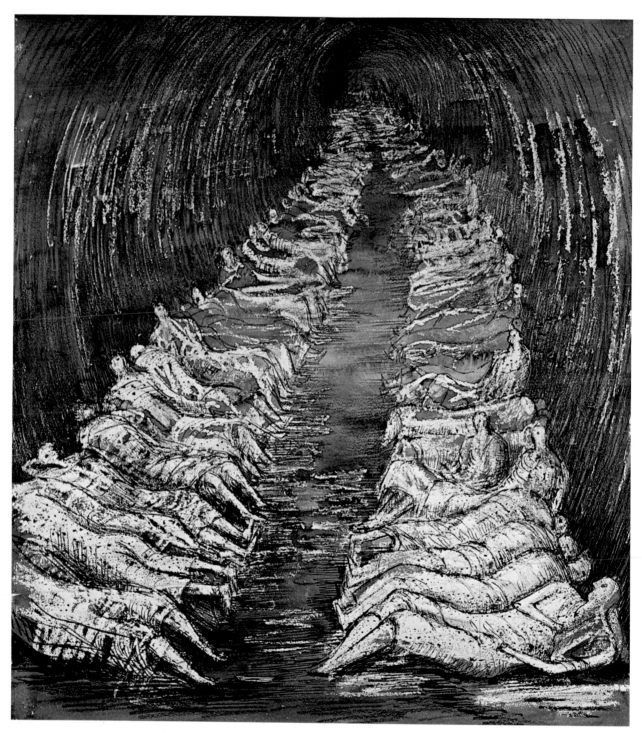

XXII Tube Shelter Perspective · 1941

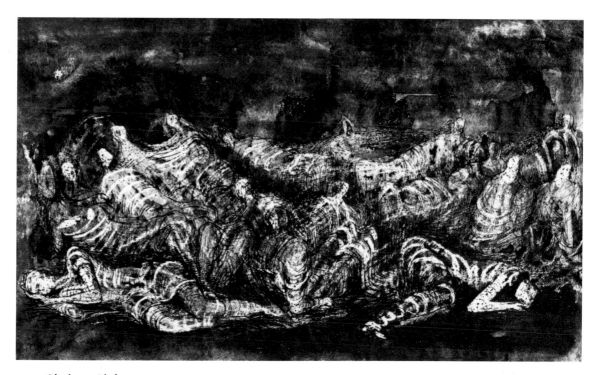

149 *Shadowy Shelter · 1940*

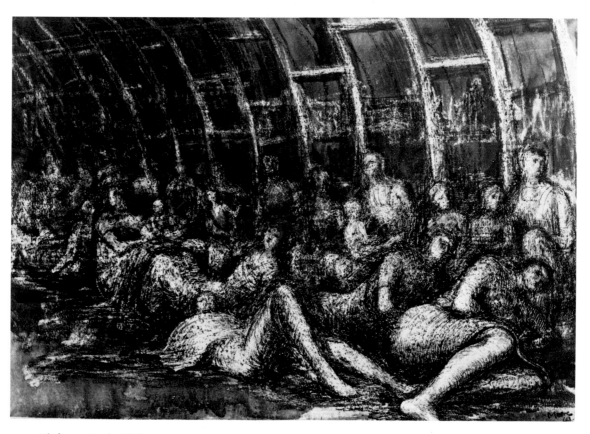

150 *Shelterers in the Tube · 1941*

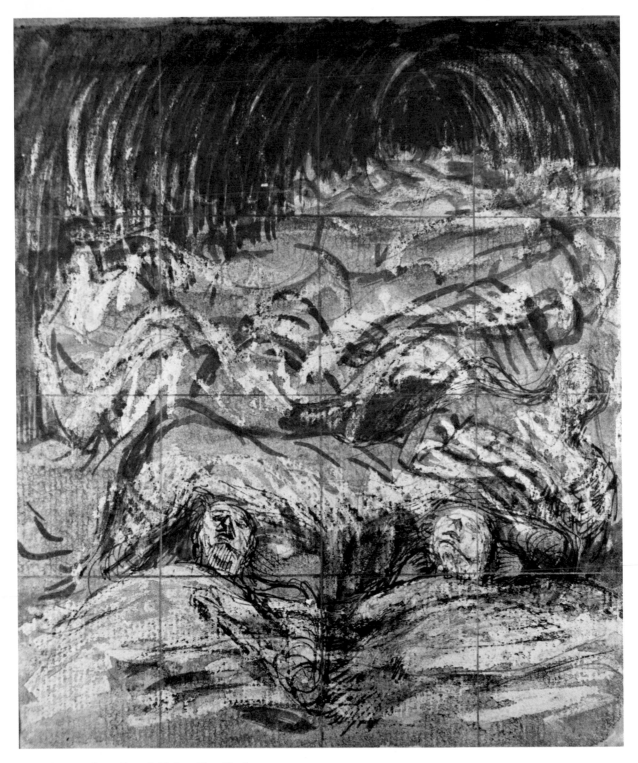

151 Page 29 from Second Shelter Sketchbook · 1941

152 Seated Women in a Tube Shelter · 1941

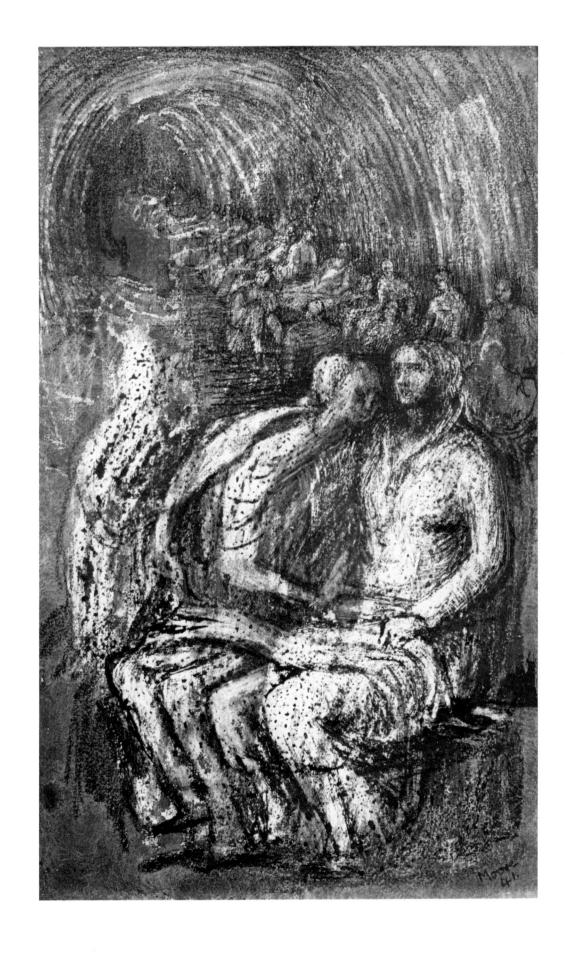

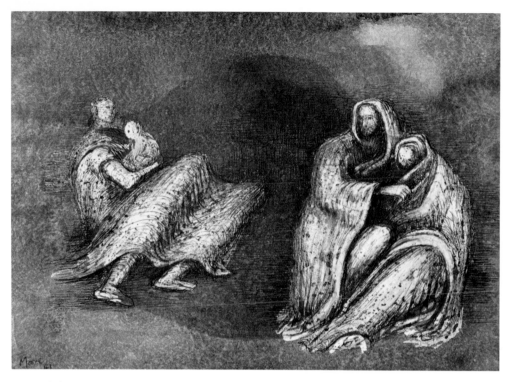

153 *Shelter Drawing · 1941*

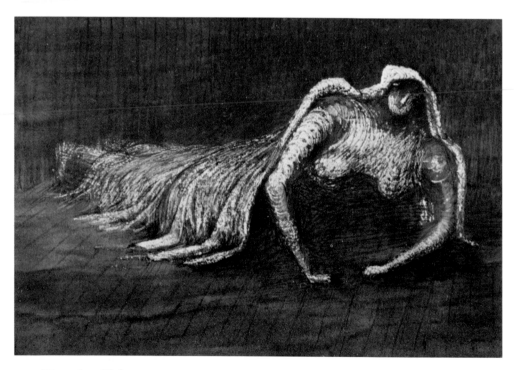

154 *Figure in a Shelter · 1941*

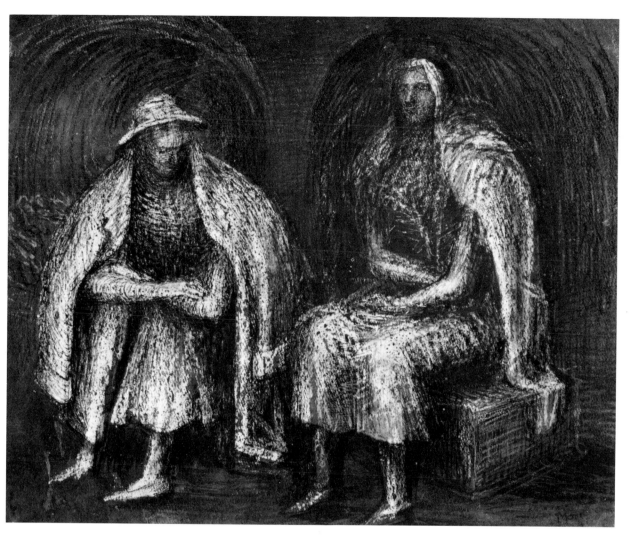

155 *Seated Shelter Figures · 1941*

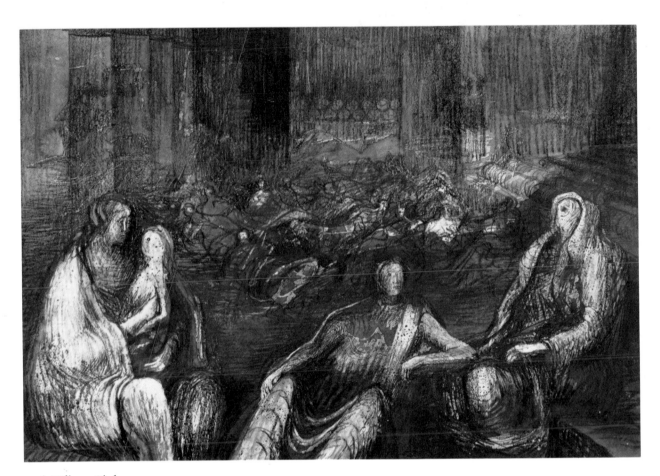

156 Tilbury Shelter · 1941

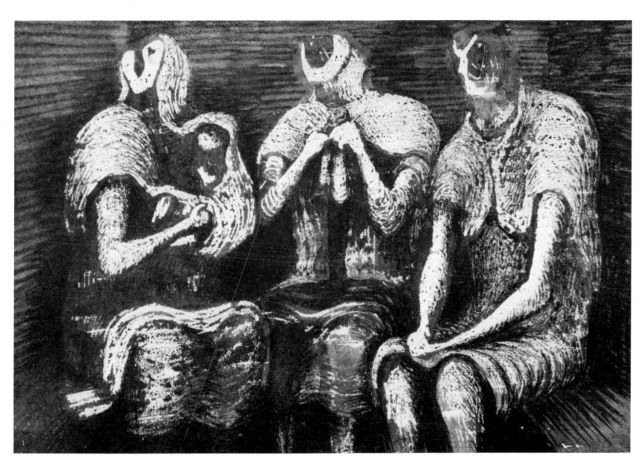

157 *Three Fates · 1941*

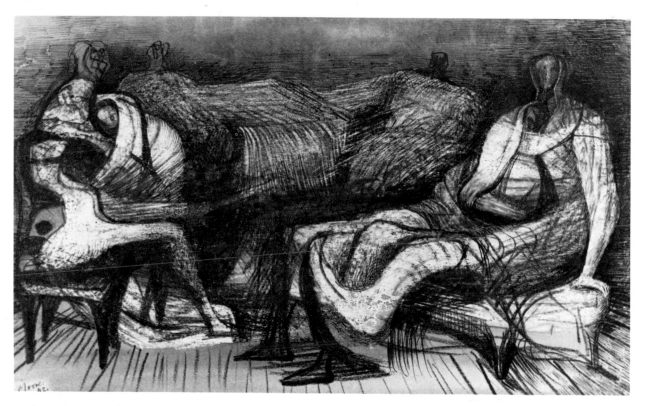

158 *Arrangement of Figures · 1942*

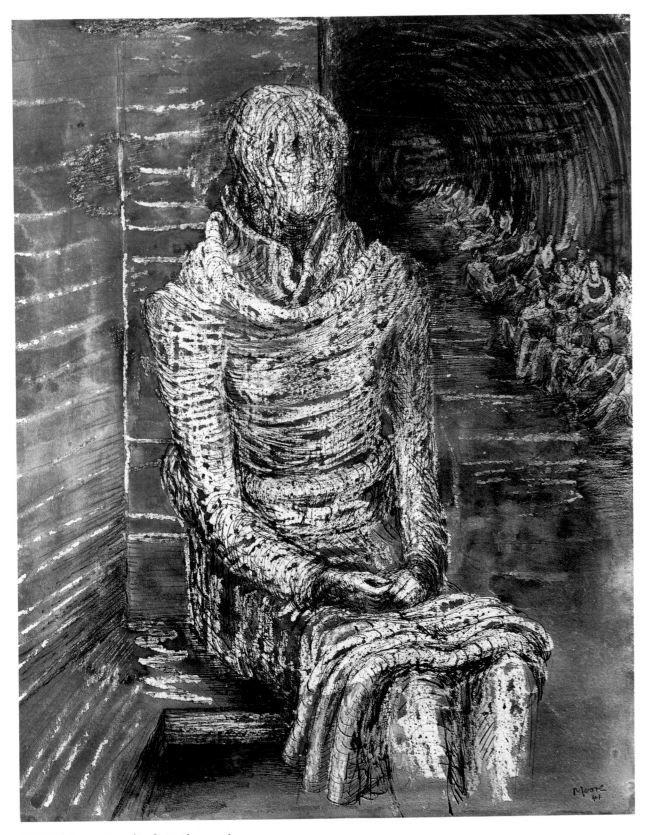

XXIII Woman Seated in the Underground · 1941

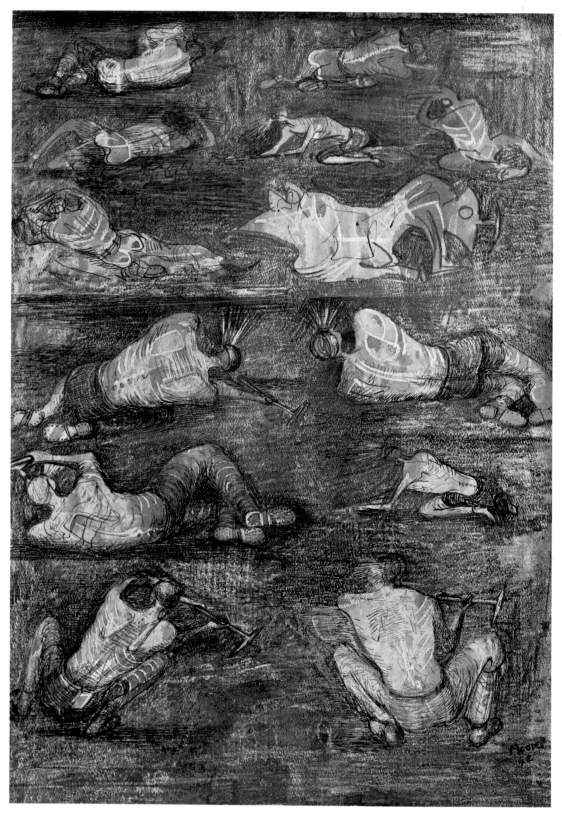

XXIV *Studies of Miners at Work* · *1942*

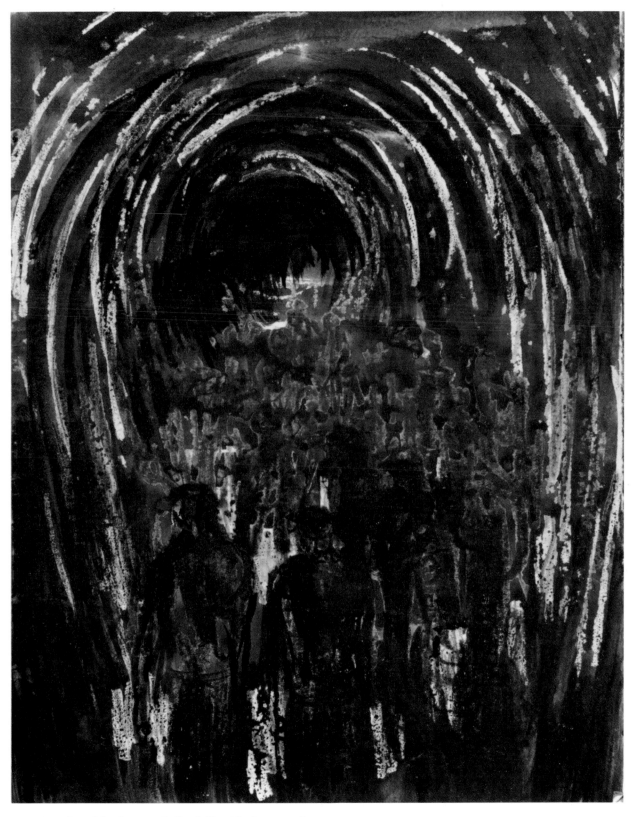

159 *Page from 'Coalmining Subject' Sketchbook · 1941/42*

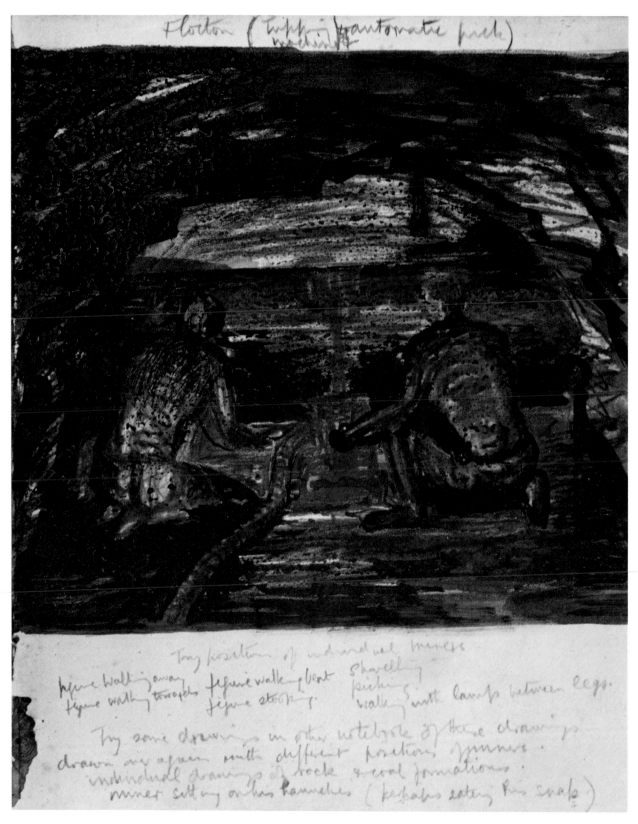

160 *Page from 'Coalmining Subject' Sketchbook · 1941/42*

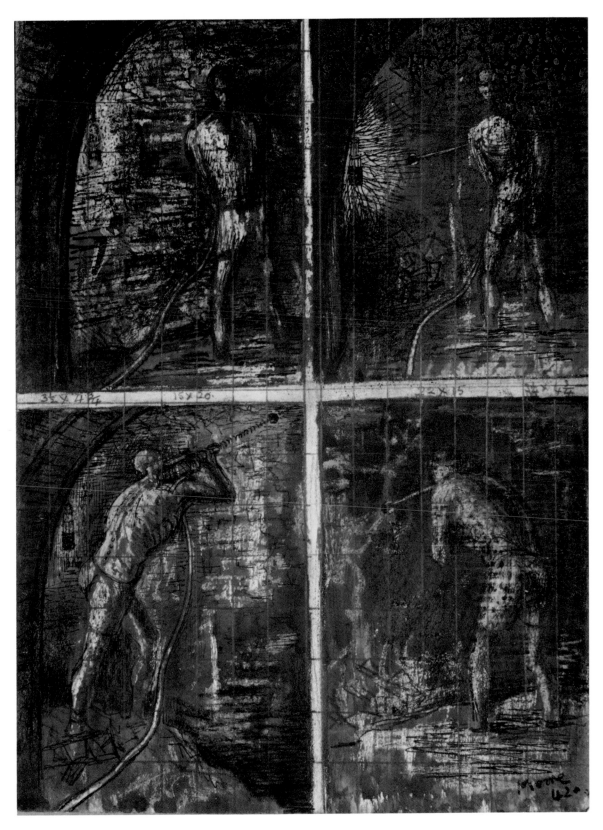

161 *Page from Coalmine Sketchbook · 1942*

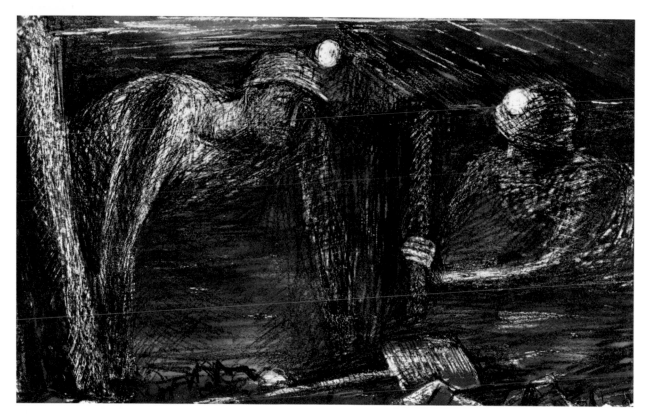

162 *At the Coal Face : Miners Fixing Prop · 1942*

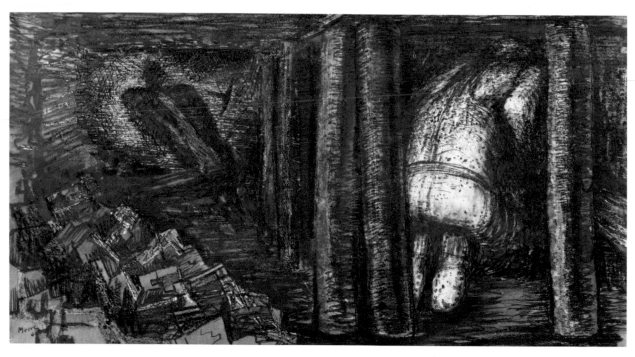

163 *Miners at Work at the Coal Face · 1942*

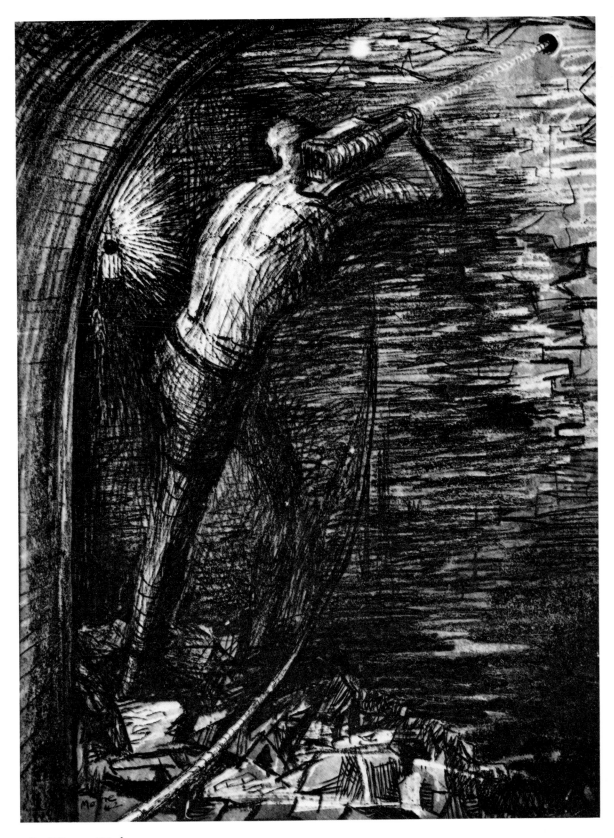

164 *Miner at Work* · 1942

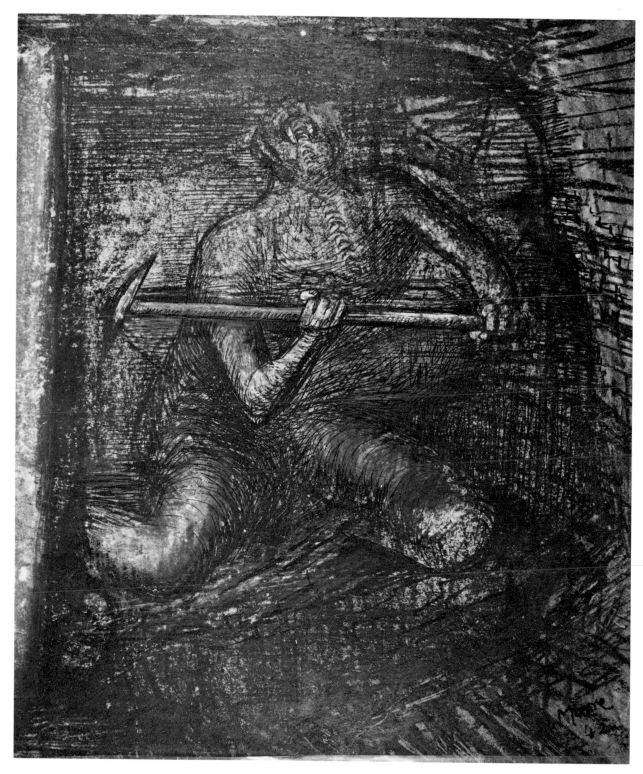

165 *Miner at Work · 1942*

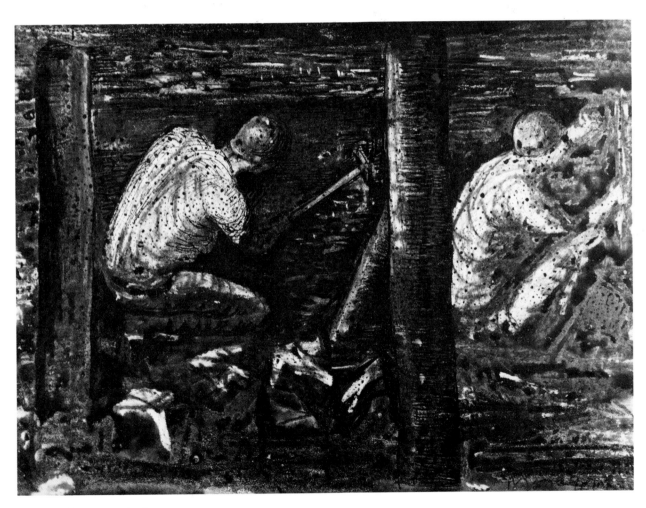

166 *Coalminers at Work · 1942*

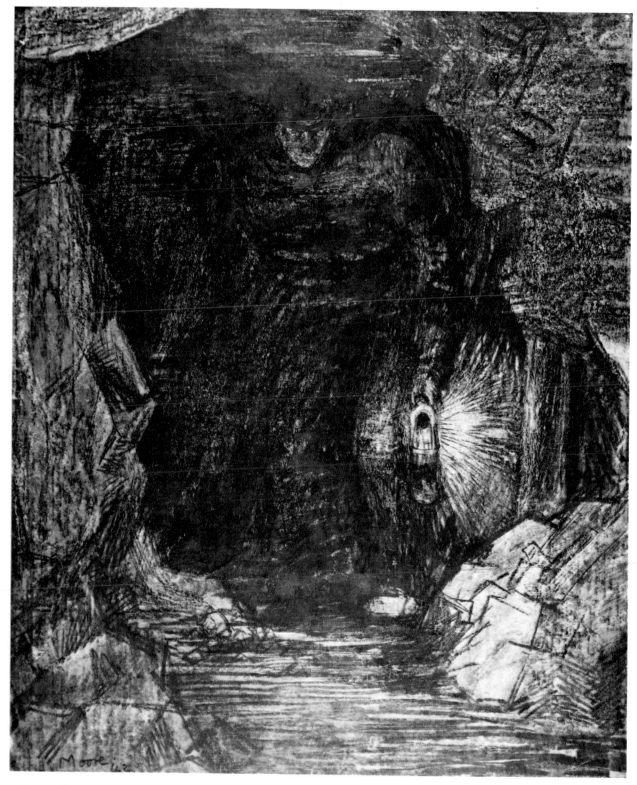

167 *Coalminer Carrying Lamp · 1942*

7 The Reclining Figure

The popular conception of Moore as the master of the reclining figure is correct. His vertical motifs, the internal-external forms and agonized columns, marvellous as they are, have been episodes. The reclining figure has reappeared at every phase of his work, and in the last few years has been the basis of his greatest sculpture. This goes back to Moore's obsession with the pull of gravity and of our relation with the earth. Once established on the ground, the figure can extend itself as a plastic unit. It can also become a part of nature, a fallen tree or a geological calamity, without ever losing some part of its first human characteristics. It can become at once more abstract and more physical.

The first reclining figures are among the life drawings. The mother playing with her child on *Pl. 168* comes from a sketchbook of 1922, and shows already the emphatic humps, the dissociation of forms and the sexuality that were to become part of the mature 'recliners'. A life drawing of 1928 (*Pl. 169*) done in England is more restrained, and, more than most of Moore's reclining women, suggests the idea of a landscape. A drawing done in Paris in the same year (*Pl. 170*) has more brio (like all the French drawings), but is also based on a contrast between the curve of the hip and the square construction of the head and shoulders. Breasts, which play so vital a part in much of the world's great sculpture, lack the tension and structure that nourish Moore's sense of form, and are usually eccentric or invisible. Among the drawings for sculpture of 1928–30 (the Mexican period) all that matters is the stability established by a balance of knee and head. But the inward-looking drawings of 1930–33, where the central caul

193

is almost always occupied by a 'recliner', show the body already subject to violent deformations, when, for example, the 'legs' are transformed into a flint (*Pl. 62*); and yet so strong is Moore's anthropomorphism that the whole still looks like a human body. One such figure, removed from its surroundings, is among the finest drawings of Moore's 'abstract' period (*Pl. 171*) – if, indeed, the word abstract can be applied to a personage with black socks and bedroom slippers.

The vintage year of reclining figure drawings is 1938. Most of them were reproduced as small figures in lead or wood executed in 1939, and these pieces follow the original drawings very closely. I would guess that the earliest is *Pl. 172*, where the figures are less articulate, and which has a backdrop of inventive contraptions left over from 1934. The foreground figure is a successor to the sarcophagus lids (*Pls. 84–86*), although with a shoe-bill that does not occur in his work again. Shortly afterwards Moore achieves a much more consistent sequence of forms (which, however, still looks back to 1934), and this was made the basis of a sculpture in lead (*Pls. 173, 174*). These small figures, made of lead melted over a primus stove in Mrs Moore's saucepan, with much excitement, were a turning point in Moore's development.

The next great reclining figure idea of 1938 appears first on a sheet of studies (*Pl. 176*, which also contains the germ of the preceding drawing in a landscape setting), and is then fully realized lying on a sunset beach, accompanied by a troupe of ghost ancestors, and, appropriately enough, a stringed wooden object (*Pl. 177*). In every respect this reclining figure was a wood idea, and it was to be carried out on a large scale in a magnificent piece of elm wood (*Pl. 179*). The result is one of the most intricate of Moore's early carvings. Also it shows most clearly (a point I shall return to later) how Moore has come to look for his forms in organic rather than crystalline structures. This flow of elaborate branches evidently meant a lot to him, for two years later he did, with undiminished excitement, a drawing of it in reverse (*Pl. 178*). But, as in the internal-external forms, the wooden character of the drawings is not final and exclusive. The figure to the right of *Pl. 180* has intimations of wood in her legs and shoulders, of metal in her ribs; and ultimately was carried out in lead. And sometimes one feels that a drawing has almost become an end in itself. Some of the best of the 1938 vintage were never carried out in sculpture, perhaps because there were no

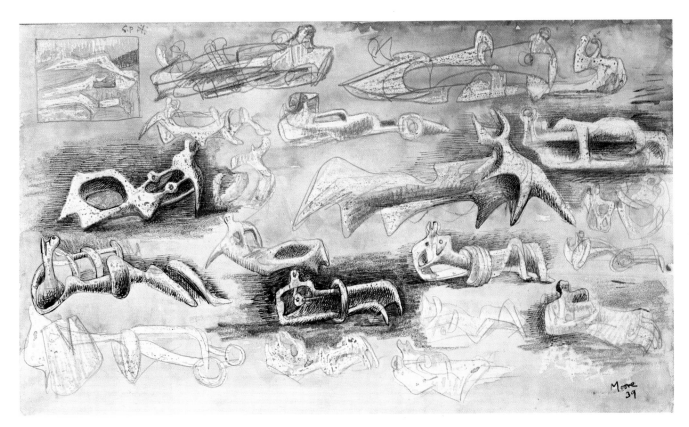

XXV Drawing for Sculpture in Metal · 1939

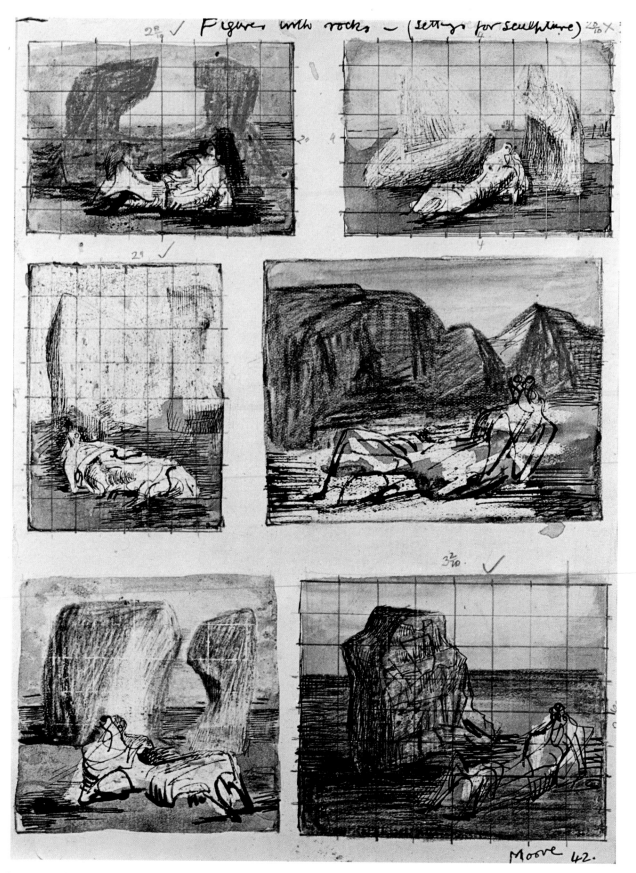

XXVI Figures with Rocks · 1942

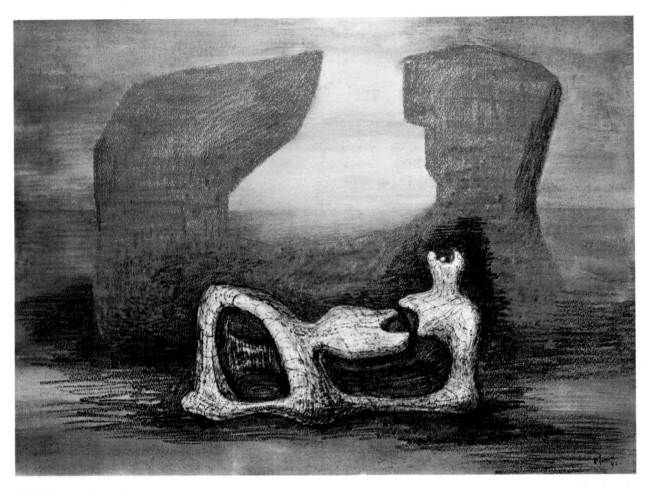

XXVII Reclining Figure · 1942

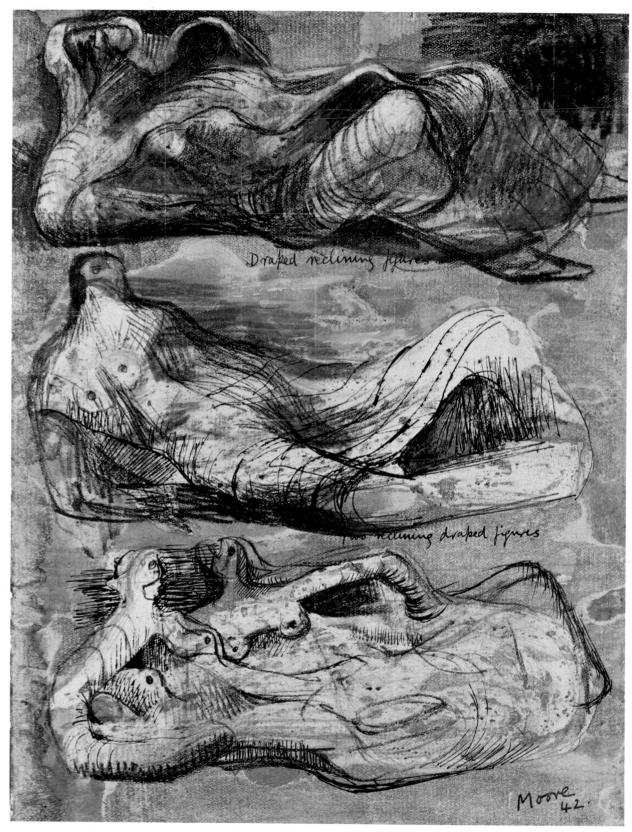

Draped reclining figures

Two reclining draped figures

Moore
42.

XXVIII *Draped Reclining Figures* · 1942

suitable pieces of wood available (*Pl. 181*), more probably because they were too complete and had become substitutes for sculpture. Finally, to prove how stubbornly an idea took possession of Moore's imagination, the great wooden figure (*Pl. 186*) with the beating heart like a crusader's helmet (1945) follows almost exactly the first study in a sketchbook of 1942 (*Pl. 185*). That this magnificent transformation of the reclining figure should have come into being a year after Moore had been making dozens of studies of 'real' people lying down in the shelters, is an example of how firmly his inner demon gripped his imagination. A few drawings in which he tries to combine the reclining figure of his formal obsessions with a memory of what he had seen, are not, to my mind, his most successful (*Pls. 187–89*). Occasionally there is a loss of conviction (and I may add, in parenthesis, that often in Moore's drawings, when he is at pains to emphasize plasticity by transverse lines drawn round the form, I feel that there has been a slackening of inspiration). But at some point in 1942 he did two of his very finest drawings, in which the reclining figures are set in front of red rocks (*Pls. 190, XXVII*). As I have said, this setting appears in a notebook of 1942 (*Pl. XXVI*), and clearly had an important meaning for him. The rocks are to some extent anticipations of the mighty forms in which his later sculptures were to achieve their grandiose architectural existence.

The reclining figures of 1938–40 are the most complete and the most *poussés* of all Henry Moore's drawings. Although many of them were the basis of sculpture, they seem to have been made for their own sakes, like Michelangelo's 'presentation drawings'. We should, therefore, be able to offer some explanation why these metamorphoses of the human body are so convincing. They are not like creatures of a new order, as the *dramatis personae* were. They are formal inventions following their own laws; and yet they involve a confluence of physical associations. For example, in the figure before red rocks (*Pl. XXVII*) the legs have become a cave, and from them extends a double tongue that threatens the figure's breasts. Some critics, following a well-known saying by Rodin, have compared Moore's reclining figures to landscapes. This has an element of truth when applied to a few of his pieces of sculpture, like the green Hornton stone 'recliner' in the Tate Gallery, which has the gentle undulations of the Downs; and the famous bronze two-piece figure that so obviously recalls Seurat's Bec de Hoc or Adle Rock in Yorkshire. But on the whole Moore's reclining figures

are not landscapes but things found in landscapes. In the later sculpture he finds erupted, eroded or collapsed rocks; in the reclining figures of 1938–39 he finds trees, and they provide him not only with the general design, but with the smooth, organic character of all the forms. This rejection of geometric shapes – rods, rectangles, cylinders – is not dissimilar in aim from the programme of such Art Nouveau designers as Victor Horta and Hector Guimard, with the allimportant difference that they rejected (or were incapable of) the basic sequences of classical art, whereas in Moore's work there is always at the back of his mind the memory of Michelangelo and the Greeks.

168 Page from a Sketchbook : Woman Playing with her Child · c. 1922

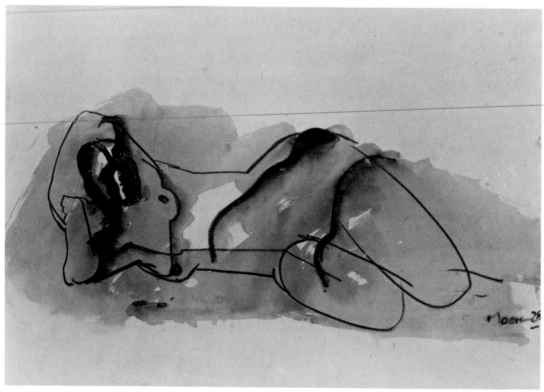

169 *Reclining Figure · 1928*

170 *Reclining Nude · 1928*

171 *Reclining Figure · 1935*

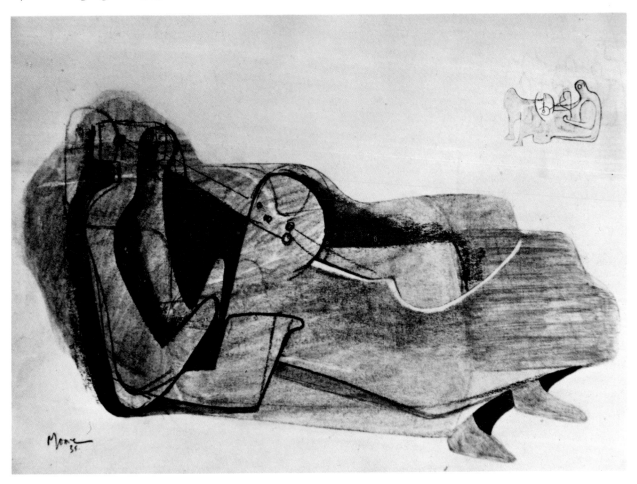

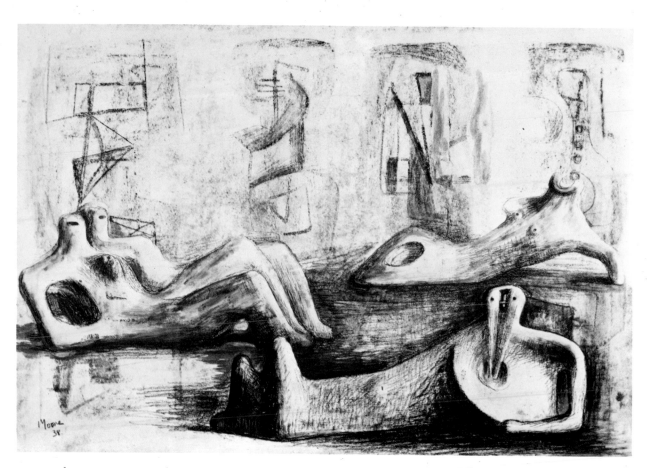

172 *Reclining Figures · 1938*

173 *Project for Figure in Lead · 1938*

174 *Reclining Figure · 1939*

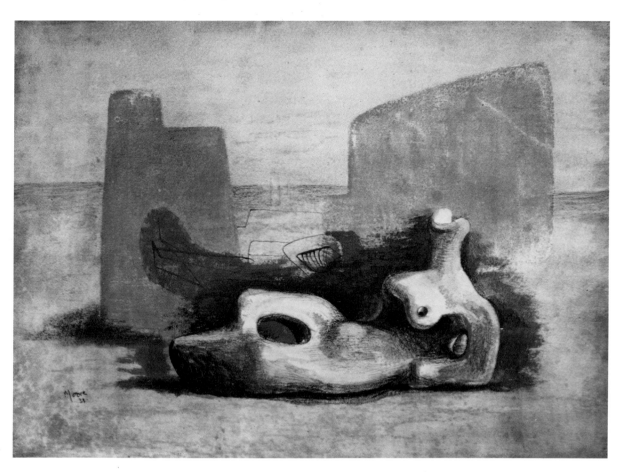

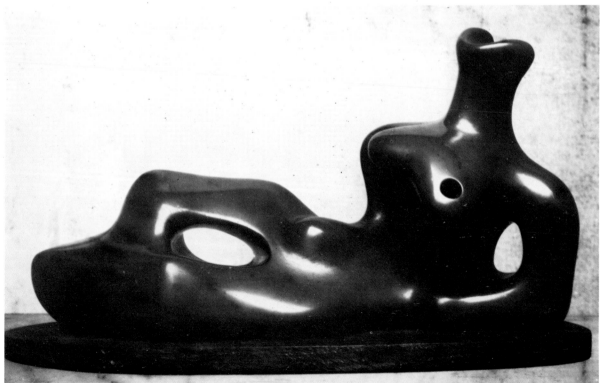

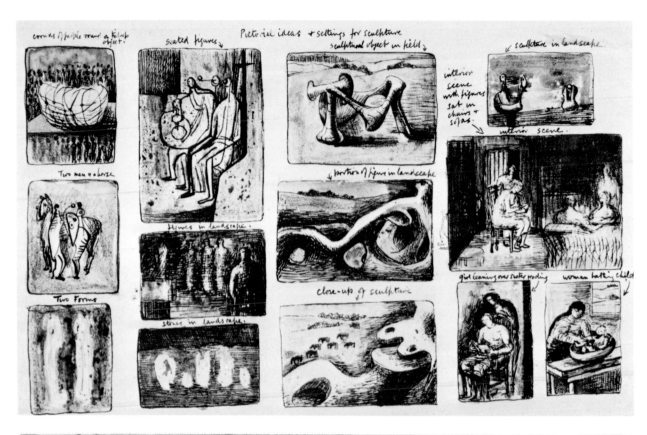

Pictorial ideas + settings for sculpture

crowds of people round a tubular object.

scated figures

sculptural object in field

sculpture in landscape.

Two men a horse

interior scene with figures sat in chairs + sofas.

interior scene.

figures in landscape.

portion of figure in landscape

Two Forms

stones in landscape.

close-up of sculpture

girl leaning over water reading

women bathing child

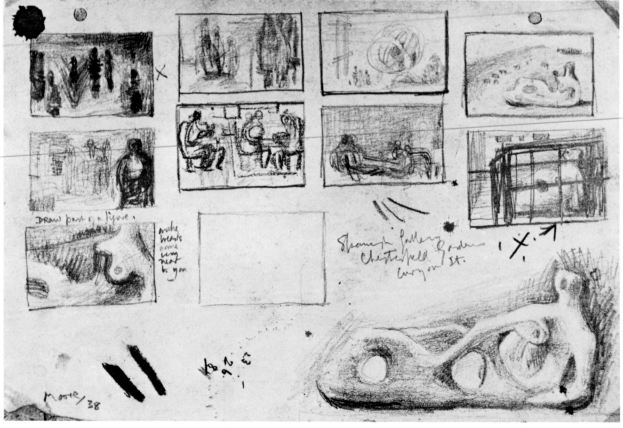

DRAW part of a figure.

make breasts come very near to you

Spanish Gallery Chesterfield Gardens Curjon St.

Moore/38

175 *Pictorial Ideas and Settings for Sculpture · 1938*

176 *Drawing for Detroit Reclining Figure · 1938*

177 *Landscape with Figures · 1938*

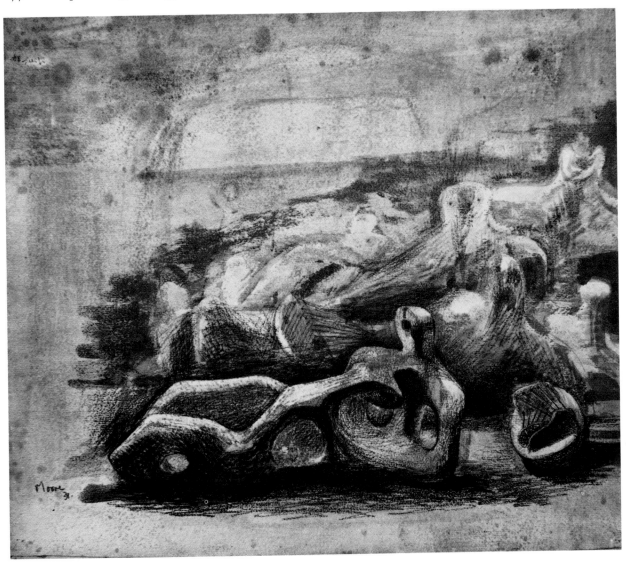

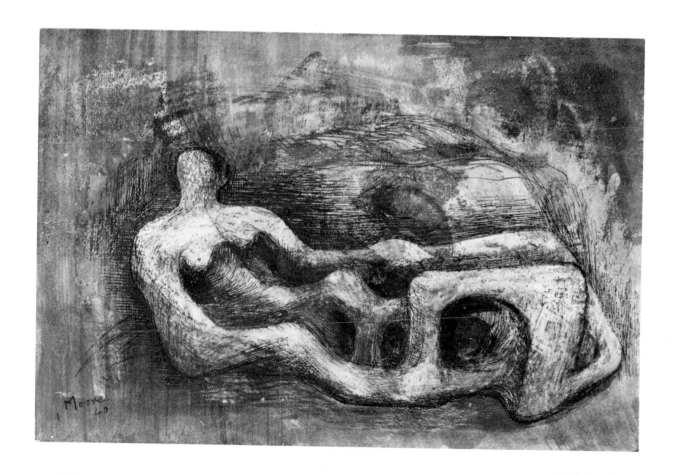

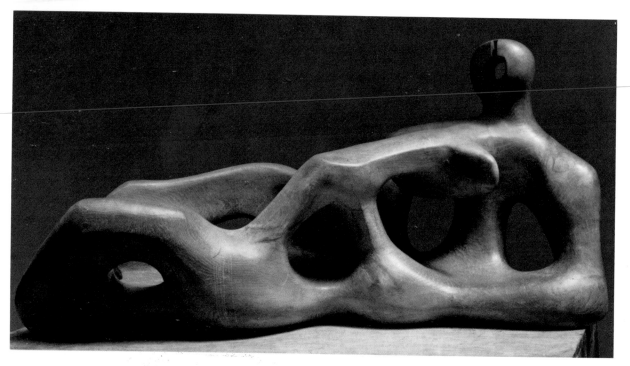

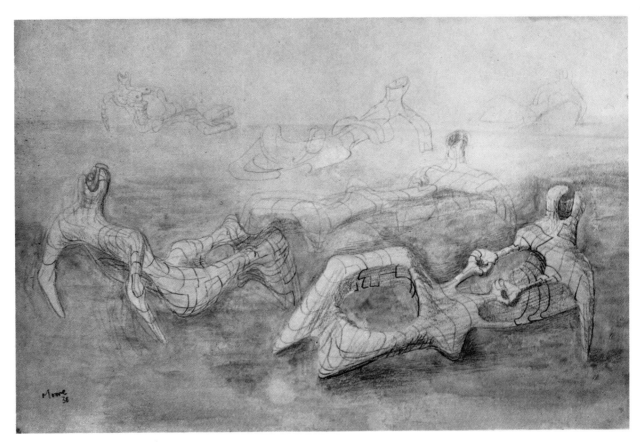

180 Ideas for Metal Sculpture · 1938

178 Study for Reclining Figure in Wood · 1940

179 Reclining Figure · 1939

181 Reclining Figure · 1938

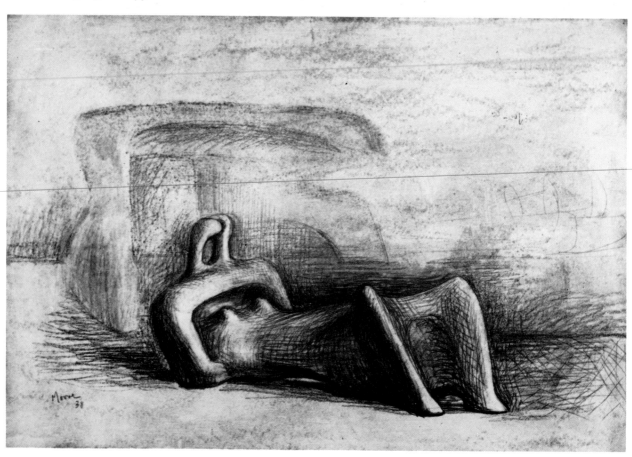

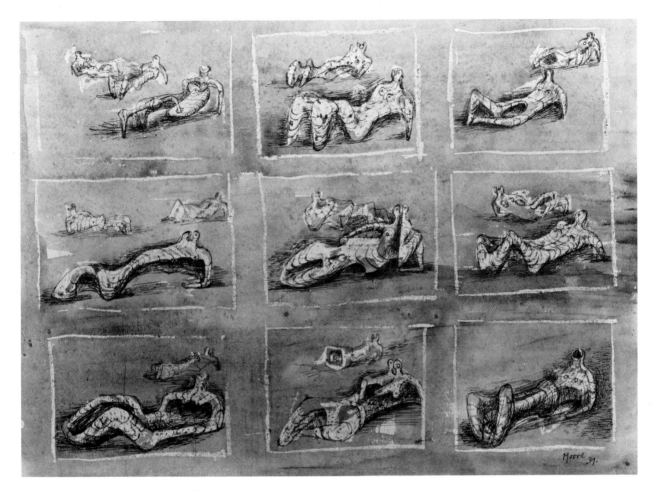

182 Reclining Figures, Drawing for Sculpture · 1939

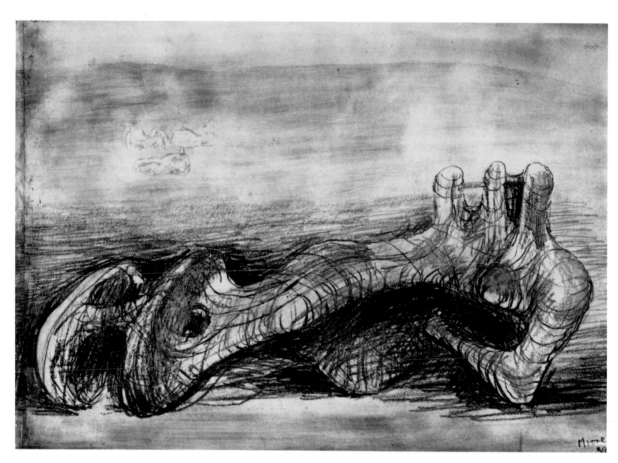

183 Study for a Reclining Figure in Wood · 1939

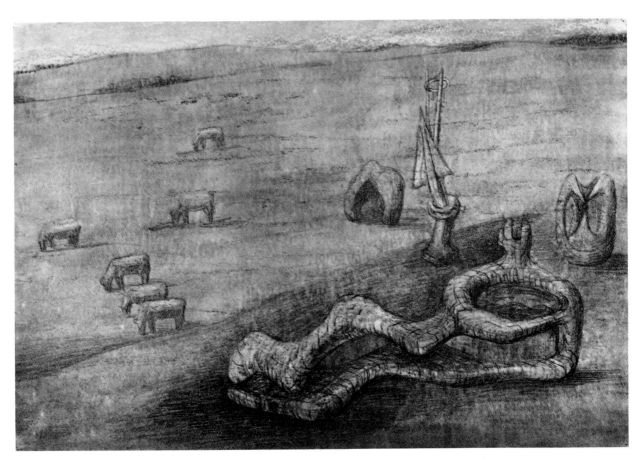

184 Sculpture in Landscape · 1942

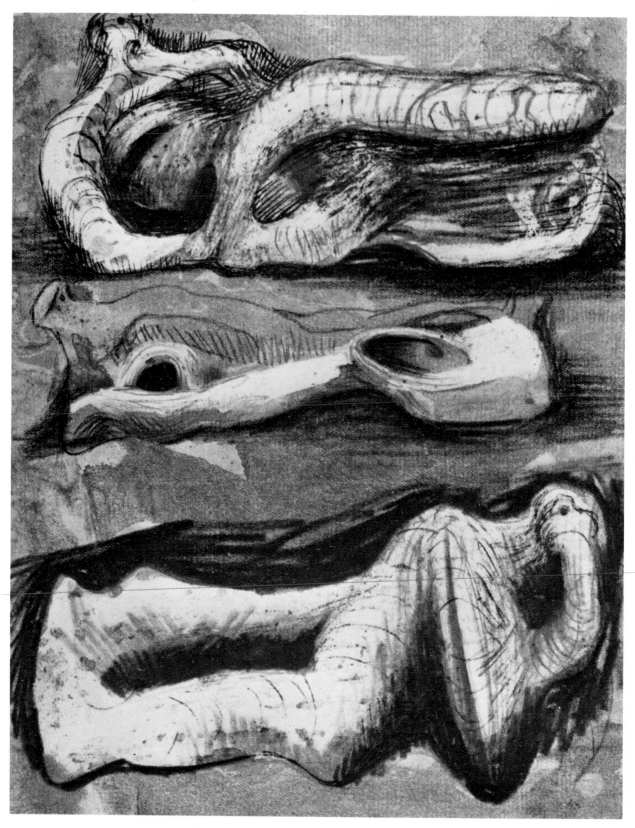

185 *Ideas for Sculpture · 1942*

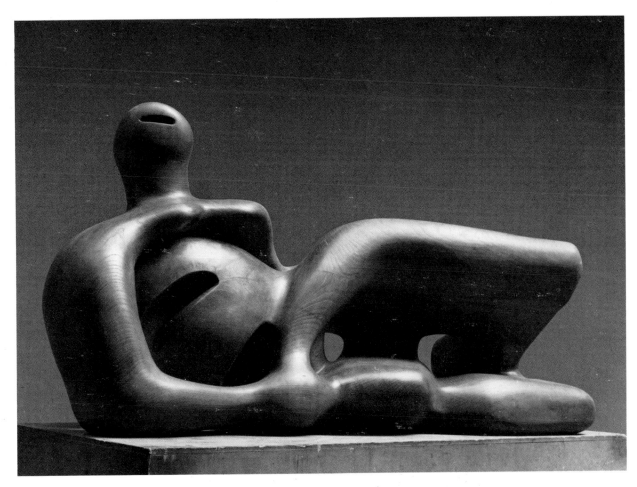

186 Reclining Figure · 1945/46

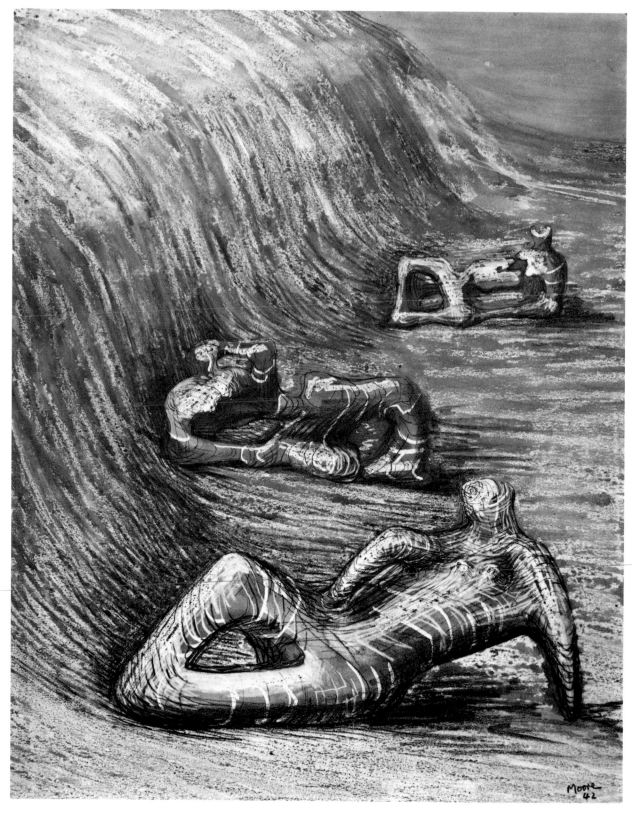

187 *Reclining Figure Against a Bank* · *1942*

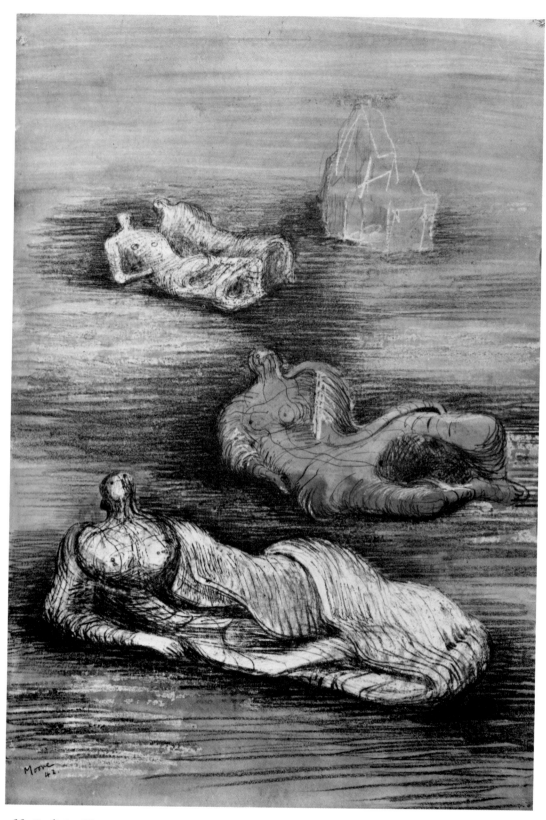

188 *Reclining Figure · 1942*

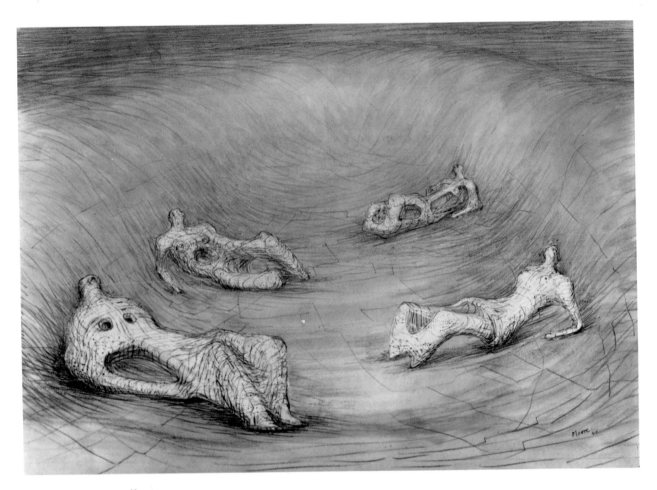

189 *Figures in a Hollow · 1942*

190 *Wood Sculpture in Setting of Red Rocks · 1942*

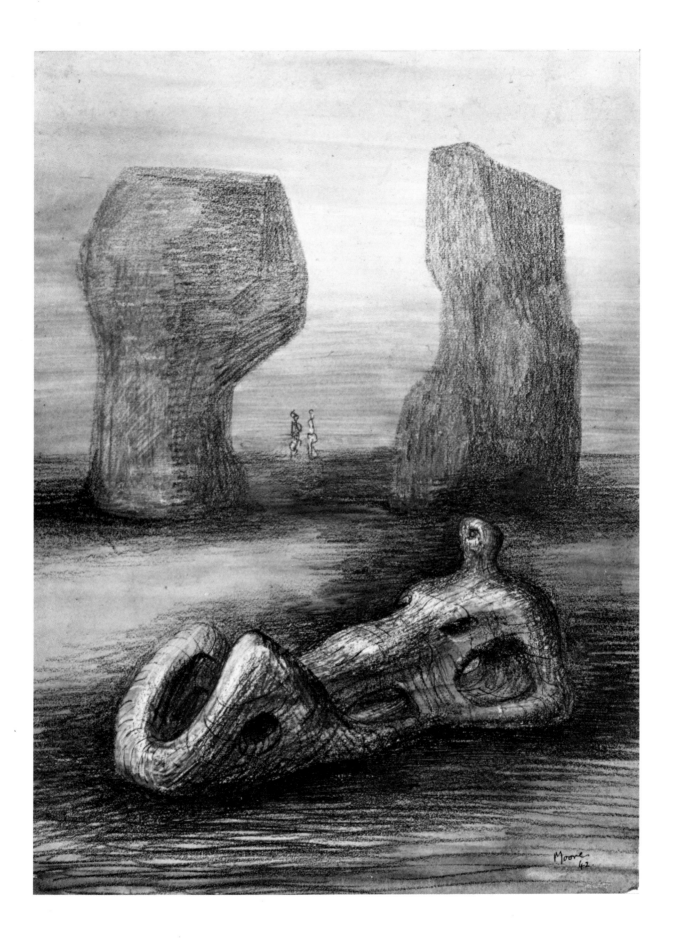

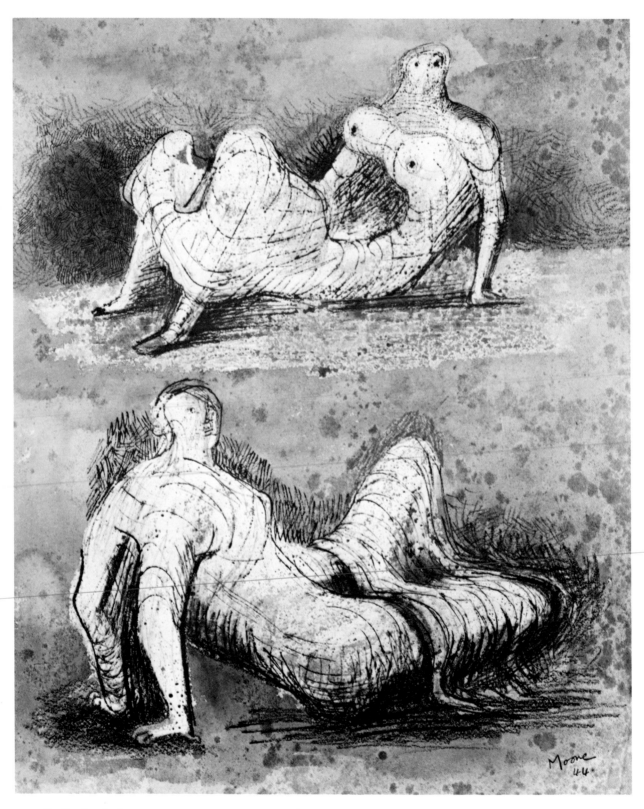

191 *Studies for Sculpture · 1944*

8 The Head

When Henry Moore's sculpture first became widely known, two things puzzled the ordinary, aspiring lover of art. One of them was holes in the middle of his figures. At the point of concentration of solid form he put holes. These holes became the subject of humorous drawings, small boys with their heads stuck in them, gangsters shooting through them, etc., and people gradually came to accept them as quite natural. The other point of incomprehension was that the heads of his figures tended to be no more than protuberances, single or double, and often took on even more peculiar shapes. It was commonly said that Moore was not interested in the human head. This is a mistake. He is, if anything, too much interested in it.

In purely plastic terms the head is a weight somewhat inconveniently balanced on the more sculpturally rewarding mass of the torso. The supporting column of the neck is too thin and, in order to relate the head to the body, the great sculptors of the past have used various devices, the wigs of early Egyptian sculpture, the Winged Horus of King Cephron, the thickened necks and plaited hair of the *korai*. This purely plastic problem of the neck was perhaps one reason why Moore's early carvings sometimes have no more than vestigial heads. But beyond this was the fact, evident in much of his sculpture, that the head meant much more to him than a mere weight. Turn on its side the drawing of a woman supporting the weight of her head on her hand (*Pl. XXIX*) and it completely changes its character. The heads in his life drawings often have a powerful inner life (*Pl. 194*). We can see that Moore's feeling for the menace and pathos of human existence might easily have given the head in his sculpture too dominating a part if he had

not found some way of reducing it. Moreover, after he had looked inwards, and discovered a body freely transposed into rock and tree forms, the head was bound to undergo a similar transformation.

For a long time the reclining figures kept their heads, which, even if they appeared to be featureless, retained some quality of inner life, and were always the point at which a composition came to rest. But these heads were for the most part devoid of that expressive or demonic element which is so strong a part of Moore's best work. The head of the stone reclining figure in the Tate is as bland as that of the Northampton Madonna. Both represent an element in Moore's art that comes out repeatedly in the drawings, his urge to create an almost classical ideal of noble, placid female beauty. Examples of this ideal will be found scattered throughout this volume, among the life drawings (*Pls. 111, 26*), the shelter drawings (*Pl. 152*), and of course the domestic interiors (*Pl. 227*), and the attempt to achieve it is almost always accompanied by a curious change in Moore's style. As in some antique mosaics where the tesserae are smaller in the modelling of the head, his pen lines become much finer, and the modelling almost *sfumato* (*Pls. 25, 152, 203, 208*). Moore suddenly denies himself the freedom with which he has attacked the rest of the figure.

He was probably aware of this disparity (although he maintained it for ten years), because in 1932 he did several drawings in which he studies the possibility of an ideal based on direct observation of the human head, which could coexist with his carvings of reclining figures (*Pl. XXX*). But these, although plastically compact, are still inexpressive. Then in 1939 Moore discovered the idea of the helmet-head, the cranial equivalent of the internal-external forms; heads which should have the same degree of metamorphosis, and the same intensity, as the bodies of his reclining figures. Several powerful drawings show the helmet head taking possession of his mind; one of them seems to record the first excited reception of the idea (*Pl. 197*); in another he restrains his hand and tries out possible combinations more deliberately (*Pl. 198*). Very soon (1940) the helmet head was modelled and cast in bronze (*Pl. 200*). It is one of Moore's most startling apparitions. The inner life, which had always fascinated him in the head, is now given a symbolic power which has probably gained by its long suppression. The idea obsessed him for at least ten years. There are two drawings of helmet heads dated 1949 (*Pls. 201, 202*) that assault one like a blow, and suggest that at

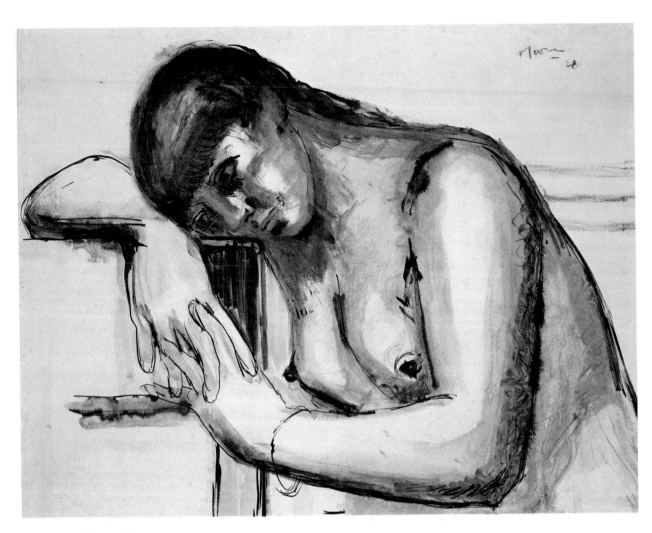

XXIX *Girl · 1928*

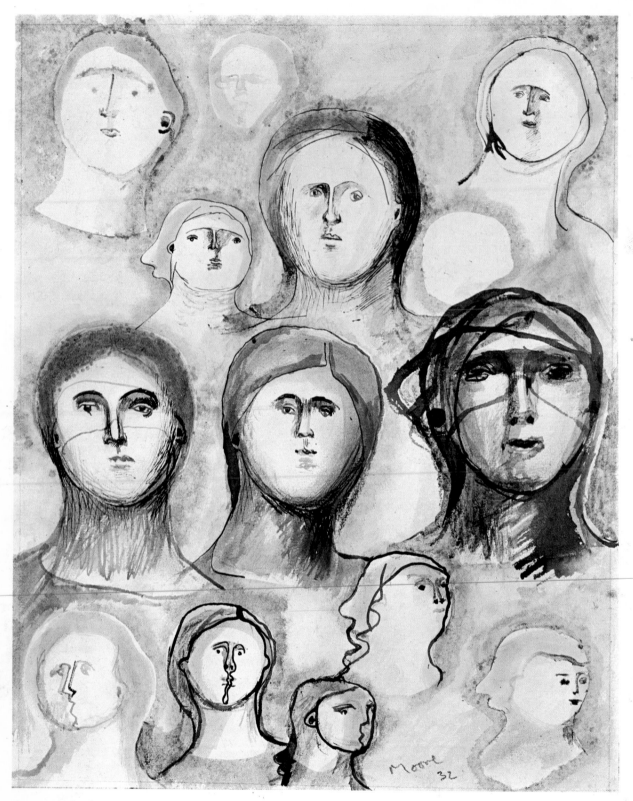

XXX Study of Heads · 1932

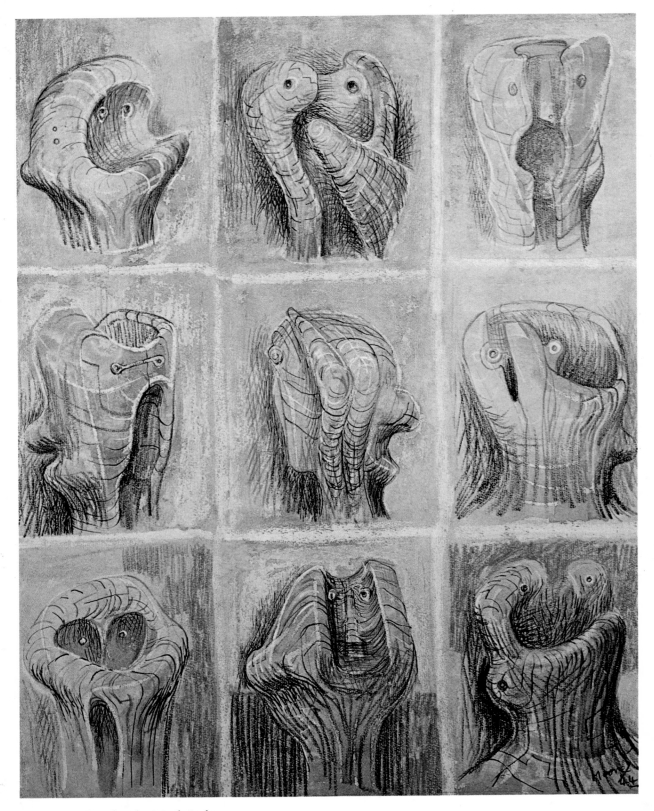

XXXI Heads : Ideas for Metal Sculpture · 1944

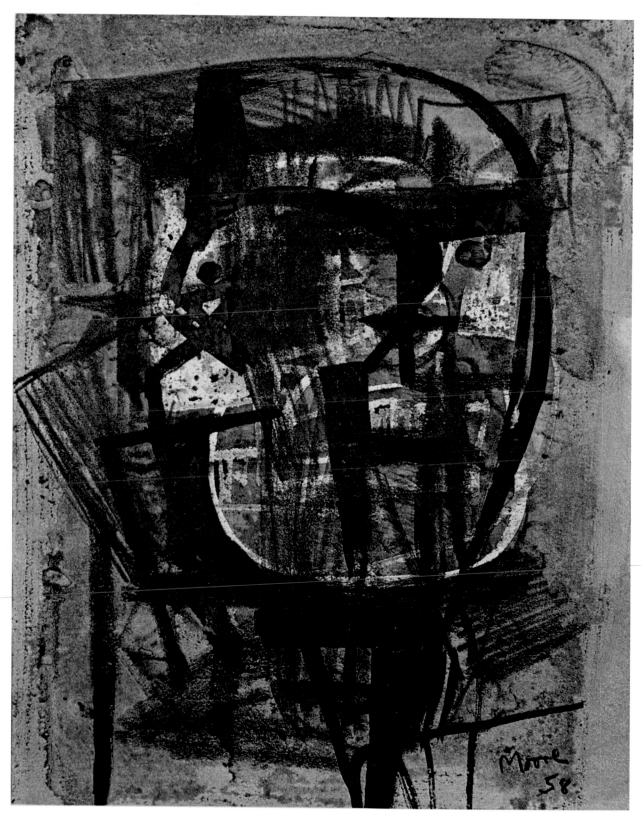

XXXII Head · 1958

the back of Moore's mind was the memory of those metal helmets worn by soldiers in a dictator's army intent on quelling a revolt. The finest of all versions of the theme are bronzes done in 1950, daunting images that seem to foreshadow the most disturbing of all his works, the nameless bronze monsters of the 1960s. The most terrifying was cast in 1963.

These formidable objects could exist only in isolation, and Moore was still looking for heads which could be used as the culmination of his figure sculpture. A drawing dated 1942 (*Pl. 203*), and still close to the shelter note-books, shows the two head solutions side by side, the beautiful girl and the hollow, yawning mask. Two years later this strange personage, and nine of his brothers, appears again in one of Moore's most informative drawings (*Pl. XXXI*). Each is a different solution of the cardinal problem: how to create a head that shall have the same degree of distortion which has grown inevitably out of his contemplation of the body, and yet retain its full vitality. In sculpture the problem was magnificently solved in the group of the King and Queen. The King's head (*Pl. 205*), a superb plastic invention, has many overtones of meaning. He is like a royal goat, confident in his wisdom and power, a *re pastore* of some pre-human arcadia. I should add that Moore seems to feel almost as violently about the heads of animals as he does about the heads of men. His bronze animal heads are among his most alarming pieces of sculpture, and a drawing which seems to represent some prehistoric turtle (*Pl. 204*) reminds one of the totem poles that accompany his Glenkiln Cross.

Meanwhile Moore had been drawing heads of 'real' people – the shelterers and miners. He has told us that the shelterers were drawn from memory; if so, it was an amazing feat of graphic reconstruction to set down so accurately the foreshortening of the sleeping head with open mouth (*Pls. 206, 207*). Many other heads of shelterers will be found in the illustrations to section 6, and they show him freest when the head provides its own element of distortion or surprise, as in the woman with plaster in her hair (*Pl. 209*). At the same time the stoicism and dignity of the shelterers led him to include a number of his 'classical' heads which are not altogether inappropriate. The two figures on *Pl. 208* are like late Roman patricians, awaiting the coming of the barbarians.

With the miners this element of distortion had been effected by coal dust, and Moore was able to make a direct transcript. A note in a sketchbook

(*Pl. 211*) shows how brilliantly he draws on the spot. He could respond immediately, not only because the faces were black, but because they were good faces. The four miners on *Pl. 212* have been idealized with sympathy; the young lad on the left seems to represent a touching memory of what work underground had meant to many of Moore's early companions.

But these experiences did not exorcize the baleful implications of the head. Almost Moore's last drawings done for their own sakes were a series of fierce, dark faces which seem to be glaring through prison bars, that in some cases have become part of their features (*Pls. XXXII* and *213*). They are the ultimate antitypes of the placid, ideal heads, and are drawn with a ferocity that proves how much Moore's inner demon sees the human head as a terrible and fascinating enemy.

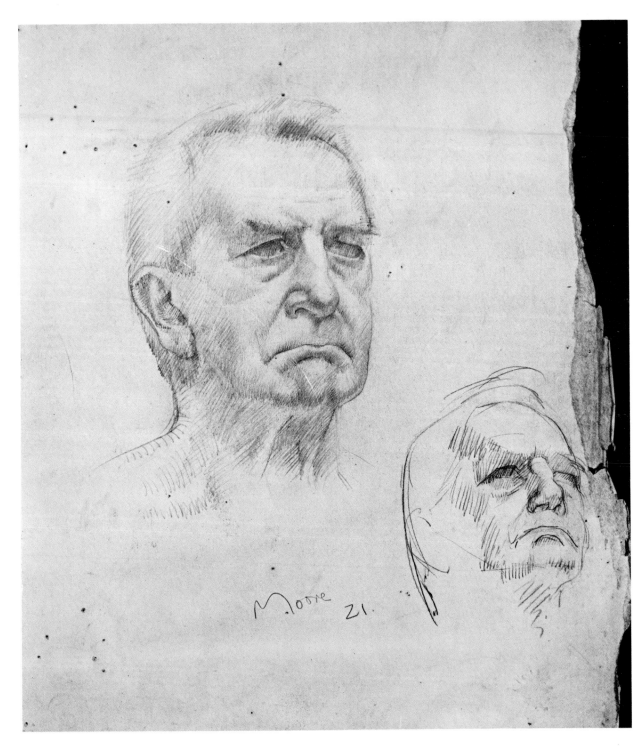

192 *Portrait Head of Old Man · 1921*

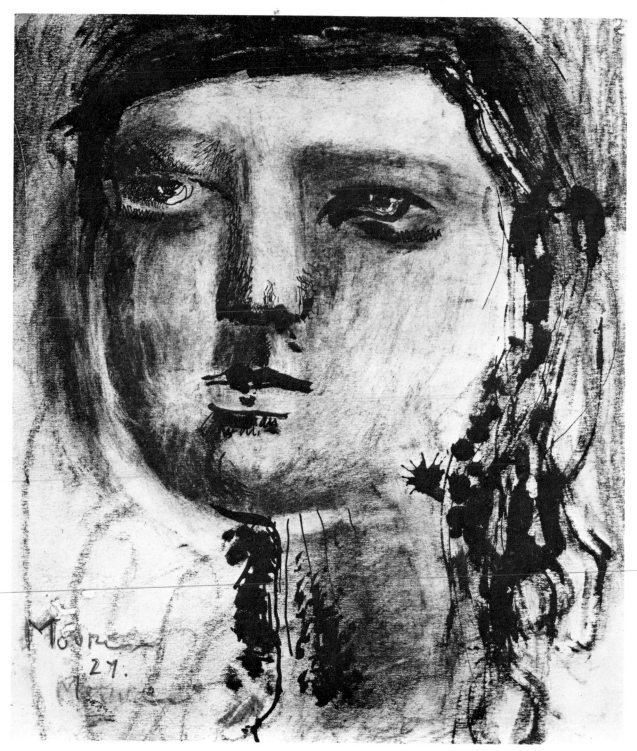

193 *Head of Girl · 1927*

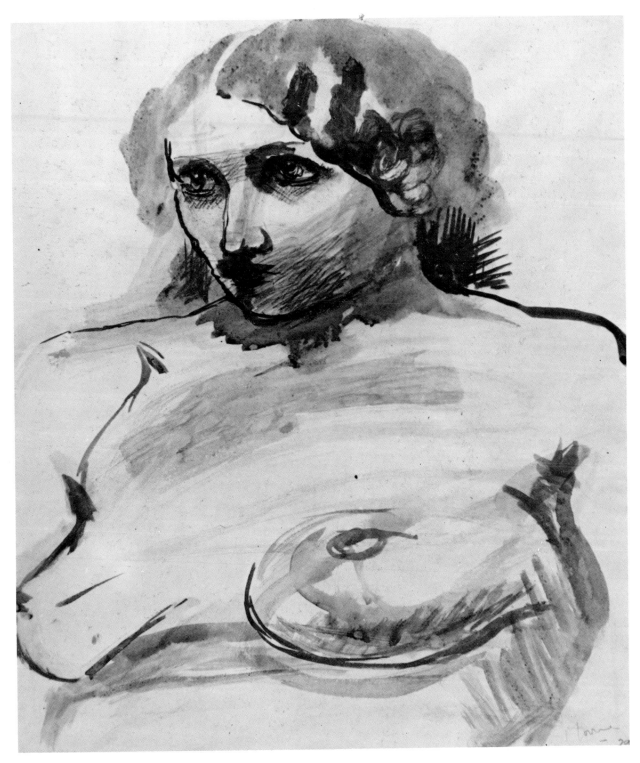

194 *Head of a Woman · 1929*

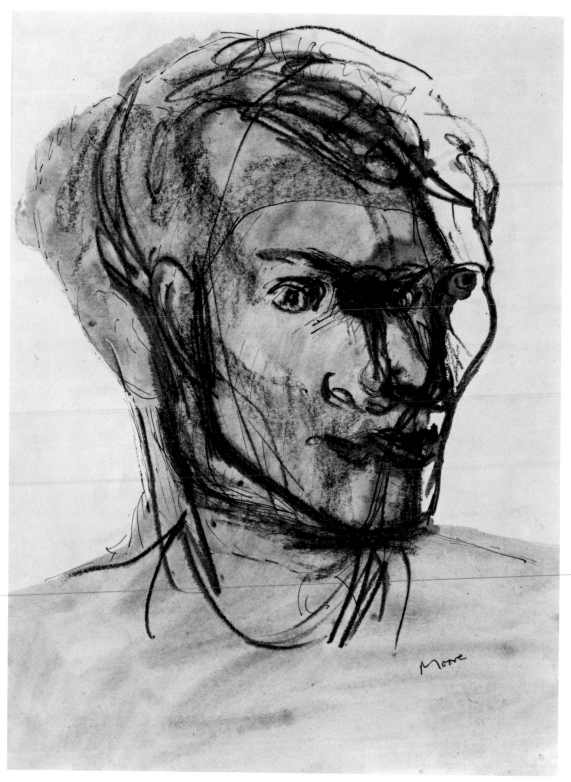

195 *Portrait of Stephen Spender · c. 1937*

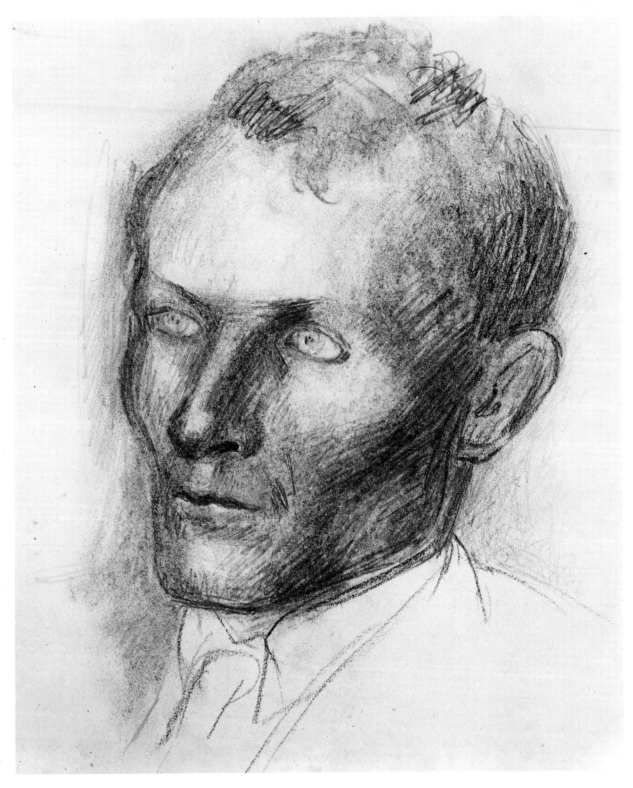

196 *Portrait of Stephen Spender · c. 1937*

197 *Heads : Drawing for Metal Sculpture · 1939*

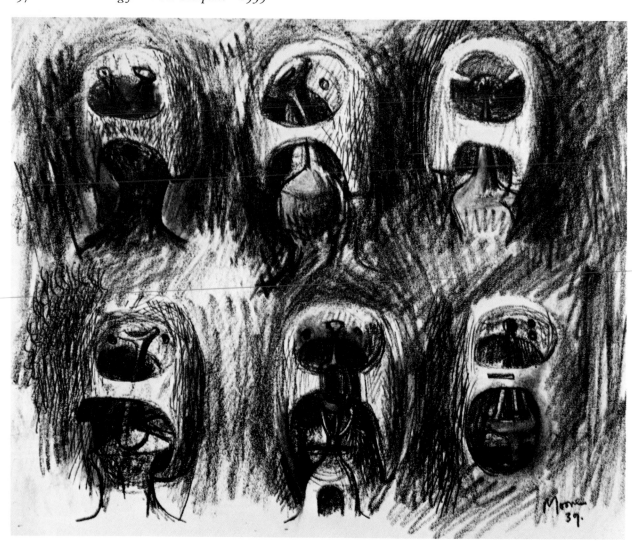

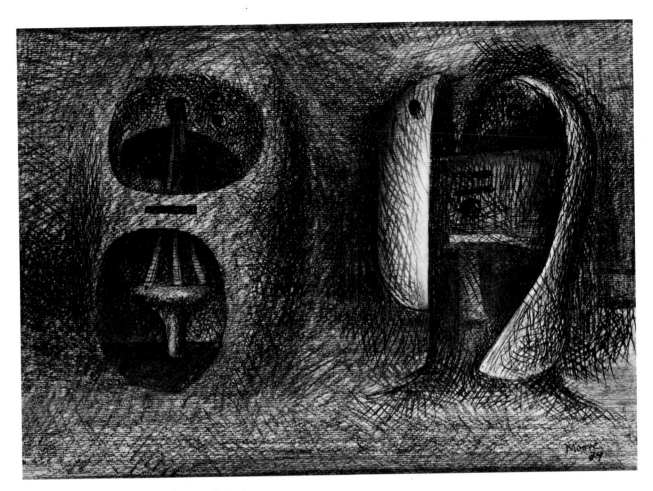

198 Two Heads: Drawing for Metal Sculpture · 1939

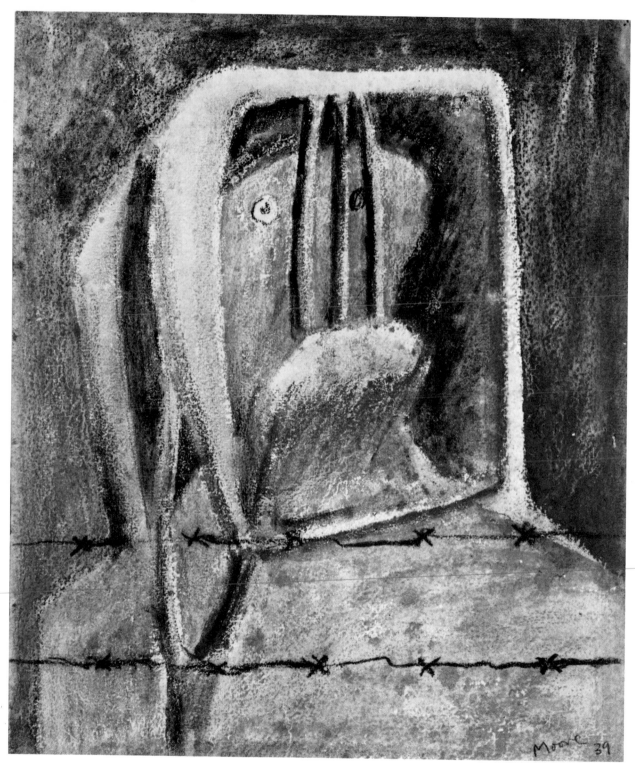

199 Spanish Prisoner · 1939

200 The Helmet · 1939/40

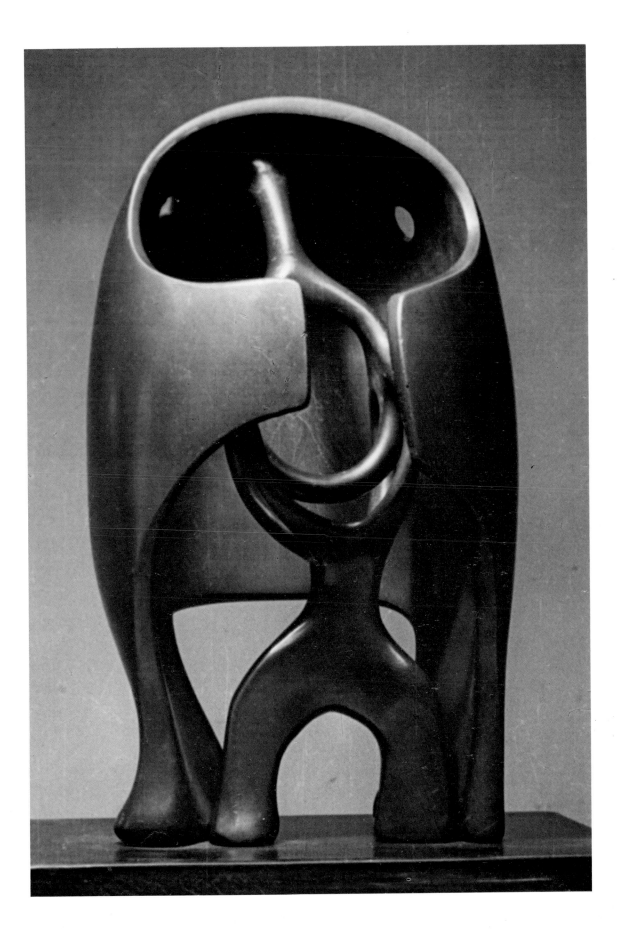

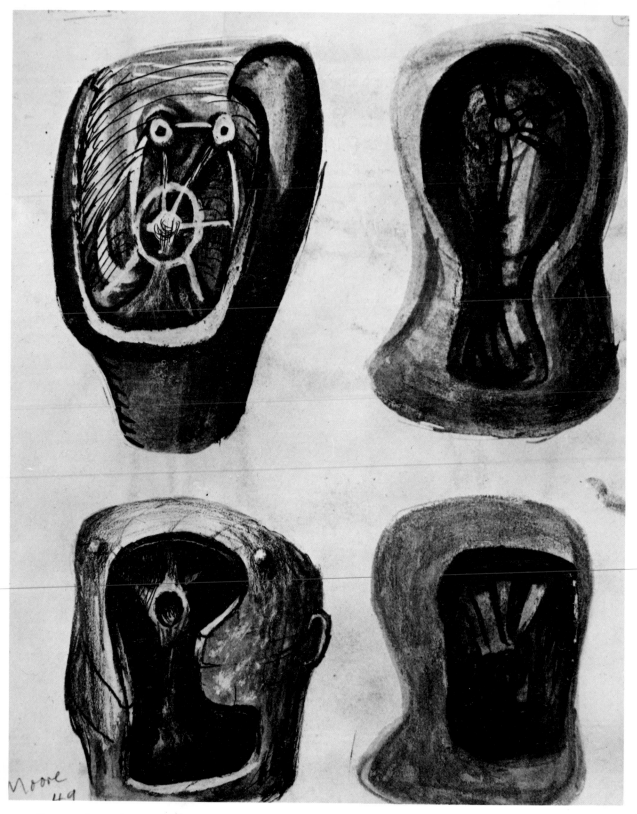

201 Drawing for Sculpture: Helmet Heads · 1950

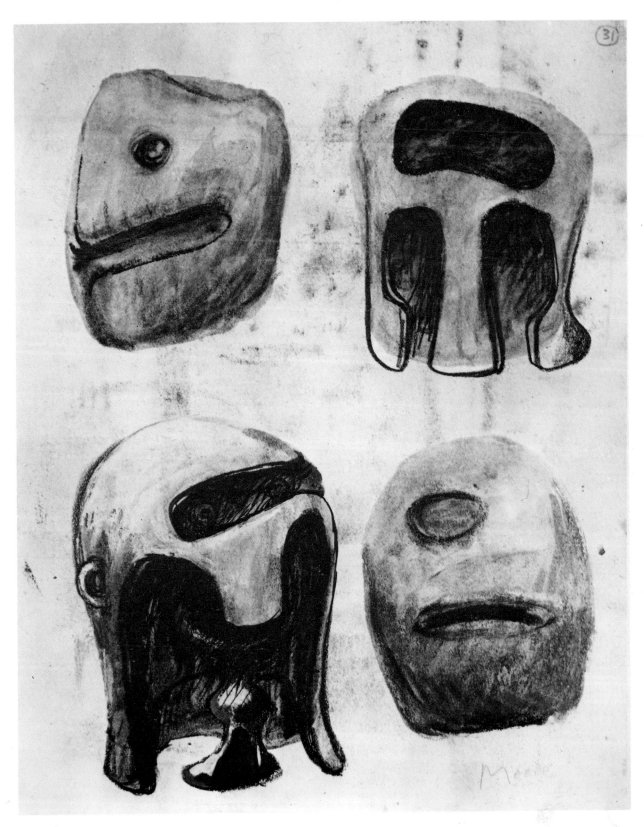

202 *Helmet Heads · 1950*

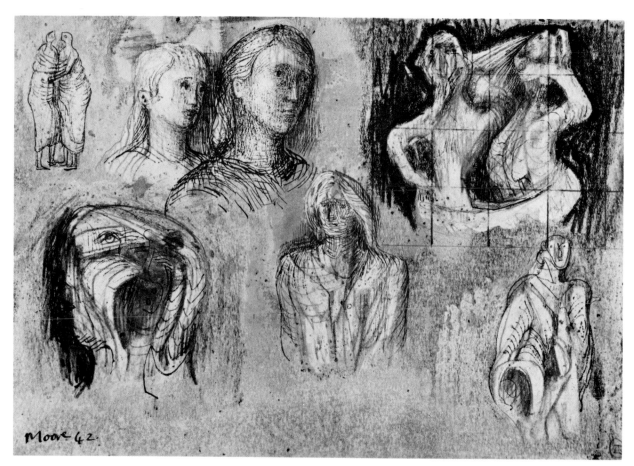

203 *Page from Sketchbook · 1942*

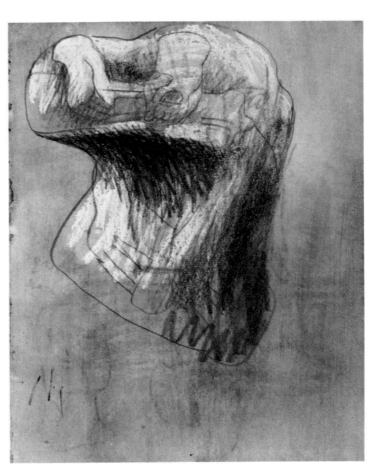

204 *Page IX from a Sketchbook, 1961/62:*
 Animal Head · 1961

205 *King and Queen (detail):*
 Head of King · 1952/53

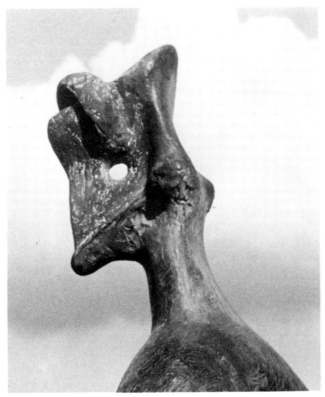

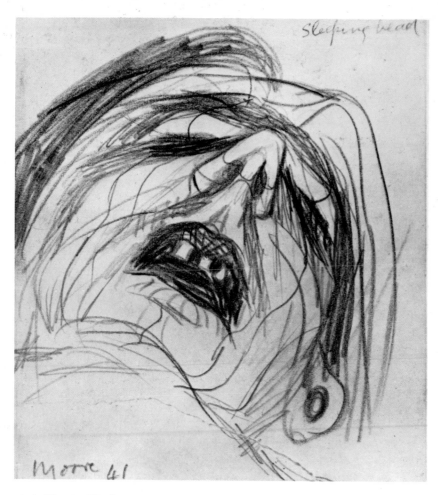

206 Sleeping Head · 1941

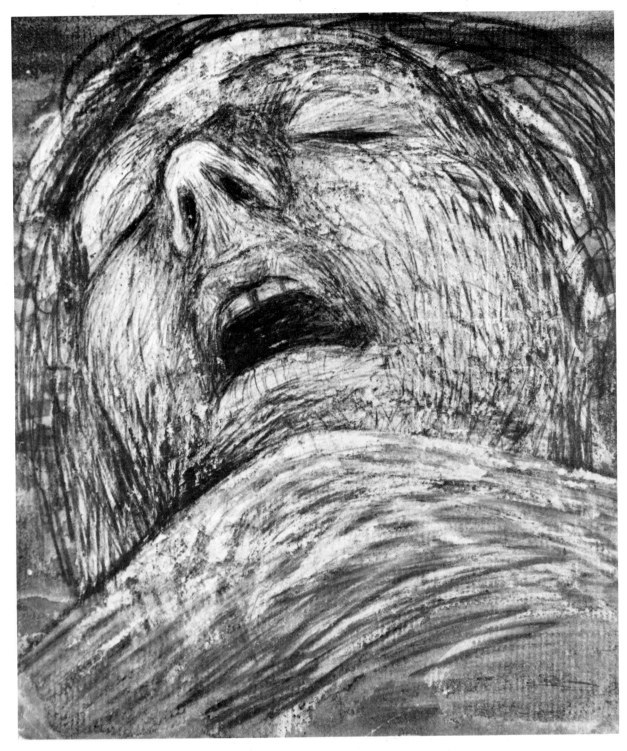

207 *Page 69 from Second Shelter Sketchbook · 1941*

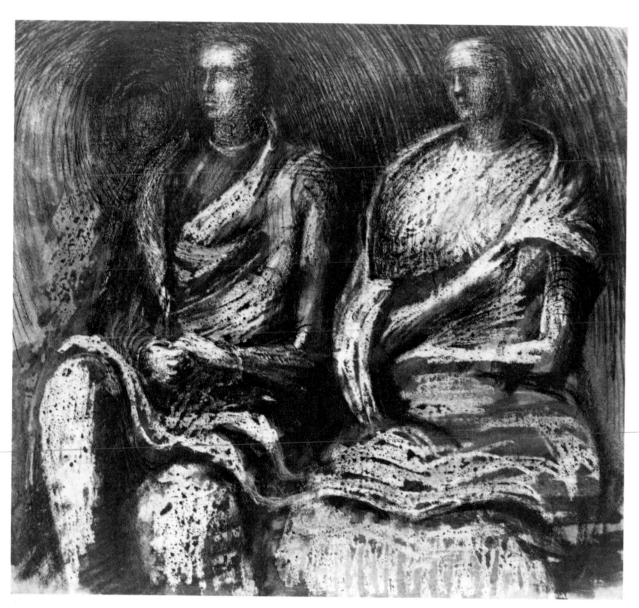

208 *Shelter Scene: Two Seated Figures · 1940*

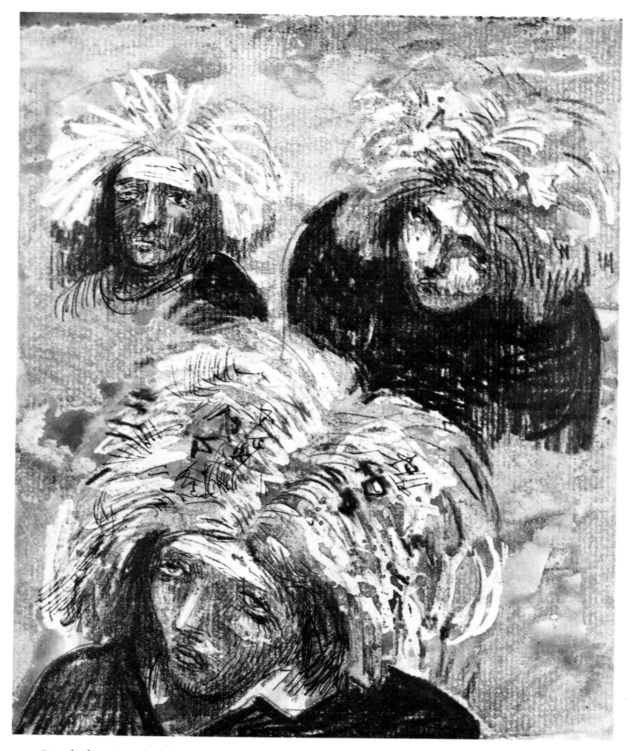

209 *Page 89 from Second Shelter Sketchbook : Woman with Plaster in her Hair · 1941*

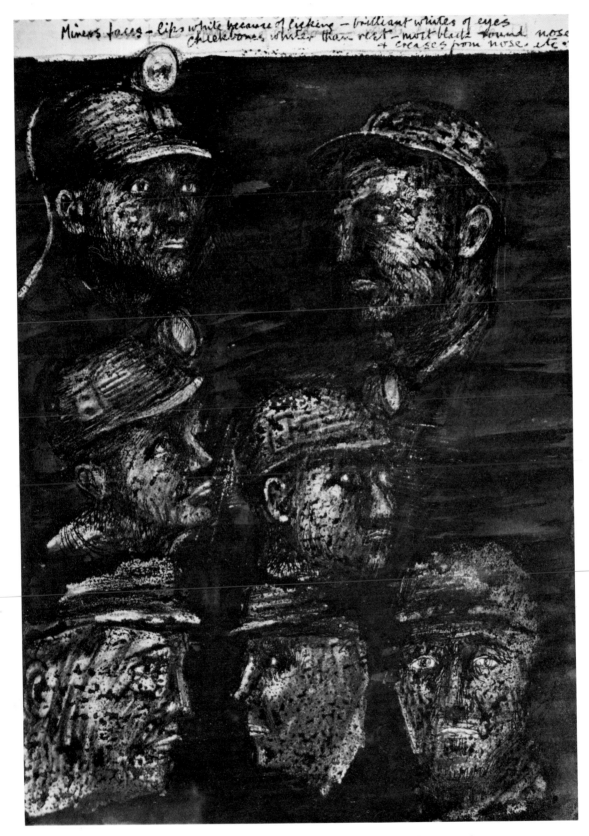

Miners faces — lips white because of licking — brilliant whites of eyes cheekbones whiter than rest — most black round nose + creases from nose. etc.

210 *Page from Coalmining Sketchbook: Miners' Faces · 1942*

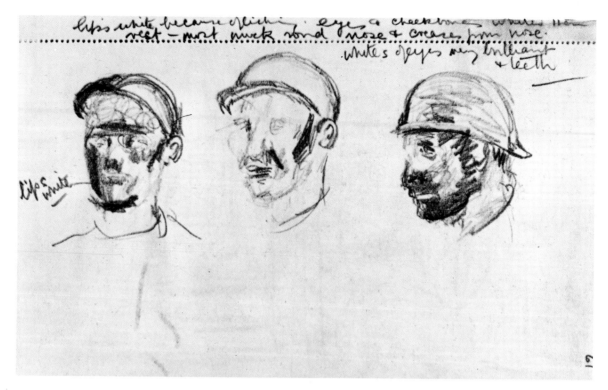

211 *Page 61 from Coalmining Notebook · 1942*

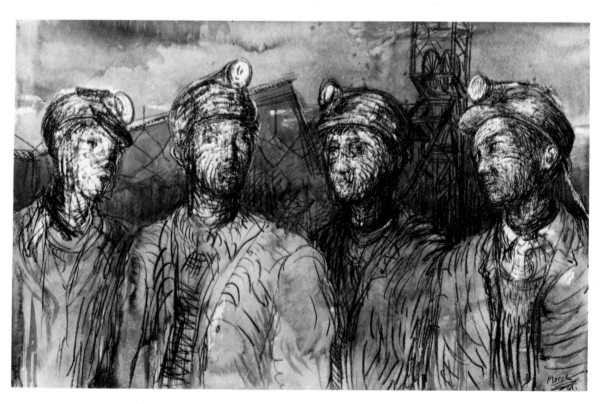

212 *Pit Boys at Pit Head · 1942*

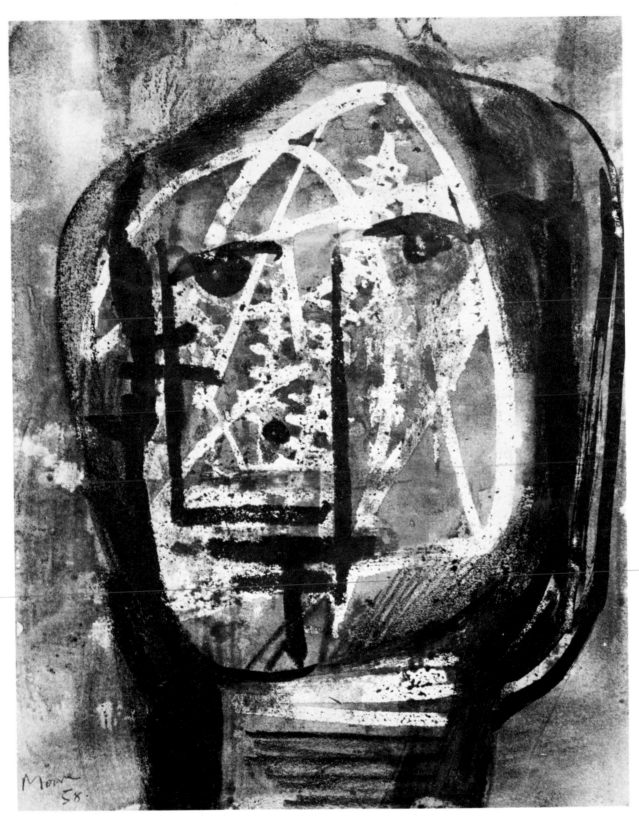

213 Head · 1958

9 Family Life

When, in about 1932, Moore began to look inwards and discovered a compulsive world of forms, the main line of his development was opened to him. It was something that he cannot explain, and he rightly leaves unread the numerous explanations written by critics and psychologists. There was also the Henry Moore who turned outwards, the lover of family life, the loyal, affectionate friend, a life-accepting man, if ever there was one. This outward-turning Moore also produced works of art, and, although they lack the intensity of his mysterious inner world, they are a necessary part of his whole character as an artist.

Speaking in 1943 about the Northampton Madonna, Moore said that the mother and child idea had perhaps been a 'more fundamental obsession' than the reclining figure. It is true that several small early carvings are of a mother and child, but the study of his drawings does nothing to support his statement. Very few drawings of the mother and child motif are dated or datable before 1940. There are one or two drawings of his family and friends, a moving portrait of his mother (*Pl. 214*), and two Giottesque drawings of his sister (*Pls. 215, 216*). These, with two portraits of Stephen Spender (*Pls. 195, 196*) and a head of a small boy, are practically all the likenesses of individual human beings that he has ever done.

The mother and child protection motif first appears in the shelter drawings, for example, on *Pl. 217*; it is the memory of a thing seen, which none the less anticipates much of Moore's work in the next ten years. It shows that in the shelters Moore was looking for what was already inside him, and he worked up these notes into larger drawings, of which one in Manchester is

the most moving (*Pl. 218*). This image of a small creature enveloped and protected by a large one expresses the same feeling that Moore claimed as his intention in the internal-external forms.

In 1943 Moore was asked to carve a Madonna and Child for St Matthew's Church in Northampton. He hesitated for some time before accepting the commission. 'I began thinking in what ways a Madonna and Child differs from carving just a mother and child.' His thoughts are evident in three drawings, *Pls. 219–21*, in which he gives the figure that 'touch of grandeur, even hieratic aloofness, that is missing in everyday life'; in fact the drawings are rather grander than the carving, where the heads have ended up with a little extra sweetness incompatible with the austere draperies (*Pl. 222*).

Two years later Moore began work on a family group. He tells us that he himself had proposed the subject to Henry Morris, a far-sighted director of education, before the war, and one cannot help wondering what he would have made of the theme in the years of the great 'recliners' and the first internal-external forms. There are in fact several drawings and bronzes of this subject which are in the style of 1940, and they have a plastic vigour which some of the later variations lack. But carried out on a large scale they would, I think, have been beyond the comprehension of the 'new town' population for whom they were intended. A similar commission was renewed in 1943, and we know from the finished sculpture that in the end Moore came to think of it in far more naturalistic and acceptably human terms.

Moore believes that a drawing dated 1946 was actually executed in 1944 (*Pl. 225*), and if so it provides a direct link with the shelter drawings. There is no graphic record of the point at which the two children present in all the drawings (*Pls. 224–29*) were cut down to one, or when Moore hit on the motif of the mother and father both holding the child, which gives the final group its sculptural unity. Other drawings of a family group were done later; they suggest that, although the theme continued to occupy his mind, it had ceased to move him.

Moore loved the concept of family life, and in 1946 his idea received the impetus of the actual through the birth of a daughter. In John Russell's charming phrase, 'the image of the family took on a new, leaping, unpredictable intensity'. He made several drawings of her as an infant and a small child (*Pls. 235, 236*), and she was to provide one new sculptural motif, a

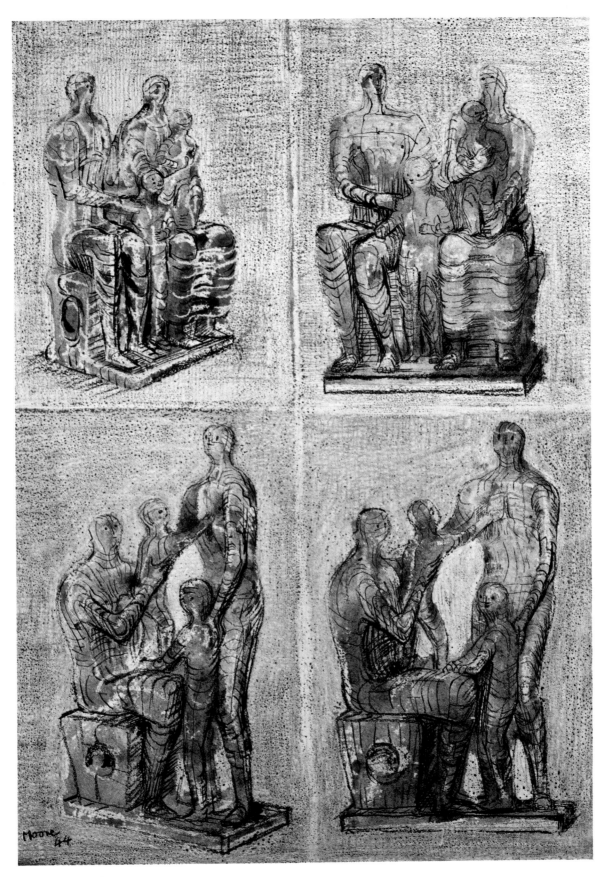

XXXIII Family Groups · 1944

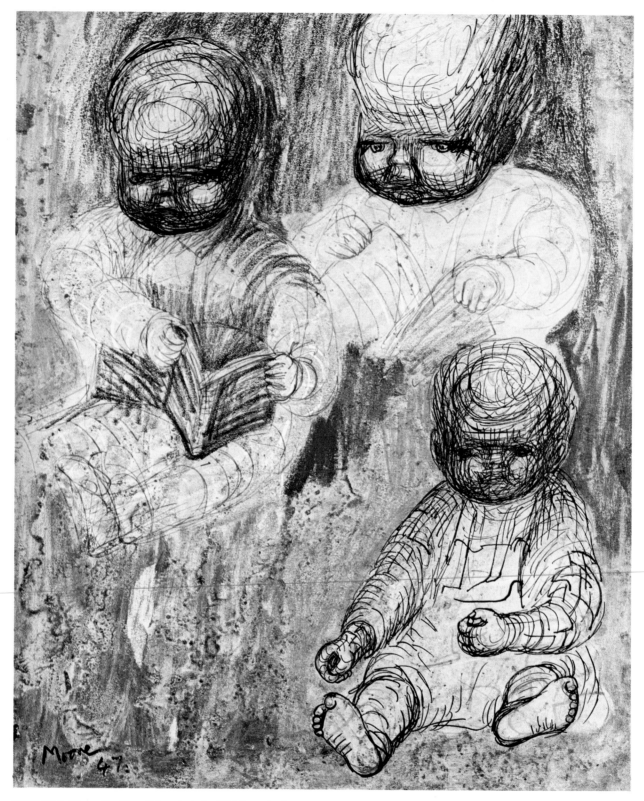

XXXIV Three Studies of the Artist's Child as a Baby · 1947

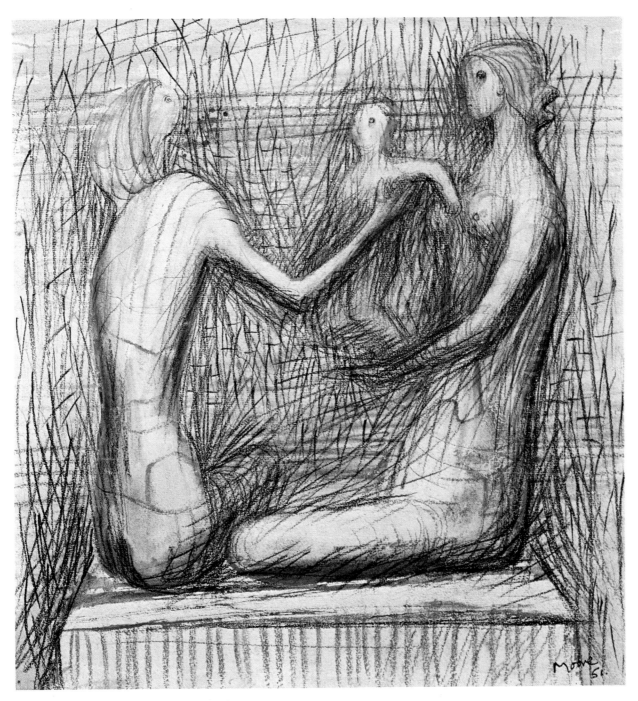

XXXV Two Women and Child · 1951

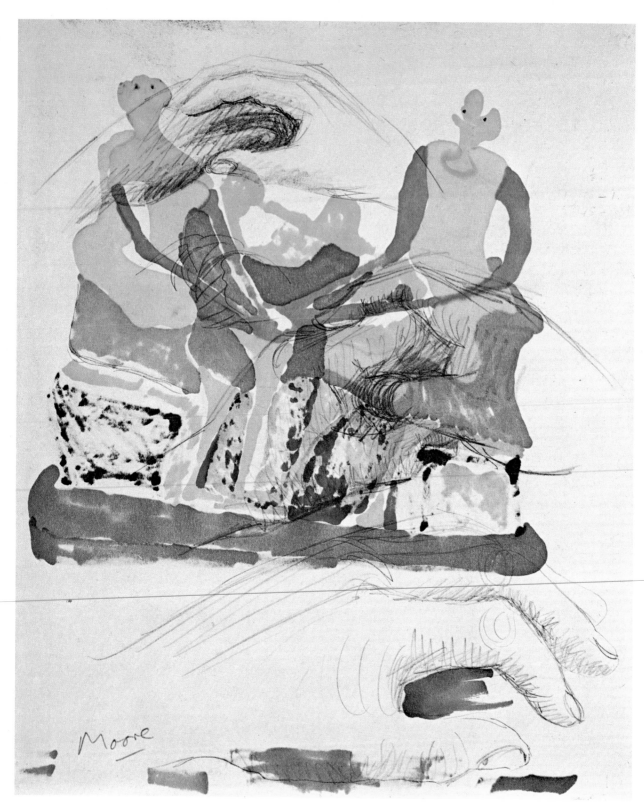

XXXVI *Family Group · 1966*

mother and child in a rocking-chair, of which there is a charming sheet of studies (*Pl. 237*). It is usually a mistake to correlate too closely an artist's family life and his work, and I therefore draw no conclusions from the fact that in the years after his daughter was born Moore did some drawings of tranquil domestic interiors in which two women are depicted sewing, reading, brushing each other's hair or winding wool (*Pls. 238–42*). They show his view of happiness based on human affection, but they entirely lack the demonic power of the reclining figure drawings, and seem to have no relationship with his great sculpture. Only one of them, of wool winders, in which the heads have vanished (*Pl. 242*), has the sculptural character of his wooden carvings with strings to suggest the lines of tension. The others, although they will always give pleasure to Moore's friends, lack that quality which he says that he admires most: 'A disturbing element, a distortion giving evidence of a struggle'. But in a few later drawings of mothers and children (*Pl. 243*), dated 1971, the struggle and the distortion return, and we realize that the mother and child motif may yet inspire some great sculpture.

As an appendix to these scenes of family life I have included some recent drawings of sheep (*Pls. 244–46*), because they too express the feeling of domestic harmony. The sheep who surround his workshop have always had a place in Moore's imagination, and appear in such early drawings as *Pls. 184* and *XII*. They are the oldest symbols of peace, and Moore has also found in them the large forms that are the basis of his sculpture.

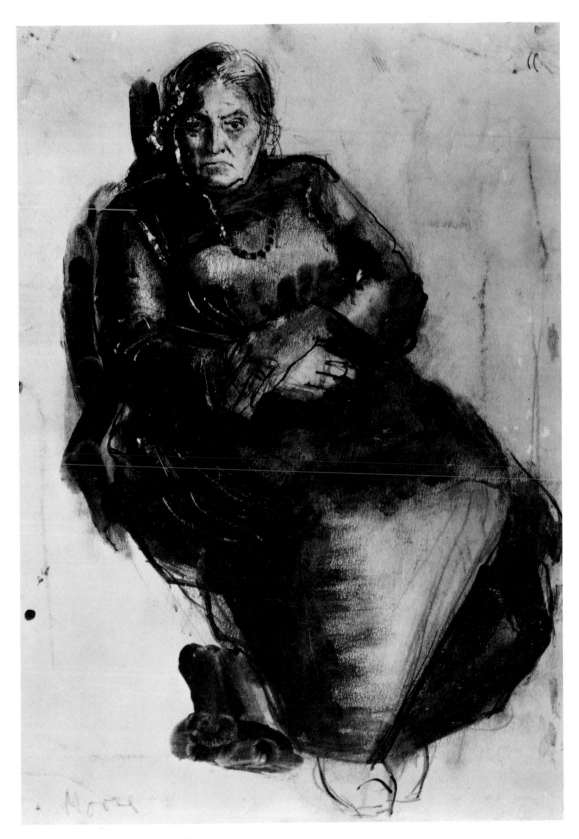

214 *Portrait of the Artist's Mother · c. 1927*

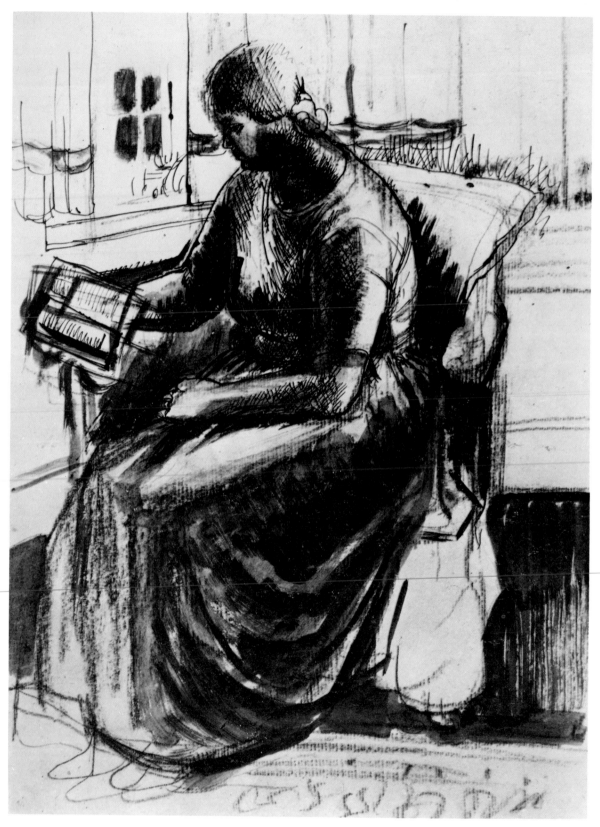

215 *Drawing of the Artist's Sister · c. 1926*

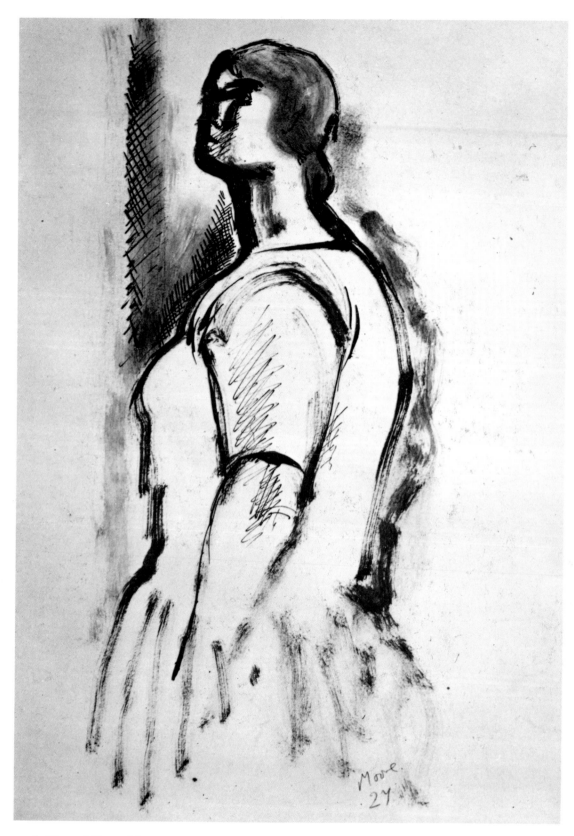

216 *Sister of Henry Moore · 1927*

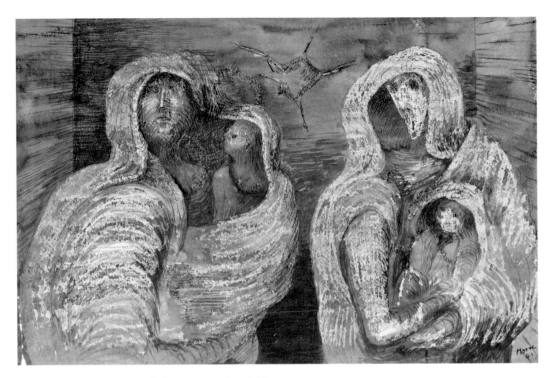

217 Shelter Scene: Swathed Figures with Children · c. 1941

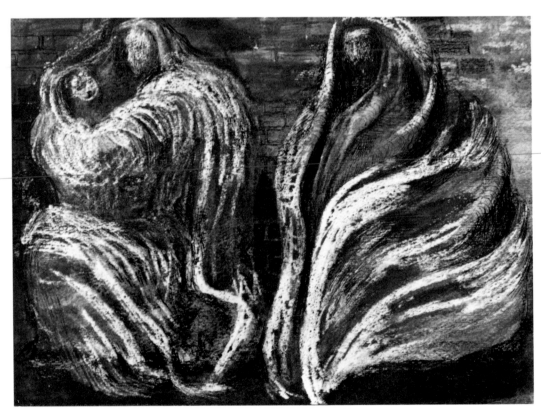

218 Shelter Scene: Two Swathed Figures · 1941

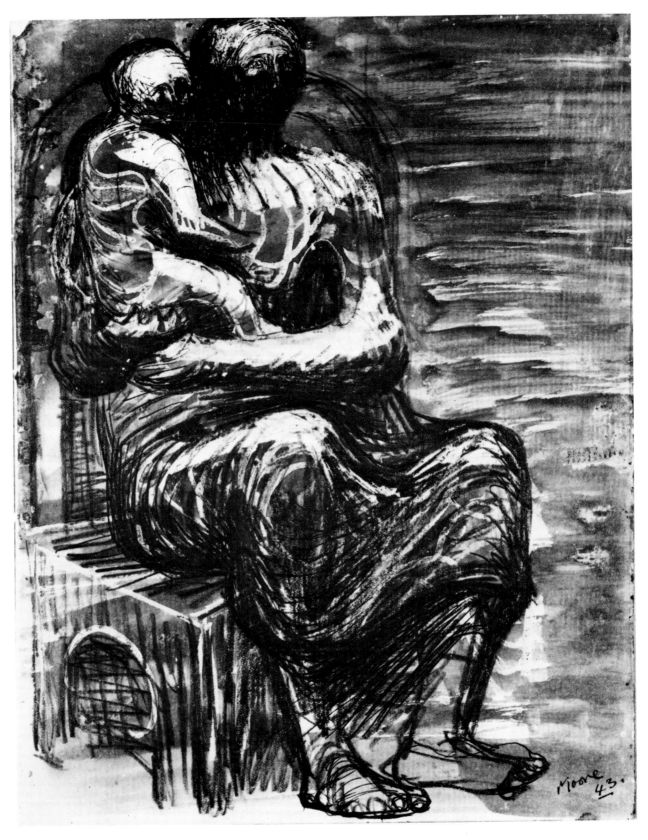

219 Study for Northampton Madonna · 1943

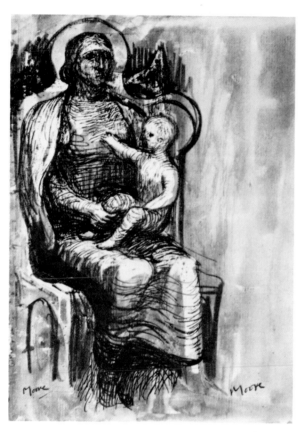 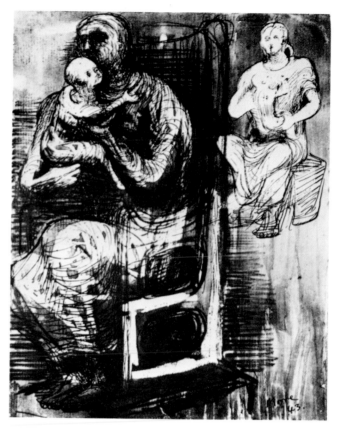

220 Study for Northampton Madonna · 1943 *221 Madonna and Child · 1943*

222 Madonna and Child (detail) · 1943/44

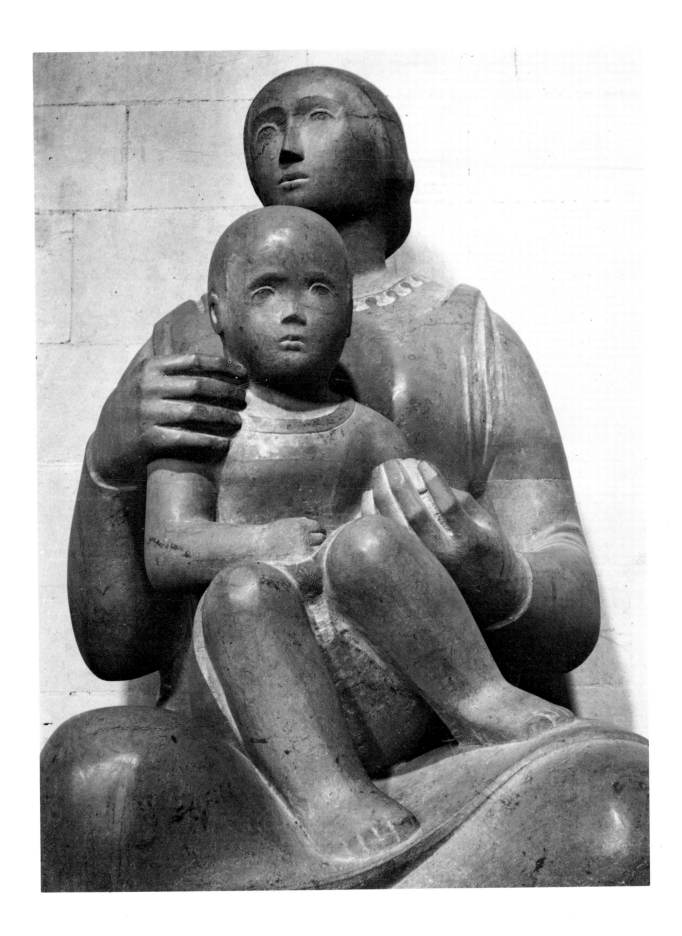

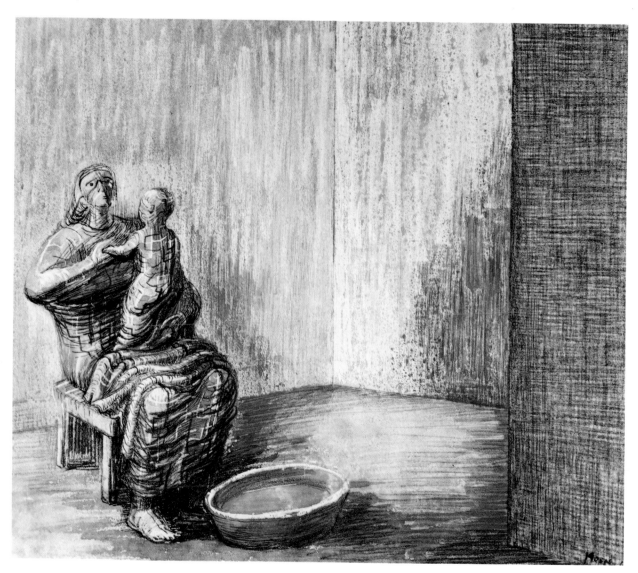

223 Mother and Child in Setting · 1944

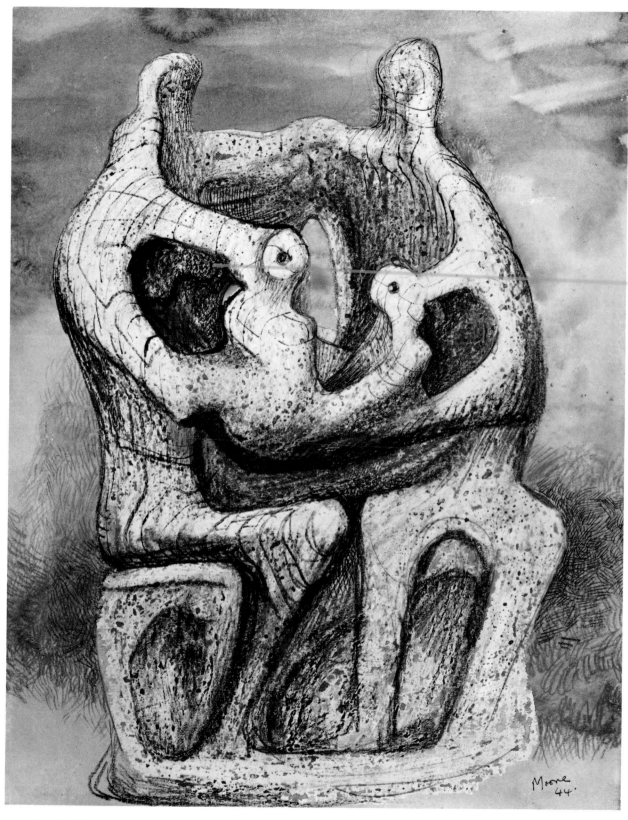

224 *Family Group: Twins · 1944*

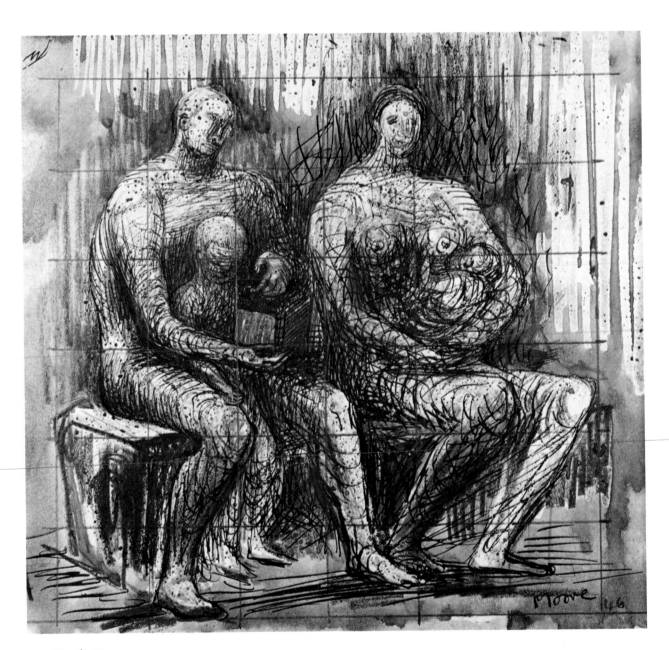

225 *Family Group* · *1944*

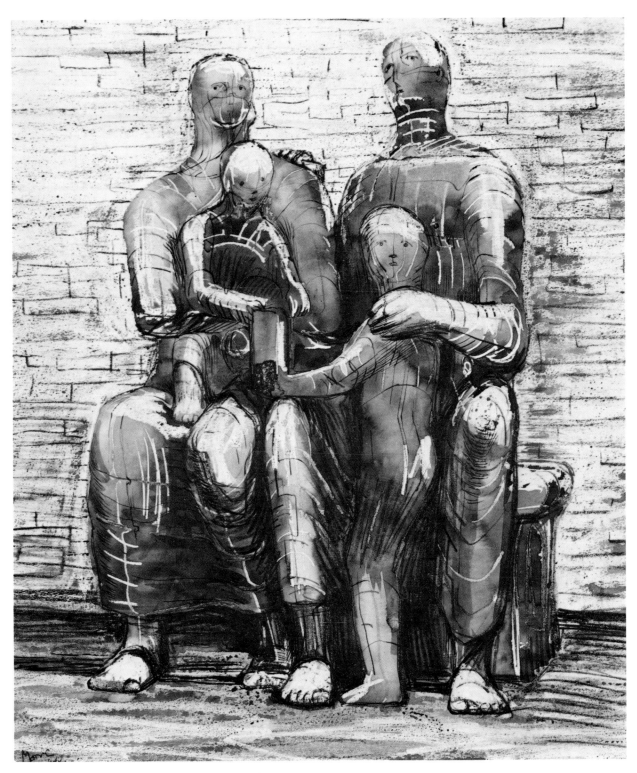

226 *The Family, Project for Sculpture · 1944*

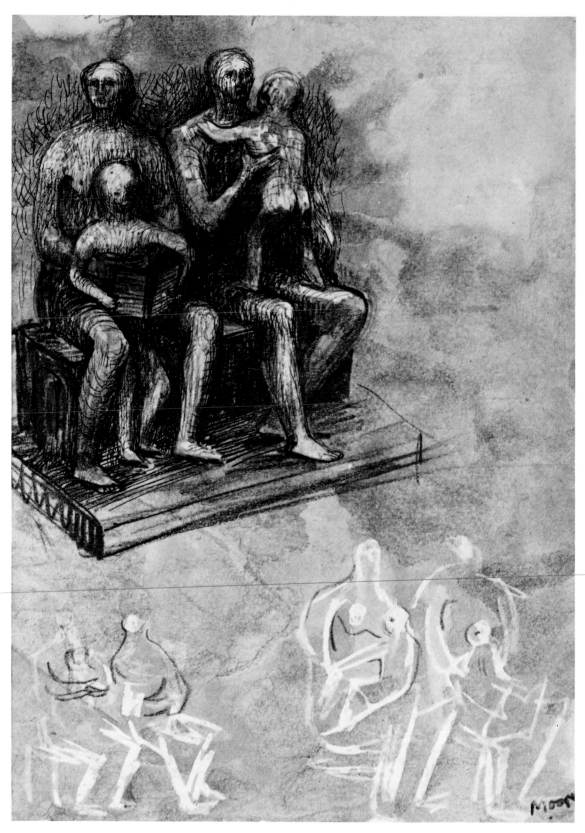

227 *Family Group (Page from Sketchbook) · 1944*

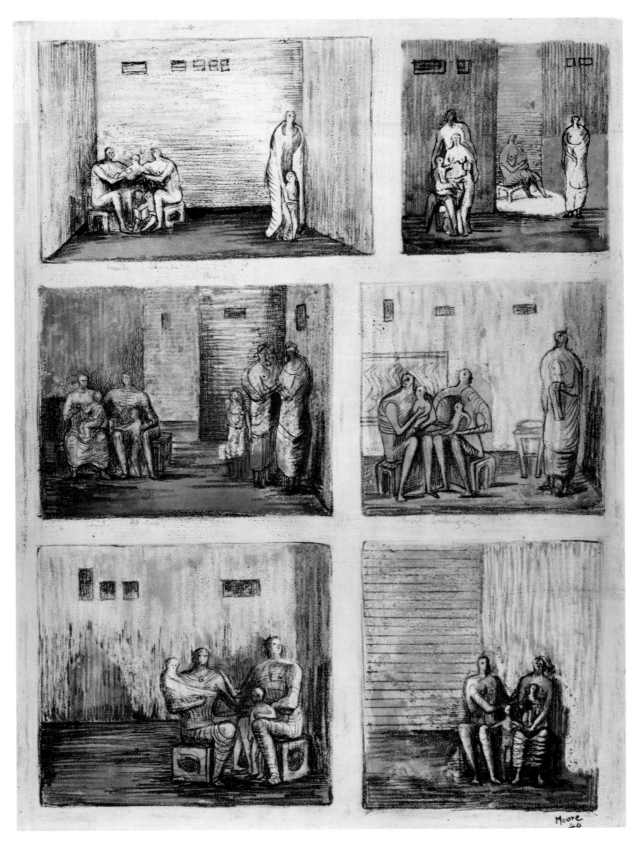

228 *Family Groups in Settings* · 1944

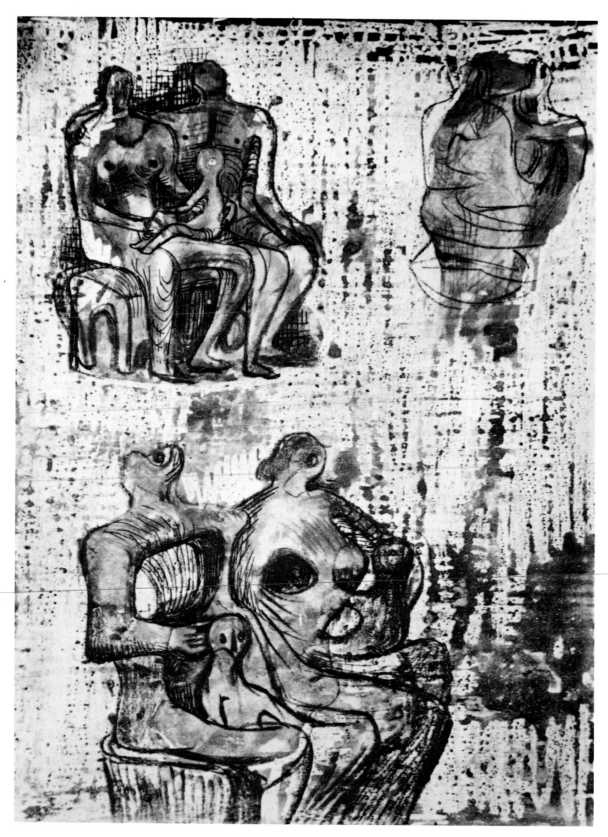

229 *Studies for a Family Group · c. 1944*

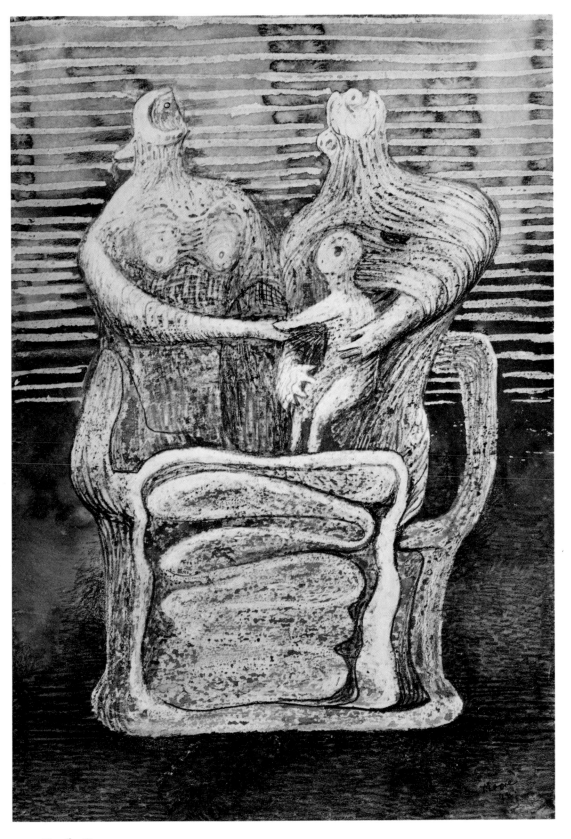

230 *Family Group* · 1944

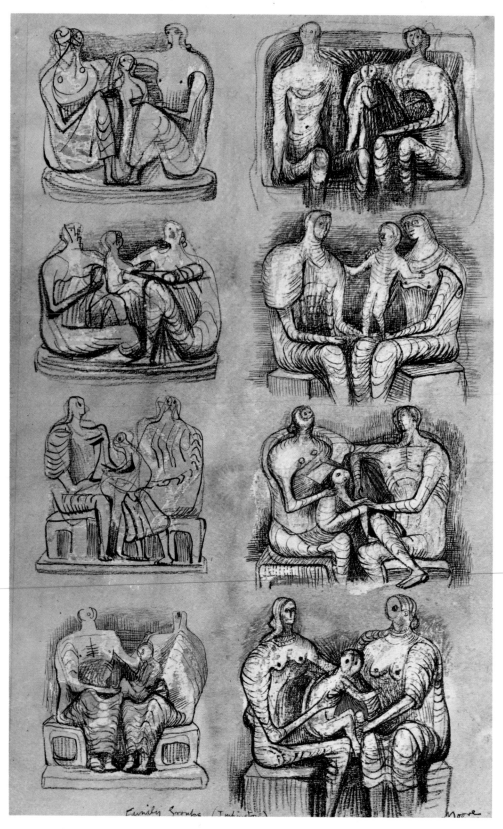

231 *Family Groups · 1944*

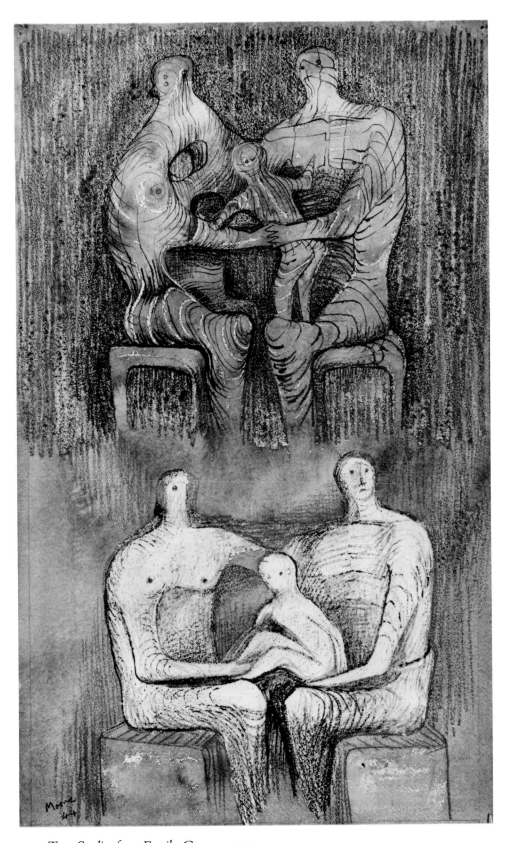

232 *Two Studies for a Family Group · 1944*

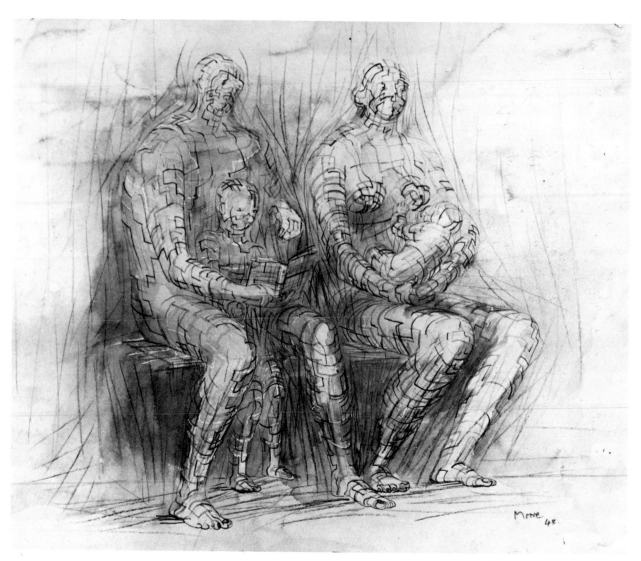

233 Family Groups · 1948

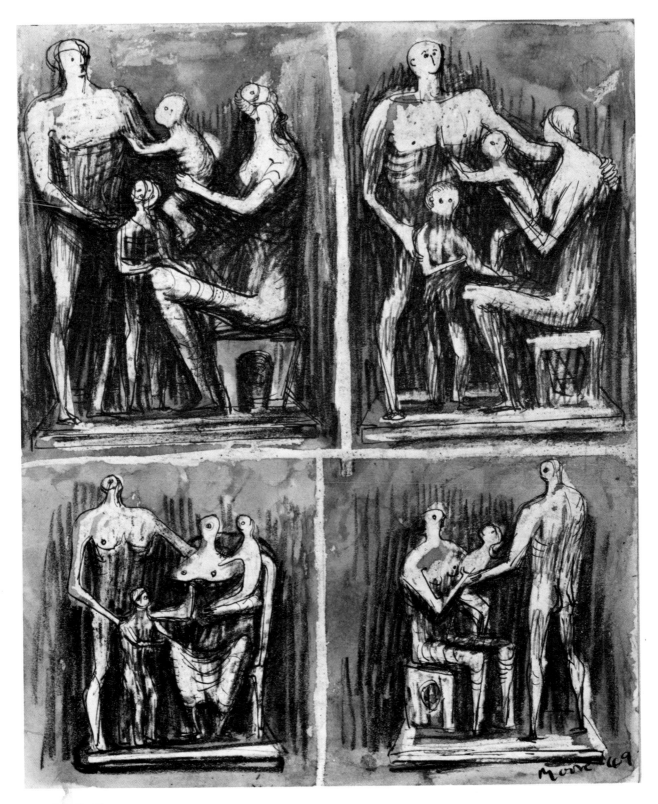

234 *Family Group* · 1949

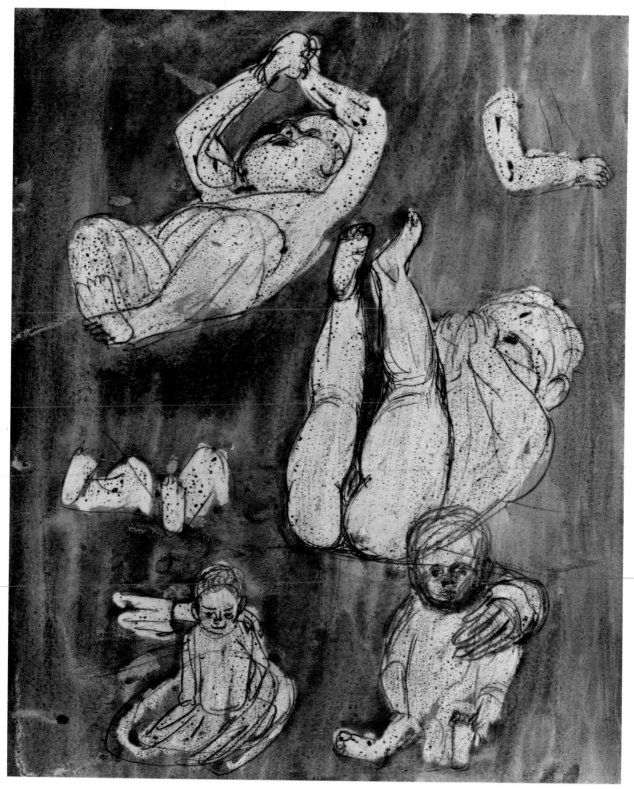

235 *Studies of the Artist's Child* · 1947

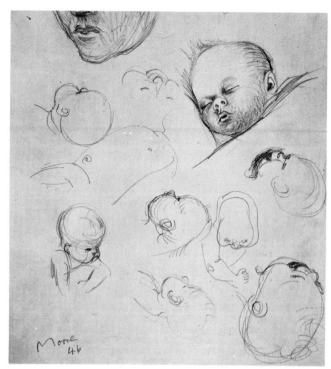

236 Child Studies (Mary as a Baby) · 1946

237 The Rocking Chair · 1948

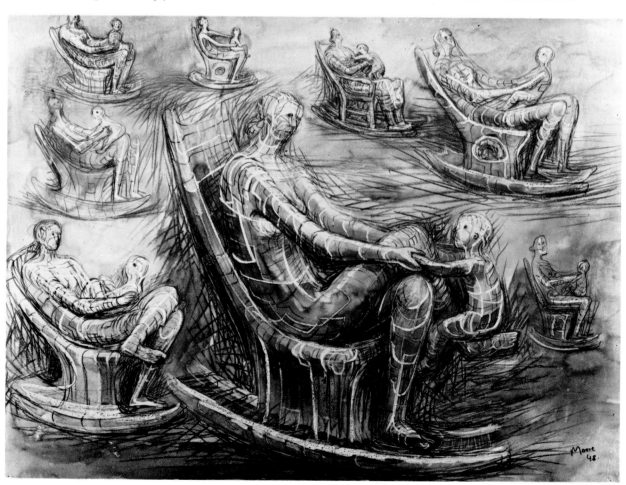

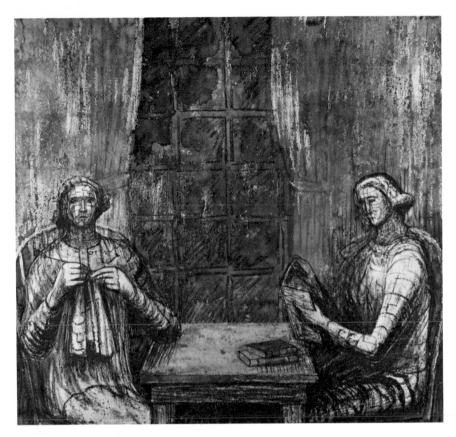

238
Two Women Seated at a Table · 1948

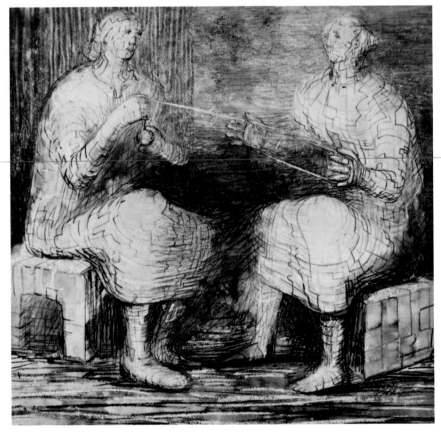

239
Women Winding Wool · 1948

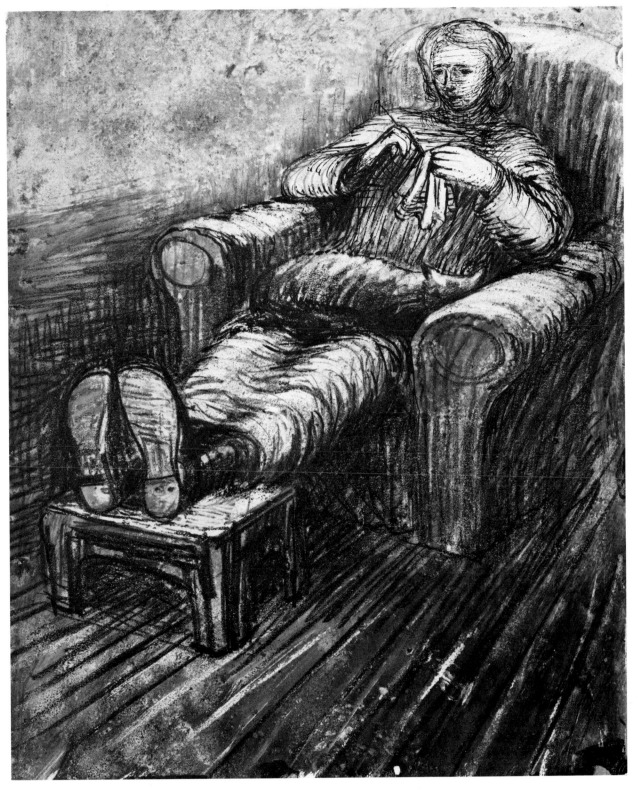

240 *Seated Figure Knitting* · 1948

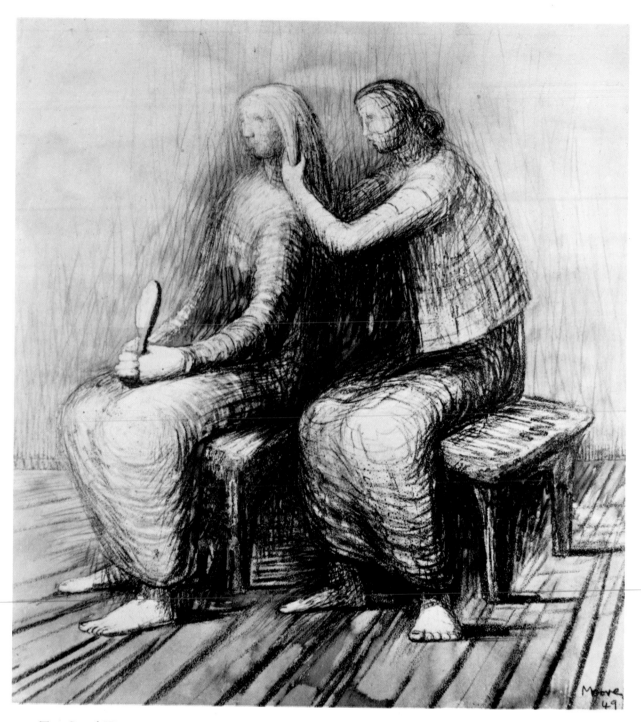

241 *Two Seated Women · 1949*

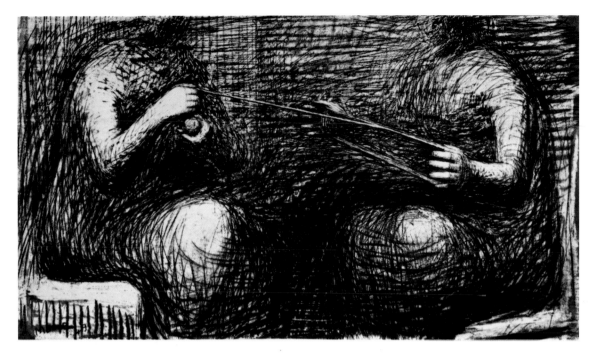

242 Women Winding Wool · 1949

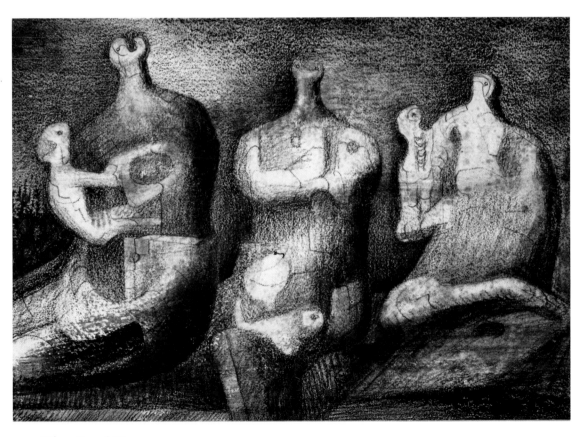

243 Three Seated Figures · 1971

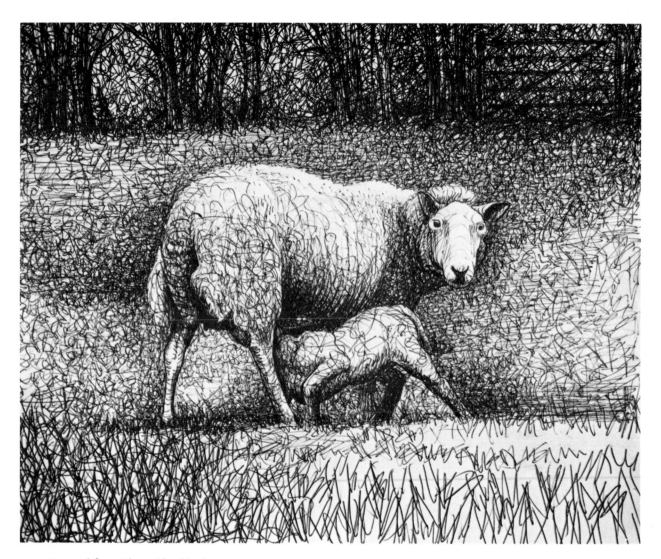

244 Page 36 from Sheep Sketchbook · 1972

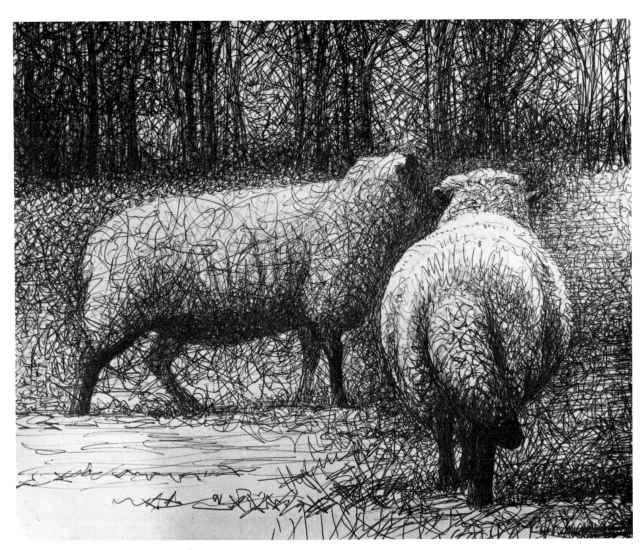

245 *Page 38 from Sheep Sketchbook · 1972*

246 *Page 45 from Sheep Sketchbook · 1973*

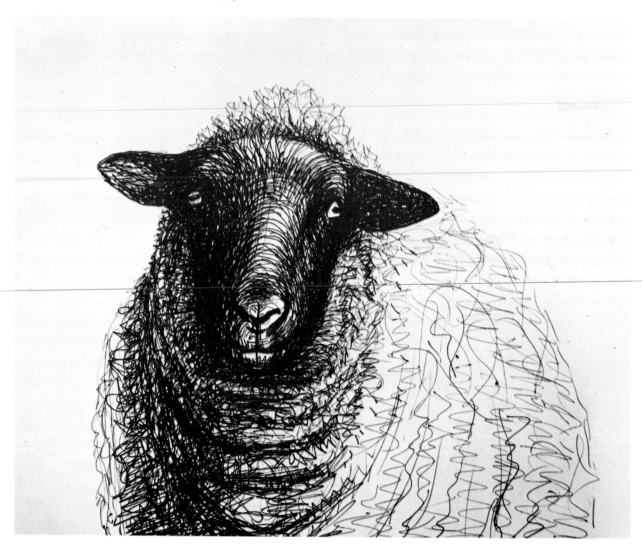

10 Later Drawings for Sculpture

After 1950 Moore gradually ceased to draw, except as a diversion, or in order to discharge immediately some violent emotion. He had come to feel that to draw a piece of sculpture from a single point of view was to limit its full plastic possibilities. Rather than draw he would take a piece of clay in his hand and turn it round as he worked on it. By this time his sculpture was much in demand, and his small models could be immediately enlarged and cast in bronze. All the forms that had been floating in his drawings were still at the back of his mind, ready to appear in the round. Another reason is that, between 1948 and 1956, Moore's imagination was charged with standing forms, beginning with the standing figure, and culminating in the awe-inspiring Glenkiln Cross and its two associates. Upright figures, except in dramatic relationship with one another, have never given Moore the same incentive to draw as seated or reclining figures, perhaps because they do not satisfactorily fill a rectangular space unless arranged in rows. There is a sheet of studies datable 1948 (*Pl. 247*), reminiscences of much earlier inventions, such as those surrounding the prophetic goblin of 1933 (*Pl. 63*). Moore originally intended to carry out three of these studies, and group them together as a metallic counterpart to the stone figures in Battersea Park; but in the end he used only one of them, that in the middle of the lower row, and follows it fairly closely, although, by a slight twist, he gives the figure more vitality. Stimulating as it is, I doubt if Moore was ever quite satisfied with this figure, because it asserted its metallic character too obviously, and a year later he did two other drawings of the standing motif which profit by his exploration of the internal-external forms (*Pls. 248,*

249). They were carried out in maquettes, and cast as small bronzes, but got no further, and, when Moore came to the final developments of the upright motif, they are like weather-worn stone columns (although in fact they are in bronze) mysteriously surviving from the cult of some primitive community. It is significant that he has recently reproduced the Metal Man in white marble, and the tension between idea and material has made the figure far more moving.

Moore hates all forms of public display, and the thought of a public commission has always had an inhibiting effect upon him. The drawing for the figure outside UNESCO (*Pl. 253*) is no more than a diagram, as dead as the drawings for the relief on the Underground building. By way of contrast is a series of drawings of reclining figures (1959–61, *Pls. 254–58*), which are explosions from his inner self, of unprecedented potency. Unlike the reclining figures of 1938, these are emphatically not 'presentation drawings'. They set down in a grandiose graphic shorthand the main elements of those great compositions that were to occupy him in the 1960s; and we can see that the element of physical violence that is so evident in the bronzes was present from the first. A few other drawings in pen and ink dated 1970 (*Pls. 260–63*) reinforce this impression of total liberation. After the age of seventy we should all be free to say and do exactly what we feel, and Moore's late drawings have the dionysiac freedom of the later poems of Po Chui, or the last works of Titian.

Thrilling as they are, these drawings are only shorthand, and are far from conveying the greatness of the late sculptures. To move slowly round one of Moore's reclining figures is to experience a series of revelations, as one space opens up and another is closed, as one association dissolves into its counterpart, as an unexpected form seems to threaten, but does not destroy, the unity of the whole. Only sculpture can give us this feeling of endless exploration.

But if Moore had not been a master of what the fifteenth-century Florentines called *disegno*, meaning by that something much more than skill, fancy or representation, his invention and confluence of ideas would not have given his sculpture its time-defying consistency. Images must be controlled by the discipline of drawing, and the more complex and recondite they are the stricter the discipline must be. It is this feeling that every form has been perfectly understood and firmly grasped that makes Moore's drawings hold their own with the greatest drawings of the Renaissance.

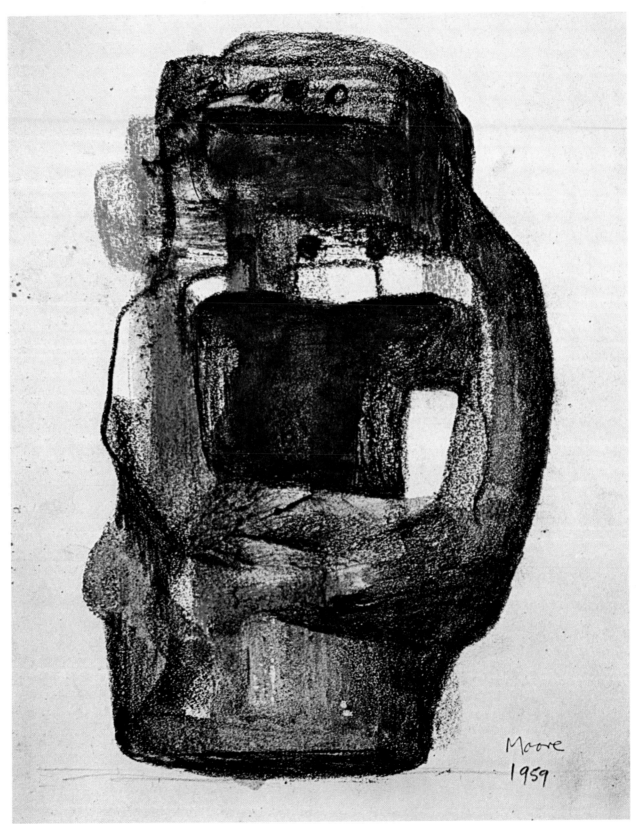

XXXVII Drawing for Stone Sculpture · 1959

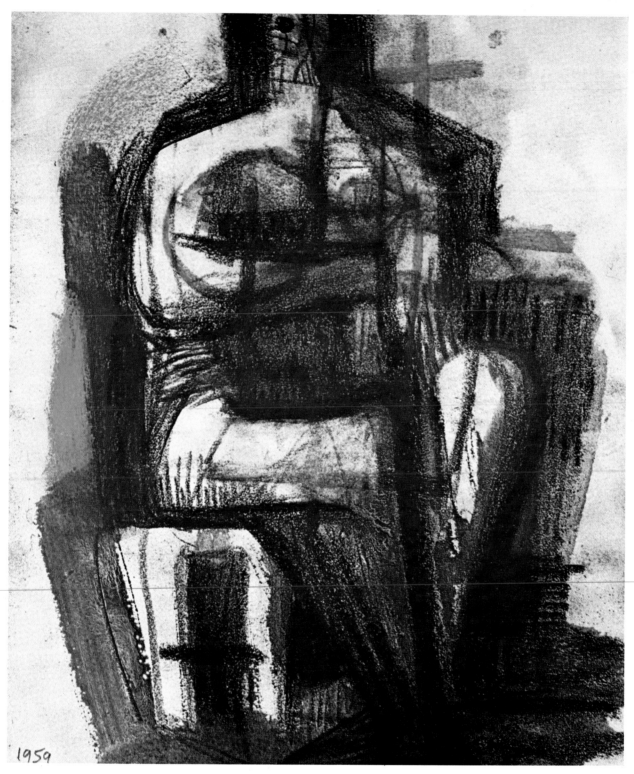

1959

XXXVIII *Seated Woman · 1959*

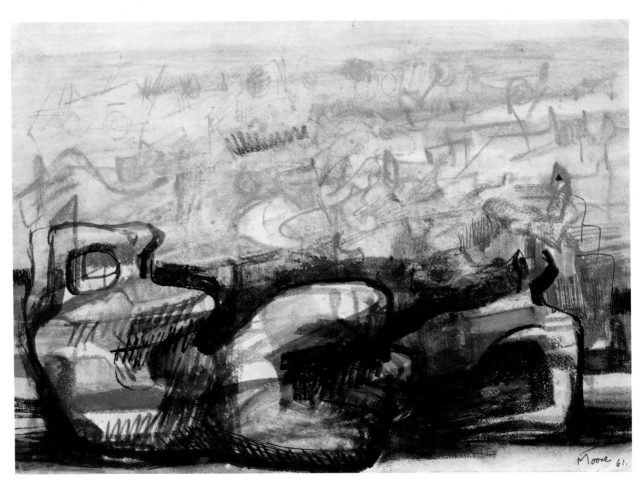

XXXIX Drawing for Sculpture · 1961

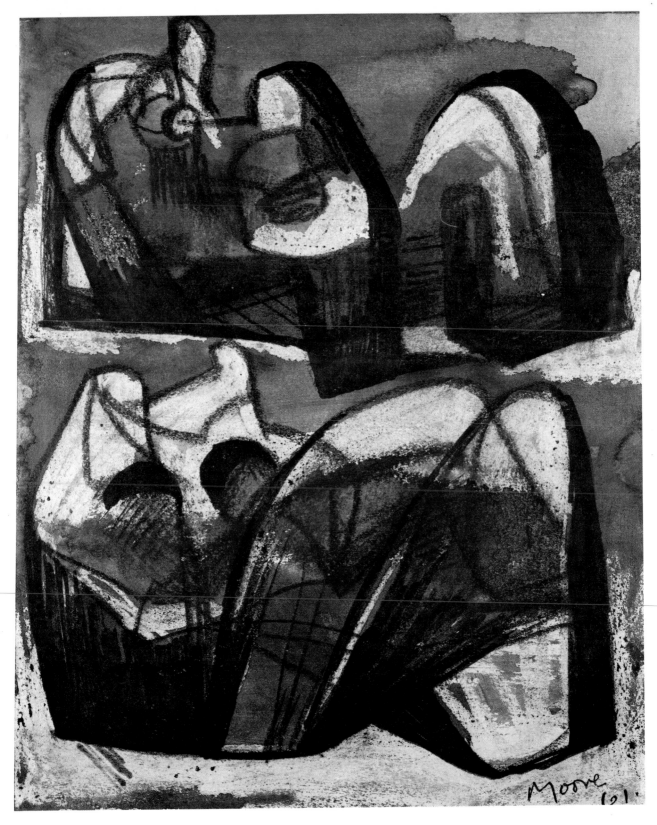

XL Two Reclining Figures · 1961

Postscript

I said that Henry Moore stopped drawing for its own sake in about 1950. At the end of 1972 he began again. There follows an account of why he came to do so that arrived too late for inclusion in the book, and is therefore printed as a postscript, exactly as Moore wrote it to me. Looking at Moore's later sculpture one finds completely new and unforeseeable departures like the marble rings of 1966. The 'black' drawings are a similar breakaway, and show that at seventy-five he is as ready to renew himself as Monet, or Titian.

THE 'BLACK' DRAWINGS

I think they've come about from doing so much drawing during the last year (and graphic work – which is the same thing) particularly the STONE-HENGE series, in some of which I tried to recapture my first impression of Stonehenge – which was seeing it in 1921 one late summer's night, by moonlight. These BLACK drawings owe a lot of course to my admiration for Seurat's drawings (I own two and look at them every day!).

But they have differences – they are not drawn from life (from the figure or from nature) – and so the space and form suggested in them is not measurable exactly, because not referable to a piece of reality! Also they may be *connected with the coalmine drawings* where there was the problem of getting form out of darkness – of making the light from the miners' helmet-lamps produce figures out of thick blackness – of drawing in the dark. Perhaps the effort (the struggle) the coalmine drawings gave me is being a help in the present 'black' drawings. And they are connected also with some of my sculptures, with my liking for the mystery of caves and holes, with something half-hidden – as in my INTERIOR-EXTERIOR and HELMET sculptures.

291

Doing them has many surprises – a flat piece of white paper becomes a world of space – of changeable depths and distances, and of mysterious glowings of light. I now like *black* for its blackness – for its strength, *its drama,* its seriousness (and unsweetness).

As each drawing develops, it is like going outside from a lighted room on a dark night – at first seeing nothing, then slowly distinguishing objects and distances – sensing space with unknown depths.

The white of the paper showing through the black chalk gives off light (almost real light) like the night sky reflected in water. I think I shall go on with this kind of drawing for a long time – besides having something new in it for me, it still uses the experience and struggle in the exploring of form that one has continually tried to make in sculpture, as well as the way of thinking three-dimensionally, which has usually been the aim in most of my drawings. And it can be done without physical effort – things about the drawing can be changed like magic. (I'm now thinking of my old !! age – that if, for any reason I'm unable to go on doing sculpture – then I know that drawing could satisfy me for the rest of my days.)

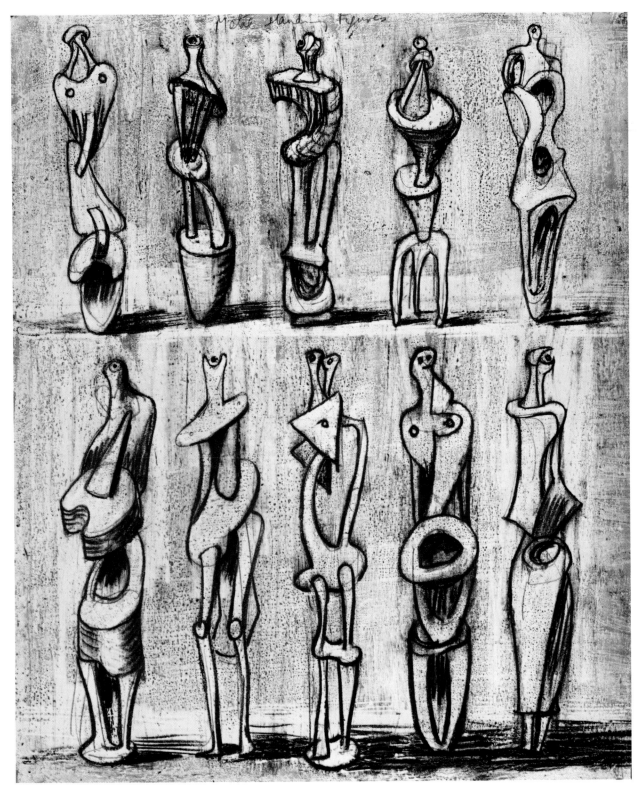

247 *Standing Figures: Ideas for Metal Sculpture · 1948*

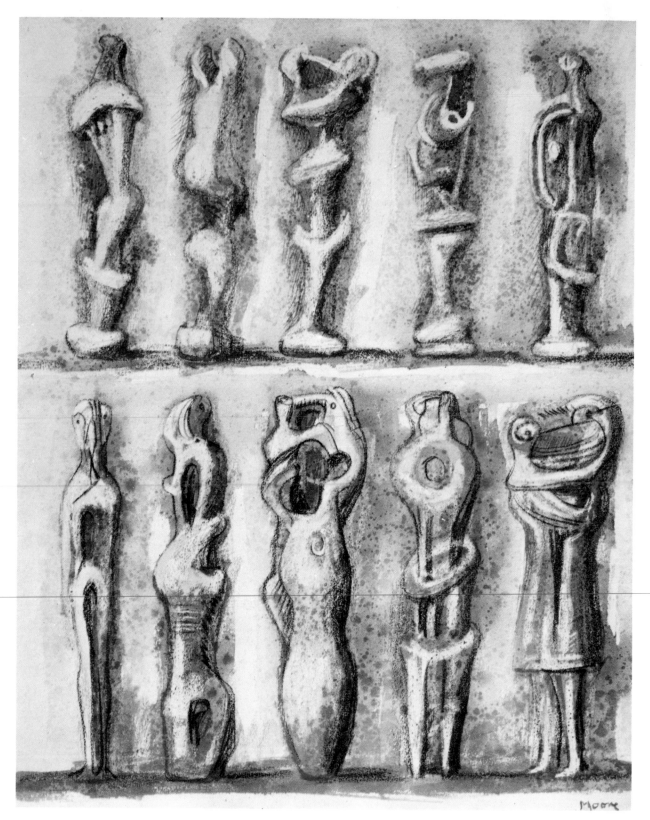

248 *Standing Forms · 1949/50*

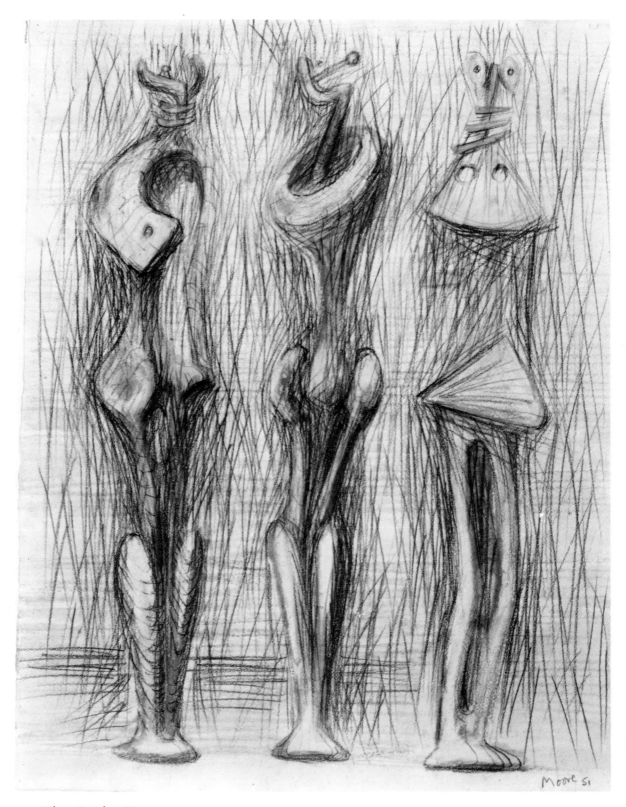

249 *Three Standing Figures · 1951*

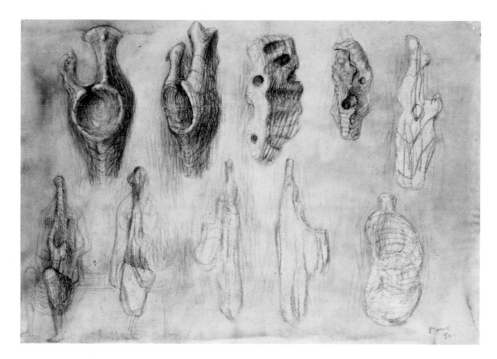

250
Tree Forms as Mother and Child · 1950

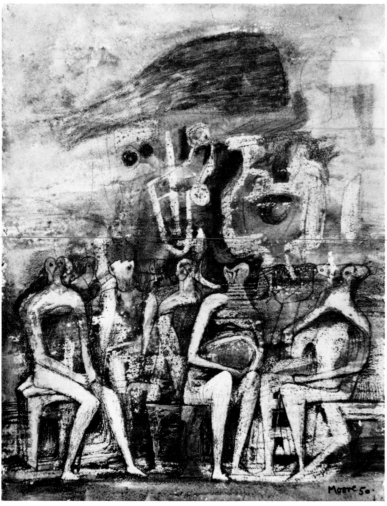

251
Group of Seated Figures · 1950

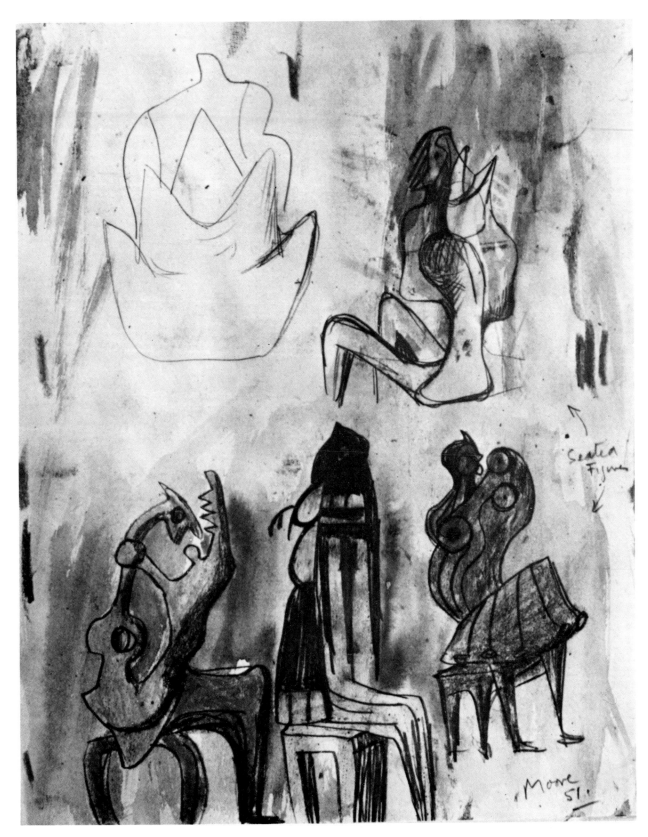

252 *Studies for Seated Figure · 1951*

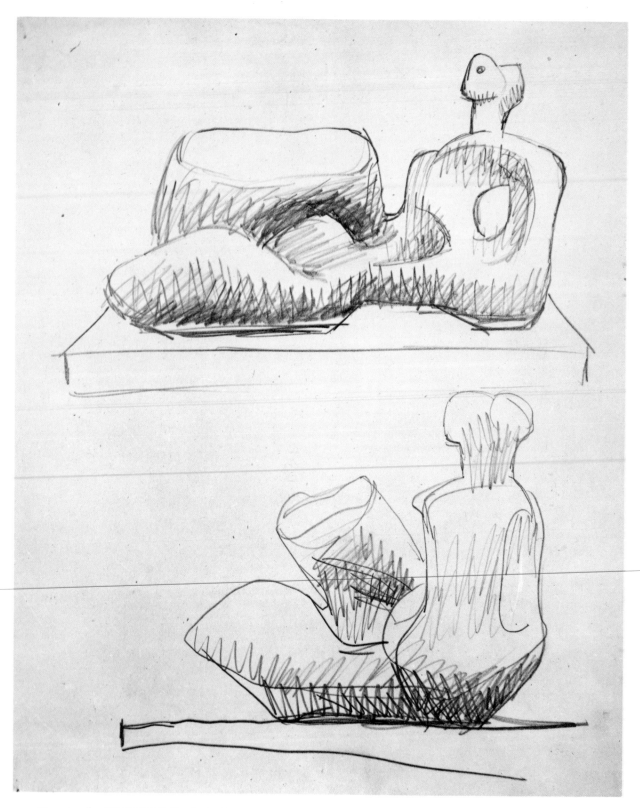

253 *Drawing for UNESCO Reclining Figure · 1955*

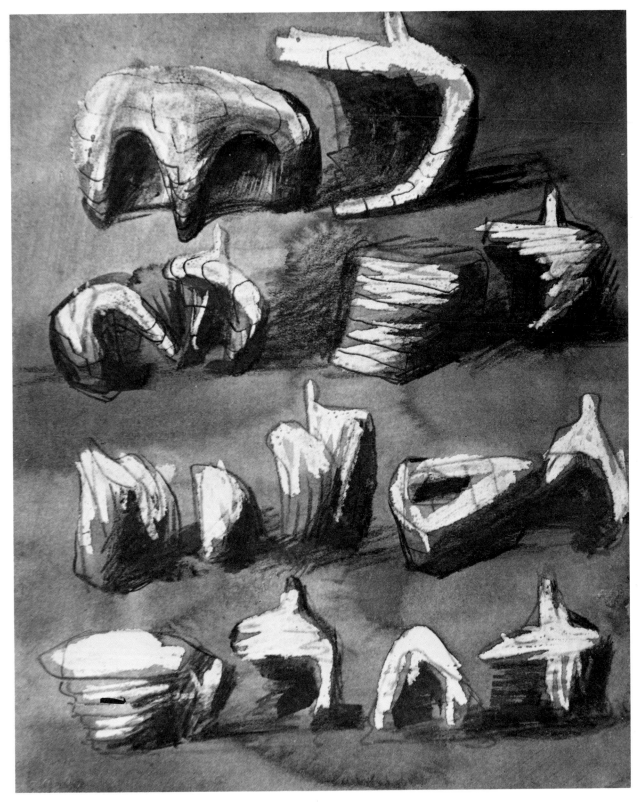

254 *Drawing for Sculpture : Two-piece Reclining Figures · 1959*

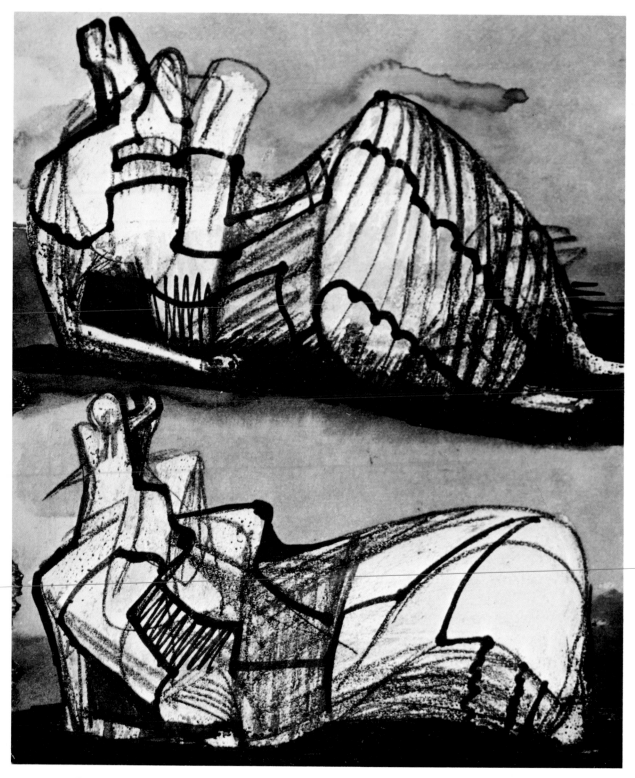

255 *Page I from a Sketchbook, 1961/62: Two Draped Reclining Figures · 1962*

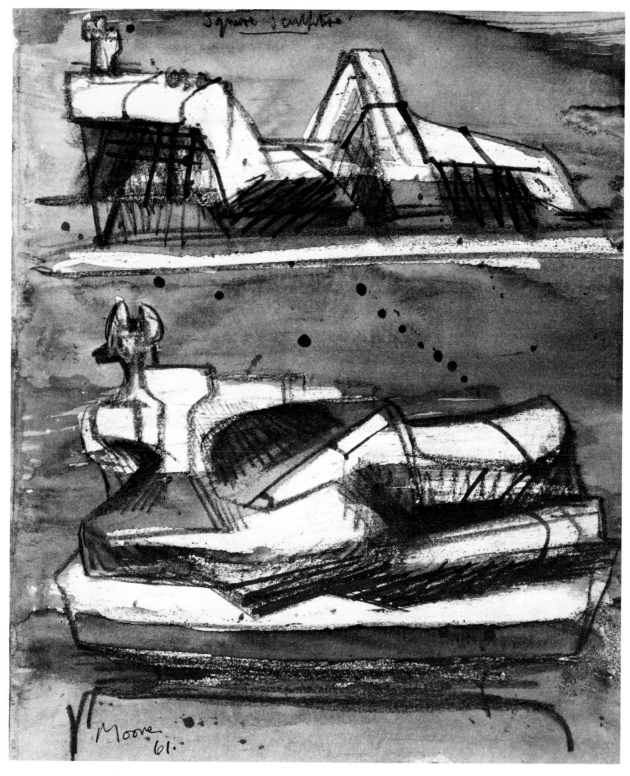

256 *Study for Reclining Sculptures · 1961*

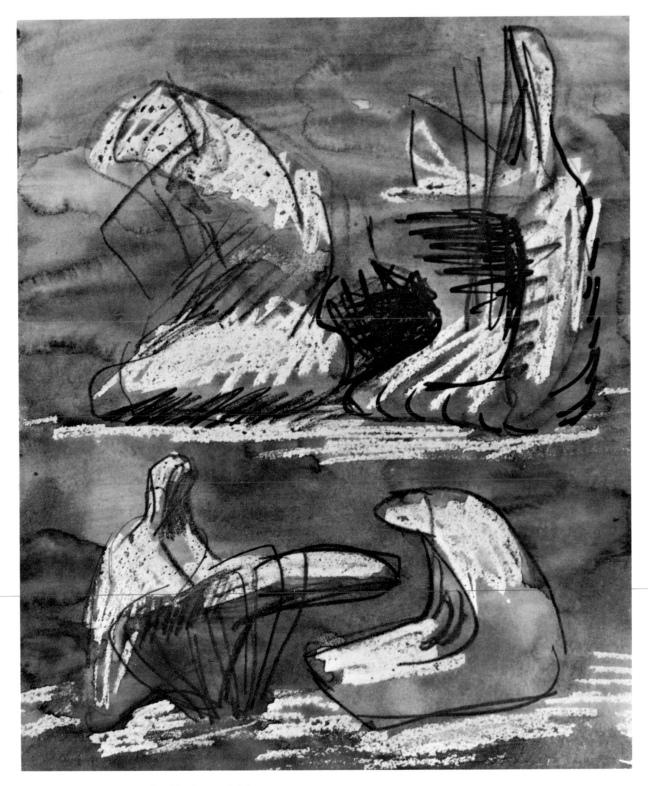

257 *Page XVI from a Sketchbook · 1961/62*

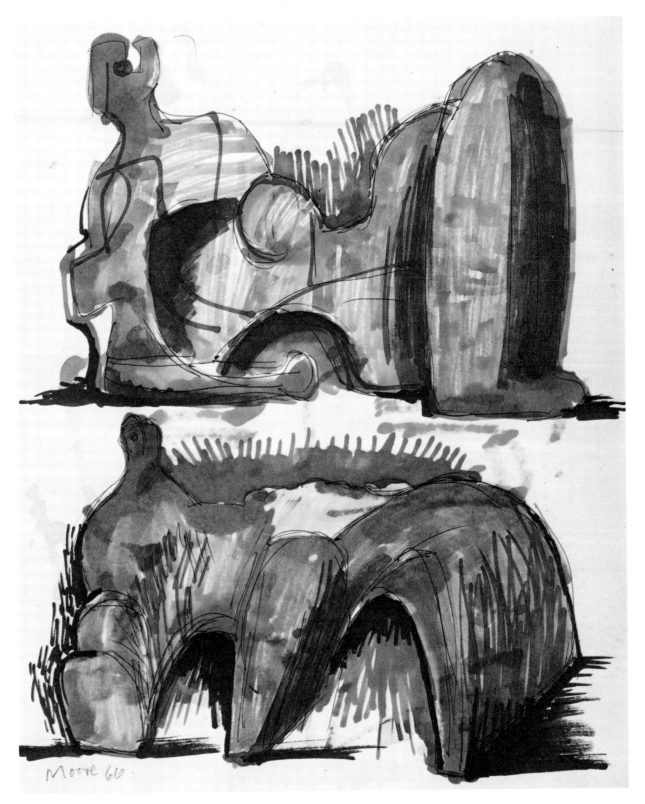

Moore 66.

258 Two Green Reclining Figures · 1966

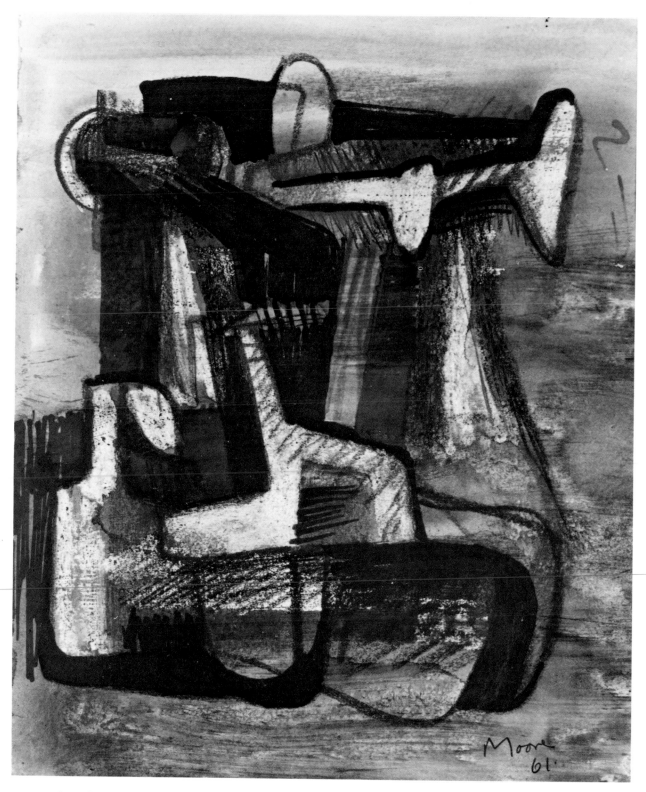

259 *Sculptural Idea* · 1961

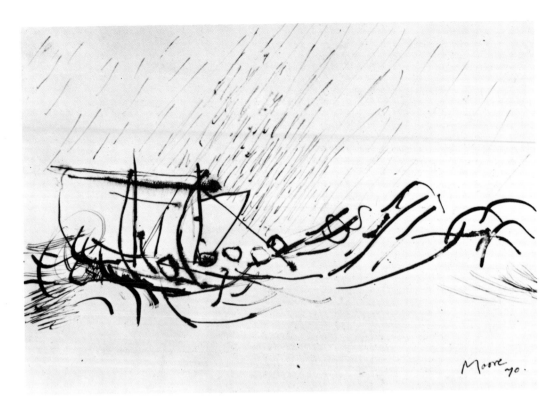

260 *Storm at Sea · 1970*

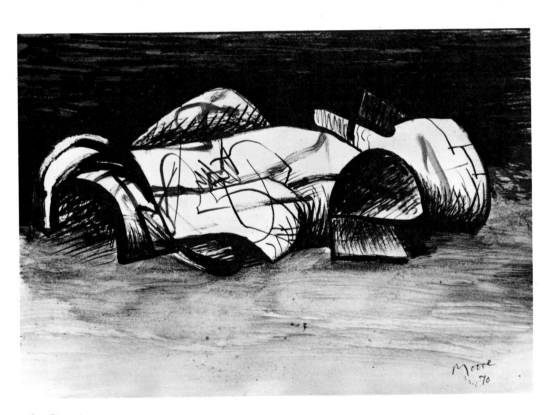

261 *Drawing · 1970*

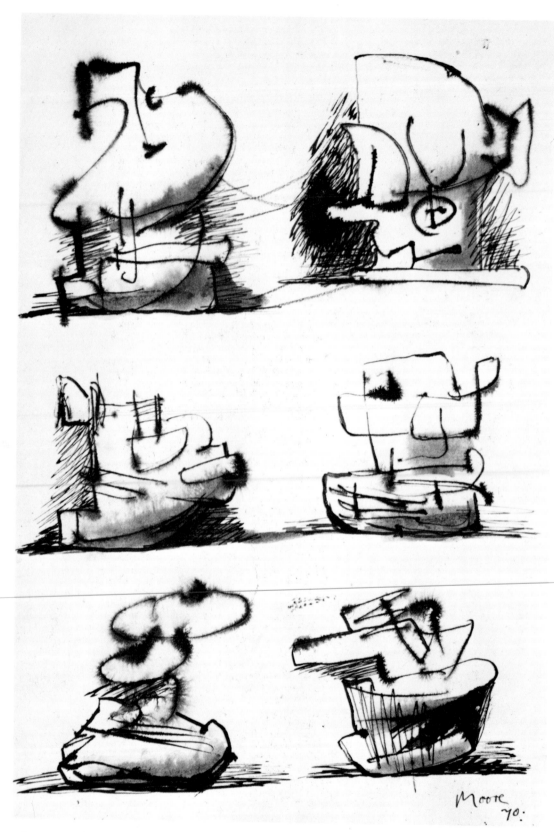

262 *Six Sculpture Motives No. VIII · 1970/71*

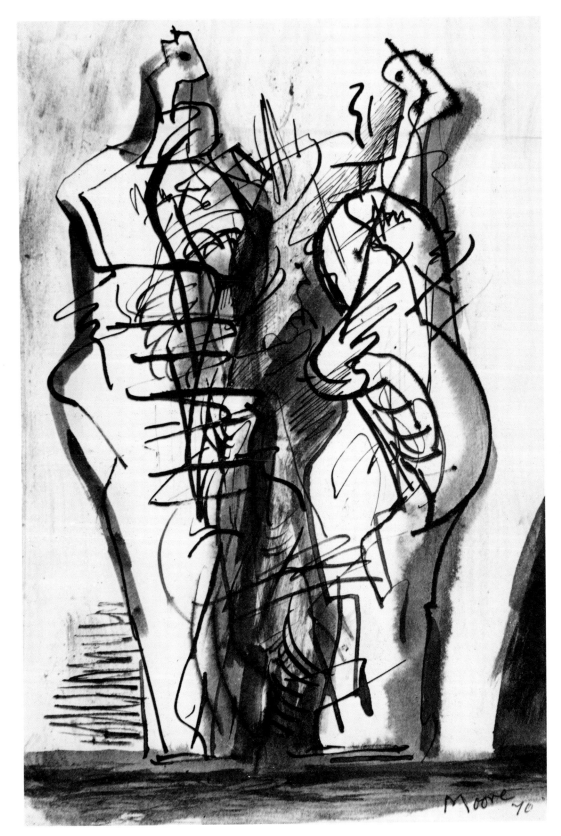

263 *Two Standing Figures No. XV · 1970*

264 Sculptural Form · 1971

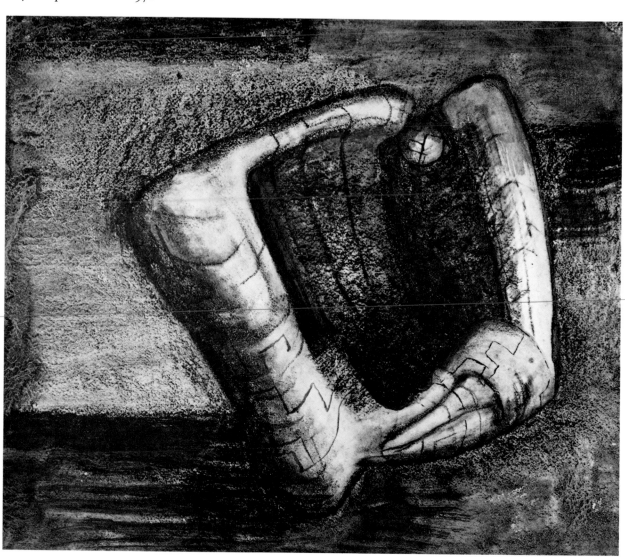

LIST OF ILLUSTRATIONS

List of Illustrations

COLOUR

XV Page 35 from First Shelter Sketchbook, 1940/41
Chalk, pen and watercolour
$7\frac{1}{2} \times 6\frac{1}{2}$ in (19·1 × 16·5 cm)
Lady Clark

XVI Page 56 from First Shelter Sketchbook, 1940/41
Pencil, crayon, pen and watercolour
$7\frac{1}{2} \times 6\frac{1}{2}$ in (19·1 × 16·5 cm)
Lady Clark

XVII Page 46 from First Shelter Sketchbook, 1940/41
Chalk, pen and watercolour
$7\frac{1}{2} \times 6\frac{1}{2}$ in (19·1 × 16·5 cm)
Lady Clark

XVIII Tube Shelter, 1940
Pen, coloured chalks and watercolour
11 × 15 in (28 × 38·1 cm)
Private

XIX Page 66 from First Shelter Sketchbook, 1940/41
Pencil, wax crayon, watercolour and pen
$7\frac{1}{2} \times 6\frac{1}{2}$ in (19·1 × 16·5 cm)
Lady Clark

XX Shelter Scene: Sleeping Figures, 1941
Pen, crayon and watercolour
$11\frac{1}{2} \times 11\frac{3}{4}$ in (29·2 × 29·8 cm)
Private

XXI Pink and Green Sleepers, 1941
Chalk, pen and watercolour
15 × 22 in (38·1 × 55·9 cm)
Tate Gallery, London

XXII Tube Shelter Perspective, 1941
Chalk, pen and watercolour
$18\frac{3}{4} \times 17$ in (47·6 × 43·2 cm)
Tate Gallery, London

XXIII Woman Seated in the Underground, 1941
Pen, crayon and wash
$18\frac{1}{2} \times 14\frac{3}{4}$ in (47 × 37·5 cm)
Tate Gallery, London

XXIV Studies of Miners at Work, 1942
Chalk, pen and watercolour
$24\frac{3}{4} \times 17\frac{1}{4}$ in (62·9 × 43·8 cm)
M. F. Feheley, Toronto

XXV Drawing for Sculpture in Metal, 1939
Pen, pencil, chalk and watercolour
10 × 17 in (25·4 × 43·2 cm)
Private

XXVI Figures with Rocks, 1942
Pencil, chalk, pen, wash and watercolour
$8\frac{7}{8} \times 6\frac{7}{8}$ in (22·5 × 17·5 cm)
Private

XXVII Reclining Figure, 1942
Chalk, pen, wash and watercolour
17 × 22 in (43·2 × 55·9 cm)
The British Museum, London

XXVIII Draped Reclining Figures, 1942
Crayon and pen
9 × 7 in (22·9 × 17·8 cm)
Mrs Charlotte Bergman, Israel

XXIX Girl, 1928
Pencil, chalk and watercolour
$15\frac{1}{4} \times 19\frac{1}{2}$ in (38·7 × 49·5 cm)
Private

XXX Study of Heads, 1932
Pen, chalk and wash
$16\frac{1}{4} \times 13$ in (41·3 × 33 cm)
Mrs Charlotte Bergman, Israel

XXXI Heads: Ideas for Metal Sculpture, 1944
Chalk, pen and watercolour
$18\frac{3}{4} \times 16$ in (47·6 × 40·6 cm)
Lord Clark

XXXII Head, 1958
Chalk, pen and wash
11 × 9 in (28 × 22·9 cm)
Lord Clark

XXXIII Family Groups, 1944
Pen, chalk and watercolour
22 × 15 in (55·9 × 38·1 cm)
Private

XXXIV Three Studies of the Artist's Child as a Baby, 1947
Crayon, pen and watercolour
$11\frac{1}{2} \times 9\frac{1}{2}$ in (29·2 × 24·1 cm)
Mrs Charlotte Bergman, Israel

XXXV Two Women and Child, 1951
Coloured chalk
13 × 12 in (33 × 30·5 cm)
Private

XXXVI Family Group, 1966
Pencil and coloured ink
11½ × 9½ in (29·2 × 24·1 cm)
Private

XXXVII Drawing for Stone Sculpture, 1959
Chalk and watercolour
11½ × 9⅜ in (29·2 × 23·8 cm)
Private

XXXVIII Seated Woman, 1959
Pink and black chalk and wash
11¼ × 9¼ in (28·6 × 23·5 cm)
Private

XXXIX Drawing for Sculpture, 1961
Chalk and watercolour
15½ × 21 in (39·4 × 53·3 cm)
Mrs Irina Moore

XL Two Reclining Figures, 1961
Watercolour, chalk and ink
11½ × 9½ in (29·2 × 24·1 cm)
The artist

BLACK AND WHITE

1 Reclining Nude, 1922
Pencil
20 × 15 in (50·8 × 38·1 cm)
The artist

2 Standing Man, 1921
Pencil
14 × 11 in (35·6 × 28 cm)
The artist

3 Seated Woman, 1921
Pencil, pen and wash
12 × 9 in (30·5 × 22·9 cm)
The artist

4 Figure Study, 1924
Watercolour, red and black chalk
16¾ × 13¾ in (42·5 × 34·9 cm)
Whitworth Art Gallery, Manchester

5 Seated Figure, 1923/4
Chalk and ink
13¾ × 10 in (34·9 × 25·4 cm)
The artist

6 Standing Girl, 1922
Pen and chalk
13¼ × 7 in (33·6 × 17·8 cm)
The artist

7 Standing Woman, 1923
Chalk and pencil
18¾ × 13¼ in (47·6 × 33·6 cm)
The artist

8 Standing Nude, c. 1923
Chalk and pen
14 × 9¾ in (35·6 × 24·8 cm)
The artist

9 Standing Woman, c. 1924
Black chalk and ink
22 × 8½ in (55·9 × 21·6 cm)
Miss Mary Moore

10 Standing Girl, 1924
Pen and pencil
19 × 6½ in (48·3 × 16·5 cm)
The artist

11 Figures with Arms Outstretched, 1927
Black and green ink and wash
11⅜ × 17¾ in (28·9 × 45·1 cm)
M. F. Feheley, Toronto

12 Seated Woman, 1957
Bronze, edition of 6
H. 57 in (144·8 cm)

13 Seated Nude, Back View, 1924
Charcoal and wash
12¼ × 9¾ in (31·1 × 24·8 cm)
Private

14 Seated Nude, Life Drawing, 1927
Pen and crayon
16½ × 13⅜ in (41·9 × 34 cm)
Mr and Mrs Gordon Bunshaft, New York

15 Seated Nude, *c.* 1928
Pen, wash and chalk
15⅝ × 10⅝ in (37·2 × 27 cm)
Private

16 Standing Figure, Back View, 1926
Pen and chalk
17¼ × 8¼ in (43·8 × 21 cm)
Miss Mary Moore

17 Standing Figure, Back View, *c.* 1924
Black ink and chalk
17¾ × 11 in (45·1 × 28 cm)
The artist

18 Three Quarter Figure, 1928
Pen, chalk and wash
Private

19 Seated Nude, 1928
Pen and green and black wash
17 × 13½ in (43·2 × 34·3 cm)
M. F. Feheley, Toronto

20 Life Drawing, Reclining Nude, 1928
Pen and wash
13 × 16⅝ in (33 × 42·2 cm)
Private

21 Standing Female Figure, 1928
Red ink
17 × 11½ in (43·2 × 29·2 cm)
The artist

22 Seated Figure, 1930
Pencil, gouache, chalk and wash
Private

23 Seated Woman with Clasped Hands, *c.* 1930
Gouache and wash
21¾ × 15½ in (55·2 × 39·4 cm)
Auckland City Art Gallery, New Zealand

24 Seated Figures, Studies for Sculpture, 1932
Chalk, pen and wash
14¾ × 10¾ in (37·5 × 27·3 cm)
Private

25 Study of Seated Nude, 1932
Pen and wash
21 × 14¾ in (53·3 × 37·5 cm)
National Museum, Stockholm

26 Drawing from Life, Seated Figure, 1933
Pen, chalk and wash
21 × 15 in approx. (53·3 × 38·1 cm)
Mrs Lois Ventris, London

27 Study of a Seated Nude, 1933/34
Pen and wash
21¾ × 15 in (55·2 × 38·1 cm)
Leeds City Art Gallery and Temple Newsom House

28 Seated Figure, 1934
Pen and wash
21¼ × 14½ in (54 × 36·8 cm)
M. F. Feheley, Toronto

29 Seated Figure, 1934
Pen and wash
22 × 15 in (55·9 × 38·1 cm)
Arts Council of Great Britain, London

30 Seated Figure, 1935
Pen and pencil
22 × 15 in (55·9 × 38·1 cm)
Lord Clark

31 Reclining Woman, 1935
Black and red wash
22½ × 15½ in (57·1 × 39·4 cm)
Leonard Winkleman, USA

32 Seated Woman, Drawing from Life, 1928
Chalk and wash
21¼ × 13¾ in (54 × 34·9 cm)
Mrs Irina Moore

33 Page from Sketchbook (Fragment), 1924
Pen and pencil
6⅞ × 6¾ in (17·5 × 17·2 cm)
The artist

34 Page 23 from No. 4 Notebook: Mother with Child on Back, 1925
Pencil and wash
9 × 6⅞ in (22·9 × 17·5 cm)
The artist

35 Mother and Child, 1924
Chalk and wash
22 × 15 in (55·9 × 38·1 cm)
Mrs Irina Moore

55 Montage of Reclining Figures and Ideas for
 Sculpture, 1932
 Pen and watercolour
 $14\frac{1}{2} \times 21\frac{1}{2}$ in $(36\cdot8 \times 54\cdot6$ cm$)$
 Mrs Denis Clarke Hall, U S A

56 Studies and Transformation of Bones, 1932
 Pencil
 12×10 in $(30\cdot5 \times 25\cdot4$ cm$)$
 Mrs Irina Moore

57 Drawing of Shells, 1932
 Pencil
 $9\frac{1}{4} \times 6\frac{3}{4}$ in $(23\cdot5 \times 17\cdot2$ cm$)$
 Arts Council of Great Britain, London

58 Transformation Drawing, 1932
 Pencil
 $12\frac{1}{2} \times 10$ in $(31\cdot8 \times 25\cdot4$ cm$)$
 Mrs Irina Moore

59 Ideas for Sculpture, 1933
 Pen and wash
 $14\frac{3}{4} \times 10\frac{5}{8}$ in $(37\cdot5 \times 27$ cm$)$
 Private

60 Drawing for Sculpture, Montage, 1933
 Pen and wash
 12×22 in $(30\cdot5 \times 55\cdot9$ cm$)$
 Private

61 Reclining Figures, 1933
 Pen, chalk and wash
 $14\frac{1}{2} \times 21\frac{1}{2}$ in $(36\cdot8 \times 54\cdot6$ cm$)$
 Helen Sutherland

62 Drawing for Sculpture, 1933
 Pen and wash
 15×11 in $(38\cdot1 \times 28$ cm$)$
 Lord Cottesloe

63 Reclining Figure and Ideas for Sculpture,
 1933
 Pen and wash
 22×15 in $(55\cdot9 \times 38\cdot1$ cm$)$
 Mrs Irina Moore

64 Reclining Figures, 1933
 Pen and wash
 15×22 in $(38\cdot1 \times 55\cdot9$ cm$)$
 Private

65 Montage, 1933
 Pen, chalk and wash
 15×22 in $(38\cdot1 \times 55\cdot9$ cm$)$
 National Gallery of Victoria, Melbourne

66 Mother and Child, Drawing for Sculpture,
 1933
 Pen and wash
 $14 \times 11\frac{3}{4}$ in $(35\cdot6 \times 29\cdot9$ cm$)$
 Mrs Irina Moore

67 Two Seated Women, 1933
 Chalk, pen and wash
 $14\frac{1}{2} \times 21\frac{1}{2}$ in $(36\cdot8 \times 54\cdot6$ cm$)$
 Private

68 Seated Woman, 1934
 Pen, pencil and wash
 $14\frac{5}{8} \times 10\frac{7}{8}$ in $(37\cdot2 \times 27\cdot6$ cm$)$
 The artist

69 Study for Sculpture, 1933
 Chalk and watercolour
 $10\frac{5}{8} \times 14\frac{1}{2}$ in $(27 \times 36\cdot8$ cm$)$
 Private

70 Drawing for Metal Sculpture, 1934
 Pen, pencil and wash
 $10\frac{3}{4} \times 14\frac{1}{2}$ in $(27\cdot3 \times 36\cdot8$ cm$)$
 Mrs Irina Moore

71 Ideas for Metal Sculpture, 1934
 Pen, pencil and watercolour
 15×11 in approx. $(38 \times 28$ cm$)$
 Private

72 Drawing for Sculpture: Head, 1934
 Pen, crayon and wash
 11×15 in $(28 \times 38\cdot1$ cm$)$
 Mrs Irina Moore

73 Reclining Form, 1934
 Pen and watercolour
 $10\frac{3}{4} \times 14\frac{3}{4}$ in $(27\cdot3 \times 37\cdot5$ cm$)$
 The artist

74 Study for Sculpture, 1934
 Pen, chalk and watercolour
 $10\frac{3}{4} \times 14\frac{1}{2}$ in $(27\cdot3 \times 36\cdot8$ cm$)$
 Private

75 Studies for Sculpture, 1934
Chalk and wash
$14\frac{7}{8} \times 22$ in ($37 \cdot 8 \times 55 \cdot 9$ cm)
The Museum of Modern Art, New York

76 Studies for Recumbent Figures, 1934
Pencil, chalk and wash
$10\frac{7}{8} \times 15\frac{1}{4}$ in ($27 \cdot 6 \times 38 \cdot 7$ cm)
The Art Gallery of Ontario, Toronto

77 Ideas for Sculpture, 1971
Black and red chalk and wash
$15\frac{3}{8} \times 22\frac{1}{2}$ in ($39 \cdot 1 \times 57 \cdot 1$ cm)
The artist

78 Study for Reclining Figure as a Three-piece
Composition, 1934
Pen and watercolour
22×15 in ($55 \cdot 9 \times 38 \cdot 1$ cm)
Lord Clark

79 Reclining Figure, 1934
Pen, chalk and watercolour
Private

80 Reclining Figure, 1935
Corsehill stone
L. $23\frac{1}{2}$ in ($59 \cdot 7$ cm)
Mrs Irina Moore

81 Ideas for Stone Seated Figures
Chalk and pen
15×22 in ($38 \cdot 1 \times 55 \cdot 9$ cm)
Mrs Peggy Anderson

82 Drawing, 1935
Chalk, pen and watercolour
18×22 in ($45 \cdot 7 \times 55 \cdot 9$ cm)
Mrs Irina Moore

83 Ideas for Two-piece Composition, 1934
Chalk and watercolour
$14\frac{3}{4} \times 21\frac{3}{4}$ in ($37 \cdot 5 \times 55 \cdot 3$ cm)
Rijksmuseum Kröller-Müller, Otterlo

84 Page from 'Square Forms' Sketchbook, 1934
Pen and wash
$10\frac{5}{8} \times 7\frac{1}{8}$ in ($27 \times 18 \cdot 1$ cm)
The artist

86 Square Forms, 1935
Chalk and wash
$10\frac{1}{2} \times 7\frac{1}{4}$ in ($26 \cdot 8 \times 18 \cdot 4$ cm)
Private

87 Five Reclining Figures, 1963
Lithograph
$24 \times 16\frac{1}{2}$ in ($61 \times 41 \cdot 9$ cm)

88 Ideas for Stone Carving, 1935
Black chalk and pen
15×22 in ($38 \cdot 1 \times 55 \cdot 9$ cm)
Private

85 Drawing, 1936
Pen and wash
16×20 in ($40 \cdot 6 \times 50 \cdot 8$ cm)
Lord Clark

89 Nine Drawings for a Carving, 1935
Chalk and wash
$21\frac{5}{8} \times 14\frac{1}{2}$ in ($54 \cdot 9 \times 36 \cdot 8$ cm)
Private

90 Eight Ideas for Sculpture, 1936
Chalk and watercolour
Stephen Spender

91 Two Stone Forms, 1936
Pen and wash
22×15 in ($55 \cdot 9 \times 38 \cdot 1$ cm)
Lord Clark

92 Drawing for Sculpture, 1936
Pencil, chalk and wash
$22 \times 14\frac{1}{2}$ in ($55 \cdot 9 \times 36 \cdot 8$ cm)
Alfred Hecht, London

93 Drawing for Sculpture, Square Forms, 1936
Chalk and wash
15×16 in ($38 \cdot 1 \times 40 \cdot 6$ cm)
Private

94 Square Forms, 1963
Lithograph
$18 \times 23\frac{1}{4}$ in ($45 \cdot 7 \times 59 \cdot 1$ cm)

95 Drawing for Stone Sculpture, 1937
Chalk and watercolour
$19 \times 23\frac{1}{2}$ in ($48 \cdot 2 \times 59 \cdot 7$ cm)
Gérald Cramer, Geneva

317

96 Drawing, 1937
Watercolour and pen
24 × 17 in (61 × 43·2 cm)
Private

97 Two Forms: Drawing for Sculpture, 1937
Chalk and wash
15 × 17 in (38·1 × 43·2 cm)
Mrs Irina Moore

98 Ideas for Stone Sculpture, 1937
Watercolour and chalk
10 × 8 in approx. (25·4 × 20 cm)
Lady Read, Yorkshire

99 Sculptural Ideas, Hollow Form, 1938
Pen, wash and chalk
15 × 22 in (38·1 × 55·9 cm)
National Gallery of New South Wales,
Sydney

100 Ideas for Sculpture, Stringed Figures, 1939
Chalk, pen and watercolour
15 × 22 in (38·1 × 55·9 cm)
George Dix, USA

101 Pointed Forms, 1940
Chalk, pen, pencil and watercolour
10 × 17 in (25·4 × 43·2 cm)
Graphische Sammlung der Albertina,
Vienna

102 Ideas for Sculpture, 1940
Chalk, pen and watercolour
17 × 10 in (43·2 × 25·4 cm)
Perry T. Rathbone, USA

103 Mother and Child, 1932
Green Hornton stone
H. 35 in (88·9 cm)
Sir Robert and Lady Sainsbury, London

104 Stones in Landscape, 1936
Pen and wash
22 × 15 in (55·9 × 38·1 cm)
Private

105 Figures in a Cave, 1936
Chalk and wash
15 × 22 in (38·1 × 55·9 cm)
The artist

106 Drawing for Sculpture, 1936
Pen and watercolour
12 × 22 in (30·5 × 55·9 cm)
Ruthven Todd

107 Ideas for Stone Figures, 1936
Pen, chalk and wash
14¾ × 21¼ in (37·5 × 54 cm)
Achim Moeller Gallery, London

108 Ideas for Metal Sculpture, 1937
Coloured chalks
15½ × 21⅝ in (39·4 × 54·9 cm)
Private

109 Drawing for Metal Sculpture, 1938
Pencil, chalk and watercolour
15 × 22 in (38·1 × 55·9 cm)
Private

110 Drawing for Metal Sculpture, 1938
Chalk and watercolour
15 × 22 in (38·1 × 55·9 cm)
Carl O. Plate, Sydney

111 Four Forms, 1938
Chalk and wash
11 × 15 in (28 × 38·1 cm)
Private

112 Ideas for Sculpture, 1938
Chalk and wash
15 × 22 in (38·1 × 55·9 cm)
Private

113 Ideas for Sculpture, 1938
Chalk, pen and wash
15 × 22 in (38·1 × 55·9 cm)
Private

114 Thirty-nine Ideas for Sculpture, 1938
Chalk, pen and wash
10¾ × 14¾ in (27·3 × 37·5 cm)
Felix H. Man, Rome

115 Pictorial Ideas and Settings for Sculpture,
1939
Pen and wash
10½ × 14½ in (26·7 × 36·8 cm)
Private

116 Sculptural Object in Landscape, 1939
Chalk, pen and watercolour
15 × 22 in (38·1 × 55·9 cm)
Sir Robert and Lady Sainsbury, London

117 Ideas for Sculpture, 1940
Crayon, watercolour and pen
$16\frac{3}{4}$ × 10 in (42·5 × 25·4 cm)
Anonymous loan to the Fogg Art Museum,
Harvard University

118 Drawing for Sculpture: Standing Figures,
1940
Chalk, pen and watercolour
15 × 10 in (38·1 × 25·4 cm)
Sir Robert and Lady Sainsbury, London

119 Standing Figures, Drawing for Sculpture,
1940
Pen and watercolour
11 × 15 in (28 × 38·1 cm)
The Hon. Alan Clark, Saltwood

120 Standing Figures, 1940
Pen, wash and watercolour
11 × 15 in (28 × 38·1 cm)
Private

121 Two Standing Figures, 1940
Chalk and watercolour
19 × 15 in (48·3 × 38·1 cm)
Stuart C. Davidson, Washington, DC

122 Two Standing Figures, 1940
Chalk and watercolour
22 × 15 in (55·9 × 38·1 cm)
Lord Clark

123 Studies of Internal and External Forms, 1948
Pen, crayon and wash
$11\frac{1}{2}$ × $9\frac{1}{2}$ in (29·2 × 24·1 cm)
Smith College Museum of Art, Northampton, Mass.

124 Upright Internal and External Form,
1953/54
Elmwood
H. 103 in (261·6 cm)
Albright-Knox Art Gallery, Buffalo, NY

125 Three Standing Figures, 1947/48
Darley Dale stone
H. 84 in (213·4 cm)
Battersea Park, London

126 Standing Figures, 1942
Black chalk and pen
22 × 15 in (55·9 × 38·1 cm)
Private

127 Figures in a Setting, 1942
Chalk, pen and wash
$14\frac{3}{4}$ × $21\frac{1}{8}$ in (37·5 × 53·7 cm)
Paul Magriel, New York

128 Group of Draped Standing Figures, 1942
Pencil, crayon and ink
The Potter Palmer Collection, Art Institute
of Chicago

129 Draped Standing Figures, 1942
Pen, crayon and watercolour
23 × 18 in (58·4 × 45·7 cm)

130 Studies for Three Standing Figures, 1945/6
Pen, crayon and watercolour
15 × 11 in (38·1 × 28 cm)
Lady Walston

131 Women Winding Wool, 1942
Chalk and pen
$15\frac{1}{2}$ × 22 in (39·4 × 55·9 cm)
New York University

132 The Presentation: Three Standing Figures
and Child, 1943
Chalk, watercolour and black ink
$13\frac{1}{2}$ × $19\frac{3}{4}$ in (34·3 × 50·2 cm)
Richard Attenborough

133 Figures in an Art Gallery, 1943
Gouache, crayon, watercolour and ink
$18\frac{1}{4}$ × $19\frac{1}{2}$ in (46·4 × 49·5 cm)
Private

134 Wrapped Madonna and Child: Night Time,
1950
Crayon, pen and watercolour
$13\frac{1}{2}$ × $9\frac{1}{2}$ in (34·3 × 24·1 cm)
Mrs Charlotte Bergman, Israel

319

135 Wrapped Madonna and Child: Day Time, 1950
Crayon and watercolour
$13\frac{1}{2} \times 9\frac{1}{2}$ in ($34 \cdot 3 \times 24 \cdot 1$ cm)
Mrs Charlotte Bergman, Israel

136 Standing, Seated and Reclining Figures Against Background of Bombed Buildings, 1940
Pen, chalk and watercolour
11×15 in ($28 \times 38 \cdot 1$ cm)
Lady Keynes

137 Gash in Road (Air-raid Shelter Drawing), 1940
Chalk, pen and watercolour
15×11 in ($38 \cdot 1 \times 28$ cm)
Sir Colin and Lady Anderson, London

138 Two Women on a Bench in a Shelter, 1940
Chalk, pen and wash
$13\frac{1}{2} \times 16$ in ($34 \cdot 3 \times 40 \cdot 6$ cm)
Lord Clark

139 Page 41 from First Shelter Sketchbook, 1940/1
Chalk, pen and watercolour
$7\frac{1}{2} \times 6\frac{1}{2}$ in ($19 \cdot 1 \times 16 \cdot 5$ cm)
Lady Clark

140 Page 7 from Second Shelter Sketchbook, 1941
Chalk, pen and watercolour
$8 \times 6\frac{1}{2}$ in ($20 \cdot 3 \times 16 \cdot 5$ cm)
Mrs Irina Moore

141 Page 32 from Second Shelter Sketchbook, 1941
Chalk, pen and watercolour
$8 \times 6\frac{1}{2}$ in ($20 \cdot 3 \times 16 \cdot 5$ cm)
Mrs Irina Moore

142 Page 63 from Second Shelter Sketchbook, 1941
Chalk, pen and watercolour
$8 \times 6\frac{1}{2}$ in ($20 \cdot 3 \times 16 \cdot 5$ cm)
Mrs Irina Moore

143 Page 68 from Second Shelter Sketchbook, 1941
Chalk, pen and watercolour
$8 \times 6\frac{1}{2}$ in ($20 \cdot 3 \times 16 \cdot 5$ cm)
Mrs Irina Moore

144 Page 86 from Second Shelter Sketchbook, 1941
Chalk, pen and watercolour
$8 \times 6\frac{1}{2}$ in ($20 \cdot 3 \times 16 \cdot 5$ cm)
Mrs Irina Moore

145 Page 24 from First Shelter Sketchbook, 1940/41
Chalk, pen and watercolour
$7\frac{1}{2} \times 6\frac{1}{2}$ in ($19 \cdot 1 \times 16 \cdot 5$ cm)
Lady Clark

146 Page 26 from First Shelter Sketchbook, 1940/41
Chalk, pen and watercolour
$7\frac{1}{2} \times 6\frac{1}{2}$ in ($19 \cdot 1 \times 16 \cdot 5$ cm)
Lady Clark

147 Four Grey Sleepers, 1941
Pen, chalk, watercolour and wash
$16\frac{3}{4} \times 19\frac{3}{4}$ in ($42 \cdot 5 \times 50 \cdot 2$ cm)
City Art Gallery, Wakefield

148 Shelter Scene, 1941
Pen, chalk and watercolour
19×17 in ($48 \cdot 3 \times 43 \cdot 2$ cm)
Tate Gallery, London

149 Shadowy Shelter, 1940
Chalk, pen, wash and watercolour
$10\frac{1}{4} \times 17\frac{1}{4}$ in ($26 \times 43 \cdot 8$ cm)
Graves Art Gallery, Sheffield

150 Shelterers in the Tube, 1941
Pen, chalk and watercolour
15×22 in ($38 \cdot 1 \times 55 \cdot 9$ cm)
Tate Gallery, London

151 Page 29 from Second Shelter Sketchbook, 1941
Chalk, pen and watercolour
$8 \times 6\frac{1}{2}$ in ($20 \cdot 3 \times 16 \cdot 5$ cm)
Mrs Irina Moore

152 Seated Women in a Tube Shelter, 1941
Chalk, pen and watercolour
17 × 10½ in (43·2 × 26·7 cm)
Lord Clark

153 Shelter Drawing, 1941
Pen, chalk and watercolour
10¼ × 14½ in (26 × 36·2 cm)
Private

154 Figure in a Shelter, 1941
Chalk, pen and watercolour
15 × 22 in (38·1 × 55·9 cm)
City Art Gallery, Wakefield

155 Seated Shelter Figures, 1941
Chalk, pen and watercolour
15 × 18 in (38·1 × 45·7 cm)
Sir Colin and Lady Anderson

156 Tilbury Shelter, 1941
Chalk, pen and watercolour
15 × 22 in (38·1 × 55·9 cm)
Private

157 Three Fates, 1941
Chalk and watercolour
15 × 21 in (38·1 × 53·4 cm)
Private

158 Arrangement of Figures, 1942
Chalk, pen and wash
13 × 21¾ in (33 × 55·3 cm)
Mrs Irina Moore

159 Page from 'Coalmining Subject' Sketch-
book, 1941/42
Chalk, pen and watercolour
8 × 6¾ in (20·3 × 17·1 cm)
The artist

160 Page from 'Coalmining Subject' Sketch-
book, 1941/42
Chalk, pen and watercolour
8 × 6¾ in (20·3 × 17·1 cm)
The artist

161 Page from Coalmine Sketchbook, 1942
Pen, pencil, watercolour and crayon
9⅞ × 7 in (25·1 × 17·8 cm)
The artist

162 At the Coal Face: Miners Fixing Prop, 1942
Chalk, pen and watercolour
13½ × 22 in (34·3 × 55·9 cm)
Leeds City Art Gallery and Temple
Newsom House

163 Miners at Work on the Coal Face, 1942
Chalk, watercolour and pen
21½ × 13 in (54·6 × 33 cm)

164 Miner at Work, 1942
Crayon, ink and watercolour
20 × 14¾ in (50·8 × 37·5 cm)
Art Museum, Portland, Ore.

165 Miner at Work, 1942
Chalk, pen and watercolour
12¼ × 10½ in (31·1 × 26·8 cm)
Mrs Irina Moore

166 Coalminers at Work, 1942
Pen, ink and crayon
5⅝ × 7⅝ in (14·3 × 19·4 cm)
Miss Mary Moore

167 Coalminer Carrying Lamp, 1942
Chalk, pen and watercolour
19 × 15½ in (48·3 × 39·4 cm)
Mrs Irina Moore

168 Page from a Sketchbook: Woman Playing
with her Child, c. 1922
Blue ink
5¼ × 8⅞ in (13·3 × 22·5 cm)
The artist

169 Reclining Figure, 1928
Chalk and watercolour
13½ × 15⅝ in (34·3 × 39·8 cm)
Private

170 Reclining Nude, 1928
Black chalk and grey wash
11½ × 16⅝ in (29·2 × 42·2 cm)
Private

171 Reclining Figure, 1935
Chalk, pencil and wash
15 × 21½ in (38·1 × 54·6 cm)
Mrs Margaret Havinden, Hertingfordbury

172 Reclining Figures, 1938
Chalk and watercolour
$14 \times 20\frac{1}{4}$ in $(35 \cdot 6 \times 51 \cdot 4$ cm$)$
Private

173 Project for Figure in Lead, 1938
Pen, chalk and watercolour
15×22 in $(38 \cdot 1 \times 55 \cdot 9$ cm$)$
Miss Isobel Walker

174 Reclining Figure, 1939
Lead
L. 12 in $(30 \cdot 5$ cm$)$
Victoria and Albert Museum, London

175 Pictorial Ideas and Settings for Sculpture, 1938
Pen, chalk and watercolour
$7\frac{1}{2} \times 11$ in approx. $(19 \cdot 1 \times 28$ cm$)$
Gordon Onslow Ford, USA

176 Drawing for Detroit Reclining Figure, 1938
Chalk and pencil
$7\frac{3}{8} \times 11$ in $(18 \cdot 7 \times 28$ cm$)$
Private

177 Landscape with Figures, 1938
Chalk and watercolour
$15 \times 17\frac{3}{4}$ in $(38 \cdot 1 \times 45 \cdot 1$ cm$)$
Mrs Edward Carter

178 Study for Reclining Figure in Wood, 1940
Pen, chalk and watercolour
7×11 in $(17 \cdot 8 \times 28$ cm$)$
Lord Clark

179 Reclining Figure, 1939
Elmwood
L. 81 in $(205 \cdot 8$ cm$)$
Detroit Institute of Arts

180 Ideas for Metal Sculpture, 1938
Chalk, pen and wash
15×22 in $(38 \cdot 1 \times 55 \cdot 9$ cm$)$
Lord Clark

181 Reclining Figure, 1938
Chalk and watercolour
15×22 in $(38 \cdot 1 \times 55 \cdot 9$ cm$)$
Lord Clark

182 Reclining Figures: Drawing for Sculpture, 1939
Chalk, pen and wash
11×15 in $(28 \times 38 \cdot 1$ cm$)$
Mrs Irina Moore

183 Study for a Reclining Figure in Wood, 1939
Chalk and wash
15×22 in $(38 \cdot 1 \times 55 \cdot 9$ cm$)$
Private

184 Sculpture in Landscape, 1942
Pen and watercolour
15×22 in $(38 \cdot 1 \times 55 \cdot 9$ cm$)$
Santa Barbara Museum of Art

185 Ideas for Sculpture, 1942
Chalk, pen and watercolour
9×7 in $(22 \cdot 9 \times 17 \cdot 8$ cm$)$
Private, USA

186 Reclining Figure, 1945/46
Elmwood
L. 75 in $(190 \cdot 4$ cm$)$
Private, Italy

187 Reclining Figure Against a Bank, 1942
Chalk, pen and watercolour
22×17 in $(55 \cdot 9 \times 43 \cdot 2$ cm$)$
Private, USA

188 Reclining Figure, 1942
Chalk, pen and watercolour
22×15 in $(55 \cdot 9 \times 38 \cdot 1$ cm$)$
Private, USA

189 Figures in a Hollow, 1942
Pen, chalk and watercolour
16×22 in $(40 \cdot 1 \times 55 \cdot 9$ cm$)$
Miss Susanne Wasson-Tucker, New York

190 Wood Sculpture in Setting of Red Rocks, 1942
Chalk and watercolour
22×15 in $(55 \cdot 9 \times 38 \cdot 1$ cm$)$
Philip L. Goodwin, New York

191 Studies for Sculpture, 1944
Chalk, watercolour and pen
$14\frac{1}{2} \times 10\frac{3}{4}$ in $(36 \cdot 8 \times 27 \cdot 3$ cm$)$
Private

192 Portrait Head of Old Man, 1921
Pencil
15 × 12 (38·1 × 30·5 cm)
The artist

193 Head of Girl, 1927
Chalk, pen and wash
11¼ × 9⅞ in (28·6 × 25·1 cm)
Graphische Sammlung der Albertina,
Vienna

194 Head of a Woman, 1929
Grey wash and black chalk
15⅛ × 13⅛ in (38·4 × 33·4 cm)
National Gallery of Canada, Ottawa

195 Portrait of Stephen Spender, c. 1937
Chalk and wash
15 × 11 in approx. (38·1 × 28 cm)
K. J. Hewett, London

196 Portrait of Stephen Spender, c. 1937
Chalk
12 × 10 in (30·5 × 25·4 cm)
Stephen Spender

197 Heads: Drawing for Metal Sculpture, 1939
Chalk and watercolour
7 × 10 in (17·8 × 25·4 cm)
Lord Clark

198 Two Heads: Drawing for Metal Sculpture,
1939
Coloured ink and chalk
11 × 15 in (28 × 38·1 cm)
Mrs Irina Moore

199 Spanish Prisoner, 1939
Chalk and wash
14½ × 12¼ in (36·8 × 31·1 cm)
Mrs Irina Moore

200 The Helmet, 1939/40
Lead
H. 11½ in (29·2 cm)
Sir Roland Penrose

201 Drawing for Sculpture: Helmet Heads, 1950
(dated 1949)
Chalk, pen and gouache
11⅜ × 9¼ in (28·9 × 23·5 cm)
Private

202 Helmet Heads, 1950
Chalk and gouache
11½ × 9 in (29·2 × 22·9 cm)
Mrs Irina Moore

203 Page from Sketchbook, 1942
Pen, crayon and watercolour
7 × 10 in (17·8 × 25·4 cm)
Private

204 Page IX from a Sketchbook, 1961/62:
Animal Head, 1961
Pencil, crayon and watercolour
11½ × 9½ in (29·2 × 24·1 cm)
The artist

205 King and Queen, 1952/53 (detail): Head of
King
Bronze

206 Sleeping Head, 1941
Pencil
4¾ × 4¼ in (12·1 × 10·8 cm)
Mark Tobey

207 Page 69 from Second Shelter Sketchbook,
1941
Chalk, pencil and watercolour
8 × 6½ in (20·3 × 16·5 cm)
Mrs Irina Moore

208 Shelter Scene: Two Seated Figures, 1940
Chalk, pen and watercolour
14¾ × 16½ in (37·5 × 41·9 cm)
Leeds City Art Gallery and Temple
Newsom House

209 Page 89 from Second Shelter Sketchbook:
Woman with Plaster in her Hair, 1941
Chalk, pencil and watercolour
8¼ × 6½ in (21 × 16·5 cm)
Mrs Irina Moore

210 Page from Coalmining Sketchbook: Miners'
Faces, 1942
Pen, watercolour, crayon and wash
10 × 7 in (25·4 × 17·8 cm)
Mrs Irina Moore

211 Page 61 from Coalmining Notebook, 1942
Pencil
$4\frac{1}{2} \times 7\frac{7}{8}$ in $(11 \cdot 5 \times 20$ cm$)$
The artist

212 Pit Boys at Pit Head, 1942
Chalk, pen and watercolour
$13\frac{1}{2} \times 21\frac{1}{2}$ in $(34 \cdot 3 \times 54 \cdot 6$ cm$)$
City Art Gallery, Wakefield

213 Head, 1958
Chalk and watercolour
11×9 in $(28 \times 22 \cdot 9$ cm$)$
Private

214 Portrait of the Artist's Mother, c. 1927
Pencil, ink and wash
$10\frac{3}{4} \times 7$ in $(27 \cdot 3 \times 17 \cdot 8$ cm$)$
Miss Mary Moore

215 Drawing of the Artist's Sister, c. 1926
Chalk, pen and wash
10×7 in approx. $(25 \cdot 4 \times 17 \cdot 8$ cm$)$
Private

216 Sister of Henry Moore, 1927
Pen and wash
$14\frac{3}{4} \times 10\frac{1}{2}$ in $(37 \cdot 5 \times 26 \cdot 7$ cm$)$
M. F. Feheley, Toronto

217 Shelter Scene: Swathed Figures with Children, c. 1941
Pen, chalk and watercolour
$14\frac{1}{2} \times 22$ in $(36 \cdot 8 \times 55 \cdot 9$ cm$)$
Private

218 Shelter Scene: Two Swathed Figures, 1941
Chalk, pen and watercolour
11×15 in $(28 \times 38 \cdot 1$ cm$)$
City Art Gallery, Manchester

219 Study for Northampton Madonna, 1943
Pen, chalk and wash
9×7 in $(22 \cdot 9 \times 17 \cdot 8$ cm$)$
Detroit Institute of Arts

220 Study for Northampton Madonna, 1943
Pen, chalk and wash
$8\frac{7}{8} \times 7$ in $(22 \cdot 5 \times 17 \cdot 8$ cm$)$
Palmer Estate Loan to the Art Institute of Chicago

221 Madonna and Child, 1943
Pen, chalk and wash
9×7 in $(22 \cdot 9 \times 17 \cdot 8$ cm$)$
The Cleveland Museum of Art

222 Madonna and Child (detail), 1943/44
Hornton stone
H. 59 in $(149 \cdot 8$ cm$)$
Church of St Matthew, Northampton

223 Mother and Child in Setting, 1944
Watercolour, chalk and pen
17×22 in $(43 \cdot 2 \times 55 \cdot 9$ cm$)$
Lord Clark

224 Family Group: Twins, 1944
Chalk, pen and watercolour
$18\frac{1}{8} \times 14$ in $(46 \times 35 \cdot 6$ cm$)$
Robert H. Tannahill, Michigan

225 Family Group, 1944
Chalk, pen and watercolour
$7\frac{1}{4} \times 6\frac{3}{4}$ in $(18 \cdot 4 \times 17 \cdot 2$ cm$)$
Mrs Irina Moore

226 The Family, Project for Sculpture, 1944
Chalk, pen and wash
26×22 in $(66 \cdot 1 \times 55 \cdot 9$ cm$)$
Sir Michael Balcon

227 Family Group (Page from Sketchbook), 1944
Chalk, pen and wash
$9 \times 6\frac{1}{2}$ in approx. $(22 \cdot 9 \times 16 \cdot 5$ cm$)$
Private

228 Family Groups in Settings, 1944
Pen, chalk and watercolour
24×17 in approx. $(61 \times 43 \cdot 2$ cm$)$
Private

229 Studies for a Family Group, c. 1944
Chalk, pen and watercolour
$8\frac{1}{4} \times 6\frac{1}{2}$ in $(21 \times 16 \cdot 5$ cm$)$
Grant-Munger Collection, Fine Arts Gallery of San Diego, Calif.

230 Family Group, 1944
Chalk and watercolour
$21\frac{3}{4} \times 14\frac{1}{2}$ in $(55 \cdot 2 \times 36 \cdot 8$ cm$)$
Kunstmuseum, Göteborg

231 Family Groups, 1944
Chalk, pen and watercolour
$19\frac{1}{2} \times 12\frac{1}{2}$ in approx. ($49 \cdot 5 \times 31 \cdot 7$ cm)
Miss Jill Craigie, London

232 Two Studies for a Family Group, 1944
Chalk, pen and watercolour
$21\frac{3}{4} \times 12\frac{5}{8}$ in ($55 \cdot 2 \times 32 \cdot 1$ cm)
Private, USA

233 Family Groups, 1948
Watercolour, pen and crayon
$18 \times 20\frac{1}{2}$ in ($45 \cdot 7 \times 52 \cdot 1$ cm)
Mrs Irina Moore

234 Family Group, 1949
Pen, crayon and wash
$11\frac{1}{2} \times 9\frac{1}{2}$ in ($29 \cdot 2 \times 24 \cdot 1$ cm)
North Carolina Museum of Art

235 Studies of the Artist's Child, 1947
Pen, pencil, chalk and watercolour
$11\frac{1}{2} \times 9\frac{1}{2}$ in ($29 \cdot 2 \times 24 \cdot 1$ cm)
Miss Mary Moore

236 Child Studies (Mary as a Baby), 1946
Pencil
$12\frac{1}{8} \times 10\frac{3}{4}$ in ($30 \cdot 8 \times 27 \cdot 3$ cm)
The artist

237 The Rocking Chair, 1948
Chalk, pen and watercolour
$20 \times 27\frac{1}{2}$ in approx. ($50 \cdot 8 \times 69 \cdot 8$ cm)
The Hon. Lady Cochrane

238 Two Women Seated at a Table, 1948
Chalk, pen and watercolour
$20\frac{1}{2} \times 22$ in ($52 \cdot 1 \times 55 \cdot 9$ cm)
Sir Robert and Lady Sainsbury

239 Women Winding Wool, 1948
Pencil, chalk and wash
21×21 in ($53 \cdot 3 \times 53 \cdot 3$ cm)
Arts Council of Great Britain, London

240 Seated Figure Knitting, 1948
Pen, chalk and watercolour
Lady Walston, Cambridge

241 Two Seated Women, 1949
Watercolour, chalk and ink
23×22 in ($58 \cdot 4 \times 55 \cdot 9$ cm)
Private

242 Women Winding Wool, 1949
Watercolour, crayon and pen
$13\frac{3}{4} \times 25$ in ($34 \cdot 9 \times 63 \cdot 5$ cm)

243 Three Seated Figures, 1971
Black chalk and wash
$11\frac{3}{4} \times 17$ in ($29 \cdot 9 \times 43 \cdot 2$ cm)
The artist

244 Page 36 from Sheep Sketchbook, 1972
Black ballpoint
$8\frac{1}{4} \times 9\frac{7}{8}$ in ($21 \times 25 \cdot 1$ cm)
The artist

245 Page 38 from Sheep Sketchbook, 1972
Black ballpoint
$8\frac{1}{4} \times 9\frac{7}{8}$ in ($21 \times 25 \cdot 1$ cm)
The artist

246 Page 45 from Sheep Sketchbook, 1973
Black ballpoint
$8\frac{1}{4} \times 9\frac{7}{8}$ in ($21 \times 25 \cdot 1$ cm)
The artist

247 Standing Figures: Ideas for Metal Sculpture, 1948
Chalk and watercolour
$11\frac{1}{2} \times 9\frac{1}{2}$ in ($29 \cdot 2 \times 24 \cdot 1$ cm)
Private

248 Standing Forms, 1949/50
Crayon and wash
23×20 in ($58 \cdot 4 \times 50 \cdot 8$ cm)
Private

249 Three Standing Figures, 1951
Black crayon and watercolour
$19\frac{1}{2} \times 15\frac{1}{4}$ in ($49 \cdot 5 \times 38 \cdot 8$ cm)
The Art Institute of Chicago

250 Tree Forms as Mother and Child, 1950
Pencil and watercolour
22×15 in ($55 \cdot 9 \times 38 \cdot 1$ cm)
Lord Clark

251 Group of Seated Figures, 1950
Watercolour and crayon
$14\frac{3}{4} \times 11\frac{3}{8}$ in ($37 \cdot 5 \times 28 \cdot 9$ cm)
Mrs Ayala Zacks, Toronto

252 Studies for Seated Figure, 1951
Pencil, chalk and wash
$11\frac{1}{2} \times 9\frac{1}{2}$ in ($29 \cdot 2 \times 24 \cdot 1$ cm)
Private

325

253 Drawing for UNESCO Reclining Figure, 1955
Pencil
$11\frac{3}{8} \times 9\frac{3}{8}$ in $(28 \cdot 9 \times 23 \cdot 8$ cm)
The artist

254 Drawing for Sculpture: Two-piece Reclining Figures, 1959
Crayon, pen and wash
$11\frac{1}{2} \times 9\frac{1}{4}$ in $(29 \cdot 2 \times 23 \cdot 5$ cm)
Mrs Irina Moore

255 Page 1 from a Sketchbook, 1961/62: Two Draped Reclining Figures, 1961
Crayon, ink and watercolour
$11\frac{1}{2} \times 9\frac{1}{2}$ in $(29 \cdot 2 \times 24 \cdot 1$ cm)
Private

256 Study for Reclining Sculptures, 1961
Crayon and watercolour
$11\frac{1}{2} \times 9\frac{1}{2}$ in $(29 \cdot 2 \times 24 \cdot 1$ cm)
Private, Canada

257 Page XVI from a Sketchbook, 1961/62
Pencil, crayon and watercolour
$11\frac{1}{2} \times 9\frac{1}{2}$ in $(29 \cdot 2 \times 24 \cdot 1$ cm)
Mrs Irina Moore

258 Two Green Reclining Figures, 1966
Pen and watercolour
$11\frac{1}{2} \times 9\frac{1}{2}$ in $(29 \cdot 2 \times 24 \cdot 1$ cm)
Private

259 Sculptural Idea. 1961
Crayon and watercolour
$11\frac{1}{2} \times 9\frac{1}{2}$ in $(29 \cdot 2 \times 24 \cdot 1$ cm)
The artist

260 Storm at Sea, 1970
$6\frac{3}{4} \times 10$ in $(17 \cdot 2 \times 25 \cdot 4$ cm)
The artist

261 Drawing, 1970
Pen and brush (with black and brown ink)
$6\frac{7}{8} \times 10$ in $(17 \cdot 5 \times 25 \cdot 4$ cm)
The artist

262 Six Sculpture Motives No. VIII, 1970/71
Pen and wash
$10 \times 6\frac{3}{4}$ in $(25 \cdot 4 \times 17 \cdot 2$ cm)
Private

263 Two Standing Figures No. XV, 1970
Pen and wash
$10 \times 6\frac{5}{8}$ in $(25 \cdot 4 \times 16 \cdot 8$ cm)
Private

264 Sculptural Form, 1971
Black and red chalk and wash
$11\frac{3}{8} \times 13\frac{3}{8}$ in $(28 \cdot 9 \times 34$ cm)
The artist

231 Family Groups, 1944
Chalk, pen and watercolour
$19\frac{1}{2} \times 12\frac{1}{2}$ in approx. ($49 \cdot 5 \times 31 \cdot 7$ cm)
Miss Jill Craigie, London

232 Two Studies for a Family Group, 1944
Chalk, pen and watercolour
$21\frac{3}{4} \times 12\frac{5}{8}$ in ($55 \cdot 2 \times 32 \cdot 1$ cm)
Private, USA

233 Family Groups, 1948
Watercolour, pen and crayon
$18 \times 20\frac{1}{2}$ in ($45 \cdot 7 \times 52 \cdot 1$ cm)
Mrs Irina Moore

234 Family Group, 1949
Pen, crayon and wash
$11\frac{1}{2} \times 9\frac{1}{2}$ in ($29 \cdot 2 \times 24 \cdot 1$ cm)
North Carolina Museum of Art

235 Studies of the Artist's Child, 1947
Pen, pencil, chalk and watercolour
$11\frac{1}{2} \times 9\frac{1}{2}$ in ($29 \cdot 2 \times 24 \cdot 1$ cm)
Miss Mary Moore

236 Child Studies (Mary as a Baby), 1946
Pencil
$12\frac{1}{8} \times 10\frac{3}{4}$ in ($30 \cdot 8 \times 27 \cdot 3$ cm)
The artist

237 The Rocking Chair, 1948
Chalk, pen and watercolour
$20 \times 27\frac{1}{2}$ in approx. ($50 \cdot 8 \times 69 \cdot 8$ cm)
The Hon. Lady Cochrane

238 Two Women Seated at a Table, 1948
Chalk, pen and watercolour
$20\frac{1}{2} \times 22$ in ($52 \cdot 1 \times 55 \cdot 9$ cm)
Sir Robert and Lady Sainsbury

239 Women Winding Wool, 1948
Pencil, chalk and wash
21×21 in ($53 \cdot 3 \times 53 \cdot 3$ cm)
Arts Council of Great Britain, London

240 Seated Figure Knitting, 1948
Pen, chalk and watercolour
Lady Walston, Cambridge

241 Two Seated Women, 1949
Watercolour, chalk and ink
23×22 in ($58 \cdot 4 \times 55 \cdot 9$ cm)
Private

242 Women Winding Wool, 1949
Watercolour, crayon and pen
$13\frac{3}{4} \times 25$ in ($34 \cdot 9 \times 63 \cdot 5$ cm)

243 Three Seated Figures, 1971
Black chalk and wash
$11\frac{3}{4} \times 17$ in ($29 \cdot 9 \times 43 \cdot 2$ cm)
The artist

244 Page 36 from Sheep Sketchbook, 1972
Black ballpoint
$8\frac{1}{4} \times 9\frac{7}{8}$ in ($21 \times 25 \cdot 1$ cm)
The artist

245 Page 38 from Sheep Sketchbook, 1972
Black ballpoint
$8\frac{1}{4} \times 9\frac{7}{8}$ in ($21 \times 25 \cdot 1$ cm)
The artist

246 Page 45 from Sheep Sketchbook, 1973
Black ballpoint
$8\frac{1}{4} \times 9\frac{7}{8}$ in ($21 \times 25 \cdot 1$ cm)
The artist

247 Standing Figures: Ideas for Metal Sculpture, 1948
Chalk and watercolour
$11\frac{1}{2} \times 9\frac{1}{2}$ in ($29 \cdot 2 \times 24 \cdot 1$ cm)
Private

248 Standing Forms, 1949/50
Crayon and wash
23×20 in ($58 \cdot 4 \times 50 \cdot 8$ cm)
Private

249 Three Standing Figures, 1951
Black crayon and watercolour
$19\frac{1}{2} \times 15\frac{1}{4}$ in ($49 \cdot 5 \times 38 \cdot 8$ cm)
The Art Institute of Chicago

250 Tree Forms as Mother and Child, 1950
Pencil and watercolour
22×15 in ($55 \cdot 9 \times 38 \cdot 1$ cm)
Lord Clark

251 Group of Seated Figures, 1950
Watercolour and crayon
$14\frac{3}{4} \times 11\frac{3}{8}$ in ($37 \cdot 5 \times 28 \cdot 9$ cm)
Mrs Ayala Zacks, Toronto

252 Studies for Seated Figure, 1951
Pencil, chalk and wash
$11\frac{1}{2} \times 9\frac{1}{2}$ in ($29 \cdot 2 \times 24 \cdot 1$ cm)
Private

253 Drawing for UNESCO Reclining Figure, 1955
Pencil
$11\frac{3}{8} \times 9\frac{3}{8}$ in (28·9 × 23·8 cm)
The artist

254 Drawing for Sculpture: Two-piece Reclin-
ing Figures, 1959
Crayon, pen and wash
$11\frac{1}{2} \times 9\frac{1}{4}$ in (29·2 × 23·5 cm)
Mrs Irina Moore

255 Page 1 from a Sketchbook, 1961/62: Two
Draped Reclining Figures, 1961
Crayon, ink and watercolour
$11\frac{1}{2} \times 9\frac{1}{2}$ in (29·2 × 24·1 cm)
Private

256 Study for Reclining Sculptures, 1961
Crayon and watercolour
$11\frac{1}{2} \times 9\frac{1}{2}$ in (29·2 × 24·1 cm)
Private, Canada

257 Page XVI from a Sketchbook, 1961/62
Pencil, crayon and watercolour
$11\frac{1}{2} \times 9\frac{1}{2}$ in (29·2 × 24·1 cm)
Mrs Irina Moore

258 Two Green Reclining Figures, 1966
Pen and watercolour
$11\frac{1}{2} \times 9\frac{1}{2}$ in (29·2 × 24·1 cm)
Private

259 Sculptural Idea. 1961
Crayon and watercolour
$11\frac{1}{2} \times 9\frac{1}{2}$ in (29·2 × 24·1 cm)
The artist

260 Storm at Sea, 1970
$6\frac{3}{4} \times 10$ in (17·2 × 25·4 cm)
The artist

261 Drawing, 1970
Pen and brush (with black and brown ink)
$6\frac{7}{8} \times 10$ in (17·5 × 25·4 cm)
The artist

262 Six Sculpture Motives No. VIII, 1970/71
Pen and wash
$10 \times 6\frac{3}{4}$ in (25·4 × 17·2 cm)
Private

263 Two Standing Figures No. XV, 1970
Pen and wash
$10 \times 6\frac{5}{8}$ in (25·4 × 16·8 cm)
Private

264 Sculptural Form, 1971
Black and red chalk and wash
$11\frac{3}{8} \times 13\frac{3}{8}$ in (28·9 × 34 cm)
The artist